ART IN MUSEUMS

New Research in Museum Studies: An International Series

Series Editor Professor Susan Pearce (Director, Department of Museum Studies, University of Leicester)
Reviews Editor Dr Eilean Hooper-Greenhill

This important series is designed to act as a forum for the dissemination and discussion of new research currently being undertaken in the field of museum studies. It covers the whole museum field and, broadly, addresses the history and operation of the museum as a cultural phenomenon. The papers are of a high academic standard, but they are also intended to relate directly to matters of immediate museum concern.

NEW RESEARCH IN MUSEUM STUDIES
An International Series

5

Art in Museums

Edited by Susan Pearce

ATHLONE
London & Atlantic Highlands, NJ

First published 1995 by The Athlone Press
1 Park Drive, London NW11 7SG and
165 First Avenue, Atlantic Highlands, NJ 07716

© The Athlone Press 1995

British Library Cataloguing in Publication Data
*A catalogue record for this book is available from
the British Library*

ISBN 0 485 90005 X

Library of Congress Cataloging in Publication Data
Art in museums / edited by Susan Pearce.
 p. cm. — (New research in museum studies : 5)
 Includes bibliographical references and index.
 ISBN 0–485–90005–X
 1. Art museums–Management. 2. Artists and museums.
3. Art patronage. I. Pearce, Susan M. II. Series.
N420.A75 1995
708'.0068—dc20 94–48059
 CIP

Typeset by Westkey Ltd, Falmouth, Cornwall
Printed and bound in Great Britain by The University Press,
Cambridge

Contents

List of Figures vii
List of Plates viii
List of Tables x

Editorial Introduction
Susan M. Pearce 1

PART ONE

1 The Chantrey Episode: Art Classification, Museums
 and the State, *c*1870–1920
 Gordon Fyfe 5

2 The Origins of the Early Picture Gallery Catalogue in
 Europe, and its Manifestation in Victorian Britain
 Giles Waterfield 42

3 The Devaluation of 'Cultural Capital': Post-Modern
 Democracy and the Art Blockbuster
 Shearer West 74

4 The Collection Despite Barnes: From Private Preserve
 to Blockbuster
 Vera L. Zolberg 94

5 The Public Interest in the Art Museum's Public
 J. Mark Davidson Schuster 109

6 Audiences – A Curatorial Dilemma
 Eilean Hooper-Greenhill 143

7 Extending the Frame: Forging a New Partnership with
 the Public
 Douglas Worts 164

8 Revolutionary 'Vandalism' and the Birth of the
 Museum: The Effects of a Representation of Modern
 Cultural Terror
 Dominique Poulot 192

9 Rome, the Archetypal Museum, and the Louvre, the
 Negation of Division
 Jean-Louis Déotte 215

10 The Historicality of Art: Royal Academy (1780–1836)
 and Courtauld Institute Galleries (1990–) at Somerset
 House
 Mary Beard and John Henderson 233

PART TWO
Reviews edited by *Eilean Hooper-Greenhill*

'He Shoots! . . . He Scores!!!': Toronto's New Hockey Hall
of Fame is a Winner
Douglas Worts 261

St Mungo's Museum of Religious Art and Life, Glasgow
Timothy Ambrose 265

From Petrarch to Huizinga: The Visual Arts as an
Historical Source
J. Pedro Lorente 268

Report on the Conference 'Towards the Genealogy of the
Museum', Nationalmuseet, Copenhagen, 23–25 September
1993
Gaynor Kavanagh 271

Call for Papers for Forthcoming Volumes 274
Editorial Policy 275
Notes on Contributors 276

Index 282

List of Figures

Figure 1.1 Floor plan of the early Tate Gallery showing
 locations of the Chantrey Bequest acquisitions 16
Figure 5.1 Comparison of the overall participation rates for
 art museums 122
Figure 7.1 A revised museum communication strategy 188
Figure 7.2 Conceptual model of museum experience 189
Figure 10.1 Courtauld Institute Galleries at Somerset House
 (1990) 239

List of Plates

Plate 1	Views of the Chantrey Rooms at the Tate Gallery at the end of the nineteenth century	22
Plate 2	Title page, *Catalogue Raisonné* of the Marquis of Stafford's Collection, by John Britton, 1808	53
Plate 3	Title page, catalogue of Marquis of Stafford's collection, by W.Y. Ottley, 1818	53
Plate 4	Title page, first catalogue of Dulwich College Picture Gallery *c*1818	57
Plate 5	Title page, catalogue of Mappin Art Gallery, Sheffield, 1914	69
Plate 6	Japanese breakfast tray, Horniman Museum, London	156
Plate 7	Japanese clothes, Horniman Museum, London	156
Plate 8	Copy of Lawren Harris's *Above Lake Superior* by a 14-year-old girl	172
Plate 9	A child's adaptation of Tom Thomson's painting *The West Wind*	172
Plate 10	Adaptation of landscape by Arthur Lismer	174
Plate 11	Image of Canadian landscape	174
Plate 12	Adaptation of a Lawren Harris painting	176
Plate 13	Visitor's reflection on town where her grandmother was born	176
Plate 14	Image of poverty	178
Plate 15	Image of a dollar sign	178
Plate 16	Projecting self into the picture	180
Plate 17	Response of a self-proclaimed 'psychic artist'	180
Plate 18	Response stressing images of death	182
Plate 19	Perspective on death imagery	182
Plate 20	Response stressing personal involvement	184
Plate 21	Reaction through transforming judgement	184
Plate 22	The Courtauld Institute Galleries, 1958: Woburn Square, London.	238

Plate 23 The Courtauld Institute Galleries, 1990:
 Gallery 5. 238
Plate 24 The Courtauld Institute Galleries, 1990:
 Gallery 8. 246
Plate 25 *The Royal Academy's Great Exhibition Room*,
 1787: P. Martini 246
Plate 26 *The Academicians of the Royal Academy*,
 *c*1772: J. Zoffany 256

List of Tables

Table 5.1 A cross-national comparison of museum
 participation rates: the United States 116
Table 5.2 Participation rates for art museums by country 121
Table 5.3a A cross-national comparison of art museum
 participation rates: Great Britain. How often do
 you go to the following? 124
Table 5.3b A cross-national comparison of art museum
 participation rates: Great Britain. Arts and cultural
 activities: which do you attend? 125
Table 5.4a A cross-national comparison of art museum
 participation rates: the Netherlands. Have you
 visited a gallery in the past twelve months? 126
Table 5.4b A cross-national comparison of art museum
 participation rates: the Netherlands. How often do
 you visit museums/exhibitions? 127
Table 5.5 A cross-national comparison of art museum
 participation rates: France. Which of these activities
 have you done in the past twelve months? 128
Table 5.6 A cross-national comparison of art museum
 participation rates: Spain 129
Table 5.7 A cross-national comparison of art museum
 participation rates: Sweden 130
Table 5.8 A cross-national comparison of art museum
 participation rates: Norway 131
Table 5.9 A cross-national comparison of art museum
 participation rates: Finland 132
Table 5.10 A cross-national comparison of art museum
 participation rates: Québec 133
Table 5.11 A cross-national comparison of art museum
 participation rates: Austria 134
Table 5.12 A cross-national comparison of art museum
 participation rates: Ireland 135

Editorial Introduction

Susan M. Pearce

Art occupies a particular – we might even say peculiar – position in both life and museums. The notion of 'art' is far from self-evident, and its development is bound up with the development of modernism itself, and with modernism's characteristic institutions, among which should be counted museums and art galleries. The genealogies of 'art' and 'museum', therefore, run hand in hand, and it is to the construction of this mutual genealogy that, one way or another, the papers in this volume are addressed.

Several papers in the volume draw out the broad parameters of this history by discussing important, specific locations where the construction of 'art' and exhibition achieved significant form: Fyfe discusses the Chantrey episode in the history of the Tate and the Royal Academy, Waterfield the significance of gallery catalogues, Poulot and Déotte the interrelationships of the ideas of 'art' and 'museum' in the French Revolution, and Beard and Henderson the practices of art-on-display at Somerset House, London.

The other group of papers explores the relationship of art museums and galleries to the public, particularly the contemporary public; what might be called the interaction between historical genealogy and post-modern society. West considers the blockbuster as an aspect of post-modern democracy and Zolberg the transmutation of the Barnes Collection. Schuster and Hooper-Greenhill discuss the dilemma inherent in the display of art to a broad public, and Worts describes one interesting public art programme in Canada.

Since this volume is aimed at an English reading public, a little historical context for the two papers by our French colleagues may be helpful. The causes of the French Revolution, which is usually dated from the assembling of the French States-General (a gathering of representatives of the nobles, clergy, and the rest – the Third Estate) in May 1789, are a matter of debate, but certainly included an ideological climate which rejected all medieval or feudal notions

1

and customs in favour of a stance of philosophical enlightenment. Unfortunately, as the Revolution progressed, this rejection some-times included the deliberate destruction – vandalism – of all works of art and culture which were 'medieval' or religious in nature. The same desire for the rational led to a (short-lived) Revolutionary calendar in which the traditional names of the months were dis-carded in favour of names like 'Nivôse' ('Snowy') which reflected natural events. These were parodied in the English press as 'Wheezy, Sneezy, Freezy, Heaty, Wheaty, Winey' and so on. In the same way, the Revolution was taken as a new beginning, and counted as the Year 1.

As the Revolution gathered strength, the Paris mob, known as 'sans-culottes' because they were in rags, became politically import-ant: in July 1789 they stormed the Bastille Prison. The States-Gen-eral amalgamated to become the National Assembly, and this in turn was succeeded by the Convention. The Convention, in alliance with the mob, allowed the execution of the King in January 1793, and permitted the Terror, which under Robespierre involved mass executions of nobles, priests and political enemies. By July 1794 the country was sick of bloodshed and Robespierre himself went to the guillotine. In the following year, France adopted a new constitu-tion, with a new National Assembly and a Directoire (Directory) of five men: when a small royalist rising took place in Paris it was dispersed by a hitherto-unknown officer, Napoleon Bonaparte. Bonaparte's rise to power had begun, and the Revolution had started its rapid drift into dictatorship.

The papers by Schuster and Hooper-Greenhill both began as lectures delivered to the international conference 'Art Museums and the Price of Success' organized in 1992 by the Boekmanstichtung, Amsterdam: I am grateful to Ineke van Ham-ersveld and Truus Gubbels of Boekmanstichtung for their generous help in making the papers available. Grants towards the costs of translation of the papers by Poulot and Déotte were made by the Universities of Pierre Mendès France, Grenoble, the College Inter-national de Philosophie, Paris, and the Ambassade de France Ser-vice Culturel through the good offices of François-Guillaume Lorrain: I am grateful to all these institutions.

The discussion on the nature of 'art in museums' is gathering momentum and needs to be carried forward. These papers are offered as a contribution to the debate.

PART ONE

1

The Chantrey Episode: Art Classification, Museums and the State, _c_1870–1920

GORDON FYFE[1]

INTRODUCTION

In the second half of the last century, so it seemed to some observers, academy salons and exhibitions were choking on a diet of canvas (White and White, 1965). In Britain and France growing numbers of would-be exhibitors had their submissions rejected or badly placed at overcrowded shows. The problem flowed from a contradiction between centralized academic systems and the enlargement of national professions which serviced the demands of dispersed bourgeois markets. Some artists found academies to be at odds with their sense of what it meant to be an artist and sought alternative means of institutional support. A collapse of public trust in academies was attended by the emergence of new modes of authorizing art, in particular that of the critic-dealer system.[2]

These developments had implications for art museums that have not been well explored. Academies were intimately associated with the lives of museums; academicians formed recruitment strata for the officialdoms of museums whilst their works were extensively purchased for national museums such as the Luxembourg in Paris and the Tate Gallery in London. However, at the end of the century this association was increasingly perceived as one inimical to art.

The problem was not an archetypal conflict between artists and museums but one of change in the nature of cultural authority. Against the view that the museum and the modern artist were antithetical, that the museum shackled modern art, Negrin (1993) has convincingly established their interdependence. Indeed, both art museums and academies developed as institutional expressions

5

of the emancipation of art from the ritual and decorative spaces of traditional upper classes. The museum sanctioned the universe of art which was a measure of the difference that the artist made to the world. However, by the late nineteenth century the power of one type of artist, the academician-artist, was widely felt to be at odds with the universalism of art. At this point the antithesis was between the academician-artist and the museum. The museum responded by evicting the academician's art.

Interwoven with the problems of markets and museums was the provocation that was modern painting. Late nineteenth-century gifts of such works to museums were not well received by those content to inherit the academic legacy. In Britain a disagreement between two institutions, the Royal Academy of Arts (RA) and the Tate Gallery, concerned the aesthetic status of modern art. The conflict turned on the divided management of the Chantrey Bequest which was a purchasing fund dedicated to British art. By means of the Bequest, the Tate acquired works of art whose selection was controlled by the RA through the trusteeship of its ruling Council.[3] Under arrangements imposed by the Treasury the Tate Gallery was obliged to accept and display Chantrey works selected by the RA.

Many of the Chantrey purchases were thought by the Tate officials to be unworthy of display in a national collection and symptomatic of a failure to meet the claims of modern art for inclusion. During the course of the early twentieth century the Tate endeavoured to free itself from the thrall of the RA. This endeavour, along with the RA's struggle to defend its interest in the Bequest is referred to here as the Chantrey episode.

The problem of the Bequest was rooted in a struggle over the classification of art. Bourdieu provides one of the most penetrating accounts of the compulsions which drive conflicts over art classification. This paper draws heavily on his analysis of cultural production and on his account of the historical gestation of the cultural field (Bourdieu, 1984; 1993). However, it is suggested that Bourdieu's emphasis on distinction underplays the importance of other dimensions of classification and so vitiates our understanding of art museums. Whilst the art museum was structured by struggles for distinction it was also shaped by other dimensions of classification: namely, community and control.

In exhibiting my case study I show how the Tate Gallery was a site of conflicting principles of classification which structured the

cultural field. A central concern is with the uncertainties which flowed from the cross-cutting ties of different classifications. It was through the medium of the shifting terms of classification that the Tate was able to produce itself as an autonomous gallery of modern art.

THE BEQUEST AND THE CULTURAL FIELD

Haskell (1976) documents countless disputes between connoisseurs which attended rediscoveries of neglected artists from the late eighteenth century. It becomes apparent that discovery and rediscovery were acts of connoisseurship which were linked to changes in cultural authority. First, the search for a fixed classical tradition was gradually displaced by the certainty that controversy in taste was inevitable. Second, Haskell shows that in the past art historical scholarship was *not* cultivated in isolation from the political and religious issues of the day; that nineteenth-century taste was less readily assigned to the domain of the personal than it is in the late twentieth century. What is hinted at in Haskell's record of the mutations of taste is the gestation of a cultural field which produces disbelief in the connection between art and interests. However, an account of the normalizing of rediscovery must go beyond a chronicle of discovery to an account of the structure of the cultural field which authorizes discoveries to be art.

The cultural field is a place of perennial discovery and discord: '[t]he definition of cultural nobility is the stake in a struggle which has been going on unceasingly, from the seventeenth century to the present day' (Bourdieu, 1984: 2). The prize has been the privileging of a pure aesthetic over a popular aesthetic which appropriates images in terms of their function. A pure aesthetic is one where 'judgement never gives the image of the object autonomy with respect to the object of the image' (Bourdieu, 1980a: 245). The controversies provoked in Britain by the reception of impressionist and post-impressionist paintings have the hallmark of such a struggle for distinction. Impressionist paintings were first exhibited in Britain in 1870. At two London exhibitions of modern French painting (the Post-Impressionist shows of 1910 and 1912) Roger Fry, the artist, critic and curator, staged a reception for modern art whilst, as it were, rubbishing Victorian academy art. These and other exhibitions yielded controversies which fractured the art world and were of a piece with the decline of the RA.

Bourdieu provides an anatomy of the cultural field which sheds light on the forces that produce changes in taste and taste's euphemizing connections with class power. The key concepts are the cultural field and the field of power. To consider the first of these, Bourdieu asks how the position of a writer or artist is constituted through the medium of an historically produced social space understood as a field of struggles for the monopoly of the power to define art. What 'carries works of art along' (Bourdieu, 1993: 183) is the struggle among different kinds of artists and interpreters with different positions and dispositions.

Struggles within the cultural field give rise to stylistic displacements (a continual process of naming new, younger, modern styles) so that contemporary art is 'condemned to fall into the past' (Bourdieu, 1980b) as dross or as consecrated art. This cycle of acquiring distinction and suffering its confiscation shapes cultural production through moments of radicalized taste (such as the post-impressionist exhibitions) which signal the claims of newcomers to occupy a privileged social and aesthetic position and their authority to displace others' tastes. Change in the meaning of art works is change in the totality that is the field of structured oppositions between established and outsiders, orthodoxy and heterodoxy, pure art and social art and so on. The classics change as the universe of co-existent works changes (Bourdieu, 1993: 31). It follows that a sociology of the nineteenth-century art world must restore those names dropped from the twentieth-century canon; those commercially successful artists such as Alma Tadema dismissed by Fry but whose very existence modified the field and provided the co-ordinates of Fry's taste (Bourdieu, 1993: 197).

By the field of power Bourdieu means the social space of the dominant class which is constituted by struggles for particular forms of capital – industrial, financial and cultural. The cultural field refracts the political and economic forces of the field of power. Bourdieu is concerned with the gestation of the former, with its autonomization – a process whose origins predate the 1800s and which can, for example, be detected in the shaping of the early RA.

The difficulties of centralized academies in containing heterogeneous bourgeois markets yielded new kinds of artists (outsiders, rebels, etc.) who formed new associations (e.g. the New English Art Club) and challenged the authority of the Academy. These were creators who were increasingly at odds with the dominant logic of

bourgeois calculation (i.e. of commercially successful art). A boundary was drawn between renown and reputation. For some artists there was, as it were, an interest in disinterestness in the glittering prizes of academic success; some suspended the immediate gratification of a renown which might impede their struggle for consecration.

In this we see the conceptual purchase of *field*, neither as social background nor as influences on the artist. It denotes a universe which is constituted by the struggles of different kinds of artists for consecration and through the medium of which they produce their identities as artists.

The formation of art institutions after the 1880s (in both Europe and North America) was an enlistment of publics for art *and* their differentiation through strong classification. A pure aesthetic, that is a way of looking which privileged art over mere pictures of things, was institutionalized in museums and other institutions (Bourdieu, 1993; Dimaggio, 1982; 1987; Goblot, 1973; Lang and Lang, 1990). In Britain this put paid to the inclusive aspirations of the mid-nineteenth century museum movement, undermined the power of the RA and provoked the problem of the Chantrey Bequest. The Chantrey episode was the state's acknowledgement of the pure aesthetic, partly as a response to the growing weight of the professional class. Three official Inquiries[4] dealt wholly or in part with the Bequest: the Crewe Report (1904) Curzon Report (1914–16) and Massey Report (1946). They are of interest because they expose the making of an aesthetic partnership between the British state and the professional class.

STATES, MUSEUMS AND CLASSIFICATION

The development of the art museum was interwoven with the process of state formation: it was a part of a cultural process through which superordinate classes organized their dominance over subordinate classes. Corrigan and Sayer (1985) and Bourdieu and Wacquant (1992: 110–13; 1993) show how modern states regulate and conduct identities through their sponsorships of institutions such as schools, exhibitions and museums. A progressive involvement of states in cultural classification (e.g. through schooling, public museums, exhibitions, etc.) organized and privileged bourgeois identities. Nineteenth-century museum building programmes

were extensions of state power – they were a double action by which the state encouraged certain human capacities 'whilst suppressing, marginalizing, eroding, undermining others' (Corrigan and Sayer, 1985: 4).

The arrangements of museums are never frozen. Museum classification, as with all classifications, contains contradictions. Museums map the culture of a capitalism whose contradictions escape and disrupt the projections of the former. The making of national collections of art is never completed, never completely tidied up because they are precipitates of continuing cultural struggles which are not innocent in relation to the uncertainties of the distribution of power. To understand why this is so it is necessary to consider the classification more directly as a social relationship.

As an institution dedicated to the acquisition, documentation, preservation and display of artefacts which it sets apart from the mundane world, the museum is an agency of cultural classification: museums *select* and *combine* artefacts which they exhibit to a public(s). Objects may be selected according to a variety of surface criteria (e.g. as masterpieces of art, as pivotal moments in the development of science) and may be displayed according to a variety of principles (e.g. in historical order, in recreation of their original contexts).

Following Bernstein (1971) and Dimaggio (1982; 1987) cultural classification at museums may be defined as the encoding of power relations between groups in differentiating rituals. Relations of power are encoded in the principles of selection and organization that are to be found at museum installations and exhibitions. Two, analytically distinct, aspects of classification warrant attention – the sign and the social class interdependencies which subtend the sign.

At the heart of the sign is the relationship between signifier to signified (e.g. painting as signifier and art as signified). Classification naturalizes the relationship between signifier and signified so that, for example, an image of the Virgin Mary *is* the Virgin Mary, a painting of mother and child *is* a Crivelli, or Whistler's mother *is* art. Classification is a stabilization of signs which has as its obverse instability, i.e. signifiers may slip past their signifieds and form new associations, as when inappropriate objects are selected for display or when artefacts are dropped from the canon.

Art classification is not something which one group or agency (such as the state) does to another, but of cultural interdependencies

(which may be more or less symmetric) between two or more groups which compete for the advantages of symbolic power and difference. Such interdependencies usually take the form, not of a single relationship between two groups, but of a chain of interdependent classes or groups (e.g. the business class, professions, fractions of the middle class and working class). A feature of such interdependencies is the struggle of dominant groups to stabilize signs, to freeze classification whilst disrupting the classification of subordinate groups. Stabilization can be fragile – the flux that is the multi-polarity of classification may offer the potential of realignments between groups which transform the rules of classification and admit new artefacts to the canon.

In modernizing societies struggles to stabilize signs have occurred in three dimensions of classification: distinction, group and control. The state's sponsorship of museums (along with other cultural institutions) was a response to these dimensions of class formation. Where other contributions to a sociology of museum and classification have tended to emphasize one dimension – namely, the struggle for distinction – I focus on three dimensions of classification that are policed by the cultural institutions of industrial capitalist societies. Art museums and their officers are locked into social divisions of cultural labour; they produce collections through the medium of the contradictory relations of classification in which they are embedded. Museums are institutional sites at which social relations of power (those of status, nation and discipline) are encoded in the differentiating rituals of collecting, display and preservation. The three dimensions of classification are relations of cultural interdependence between groups which subtend museums.

Classification as distinction
During the nineteenth century art academies melded two economies of distinction: one was rooted in patrimonial authority, the other in the impersonal authority of the market. Whilst they bore the inscription of patrimonial power, academies developed as institutions regulating the commercialization of art. They expressed the authority of a patronage that was progressively mediated by the market.

Academies had their origins in a courtification of art. Elias (1983) shows how expenditure on luxuries such as art collections was a refinement of court life whose mainspring was competitive

cultural struggle within a 'status-consumption ethos'. In seventeenth-century France the class tensions of state formation placed a premium on royal strategies which exploited the nobility's need for social distance from the bourgeoisie whilst drawing a section of the bourgeoisie into the court through new cultural forms, e.g. academy exhibitions. The king's power was consolidated through cultural tactics which made visible the distance between himself and the nobility. The authority of monarchy was expressed in palaces, academy exhibitions, etc., which illuminated the power of the patron. Moreover, state building had a public symbolic dimension which had not been separated from the private prerogatives of monarchy and the upper classes.

The struggle for distinction, driven by the pressure of bourgeois outsiders for admission to the upper class, was serviced by a commercialization of culture which stretched the lines of communication. The attenuated relations of developing cultural markets spawned institutions of cultural capital – exhibitions, criticism, art dealing, etc. – which mediated the association between insiders and outsiders. Bourgeois revolutions of market and politics stigmatized the power of upper classes who lived off conspicuous competition for leisured distinction as opposed to gainful occupations. Despite national differences in their evolution a common denominator of museums was the transformation (by means of expropriation, donation and purchase) of princely and aristocratic art into national collections.

These developments had two aspects. First, there was privatization of the struggle for distinction so that taste was individualized, interiorized and transformed into cultural capital. Second, the embourgeoisment of central cultural institutions secured a sense of the difference between national art institutions and the private interests of monarchs and princes in collecting. In nineteenth-century Britain privatization of taste was well advanced as the RA struggled to regulate the instabilities of the market. Nonetheless, particularly in its early years, London's RA (as a Society institution with a royal connection) bore the traces of patrimonial power.

The interplay between the private and the public gave the RA its character as the most powerful fine arts institution in Victorian Britain. It made the Exhibition a strategic site of art classification. It was there that the profession displayed its achievements, it was there that Society flocked to judge the results. As a fashionable

institution with its annual rituals of dining and private viewing, the RA and its Exhibition translated the status struggles of Victorian Society into the hierarchies of art. It was a strand in the institutional fabric of the Season through which the aristocratic identity of the upper class was secured within a developing capitalist society.

Bourgeois occupation of institutions such as art exhibitions, which were hegemonized by aristocracies, favoured an estate system of cultural stratification. Fashionable art institutions, such as the RA Exhibition, were compatible with an enlisting of subaltern classes as juniors in a battle for distinction that did not endanger an enduringly superior upper class. The relationship between art and power was patent; judgements of taste were interwoven with the conviviality of Good Society.

The residues of patrimonial cultural power came under attack from the reforming bourgeoisie which had emerged in the wake of industrial modernization and which saw the RA as an unreformed cultural monopoly. Moreover, the very growth of Society undermined the RA's legislative powers, extended its lines of communication and enhanced the power of interpreters such as dealers and critics to determine value (Bauman, 1992). Thus, in the long run, the processes of status struggle and state formation undermined the capacity of the RA to preside over the art politics of the nation.

British nineteenth-century official arts expenditure points to a society that was well down the modernizing road of containing traditional cultural power. There is a good case for arguing that, in this respect, Britain was more bourgeois than its European counterparts – e.g. in its early containment of royal arts expenditure, in the shaping of the RA itself and in the subordination of official arts expenditure to the Treasury.

A feature of the British state was the Treasury's consolidation of power over other departments of the Civil Service including expenditure by museums and galleries. As Ingham (1984) argues, the Treasury had its sights trained on aristocratic 'appropriation of the state's revenues'. It was informed by a Benthamite/Ricardian reforming ideology of non-interference which also shaped arts policies, for arts expenditure was particularly susceptible to charges of aristocratic excess (Ingham, 1984: 129). Ingham argues 'that the state set itself against a section of the traditional dominant class, but not at the behest of the emerging industrial bourgeoisie' (Ingham, 1984: 9). A purpose-made National Gallery building (opened

in 1838) was sanctioned by a Parliament made wary of voting money to refurbish palaces and for public works by the subterfuge of the Prince Regent (Minihan, 1977: 11). Patronage, collecting and influence over the National Gallery were confirmed as personal rather than official activities of monarchy.

The ideological significance of the arts ran beyond expenditure: they highlighted the virtues of a minimalist state that privatized taste, left individuals to their own creative devices and encouraged donations. The Chantrey arrangements were of a piece with Treasury practices which favoured a gift horse and looked for savings. Most government museum expenditure was sanctioned by Parliamentary votes and paid through the Treasury. The annual purchase grant to the National Gallery was cut from £10,000 to £5,000 at the close of the last century whilst the Tate had no grant from its inception until the 1940s. The Curzon Report reckoned that the annual average Parliamentary grant to the National was £13,262 in the period 1865–89, £6,844 for 1892–1901 and £9,200 for 1902–11 (Curzon Inquiry: 7). In the 1920s gifts to the British Museum and the Victoria and Albert Museum substantially outstripped the values of their purchase grants (PEP Arts Enquiry, 1946: 108–10).

Classification as the projection of group
The development of museums was a process whereby European national bourgeoisies expropriated aristocratic treasures *and* projected myths of national identity. Duncan and Wallach (1980) show how national art museums, by placing artefacts within the scheme of a universal art history, fostered the illusion of a classless society. Art museums proposed art as 'genius mediated by national spirit'; they addressed the visitor as one who shared 'in the spiritual wealth of the nation', but without reference to inequalities of cultural capital as they relate to class, sex and other differences (Duncan and Wallach, 1980: 454). The state's transactions with class were mediated through the symbols of a *national* gallery or museum. Museum art was distanced from interests. Art offered the state a nationalized culture apparently innocent of conflicts that it refereed and struggled to contain.

However, the process of class formation generated a tension in the project of the museum whose universality derived from the shared upper-class culture of European court societies with its classical tradition of old master collecting. National galleries such as the

Luxembourg (opened in 1818) and the Tate (opened in 1897) which proposed local national schools of art were a 'displacement of the centre of gravity [of cultural power] from courtly society on a European scale to various national bourgeois societies' (Clegg, 1989: 256).

Internally, European bourgeois classes were divided by status struggles *and* engaged in struggles for control over subordinate classes. Externally, they were enmeshed in struggles for national symbolic and economic power. The building of museums of national art, such as the Tate, was a process of classification in which European national bourgeoisies defined themselves against each other.

Classification as control
Corrigan and Sayer (1985) detail the state's formation as it projected civilization onto subordinate classes. The latter were brought under surveillance and discipline by means of what Bennett (1988) calls the exhibitionary complex – that configuration of museums and industrial expositions which caught, positioned and disciplined the eye. Whilst classification was the reproduction of the difference between Society and society it was also Society's turning of its own improvement on a working class that it increasingly knew as productive labour.

At museums working-class visitors were encouraged to attend to their demeanour, to restrain their behaviour in favour of others' pleasure and to know the meaning of private contemplation. The politics of art were marked by frank references to class, to personal habits and behaviour, to anxieties concerning the safety of exhibits and the suitability of visitors: 'the promiscuous access of the mob ... the invasion of the populace ... the rush of a crowd' (Shee, 1837: 18–24); 'persons whose filthy dress tainted the atmosphere' (Waagan, 1853: 123); idle people whose children 'cracked nuts' (quoted in Fox, 1977: 75). Creativity became a target of official inquiry and intervention that registered the interdependence of working-class leisure, the requirements of capital accumulation and social control.

THE TATE GALLERY
The Tate was a benefaction by Henry Tate, the Liverpool sugar magnate. The idea for a National Gallery of British Art was precipitated by concern over two matters: congestion at Trafalgar Square

which, some felt, marginalized the British School, and the absence of an English equivalent to the French Luxembourg – namely, a gallery dedicated to contemporary masterpieces by British artists. The Tate's foundation was also part of a reinvigorated campaign to diffuse the arts to the working class, which in the 1880s had spawned the Whitechapel and South London Galleries. The spectre of mass democracy provoked an urgent middle-class sense of the need to dispense the cultural prerequisites of a disciplined citizenship – education, sobriety, morality and taste. The early 1900s were years

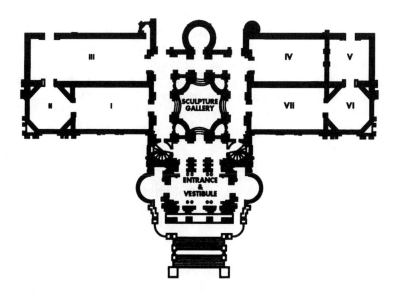

Figure 1.1: Floor plan of the early Tate Gallery showing the locations of the Chantrey Bequest acquisitions in Galleries I and VII (after E. T. Cook, A Popular Handbook to the Tate Gallery, 1898, Macmillan, London).

I Chantrey Collection	IV and V National Gallery pictures
II Watts Collection	VI Watts Collections
III Tate Collection	VII Chantrey Collection.

in which citizenship was defined legislatively (in 1905 and 1914). As others have shown, the museum was one of a panoply of institutions which registered a British imperial identity in which class divisions were supposedly to be dissolved (Coombes, 1991).

The RA had a strong presence at the Tate. The Treasury ruled that the Chantrey Bequest was to be housed at the Tate whilst Tate donated his own collection (largely by RA painters) (Fig. 1.1). RAs were consulted on the design of the Gallery (Hamlyn, 1991). The Tate was under the direct jurisdiction of the Board of Trustees of the National Gallery at Trafalgar Square (where the director was E.J. Poynter, President of the RA).

The Tate's Keepers had their origins in the fragmentation of the late nineteenth-century art world. Charles Holroyd (1861–1917) was a member of the Royal Society of Painter-Etchers (founded to promote etching as an art neglected by the RA). D.S. MacColl (1859–1948), a writer and artist, belonged to the New English Art Club (NEAC) founded in the late 1880s as an alternative to the RA. MacColl was among the New Critics (including R.A. Stevenson and George Moore) who introduced the middle class to the language of the pure gaze which marginalized the subject painting as a work of art and called for the recognition of new aesthetic objects – the quality of the medium, the formal properties of an artist's style (Flint, 1984). Charles Aitken (1869–1936) directed the Whitechapel Gallery (where he showed NEAC work) before joining the Tate. J.B. Manson (1879–1945), a member of the NEAC and later the Camden Town Group, was a painter and writer drawn to Impressionism.

MacColl, Aitken and a later Director, Rothenstein, attacked the RA's Chantrey prerogatives. After MacColl they presided over the Tate's colonization by modern and foreign art. The Curzon Report recommended the acquisition of modern foreign pictures (Curzon Inquiry: 342). There were gifts from a generation of wealthy new collectors – Hugh Lane's legacy (1915), Samuel Courtauld's endowment of a purchasing fund for modern French pictures (1923) and Lord Duveen's provision for a gallery of modern art (1926). Official recognition for the Tate's role as gallery of modern foreign art came with a Treasury Minute of 1917.

As an outpost of the National Gallery, as a National Gallery of British Art, as the recipient of Chantrey purchases and as a gallery of contemporary foreign art, the early Tate had a complex and

uncertain identity. It was caught in the crossfire between (*i*) those RAs who were widely thought of as the British School, were wedded to a representational aesthetic and who pressed their Chantrey rights; (*ii*) those English art groups which had emerged from the modernist revolution and had affiliations with European art, e.g. the NEAC, Allied Artists, the Camden Town Group, the London Group and (*iii*) intermediaries such as the critic Roger Fry who reformulated critical language, named styles (e.g. post-impression-ism) and interpreted the new departures of European modernism to a British audience.

The course charted for the Tate by the National Gallery Trustees was one in which *foreign* was judged to be dangerous water: 'We have not in our minds any idea of experimentalising by rash pur-chase in the occasionally ill-disciplined productions of some con-temporaneous continental schools' (Curzon Inquiry: 342). In the early 1920s the Tate's post-war renaissance was announced with a transfer of British masters from Trafalgar Square and the admission of 'the most advanced types of painting' (Galerien, 1921: 187). In 1924 the essayist E.V. Lucas noted the presence of 'old Royal Academy favourites' *and* the works of foreign artists – Boudin, Degas, Gauguin and Rousseau. In 1934 the *Birmingham Post* ob-served the promotion of a 'peaceful revolution' and the elimination of 'a certain incongruous mixture of Victorianism with contempo-rary work' (Buckman, 1973: 38). By the late 1930s Rothenstein was consigning Chantrey works to store, rehabilitating the Turner col-lection and finding space for the moderns (John Rothenstein, 1966).

THE BEQUEST AND THE STATE

The Chantrey Bequest, the RA and the state c. 1800–70
Sir Francis Chantrey RA (1781–1841) was an academician whose Smilesean success was built on the business of sculpture. His wealth flowed from the demands of fashionable Society for portrait, public and funereal sculpture and from his wife's dowry of £10,000. Mar-riage and career took him from poor craftsman to artist and was of a piece with the RA's consolidation of its professional status and influence. Chantrey made a Bequest of £105,000 for the purchase of works of art.[5] He instructed that the fund be devoted to the encouragement of British fine art only and that the Bequest be

administered by the RA. Chantrey, the Bequest and the man, were creatures of the academic system as it developed and expanded in Britain during the first half of the last century.

The RA was a key player in an expanding state art apparatus. (Charles Eastlake (1793–1865) was a President of the RA and first director of the National Gallery; E.J. Poynter (1836–1919) occupied posts as a President of the RA, as a Director for Art at South Kensington and as a Director of the National Gallery. For a period the RA shared occupancy of the National Gallery building at Trafalgar Square).

The divisions of capitalism pulled the institutions of state art in three directions: towards the ascriptive powers of the aristocracy, towards the developing industrial/middle classes who sought to corral art as cultural capital, and towards the professionals (artists, connoisseurs, dealers, critics, etc.) who produced and interpreted art. The middle class, which had an antagonistic relationship to the privileges of aristocratic culture increased its weight within the world of the official fine arts. At mid-century, industrial capitalists and a growing population of clerical and professional workers shared a middle-class consciousness structured by the economic, political and cultural tensions with the old order (Scott, 1991). Academic ideals of high art history painting were reoriented as a cult which served the national needs of an empowered bourgeoisie. The cult reflected on the Englishness of bourgeois power, retailed the Whiggish story of its progress and depicted the founding myths of its state – e.g. the checking of arbitrary monarchy and the extension of the Franchise (Strong, 1978: 32–3). Robert Vernon (1774–1849), John Sheepshanks (1787–1863) and Henry Tate (1819–99) were among non-aristocratic capitalist patrons who supported a popular anecdotal and moralizing art by artists who were thought of as a British school.

In the 1850s and 1860s South Kensington emerged as a contervailing middle-class force within the state. It grew out of Select Committee proposals of 1835 and was funded by profits from the 1851 Exhibition's celebration of industrial capitalism. Its officers and supporters were outsiders to the fine arts establishment. South Kensington threatened to absorb elements of the fine arts; it established a distinctive architectural and decorative style, forged an educational partnership with industrial capitalism and promoted itself to working-class visitors. It was to South Kensington that one

of the definitively middle-class collections was given (namely, the Sheepshanks collection) whilst it also serviced a middle-class taste for watercolours.

Tensions within the propertied capitalist class gave official art institutions a divided though inclusive character. Pronouncements of statesmen, intellectuals and the developing bourgeois press pointed to art as a medium that would enrol all classes in the mission of civilization: 'the enjoyment of art was accessible alike to the Royal Academician and to Kingsley's labourer wandering the National Gallery' (Minihan, 1977). Divisions between the old and new orders were associated with competitive struggles for cultural hegemony (through religion, art and education) over subordinate classes. The RA exploited the indeterminacies of the field of power; so, for example, it resisted radical bourgeois attempts to open up its affairs to public scrutiny and subordinate it to a reformed parliament. During the 1860s, the RA outmanoeuvred the bureaucratic state. The threat of being put on a 'foreign footing' presumably as a part of an arts ministry, led to talk of the Queen supporting a new academy (C.E. Smith, 1895: vol. 2: 167). Such a proposal was made before a Royal Commission of 1863 (Pearson, 1982: 13) and one of the issues dogging cultural politics in the 1860s was whether or not the RA would go to South Kensington as a part of Prince Albert's grand vision of cultural reorganization (*Survey of London*, 1963; *Survey of London*, 1975).

The RA's institution and development conformed to an Anglo-American pattern in which the professions serviced the state as semi-independent corporations of experts (Johnson, 1982; Savage *et al.* 1992: 29; Torstendahl, 1990: 1–8). There was a symbiosis between state formation and professional autonomy which is evident in the emergence of the RA as an ambiguous, partly private, partly public corporation servicing the state's artistic requirements. By contrast we have the Continental mode (Torstendahl, 1990) as illustrated by the French academy with its élite salaried administrators and teachers, its state monopoly and its official prizes (Pevsner, 1973).

This professional autonomy *vis-à-vis* the state is crucial for understanding the meaning of the Chantrey episode. The gift was an initiative aimed at enhancing the profession *and* encouraging the state to sponsor the building of a national gallery which would celebrate British artists. It became an arrangement which permitted the RA (as Chantrey trustee and as the representative of the profes-

sion) to demonstrate its artistic achievements and to determine the contents of the National Gallery of British Art.

The Chantrey Bequest was a response to the tensions of a developing cultural field in the first half of the century. There was a prohibition on charitable expenditure which was consistent with the RA's professionalizing rupture with friendly society mutuality – something which was still an issue in the 1840s (Pye, 1845). As already noted, Chantrey instructed that the fund be devoted to the encouragement of British Fine Art only, and the RA was to administer the Bequest! Purchases were to be of the highest merit; with the proviso that they were created in Britain works might be by artists of any nation and prices paid were to be liberal.

The object was to create 'a public collection of British fine art'. The Bequest was a substitute for the official patronage which was observed on the Continent but felt to be absent in Britain. It was a response to the widely appreciated problem that the received academic tradition gave professional precedence to an art for which there was little demand by private patrons or by officialdom – namely, history painting in the grand manner.

The Chantrey Bequest, after 1870

By 1903 110 Chantrey works had been acquired. Most were subject paintings with historical, classical, religious and literary themes (*Cromwell at Dunbar*, 1886; *The Bath of Psyche*, 1890; *The Story of Ruth*, 1877; *Amy Robsart*, 1877). There were domestic scenes (*Mother's Darling*, 1885), also historical costume pieces (*My Lady's Garden*, 1899), landscapes, seascapes (an aggregate of 34 works fall into this category). Some were representations of an idealized national past. Others, e.g. seascapes such as *Britannia's Realm* (1886) by Brett or *The Pool of London* (1887) by Parsons, denoted Britain's commercial and imperial identity. Of the 110, 105 had been purchased at the RA's annual Exhibition (*Chantrey and his Bequest*: 27–31). Of about £60,000 expended up to 1903, 'over £30,000 was paid to members of the Academy, between £17,000 and £18,000 to those who shortly after became members, between £12,000 and £13,000 to other exhibitors' (MacColl, 1904: 4–5).

Visitors to the early Tate were confronted by Chantrey paintings which were arranged to occupy rooms to both sides of the sculpture gallery. In this manner assembled assessments of the collection's calibre entered public consciousness.

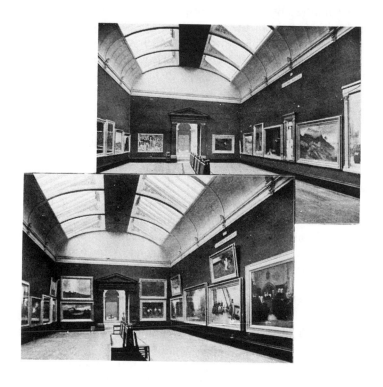

1 Views of the Chantrey Rooms at the Tate Gallery at the end of the nineteenth century (from the *Art Journal*, 1899).

Critics of the collection argued that it was incomplete. Among works thought to be missing were examples of the modern French school and British artists influenced by it. (At the Crewe and Curzon Inquiries witnesses produced lists of unrepresented artists.) Critics thought in terms of lost opportunities: of Whistler's mother rather than *Mother's Darling* and of the failure to acquire the works of foreign artists who had worked in Britain (e.g. before the Crewe Inquiry, MacColl argued that a Monet might have been acquired).

The collection was stigmatized. The RA was accused of purchasing inferior art. Works like Joseph Clarke's *Mother's Darling*, Hubert Herkomer's *Found* and J. Young Hunter's *My Lady's Garden* were seen as examples of Chantrey failure. By the 1930s there were rumours that the worst Chantrey examples were displayed by the Tate 'as a standing reproach' to the Academy. To the Tate the standard of the collection was 'deplorable': 'Alpine valleys, puppies in baskets, ladies in eighteenth century dress standing on chairs, affrighted by mice, and the like' – all exhibited as the 'climax' of the Tate's collection (John Rothenstein, 1966: 4).

In 1949 the collection (now in excess of 400 works) was exhibited as a whole. The proposal for the exhibition had come from the Tate and was understood (by the President of the RA) to be a challenge by the Tate to the RA. It attracted a large audience over eight weeks: in excess of 99,000. Much of the middle-class press was hostile: 'the equivalent of the best seller in fiction' (*The Times*, 8 Jan. 1949); 'a collective taste informed by little more than ostentatious materialism and its concomitant sentimentality' (*The Guardian*, 8 Jan. 1949); 'a skeleton which the Academy has long kept in the Tate Gallery's cupboard' (*News Chronicle*, 8 Jan. 1949) (cf. *Daily Telegraph*, 7 Jan. 1949).

The Bequest figured in public inquiries which sought to determine the legitimacy of the RA's position: a select committee of the House of Lords (the Crewe Report, 1904) and a committee appointed by the Trustees of the National Gallery in 1911 (the Curzon Report). What was at stake was less the question of the RA's guilt (Crewe cleared the RA of corruption) than the production and circulation of an official discourse which proposed the academy's irrelevance to a universal art (and thus its unsuitability to dictate Chantrey choices). The Inquiries gave official recognition to the following: (*a*) that the RA's interpretation of the terms of the Will was unduly narrow, (*b*) that the collection was unrepresentative of British art and (*c*) that the purchases were largely of inferior works. Crewe made two main recommendations: it proposed a broader purchasing base and the establishment of a purchasing committee composed of the President of the RA, one Academician and one Associate Member.

Curzon was more hostile to the RA than Crewe. Curzon observed frankly that his object was to break down the Chantrey arrangement in the face of likely protest from the Chantrey

Trustees. That the Tate could consign Chantrey pictures to store in the 1930s was partly because this was sanctioned by an official discourse that knew Chantrey pictures to be ridiculous.

There was a protracted struggle between the RA and the Tate. The RA was concerned that its rights were threatened; the Tate was on guard against the possibility that the RA's influence at the gallery might grow. After 1917, when proposals to give the Tate independence from Trafalgar Square were first mooted, the atmosphere was one of suspicion and hostility. The Keeper of the Tate, Charles Aitken, expressed the belief that the RA was using the proposals as an opportunity to increase its grip on his gallery.[6] The problem for the Tate was in making the distinction, which it established with the Treasury, between *ex officio* membership of its board by the RA and an individual RA's membership as artist-trustee.

Treasury Minutes of 1897 and 1898 assured the RA that Chantrey's Will was inviolable, that the Tate had no powers of selection or elimination in the Bequest. There were times when the protagonists sat on their absolute rights; there were moments when they thought more pragmatically of 'altered conditions' (Blomfield, 1932: 280) or of 'theoretical rights' (*Chantrey Files* [hereafter CF]: Witt to Aitken, 23 Jan. 1929). Curzon gave currency to the idea that the Tate need not display Chantrey works. In 1918 Chantrey Conferences between the Tate and RA yielded an RA concession – that it would consult the Tate over purchases and in 1922 two Tate representatives joined the committees responsible for selecting Chantrey works. In the late 1920s relations deteriorated; the RA rejected selections in 1926 and 1927 and the Tate boycotted meetings. President Dicksee of the RA insisted that the RA Council reserved the power of final decision in Chantrey choices (*CF*: Dicksee to D'Abernon, 26 Nov. 1927, 7 Dec. 1927). Aitken insisted on the Tate's duty to refuse works deemed unworthy (*CF*: Aitken to Lamb, 26 Nov. 1928). In 1929 the parties were, with the RA under a new President (William Llewellyn), pulling back from complete estrangement.

At the end of the 1930s the Tate was reasserting its position, refusing to hang Chantrey works (John Rothenstein, 1966: 207–17). In 1939 the Director of the Tate admitted that there was justification for a Major Cardew's charge that 'the work of all painters prominent in England from 1850 to 1900 [including many Chantrey works] is

practically excluded' from exhibition (*CF*: Cardew to Lutyens, 8 Jun. 1939; Rothenstein to Lamb, 14 Jun. 1939). By 1946 the Tate was in receipt of a purchasing grant while the Massey Inquiry (reporting in the same year) took for granted Chantrey inferiority. In 1951 the Tate was able to assure the RA's President that 'all causes of friction' had been eliminated despite having complained earlier in the year about the RA's lack of cooperation (*CF*: Rothenstein to Kelly, 12 Jun. 1951). Chantrey choices continued to provoke disagreement. In 1954 the link between the Tate and National Galleries was severed by Act of Parliament and in 1956 it was agreed that the Tate Trustees were 'to receive only those works that they were willing to accept' (Hutchison, 1968: 190). By the 1960s rising government funding had secured the Tate's autonomy *vis-à-vis* the RA.

What *was* the Chantrey problem? At its heart was a struggle over distinction. A powerful, though declining, professional body (the RA) had control over the purchasing fund for a national collection. The fund yielded a collection of stigmatized popular art which was housed at a national gallery which was, in turn, being drawn into the orbit of an esoteric modern art. The dispute was one in which the parties were unable to settle 'out of court' and in which the government (particularly one at war) drew back from radical measures. Whilst the balance of power between the protagonists was often uncertain, the Tate was able to challenge and marginalize, though not expropriate, the Bequest from the RA. How may this be explained? I turn to a consideration of how the shifting balances of class-cultural power increased the autonomy of the Tate *vis-à-vis* Chantrey arrangements.

THE SOCIAL CONSTRUCTION OF THE CHANTREY PROBLEM

At mid-century the three fractions of the upper class – land, finance and industry – were interdependent but not integrated. Divisions within the propertied class had created an expansive fine arts system which had empowered the middle class and (e.g. through the purchases of the Bequest) accommodated its art in a national collection. However, the upper class began to fuse in the face of agricultural depression, changing world markets, the political demands of the working class and the emergence of the representative state. The aristocracy lost its identity as a purely land-owning upper class and was drawn into closer associations with finance, industry

and particularly the professions (Massey and Catalano, 1978; Scott, 1991: 61).

An effect of these changes, combined with the Treasury's funding arrangements, was to make the Tate Gallery a site of competing classifications. On the one hand, confronted by the twin threats of mass democracy and the mass media the state was drawn into the business of creating a national collection of British art; the building of a national collection was imbued with the politics of democracy. On the other hand the structuration, or active constitution, of the upper class favoured realignments between official institutions and spawned new aesthetic partnerships between class fractions and the state. This shifted the balance of class-cultural power at the Tate away from the broader middle class and towards the professional class, just as the decline of land drew the aristocracy into closer association with the cultural state. The Curzon Inquiry brought two subjects into the same frame: the fate of aristocratic art and the making of an aristocracy of culture. Its remit was to 'inquire into the Retention of Important pictures, and other matters connected with the National Art Collections [i.e. the Chantrey Bequest]'.

Recent scholarship establishes the variety of aristocratic responses to agrarian decline, one of which was cultural collaboration with other sections of the upper class (Cannadine, 1990). Aristocrats became stewards of national treasures whose potential for export was converted into a collective anxiety. They were heavily recruited as trustees in the developing national museum system (Cannadine, 1990: 578–81). As museum trustees, aristocrats established an identity that was consonant with the ideological requirements of a disinterested state: Lords Crewe and Curzon presiding over Chantrey inquiries (the former a committee of the House of Lords), the ubiquitous Lord Crawford on the Board of the National Gallery and hatching the BBC, D'Abernon chairing the Tate Board and Lord Plymouth chairing RA – Tate Chantrey conferences in 1918–19. In the late 1930s the Tate Board was 'seignorial in tone, dominated by aristocratic connoisseurs and men of affairs' (John Rothenstein, 1966: 19).

CLASS AND STATE FORMATION

The representative state was at once an interventionist state (Hall, 1984) which enhanced the size of the middle class, increasing the

weight of cultural capital as a basis of power. Between 1880 and 1911 the increase in ten key professions was in excess of 80 per cent and twice as high as this among civil servants (Perkin, 1989: 78–80). As Savage *et al.* (1992) argue, state sponsorship of professional expansion was a distinctive feature of British class formation. As distinct from those who have stressed aristocratic survival as the key to twentieth-century British institutions, Savage *et al.* (whilst acknowledging the effects of divisions within the propertied class) also stress the evolution of a relatively cohesive, male metropolitan professional class. It is significant that the early officers of the Tate were not RAs – by kinship and occupation they had strong affiliations with professions such as banking, the church and teaching.[7]

The balance of cultural power shifted towards the professions. The professional class pressed the privilege of cultural capital *against* economic capital (securing its own reproduction through credentialism) and disqualifying others from speaking on grounds of lack of expertise. Its exploitation of economic capital's dependence on cultural capital went hand in hand with the state's domestication of economic capital (e.g. through taxation and inheritance laws) and with the promotion of cultural capital as a resource to be exploited by the state (e.g. as intelligence, qualifications). The professions had a stake in clarifying and legitimating inequalities of cultural capital as the natural order of things (Carey, 1992). Thus, Fry, who spoke for expertise as a witness before the Chantrey Inquiries and recommended expropriation of the Bequest from the RA, located Alma Tadema's constituency among 'the half educated members of the lower middle class' (Tillyard, 1988: 216).

Middle-class expansion intensified the struggle for distinction as the professions perceived their boundaries to be threatened by a lower-middle-class army of clerks and administrators (Perkin, 1989; Banks, 1954: ch. 7). Political enfranchisement magnified the lower-middle-class sense of working-class incursion – increasingly it sought difference on the terrain of secondary education. At the same time the professional class differentiated itself from the economically superior plutocracy of industrialists and financiers who cultivated aristocratic displays of wealth. The visibility of the plutocrat's search for distinction was the target of cultural strategies that exposed the vulgarity of conspicuous display and the effort that was necessarily a *failure* to achieve the ease of distinction. Through

Du Maurier's Society cartoons of the 1870s and 1880s, through to *Trilby* (Du Maurier, 1896), *Hadrian VII* (Rolfe, 1903), *The New Republic* (Mallock, 1906) as well as memoirs of the late Victorian art world (Carr, 1908) flows the frisson of discovering the outsider artist (e.g. Lawson), the superiority of ascetic distinction and the vulgarity of commercial success.

Professional interests were accommodated by educational reform and by the attack on aristocratic patronage. The Northcote-Trevelyan reforms introducing open competition to the Civil Service were not the elimination of the aristocracy, but its partial displacement towards cultural capital. Gladstone sold reform to the aristocracy on grounds that their distinction from the mass, their superior 'natural' gifts and their acquired advantages of 'birth and training' would stand them in good stead (Ingham, 1984: 139–42). This in a reformed Civil Service which, as he explained, retained recognition for aristocratic merit at the upper echelons. An aesthetic which naturalized the gulf between élite and masses had an affinity with the developing mandarin culture of the Civil Service and particularly with the Treasury.

Reform promoted a cult of public service that drew on the culture of the humanities whilst it marked its distance from the material world of industrial capitalism. As a reworking of the distinction embodied in the aristocratic leisured gentleman it was a middle-class bridgehead to the upper class. Reform endorsed the separation of the routine clerk from the intellectual means of production. A shift towards cultural capital as a basis for power was promoted by an enlarged state enhancing the power of professions and civil service. Chantrey was a problem which *signified* these changes in the social structure; it was a facet of a class structuration which was both economic *and* cultural.

Enlargement of the professions included fine artists and museum officials who challenged the prerogatives of the RA. Art institutions were sites at which struggles to make the difference between mental and routine non manual labour palpable took place. One officer at the National Gallery in the early 1900s believed that he had been passed over for promotion because he had 'needlessly and heedlessly' passed an examination that had tarred him with the brush of Second Division Clerk (Holmes, 1936: 263–4).

The reproduction of the professional class placed it at odds with Chantrey pictures. Their accessibility via the codes of school

history, literature and Victorian morality gave Chantrey art irredeemable provincial and lower-middle-class associations. Its passage through the Exhibition tarred it with the brushes of interest and conspicuous consumption. Expertise, the need for a national collection which was distinguished, the metropolitan sense of London as the locus of cultural power were among the tacit assumptions which drove the Inquiries of 1904 and 1911. They gave coherence to a metropolitan perception of creativity which stigmatized Chantrey pictures. Stigmatization went hand-in-hand with a growing rapport between the Treasury and the Tate. The appointment of MacColl as Keeper at the Tate in 1906 was said to be a strengthening of the anti-Academy lobby in official circles. Before the Curzon Inquiry MacColl claimed the Treasury had encouraged him to create deadlock with the RA by refusing to accept Chantrey pictures.

The Chantrey arrangements were of a piece with the consolidation of Treasury power over the cultural state. A mode of acquisition that was heavily dependent on gifts and bequests corresponded to Treasury practices. Division of responsibility in the management of the national collection does not imply the absence of centralized control over metropolitan galleries and museums. The public players in the Chantrey affair were, of course, the RA and the Tate Gallery. Behind the scenes, was the Treasury controlling expenditure; the situations of the RA and the Tate were interwoven with Treasury power.

In refereeing the Chantrey affair the Treasury was not unsympathetic to the plight of the Tate; consolidation of Treasury power spawned an ethos that was consonant with the aristocratic Curzon style, with the notion of modern art promoted by the Bloomsbury group and other intellectuals. At the same time MacColl of the Tate espoused a philosophy of patronage that was consonant with Treasury aims: 'It is no business of the State directly to "encourage" art any more than it is its business to encourage eating and drinking' (MacColl, 1931: 375). His successor as Keeper at the Tate, Charles Aitken, noted the Tate Board's success in enlisting 'gifts and pictures worth more than a quarter of a million' (*CF*: Aitken to Cameron, 17 Jul. 1920).

The politics of the Bequest may have been linked to an ideological convergence between the Treasury and the Tate. Minihan suggests that there was an *affinity* between the shift away from generous

mid-century cultural subsidies and aesthetic attitudes which drove a wedge between art and the public (Minihan, 1977: 166). Treasury containment of public arts expenditure accompanied artistic ideas which celebrated the antagonism between artists and publics. Why bother funding art when, by definition, the true artist and the actual public were poles apart? It is also plausible that there was an affinity between the spirit of a reformed Treasury and the Tate.

Implementation of open competition was a protracted affair; patronage continued as a feature of the Civil Service into the present century (Bourne, 1986; Cannadine, 1990). Nonetheless, the *process* of professionalization is evident (Cannadine, 1990: 243); '[i]n every ministry, there is a clear point when the old nobility bowed out and the new professionals took over: . . . 1911 in the Treasury' (Cannadine, 1990). Among the key Treasury figures dealing with the Tate and the RA were Francis Mowatt (1837–1919), Thomas Little Heath (1861–1940), J. Bradbury (1872–1950), George Lewis Barstow (1874–1966) and R. S Meiklejohn (1876–1962). Mowatt belongs to an earlier generation but the others were products of an opening-up to new men of talent who arrived via the reformed and élite public schools (Roseveare, 1969: 152–81): a generation whose dazzling intellectual achievements readily fused with aristocratic distinction. Opening up to them was a closure against the mechanical clerk. Reform secured the distinction of mental labour in the service of the state through a translation of aristocratic culture into cultural capital.

THE CULTURAL FIELD

Chantrey made his Will in 1840; it did not come into force until 1877. The collection was not consolidated at a museum till the Tate opened in 1897. When the protagonists came to do discursive battle at the official Inquiries of 1904 and 1911, they projected the wishes of a man who had died before the middle of the previous century onto the cultural field of the early twentieth century. MacColl imagined Chantrey professing support for Degas, Monet, Pissarro and Rodin: 'You must suppose the testator to be a continuing being. If he has to pronounce a judgement on the art of our day you must not have him cut off dead in his grave and put to him things which had not come about in his time' (Crewe Inquiry: 593).

The Inquiries are windows of opportunity for observing the

criss-cross of art classification. We glimpse London County Council schoolchildren at the Tate. We encounter the problem of defining British art. When and where were British artists? Chantrey instructed that works purchased might be executed by artists of any nation provided that they were entirely executed within the *shores of Great Britain*. The Will, as interpreted by RA purchases, proposed a more narrowly national definition of British art. What was the meaning of British in the Will? Did it mean art produced in Britain and perhaps by foreign artists or did it mean art produced by British nationals?

William Armstrong of the National Gallery of Ireland declared that: 'art, to be interesting must be national' (Curzon Inquiry: 64). However, confronted with the ambiguous story of nation-building, faced with a legacy conceived in a less narrowly national tradition of patronage, classification of British art ran into the sands of anachronicity. How many of the early Academicians were foreign (Crewe Inquiry: 521–2)? Was van Dyck, as an artist who had painted in England, to be assigned to the National at Trafalgar Square 'as a foreigner or to the Tate as an Englishman'? (Curzon Inquiry: 406). If the Chantrey Bequest was a national gallery of British art, why were no selections made from Scottish exhibitions? (Crewe Inquiry: 562–3) What was British art? Was modern art really foreign art?

Out of the Chantrey flowed a discourse which sanctioned the autonomy of the cultural field and the struggle for distinction. The 1904 Inquiry expressed concern about the popularity of some Chantrey works: '[t]he collection . . . contains too many pictures of a purely popular character, and too few which reach the degree of artistic distinction aimed at by Sir Francis Chantrey' (Crewe Inquiry: 498). The Committee was echoing the assessments of MacColl who had called for a purchasing policy that 'forestalled public opinion in recognizing genius' and did not go for the most popular pictures of the year.

Critics of the RA were proposing that purchasing art is a wager on the future, one which created a distance between the collector and popular art in the present: 'it is a matter of exact arithmetic to foretell at what date Degas will be added to the canon. In about a year he will be too great to paint as he does; in another year he will have taught us . . . in three he will "make an appeal to the ordinary person". In five years *L'Absinthe*, or some other work of the master,

will be in the National Gallery, if we can afford it' (MacColl, quoted in Thornton, 1938: 25–6). The popular *Trilby* drew its readers into the world of difference between merit and sale: 'this picture is well known to all the world by this time, and sold only last year . . . for three thousand pounds. Thirty-six years! That goes a long way to redeem even three thousand pounds of their cumulative vulgarity' (Du Maurier, 1896: 208.) The gap between present popularity and art was yawning open.

The Will instructed that preference be given to works of the highest merit. Were the most meritorious works those acclaimed at the RA Exhibition? The Inquiries probed the selection practices of the Trustees. Were exhibitions other than the RA Exhibition surveyed? Were works bought under commission? Were portraits candidates for selection? Did the Trustees visit artists' studios? The 1904 Inquiry noted the absence of such visits. Recognition of these omissions signified change in the basis of cultural authority. At stake was the notion that artistic value had a central academic authority rooted in Society which passed down judgements on what the market was doing.

The symbolic revolution of modern art was an autonomization of artistic production in which the hierarchies of academic art were overthrown (Bourdieu, 1993; White and White, 1965). The Inquiries were discursive interventions which elided the relationship between art and power – representing it as the apparently fortuitous association between discovery, discrimination and the artist as autonomous creator. They gave coherence to a radically individuated creativity, uncoupled cultural authority from Society and recognized the world of modern art. However, that uncoupling was a coupling with an empowered professional class. The RA with its Exhibition was a visible source of cultural power so that Society and the Academy shared centres; the turning of the Bequest into a problem was an assault on that system of authorizing creativity.

Whereas the ideology of earlier nineteenth-century collecting reflected interdependence between patrons and a broadly based middle-class patronage, art was now cultivated as distinction from the broader middle class by arts professionals who enlisted the wider professional class. The structuration of the business class was an undermining of the Exhibition as an agency of classification. Collections which had been largely formed from this source, such as those of Thomas Mappin and Henry Tate, lost credibility as art

in the cultural field. Newer collectors such as William Graham, Frederick Leyland and George Rae eschewed the taste of contemporary publics (Macleod, 1987).

CONCLUSION

Assessments of the English reception of modernism and the fate of Victorian painting have usually had a different focus from the one provided here. In the past, as Tillyard (1988) shows, received wisdom dramatized the English reception of modern art by privileging the agency of pioneer critics and collectors at the expense of shifts in the visual habitus of the urbanized professional class. This paper has been concerned with an association between that transition and a reordering of the relations of state cultural power.

Interpretation of the Bequest was pulled in two directions: towards a popular national art which equated merit with RA Exhibition success and towards an élitism which did not expect validation from a contemporary art public. The problem was conflict over art classification; the Tate confronted the difficulty of reconciling the invention of national tradition with the mapping of distinction. The problem was an aspect of state formation.

First, state formation was a process which pitched official institutions against each other; the problem of the Bequest opened up fissures within the state. The key players, the RA, the Tate and the Treasury, constituted a configuration of institutional power caught up in the cross-cutting ties of economic and cultural interdependence which extended into other parts of the state and into the wider society. The protagonists were different kinds of intellectuals – Curzon, that 'most superior person', an aristocrat struggling for office within the bureaucracy of Empire and Viceroy of India, MacColl, Rothenstein and others located as arts officials and, of course, the artists of the RA.

Second, Chantrey was *part* of a remaking of the relationship between knowledge and power which fractured the public sphere of late Victorian culture. The Bequest was a site of official struggle over classification, a struggle to make the difference between art and pictures palpable. Its outcome was a separation of the RA from the means of determining a national collection. In endorsing this separation the state was responding to the autonomization of the cultural field. The collection was, as it were, laid over the shifting

continents of the field of power and the cultural field. Tremors, if not an earthquake, were inevitable.

Third, the outcome of the struggle was the forging of an aesthetic partnership between the state, the professional class and a declining aristocracy. The class politics of British democracy deepened the state's commitment to delivering a national culture to subordinate classes; it spawned a stratum of professionals whose reproduction as a class depended on the struggle for distinction from economically superordinate and culturally subordinate groups. Lord Curzon would have endorsed the critic Hamerton's insistence in the 1870s that '[t]he multitude is not the supreme judge' and Steven's impatience with the painter who cares to score by playing on the literary tastes and social instincts of the crowd (Hamerton, 1889: 270; Stevens, 1897: 4–5).

Fourth, elements within the field of cultural production *and* elements within the field of the state converged on a conception of disinterested patronage. The Treasury favoured gifts. Those of Chantrey and of Tate became problems in that they consecrated commercial production: i.e. they threatened the developing autonomy of the cultural field and drew fire from those artists who had a stake in the distinction of commercial failure.

Lastly, the case has implications for our appreciation of the role of museums as classifying agencies. Museums are not essential subjects which enter cultural politics to pursue their predetermined interests. Nor are they reflexes of external structural forces: a museum collection is the meeting point of structure and agency. Art museums represent coalitions of interests (e.g. between artists, donors, trustees, directors, curators, educators, administrators, marketeers, etc.) which are tied into the cross-cutting principles of classification. The shifting balance of power between these, as it is interwoven with state and society, shapes the character of museums. Museums, like people, do not make their art history in circumstances of their own choosing: they make both it and themselves through the medium of the contradictory relations of art classification in which they are embedded and which may cut across their attempts to forge a singular institutional identity.

Some coalitions may become highly unstable, as did the one between Academy artists and officials at the Tate. The Tate's early officers struggled to separate the RA from the means of determining the collection and to form a collection of modern art. They

attempted to establish the identity of their gallery in the face of adverse Chantrey arrangements. What the Tate meant as a gallery of art cannot always have been clear; it may have seemed that there was more than one Tate Gallery.

NOTES

1 I am grateful to the Tate Gallery for access to the Chantrey Files and to Jennifer Booth and her colleagues at the Tate Gallery Archive for their help. The following have also helped: Christine Fyfe, Helen Hills, Kevin Hetherington, Sharon Macdonald, John Law, Mike Savage, Charles Swann, Brandon Taylor and Chris Wakeling. Versions of the paper have been presented at a meeting of Keele University's Museum Group and at the 1993 Conference of the Association of Art Historians held at the Tate Gallery in London.

2 The pioneering work of the Whites (1965) establishes this for France. On Britain see Fyfe (1986). The 1863 Royal Commission of Inquiry into the Royal Academy (RA) identified want of space as a major problem; by the 1880s an overcrowded annual Exhibition made up a stock of common knowledge about the RA. See Hutchison (1968) for figures on the rising number of submissions and rejections of works at the RA.

3 The RA had two levels of membership. There were 40 full members (RAs) who, with the exception of the first generation were elected from Associate Members (ARAs). There was a maximum of 20 ARAs. ARAs were elected from the exhibitors at the RA annual Exhibition to which all artists were invited to submit their work. Control over selections for the Exhibition was in the hands of the Academy's governing Council.

4 The Chantrey Bequest was sole subject of the Crewe Inquiry, one of two subjects covered by the Curzon Inquiry and one of several covered by the Massey Inquiry:
Chantrey Trust: Report, Proceedings and Minutes of Evidence, Select Committee House of Lords, UK Parliamentary Papers, (1904) 357, v, 493 (Crewe Inquiry).
National Gallery, Committee of Trustees, UK Parliamentary Papers, 1914–16 Cd. 7878, 1914–16 Cd. 7879, (Curzon Inquiry).
The Report of the Committee on the Functions of National Gallery and Tate Gallery and, in respect of paintings, of the Victoria and Albert Museum together with a Memorandum thereon by the Standing Commission on Museums and Galleries, UK Parliamentary Papers, Cmnd 6827, May 1946, 4. (Massey Inquiry).

5 Chantrey's Will was published as an appendix to the Royal Commission inquiring into the affairs of the RA: United Kingdom Parliamentary Papers, 1863: 3205; also in *Chantrey and his Bequest* (1904) 15–22 (extract); MacColl, D.S. (1904).

6 Aitken voiced concern that the RA 'failing to get a favourable reception at the Treasury' had agreed 'nominally to a policy of friendly discussion'. On his account the aim of the RA was to 'limit concession to polite words and meanwhile secure as many Trusteeships as possible with a view to learning the policy of the Board if not dominating it' (*Chantrey Files*: Statement by the Director in Regard to the Four Chantrey Conferences and the Attitude of the Board towards the Treasury in Respect of the Chantrey Bequest). However, the part referring to the policy of the RA is marked 'omitted'.

7 Holroyd (son of a merchant) was originally destined for a career as a mining engineer; MacColl (son of a clergyman) studied at London University; Aitken studied history at Oxford and was a schoolmaster before becoming Director of the Whitechapel Art Gallery; Manson (son of a writer) began his career as a bank clerk, abandoning this to study art in Paris.

BIBLIOGRAPHY

Banks, J.A. (1954) *Prosperity and Parenthood: A Study of Family Planning among the Victorian Middle Classes* (London: Routledge & Kegan Paul).

Bauman, Z. (1992) *Intimations of Postmodernity* (London: Routledge).

Bazin, G. (1958) *Impressionist Paintings in the Louvre* (London: Thames & Hudson).

Bazin, G. (1979) *The Louvre*, rev. edn (London: Thames & Hudson).

Bell, Q. (1963) *The Schools of Design* (London: Routledge & Kegan Paul).

Bennett, T. (1988) 'The exhibitionary complex', *New Formations*, no. 4, 73–102.

Bernstein, Basil (1971) *Class, Codes and Control*, vol. 1 (London: Routledge).

Blomfield, Sir Reginald (1932) *Memoirs of an Architect* (London: Macmillan).

Bodkin, T. (1956) *Hugh Lane and his Pictures* (Dublin: Arts Council).

Boime, A. (1971) *The Academy and French Painting in the Nineteenth Century* (London: Phaidon).

Bourdieu, P. (1968) 'Outline of a sociological theory of art perception', *International Social Science Journal*, vol. 20, 589–620.

Bourdieu, P. (1980a) 'The aristocracy of culture', *Media, Culture and Society*, vol.2, no.3, 225–54.

Bourdieu, P. (1980b) 'The production of belief: contribution to an economy of symbolic goods', *Media, Culture and Society*, vol. 2, no. 3, 131–63.

Bourdieu, P. (1984) *Distinction: A Social Critique of the Judgement of Taste*, (London: Routledge & Kegan Paul).

Bourdieu, P. (1990) *In Other Words: Essays Towards a Reflexive Sociology*, (Oxford: Polity).

Bourdieu, P. and Darbel, A. (1991) *The Love of Art: European Art Museums and their Public* (Oxford: Polity).

Bourdieu, P. and Wacquant, Loic J.D. (1992) *An Invitation to Reflexive Sociology* (Oxford: Polity).

Bourdieu, P. (1993) *The Field of Cultural Production* (Oxford: Polity).

Bourne, J.M. (1986) *Patronage and Society in Nineteenth-Century England,* (London: Edward Arnold).

Buckman, D. (1973) *James Bolivar Manson 1879–1945* (London: Maltzahn Gallery).

Bullen, J.B. (ed.) (1988) *Post-Impressionists in Britain: The Critical Reception* (London: Routledge).

Cannadine, D. (1990) *The Decline and Fall of the British Aristocracy* (New Haven and London: Yale University Press).

Carey, J. (1992) *The Intellectuals and the Masses: Pride and Prejudice among the Literary Intelligentsia 1880–1939* (London: Faber & Faber).

Carr, J.C. (1908) *Some Eminent Victorians: Personal Recollections in the World of Art and Letters* (London: Duckworth).

CF *(Chantrey Files)* Statement by the Director in Regard to the Four Chantrey Conferences and the Attitude of the Board towards the Treasury in Respect of the Chantrey Bequest (RA Archive).

Chantrey and his Bequest: a complete illustrated record of the purchases of the Trustees, with a biographical note, text of the will etc. (1904) (London: Cassell).

Clegg, Stewart R. (1989) *Frameworks of Power* (London: Sage).

Clemenson, H.A. (1982) *English Country Houses and Landed Estates* (London: Croom Helm).

Coombes, A.E. (1991) 'Ethnography and the formation of national identities' in S. Hiller (ed.) *The Myth of Primitivism* (London: Routledge) pp. 189–214.

Cooper, Douglas (1954) *The Courtauld Collection: A Catalogue and Introduction* (London: Athlone).

Corrigan, P. and Sayer D. (1985) *The Great Arch: English State Formation as Cultural Revolution* (Oxford: Basil Blackwell).

Cowdell, T.P. (1980) *The Role of the Royal Academy in English Art 1918–1930,* Phd thesis, University of London.

Crewe Inquiry (1904) *Chantrey Trust: Report, Proceedings and Minutes of Evidence,* Select Committee House of Lords, UK Parliamentary Papers, 357, v, 493.

Curzon Inquiry (1914–16): *National Gallery,* Committee of Trustees, UK Parliamentary Papers, Cd. 7878, Cd. 7879.

Davidoff, L. (1976) *The Best Circles* (London: Croom Helm).

Davis, F. (1981) 'Lesson in tolerance: "Some Chantrey Favourites" at the Royal Academy', *Country Life,* 7 May, vol. 169, no.4368, 1252–3.

Dimaggio, P. (1982) 'Cultural entrepreneurship in nineteenth-century Boston', *Media, Culture and Society,* 2 pts, vol. 4, no 1, 33–50 and no. 4, 303–22.

Dimaggio, P. (1987) 'Classification in art', *American Sociological Review,* vol. 52, 440–55.

Du Maurier G. (1896) *Trilby: A Novel* (London: Osgood, McIlvaine).

Duncan, C. (1991) 'Art museums and the ritual of citizenship' in Ivan Karp and

S.D. Lavine (eds) *Exhibiting Cultures: The Poetics of Politics of Museum Display* (Washington and London: Smithsonian Institute) pp. 88–103.

Duncan, C. and Wallach, A. (1980) 'The universal survey museum', *Art History*, vol. 3, no. 4, 448–69.

Edwards, E. (1840) *The Administrative Economy of the Fine Arts* (London).

Elias, N. (1978) *The Civilizing Process, vol. 1: The History of Manners* (Oxford: Basil Blackwell).

Elias, N. (1982) *The Civilizing Process, vol. 2: State Formation and Civilization*, (Oxford, Basil Blackwell).

Elias, Norbert (1983) *The Court Society* (Oxford: Basil Blackwell).

Flint, K. (ed.) (1984) *Impressionists in England: The Critical Reception* (London: Routledge & Kegan Paul).

Fox, C. (1977) 'Education: fine arts and design' in G. Sutherland *et al.*, *Education* (Dublin: Irish Academic Press) pp. 68–101.

Fuller, Peter (1978) 'The Tate, the state and the English tradition', *Studio International*, vol. 194, no.988, 6–18.

Fyfe, G.J. (1986) 'Art exhibitions and power during the nineteenth century' in J. Law (ed.) *Power, Action and Belief* (London: Routledge) pp. 20–45.

Galerien, T. (1921) 'The renaissance of the Tate Gallery', *The Studio*, vol. 82, no. 344, 187–97.

Girouard, Mark (1979) *The Victorian Country House*, rev. edn (London, Book Club Associates).

Goblot, Edmond (1973) 'Cultural education as a middle-class enclave' in Elizabeth Burns and Tom Burns (eds) *Sociology of Literature and Drama*, (Harmondsworth: Penguin) pp. 433–44.

Grana, C. (1971) *Fact and Symbol* (New York: Oxford University Press).

Gruetzner, A. (1979) 'Two reactions to French painting in Britain' in *Post Impressionism: Cross-currents in European Painting* (London: Royal Academy of Arts/Weidenfeld & Nicolson) pp. 178–82.

Gucht, Vander D. (1991) 'Art at risk in the hands of the museum: from the museum to the private collection', *International Sociology*, vol. 6, no. 3, 362–3.

Hall, S. (1984) 'The rise of the representative/interventionist state' in G. Maclennan, D. Held and S. Hall (eds) *State and Society in Contemporary Britain* (Oxford: Polity) pp. 7–49.

Hamerton, P.G. (1889) *Thoughts about Art* (London: Macmillan).

Hamlyn, R. (1991) 'Tate Gallery' in G. Waterfield (ed.) *Palaces of Art: Art Galleries in Britain 1790–1990* (London: Dulwich Picture Gallery) pp. 113–16.

Haskell, F. (1976) *Rediscoveries in Art: some aspects of taste, fashion and collecting in England and France* (Oxford: Phaidon).

Haskell, F. (1987) 'The artist and the museum' in *The New York Review of Books*, 3 Dec. pp. 38–41.

Hobsbawm, E. (1983) 'Mass producing traditions: Europe 1870–1914' in E. Hobsbawm and T. Ranger (eds) *The Invention of Tradition* (Cambridge: Cambridge University Press) pp. 263–307.

Holmes, C.J. (1936) *Self and Partners (Mostly Self): Being the Reminiscences of C.J. Holmes* (New York: Macmillan).

Hutchison, S.C. (1968) *The History of the Royal Academy* (London: Chapman and Hall).

Ingham, Geoffrey (1984) *Capitalism Divided?* (London: Macmillan).

Johnson, T. (1982) 'The state and the professions: peculiarities of the British' in A. Giddens and G. Mackenzie (eds) *Social Class and the Division of Labour: Essays in Honour of Ilya Neustadt* (Cambridge: Cambridge University Press).

Jones, T. (1960) *Henry Tate 1819–1899: A Biographical Sketch* (London: Tate & Lyle).

Laidlay, W.J. (1907) *The Origin and First Two Years of the New English Art Club* (London: published by the author).

Lamb, W.R.M. (1951) *The Royal Academy* (London: G. Bell).

Lambert, R.S. (ed.) (1938) *Art in England* (Harmondsworth: Penguin).

Lang, G.E. and Lang, K. (1990) *Etched in Memory: The Building and Survival of Artistic Reputation* (Chapel Hill and London: University of North Carolina Press).

Lucas, E.V. (1924) *A Wanderer among Pictures: A Companion to the Galleries of Europe* (London: Methuen).

MacColl, D.S. (1904) *The Administration of the Chantrey Bequest: Articles reprinted from 'The Saturday Review', with additional matter, including the text of Chantrey's Will and a list of purchases* (London: Grant Richards).

MacColl, D.S. (1912) *The Uses of an Art Gallery: An Address at the Royal Manchester Institution* (Manchester: Maclehose).

MacColl, D.S. (1931) *Confessions of a Keeper and other Papers* (London: Maclehose).

MacConkey, K. (1989) *British Impressionism* (London: Phaidon).

Macleod, D.S. (1987) 'Art collecting and Victorian middle class taste', *Art History*, vol. 10, no 3, 328–50.

Mallock, W.H. (1906) [1877] *The New Republic* (London).

Malraux, A. (1954) *The Voices of Silence* (London: Secker & Warburg).

Massey, D. and Catalano, A. (1978) *Capital and Land: Landownership by Capital in Great Britain* (London: Edward Arnold).

Massey Inquiry (1946): *The Report of the Committee on the Functions of the National Gallery and the Tate Gallery and, in respect of paintings, of the Victoria and Albert Museum together with a Memorandum thereon by the Standing Commission on Museums and Galleries*, UK Parliamentary Papers Cmnd 6827, May, 4.

Minihan, J. (1977) *The Nationalization of Art* (London: Hamish Hamilton).

Negrin, L. (1993) 'On the museum's ruins', *Theory, Culture & Society*, vol. 10, no. 1, 97–125.

Pearson, N. (1982) *The State and the Visual Arts* (Milton Keynes: Open University Press).

PEP (1946) *The Visual Arts*, A Report Sponsored by the Dartington Hall Trustees (London: Oxford University Press).

Perkin, H. (1989) *The Rise of Professional Society since 1880* (London: Routledge).

Pevsner, N. (1973) *Academies of Art Past and Present* (New York: De Capo Press).

Pye, J. (1845) *Patronage of British Art* (London: Longman, Brown, Green & Longmans).

Quilter, Harry (1903) 'The last Chanty of Chantrey', *The Contemporary Review*, vol 84, August, 253–64.

Reitlinger, Gerald (1961) *The Economics of Taste: The Rise and Fall of Picture Prices 1760–1960* (London: Barrie & Rockliff).

Robertson, David (1978) *Sir Charles Eastlake and the Victorian Art World*, (Princeton: Princeton University Press).

Rolfe, F. (1903) *Hadrian VII: A Romance* (London: Chatto & Windus).

Roseveare, H. (1969) *The Treasury: The Evolution of a British Institution* (London: Allen Lane/Penguin Press).

Rothenstein, John (1962) *The Tate Gallery* (London: Thames & Hudson).

Rothenstein, John (1966) *Brave Day Hideous Night* (London: Hamish Hamilton).

Rothenstein, William (1932) *Men and Memories: Recollections of William Rothenstein 1900–1922* (London: Faber & Faber).

Rothenstein, William (1939) *Men and Memories: Recollections of William Rothenstein 1922–1938* (London: Faber & Faber).

Rubinstein, W.D. (1981) *Men of Property* (London: Croom Helm).

Savage, M., Barlow., J., Dickens, P. and Fielding, T. (1992) *Property, Bureaucracy and Culture: Middle-Class Formation in Contemporary Britain*, (London: Routledge).

Scott, John (1991) *Who Rules Britain?* (Oxford: Polity).

Seed, J. and Wolff, J. (1984) 'Class and culture in nineteenth century Manchester', *Theory, Culture and Society*, vol. 2, no. 2, 38–53.

Shee, M.A. (1837) *A Letter to Lord John Russell . . . on the Alleged Claims of the Public to be Admitted Gratis to the Exhibition of the Royal Academy* (London).

Shee, M.A. (1838) *A Letter to Joseph Hume Esq M.P.* (London).

Smith, C.E. (ed.) (1895) *Journals and Correspondence of Lady Eastlake*, 2 vols (London: John Murray).

Smith D. (1982) *Conflict and Compromise: Class Formation in English Society: A Comparative Study of Birmingham and Sheffield* (London: Routledge & Kegan Paul).

Spielmann, M.H. (1900) 'The National Gallery in 1900, and its present arrangements', *The Nineteenth Century*, vol. 48, 54–74.

Stevens, A. (1897) *The Year's Art* (London: J.S. Virtue).

Stone, Lawrence, and Stone, J.C. Fawtier (1984) *An Open Elite? England 1540–1880* (Oxford: Clarendon).

Strong, R. (1978) *And When Did You Last See Your Father? The Victorian Painter and British History* (London: Thames & Hudson).

Survey of London: Parish of St. James Westminster (1963) pt 2, vol. 32 (London: Athlone).

Survey of London: The Museums Area of South Kensington and Westminster (1975) vol. 38 (London: Athlone).

Thornton, A. (1938) *The Diary of an Art Student of the Nineties* (London: Isaac Pitman).

Tillyard, S.K. (1988) *The Impact of Modernism* (London: Routledge).

Torstendahl, R. (1990) 'Introduction: promotion and strategies of knowledge' in R. Torstendahl and M. Burrage, *The Formation of Professions* (London: Sage) pp. 1–10.

Waagan, G.F. (1853) 'Thoughts on the new building proposed for the National Gallery of England', *The Art Journal*, vol. 5, 101–3, 121–5.

Watney, S. (1983) 'The connoisseur as gourmet', in Formations Editorial Collective, *Formations of Pleasure* (London: Routledge & Kegan Paul) pp. 66–83.

Weiner, Martin J. (1981) *English Culture and the Decline of the Industrial Spirit 1850–1980* (Harmondsworth: Penguin).

White, H.C., and White, C.A. (1965) *Canvases and Careers* (New York: John Wiley).

Williams, R. (1980) *Problems of Materialism and Culture* (London: Verso).

2

The Origins of the Early Picture Gallery Catalogue in Europe, and its Manifestation in Victorian Britain

GILES WATERFIELD

INTRODUCTION

In spite of strong recent interest in the development of systems of classification, the early history of the classification of paintings and sculpture – a subject less dry than might at first appear – has received relatively little attention. This paper considers how those responsible for the care of paintings in late eighteenth and early nineteenth century Europe, when the distribution, preservation and display of paintings began to be organized in a pattern familiar to the modern observer, dealt with the demand for publications that would record, classify, elucidate and publicize collections of art; and how these patterns reflected increasingly powerful nationalistic considerations. The second part of the paper considers the influence exerted by these ideas upon the cataloguing of paintings (rather than sculpture or the applied arts) in the emergent public collections of nineteenth century Britain, an influence which was limited and which was confronted with the problem of the definition of a native British school. The development of cataloguing in nineteenth century Britain revealed much about attitudes to art in this country and about the lack of sophistication in analysing the art of the past and present in all but the most refined and cosmopolitan circles.

THE ORGANIZATION OF CATALOGUES IN EIGHTEENTH-CENTURY EUROPE

The cataloguing system that prevailed in eighteenth century Europe, based on a division by national schools, was not arrived at without experiments in other directions, but so entrenched today is

this idea that we find it hard to conceive of any others applying to the arrangement of paintings, whether in catalogues or on gallery walls. The two are closely but not fully linked: experiment was often undertaken in the early days of public galleries in the hanging or listing of pictures which was not repeated in the alternative process. The interest that recently greeted the National Gallery's experiment in juxtaposing, albeit in separate rooms, late mediaeval works of the Italian and the Northern schools – making period rather than place the prime determinant of classification – characterized this expectation; even though a similar, indeed more highly developed, practice was followed in the Manchester Art Treasures Exhibition in 1857, where the early Italian paintings were arranged on a wall opposite the Northern works in order to illustrate the respective development of the two schools. The classification of paintings by school was accepted in gallery publications and especially in sale catalogues during the eighteenth century, but was not reflected in the arrangements for hanging paintings until the very end of the century. This shift of organization emerged during a period when allegiances moved from the prince as embodiment of temporal power to the nation state, and during which new museums, especially museums of art, generally based as they were on the holdings of a dispossessed or apparently altruistic monarch, emerged as one of the most potent symbols of the apparatus of government.

The classification of early collections, from the sixteenth through to the mid-eighteenth centuries, differs fundamentally between what were described as the productions of Nature – loosely, scientific collections – and the productions of Art. For early scientific collections the arrangement of objects into classes was fundamental, allowing objects of no intrinsic financial value, or with a value derived primarily from their exoticism or provenance, to acquire a holistic importance, in a microcosm testifying to the glory of God the Creator. (The catalogue, of every type, was to be intimately related to the transformation of specimens, whether natural or artificial, into objects of value.) The ambitious catalogue of the museum belonging to the London Royal Society, published by Nehemiah Grew in 1681, an example of many such produced in London as elsewhere in Europe, organized the objects on the basis of their physical properties, with further subdivisions in each group. In such a system, there was no specific place for paintings with the exception of portraits, which had a distinct documentary role. Where they

appeared at all, pictures were included under such headings as 'Mechanick artificiall Works': their descriptions, which seldom included even the name of the artist, contained little information that would assist towards classification (see MacGregor, 1983: 293).

The earliest catalogues of paintings in Europe were generally straightforward inventories. Paintings and other works of art were listed according to the position in which they were to be found in noble collections. The earliest and easiest classification of works of art, following scientific taxonomy, was through medium: drawings and prints being generally described apart from paintings. Private inventories, which in response to the growing vogue for buying paintings were increasingly common in the seventeenth century in Britain as in other countries, generally included little information beyond essential details of position, artist and title. The manuscript inventory of the royal pictures produced by Abraham van der Doort, Surveyor of the King's Pictures, for Charles I, was exceptionally advanced in its inclusion not only of each picture's dimensions, support and location, but of comments on condition and framing, and notes on whether the light fell from the right or left, a consideration not mentioned by later cataloguers (Millar, 1958).

During the eighteenth century, private art collections, like private scientific museums, became increasingly available to one public, even if this public was limited primarily to the aristocracy, amateurs of art and artists. This tendency stimulated the development of the art catalogue. Such publications were also encouraged by the growth of the art trade, which, notably in Paris, was also engaged in the publication of elaborate sale lists. For private, or semi-private, collections, three principal types of publication emerged in the later eighteenth century which could broadly be described as catalogues, though their taxonomical or critical ambitions were limited.

The first type was the inventory-catalogue. This gave the location of each work, its artist and title, and sometimes its size. In a number of cases the dimensions of the figures (life size, half size, etc.) were itemized, reflecting contemporary concern over the mutual relationship of such figures, which has recently tended to be ignored. Sometimes the previous ownership of a painting was mentioned, though in the case of the most important aristocratic owners, who felt no need for such self-assertion, this was seldom the case. Since these books were intended, in the absence of other systems of information, for use by visitors moving from room to room, the

works of art were listed according to their position within the building, which by the 1780s in Italy and Germany generally reflected school and chronology. Such co-ordination between the arrangement of paintings in catalogues and in galleries came to be strained as public galleries became more numerous, with increasing theoretical demands made on systems of classification, demands which might come into conflict with display. The tension between the pragmatic and the historical approaches surfaced in the introduction to the *Description of the Royal Picture Gallery and the Cabinet in Sans-Souci*, of 1770, in which the writer declared that the new edition had a rearranged text, so that the paintings were listed 'not according to School and period, as the Masters followed one after another and lived, but so that as one stands in front of the picture, one can at once read its description' (Sans-Souci, 1770).

The second form of catalogue was the expository guide. This provided basic information as well as a brief commentary on all, or most, of the pictures. Such guides were printed in a small manageable format and were also intended for use in the palace or gallery, where they were kept on sale. The texts, of very variable quality, were aimed at a lay audience: there hardly existed a developed language for the discussion of works of art. A good example of the relationship between these two types of catalogue was provided in the 1780s by the Upper Belvedere, Vienna, where the pictures of the Emperor of Austria had recently been placed on public view in a careful display based on chronological and geographical considerations. In 1781 the historian Christian von Mechel, on the orders of the Emperor, published a catalogue entitled *Catalogue of the Paintings in the Imperial and Royal Picture Gallery in Vienna*. The preface explained that a detailed *catalogue raisonné* would be produced in due course. Brief notes were given on the contents of each room (these were arranged according to school), but works of art were merely listed, with stars indicating the finest. This publication was followed in 1785 by a commercially printed work, *Reflections on the Imperial and Royal Picture Gallery in Vienna*. The anonymous author, regretting that von Mechel had not yet produced the promised *catalogue raisonné*, offered his reader individual explanatory texts, written in what he described as a 'biedermannisch' style, perhaps best translated as 'down to earth'. (Vienna, 1785: 4). Though in this instance interpretative material for the lay visitor was not provided by the institution itself, a comparable interest in

explaining works of art in simple terms is to be found throughout the early history of galleries, and was often satisfied commercially rather than by the institution.

The third type of publication was a presentation volume, especially associated with royal or noble collections. Usually a folio, with a handsome ornamental frontispiece, such volumes generally contained large engravings of some or all of the works in the collection, accompanied by an explanatory or descriptive text, again of unreliable quality. These volumes, produced for example at Dresden in 1762, Düsseldorf in 1778, and Paris (for the Palais Royale) in 1786, were sometimes produced at the expense of the owner, but might also be commercial ventures. Often described as 'galleries', the volumes were meant as art museums on paper, offering amateurs the opportunity to experience through engravings works they might otherwise not see. Such volumes may be compared to the ambitious publications, often printed in individual sheets but intended for binding into folio volumes, produced by printsellers at the close of the eighteenth century, of which Boydell's 1785 *Catalogue of the Pictures, &c, in the Shakespeare Gallery, Pall-Mall* is a famous example. All three types of publication survive today, the second perhaps with less vigour than the others, having been replaced in many cases by the expository label.

The consensus over the preferability of the primary classification of works of art by national school which emerged in the last years of the eighteenth century was not achieved without consideration by the very small international circle of experts of other options, some of which continued to play an important part in the catalogues and displays of the nineteenth century. The taxonomical arrangements devised for natural history and other collections in the seventeenth century were developed in the eighteenth into Linnaeus's system of binomial nomenclature. It is unwise, however, to detect too close a connection between such a system and the new modes of classification being developed for painting or sculpture. Such objects, the productions of Art and individuals, could of their nature scarcely be evidence of the work of the Creator, being valuable through their diversity rather than through their adherence to a class. The lack of any such influence, for at least one important writer, was stated by the Abate Lanzi, who in 1792 published the revealingly titled *Pictorial History of Lower Italy, or the Florentine, Sienese, Roman, and Neapolitan Schools, reduced to*

a compendious and methodical form, adapted to facilitate a knowledge of Professors and of their Styles, for the lovers of the art. In his preface, Lanzi discussed the system he had devised in order to present this subject (Lanzi, 1825: ix), citing a number of alternative approaches which he had examined and found unsuitable. In view, he said, of the 'infinite diversities of a mixed character' which 'had arisen in every school' and the changing manner of individual artists,

> we cannot easily reduce them to any particular standard . . . We cannot, therefore, adopt the method of the naturalist, who having arranged the vegetable kingdom, for example, in classes more or less numerous, according to the systems of Tournefort or of Linnaeus, can easily reduce a plant, wherever it may happen to grow, to a particular class, adding a name and description, at once precise, characteristic, and permanent.

The uniqueness and essential unpredictability of the work of art made it unsuitable to a system which functioned through the identification of shared qualities. The debt owed by such early cataloguers of art as Lanzi to scientific taxonomy was a readiness, characteristic of an age when the dictionary and encyclopaedia emerged as established forms, to regard an organized system of classification as essential to the control of a new discipline.

A number of modes of classification for paintings were found more appropriate for the physical installation of pictures than for printed works of reference. From the late seventeenth century, a convention existed that in a private house works of art should be arranged in different rooms according to their genre, with family and royal portraits for example often being shown in the dining-room; the custom survived into the nineteenth century. Organization according to provenance, which gave the individual work of art a heightened status, provided a further form of categorization. Works might be listed according to the collections to which they previously belonged: the relationship between object and owner became mutually fruitful, each shedding lustre upon the other.

A further form of categorization, intrinsic to the alphabetical arrangement used in most works of reference, depended on the individual artist, especially on the notion of the great master. A room in a museum might be devoted to a single artist, or might contain works grouped around an eponymous masterpiece: used in the Museo Pio-Clementino in the Vatican and later at the

Thorwaldsen Museum in Copenhagen, this system particularly applied to classical sculpture. In catalogues classical sculptures were generally, at least into the nineteenth century, listed according to type: i.e. statues, busts, bas reliefs, etc. (see for example Blundell, 1803). Such a practice, in which the arrangement of paintings or sculpture in the gallery worked in parallel with their listing in the catalogue, can be seen in the volume devoted to the Electoral Gallery of Düsseldorf, published in 1778 by Christian von Mechel: *La Galerie Électorale de Düsseldorff.* The relatively old-fashioned arrangement of paintings (it followed the arrangement recorded in 1750) was based partly on schools and partly on artists. Thus the first room contained Flemish paintings; the second, paintings of various schools, with Dou giving his name to the room. The third and central room, perhaps significantly, held the Italian paintings. The next room was dominated by the work of the still vastly admired van der Werff, while the fifth room, arguably the culmination of the series, contained the Rubenses which today hang at the centre of the Alte Pinakothek. There was no attempt here at chronological arrangement: rather, emphasis was laid on the Rubenses, works which, according to von Mechel, contributed more strongly than any of his other paintings to his reputation, and contained, in *The Last Judgement*, shown in the centre of the principal wall, a painting regarded as his supreme achievement. This interest in the greatest works of the greatest masters is characteristic of the non-historical approach to picture-collecting associated with the dynastic collections of the eighteenth century, based on academic doctrine, according to which only the major achievements of art, primarily of the sixteenth and seventeenth century art, deserved collection and study.

The most important alternative to national classification was the chronological division. With the growing recognition in late eighteenth century Europe of the historical though not as yet the artistic value of paintings executed before 1500, it came to seem more appropriate to present the gradual development of painting than to exhibit and chronicle only works from the canon. As the number of historically inspired collections grew in the last years of the eighteenth century, in Britain rather later than in Italy, France or Germany, paintings were increasingly shown in historical order, as von Mechel demonstrated in his catalogue of the Vienna collection. Such a sequence was less easily applied to a reference work, in which

alphabetical order offered greater convenience, but from the late eighteenth century it became usual for the date and place of the birth and death of the artist to be included, in the main text or an appendix. Both in galleries and in catalogues chronology therefore played a consistent but secondary role: it became usual, though not universal, in the nineteenth century for galleries to be arranged by school, and within those divisions by period. The relationship between the two divisions continued to be much discussed.

During the last third of the eighteenth century, a discourse developed in the international circle of art connoisseurs around the theme of cataloguing works of art and around the importance of national considerations. Two writers may be cited who asserted the overriding importance of nationality. It was a discourse which owed much to contemporary views on sculpture, especially to Winckelmann. Unlike his predecessors, whose studies concentrated on the lives and works of great artists, Winckelmann regarded the purpose of art history as the study not of the lives of individual artists, but of the origins, rise to perfection and decline of the schools, and the examination of the different styles produced by various peoples as a result of the meteorological climate to which they were exposed, their political constitution and ways of thought, their attitudes to artists and the use to which the arts were put in their society. This became a judgmental study which led, for the German critic, to the triumph of the Greeks. Winckelmann influenced the cataloguing of paintings by such writers as the Abate Lanzi and von Mechel, who discussed their endeavours to develop the national categorization of paintings. In the preface to the 1781 Vienna *Catalogue*, von Mechel explained that the newly arranged gallery was intended as a visible history of painting. In the catalogue, the pictures were listed by school. The Italian school was organized by city state (Venetian, Roman, Florentine, Bolognese, Lombard and the rest), reflecting the historical, as well as the artistic, development of the country. It was followed by the Netherlandish (which included the few French paintings, also a common convention of the pre-French Revolutionary period), Old Flemish, and German schools. In this early instance, national divisions were taken as an indication of stylistic tendencies rather than as intrinsically valuable. Von Mechel explained that artists were allocated to schools less by their place of birth, than by their style: otherwise Rubens and Mengs would be inappropriately

placed in the German School, and Spranger among the Dutch (Vienna, 1781: xix).

THE PROBLEM OF DEFINITION OF THE NATIONAL SCHOOL IN FRANCE AND BRITAIN

The late eighteenth century acceptance of categorization by national school posed problems for certain nations, especially since Winckelmann related the quality of a nation's painting so closely to the political and intellectual vigour of its people. The problem was acute for France, and even more so for Britain. In catalogues which attempted such analysis, the collections of pre-Revolutionary Europe were generally grouped around two major schools: Italy (always placed first in order of description and, by implication, in order of excellence) and the Netherlands. Germany and Spain were described as of secondary, though notable, importance – although in some instances, notably in German catalogues, the second major category was extended to include German art. France was included by virtue of a few seventeenth century artists, most of whom practised in Rome. (Even in the catalogue of the Palais Royale, of 1786, the French paintings were illustrated last, after the Flemish, Dutch and German.) It was a problem that the French had already addressed during the eighteenth century, and that they confronted with vigour during the Revolutionary period and under Napoleon. Thus the connoisseur and dealer J.B.P. Lebrun, in his *Quelques Idées sur la Disposition, l'Arrangement et la Décoration du Muséum National*, of 1796, advocated the division of the Grande Galerie of the Louvre into nine sections which would form a complete museum of art. The fifth to the eighth sections were to be devoted to the art of France, respectively to old French sculpture and Gothic decoration, old French painting, recent French sculpture and architectural decoration, and recent French painting, so that painting, sculpture and architecture would compete in the adornment of the finest monument of their country (Lebrun, 1796: 15–17). A similar assertion of the long tradition of French culture was made by Lenoir's Musée des Monuments Français, established in 1793. In the following years the perceived inadequacy of the French school was compensated for by the creation of the Musée Napoléon and the active official encouragement of a native school.

For Britain, the problem was even more severe, since not a single

British painter was represented in the great European collections other than at St Petersburg, and there only through the chance of the purchase of the Houghton collection. The apparent incapacity of the British in the visual arts had been noted by Winckelmann and echoed by early chroniclers of British painting, notably Horace Walpole. The cataloguing of mezzotints, regarded as a specifically British form, had in the eighteenth century already explored the dimension of national classification. With the increased public recognition of art as a financial and spiritual commodity, as a result of the opening throughout Europe of public museums, the possession of a national school of painting became mandatory for a nation that aspired to be civilized. It was a task of nineteenth century historians in Britain to find a place in the school-dominated interpretation of art for the productions of their own nation, a task in which catalogues of art were to assist.

BRITISH CATALOGUES OF PRIVATE COLLECTIONS

The standard of art publications in Britain lagged, until well into the nineteenth century, behind those of other major European nations. The earliest individual catalogue for a country house collection dealt with Wilton House, where lists of the classical sculpture and medals were published in 1720, followed in 1731 by *A Description of the Earl of Pembroke's Pictures*. Not until the 1760s did such publications become common for collections both in London and in the country, though it cannot be assumed, in London as in Paris, that a printed catalogue guaranteed accessibility. Following his innovative *Aedes Walpolianae* of 1747, Horace Walpole produced a further early example in the volume published at Strawberry Hill in 1760: *Catalogues of the Collections of Pictures of the Duke of Devonshire, General Guise, and the late Sir Paul Methuen*. The objects in these three important collections were listed by location, even though Devonshire House, for example, could be seen only by the favoured scholar or connoisseur: information was restricted to the position of the picture, the artist and the subject. Similar inventories were given in the guides to the attractions of London and other cities which were produced from the 1760s onwards, such as Dodsley's *London and its Environs* of 1761. The provision in these publications of only basic information was comparable to contemporary catalogues of Royal Academy exhibitions

and auctions, the two principal theatres for the display of paintings in late eighteenth century London.

With the decision in the first two decades of the nineteenth century by a small number of noblemen to open their London houses to a public which, though still selected, was wider than before, catalogues in Britain developed more sophisticated forms, following aristocratic precedent on the Continent. The catalogues published at this period reflected the contemporary debate over the merits of foreign and native art. In this debate, the publications produced for these owners played an important role, expressing political and nationalistic views which sometimes bordered on xenophobia.

The second Marquess of Stafford, the richest private citizen in Britain, was the first nobleman to open his London house on a regular basis to visitors: Cleveland House could be seen once a week during the social Season from 1806 onwards. The production of suitable catalogues, in this well-organized operation, was part of the transition from private to public gallery, as the two catalogues published for Lord Stafford at Cleveland House illustrate. John Britton's *Catalogue Raisonné* of 1808 was an example of the second, expository, type of catalogue, to be used in front of the pictures (see Plate 2). Ten years later William Young Ottley, a historian and a leading collector of drawings and early Italian paintings, published a sumptuous four-volume example of the third type of catalogue (see Plate 3). Ottley's volumes, with their large engravings and explanatory texts, were revealingly titled: *The Collection of Pictures of The Most Noble The Marquis of Stafford, In London; Arranged According to Schools, and in Chronological Order.* For Ottley, this was an idealized catalogue, reflecting his awareness of developments on the Continent. He used the publication to create a chronologically arranged gallery on paper: this was not fully reflected in the actual hanging. Although the pictures were divided according to school, the arrangement remained true to the traditional aristocratic style in creating symmetrical patterns on the walls based on visual criteria.

In the Preface, Ottley outlined his intention to create a primary division by school: 'the pictures of the several schools will be described in chronological order, agreeably to the periods in which the respective artists flourished' (Ottley, 1818: preface). His aim was to complete 'the chain of history' (Ottley, 1818: x). He outlined how

ENGRAVINGS

OF THE

MOST NOBLE

The Marquis of Stafford's

COLLECTION OF PICTURES,

IN LONDON,

ARRANGED ACCORDING TO SCHOOLS,

AND IN

CHRONOLOGICAL ORDER,

WITH

REMARKS ON EACH PICTURE.

By *WILLIAM YOUNG OTTLEY, Esq. F.S.A.*

THE EXECUTIVE PART UNDER THE MANAGEMENT OF

PELTRO WILLIAM TOMKINS, Esq.

HISTORICAL ENGRAVER TO HER MAJESTY.

VOL. I.

London:

PRINTED BY BENSLEY AND SON, BOLT COURT, FLEET STREET.

FOR

LONGMAN, HURST, REES, ORME, AND BROWN, PATERNOSTER ROW; CADELL AND DAVIES, STRAND, AND P. W. TOMKINS, NEW BOND STREET.

1818.

3 Title page, catalogue of Marquis of Stafford's collection, by W.Y.Ottley 1818.

CATALOGUE RAISONNÉ

OF THE

PICTURES

BELONGING TO THE MOST HONORABLE

THE MARQUIS OF STAFFORD,

IN THE

GALLERY OF CLEVELAND HOUSE.

COMPRISING

A LIST OF THE PICTURES,

With illustrative Anecdotes, and descriptive Accounts of the Execution, Composition, and characteristic Merits of the principal Paintings.

By JOHN BRITTON, F.S.A.

Hail, Painting, hail! whose imitative art,
Transmits through speaking eyes the glowing heart!

LONDON:

PRINTED FOR LONGMAN, HURST, REES, AND ORME, PATERNOSTER-ROW;
AND FOR THE AUTHOR.,

1808.

2 Title page, *Catalogue Raisonné* of the Marquis of Stafford's Collection, by John Britton, 1808.

the paintings were to be listed, in six classes, inviting through the tone of his text a political and nationalistic interpretation more overt than this conventional division usually permitted. Ottley's first two classes were appropriated to the Italian school, divided into Lower and Upper Italy: Lower Italy, 'to which we are in a more especial manner indebted for the revival of Painting' (Ottley, 1818: ix) took first place. The Netherlands, placed with Switzerland and Germany in the third school, earned the usual disapprobation, already apparent in Britton's 1806 catalogue:

> The Dutch and Flemish painters had more of the mechanism . . . than the mind, of art. They copied visible objects with care and fidelity, but as most of them were confined to a country that had nothing beautiful or grand, it is not very surprising that their pictures are devoid of these qualities. (Britton, 1808: 117)

Most revealing were Ottley's comments on the French paintings, reflecting a common prejudice against Britain's neighbour and rival (a prejudice not felt against the politically insignificant Italians) but expressed with an unusual degree of vituperation, even three years after Waterloo: 'The French School . . . has never been in very high reputation out of France' (Ottley, 1818: xi). He excepted Gaspard Poussin and Claude, and continued

> we are unwilling to separate NICCOLO POUSSIN from his near relative, or from the genial clime which matured his talents. On the banks of the Tyber his pensive and tranquil mind found an asylum replete with materials to enrich a genius that could ill encounter the envy and the intrigues inseparable from Parisian Patronage.

Poussin was relieved from the stigma of belonging to the treacherous French nation through honorary membership of the Italian school. An illustrated catalogue, with minimal text, was published in 1821 by J. Young for the Earl Grosvenor's collection at Grosvenor House in London, which was also shown to the genteel public; while the opening of his collection of British paintings on a similar basis by Sir John Leicester was the occasion for the production in 1819 of a tendentious catalogue by William Carey, proclaiming at length the excellence of the native school.

CATALOGUES OF PUBLIC COLLECTIONS

With the opening of galleries on a regular basis to the general public, catalogues became an indispensable if often limited form of communication. The public capable of travelling and of finding the leisure to visit galleries at the time that they were open to visitors was still small, although great crowds visited the National Gallery from its earliest days. At Dulwich College Picture Gallery, open to visitors from 1817, the standard three types of catalogue were available within a few years. An inventory-catalogue was prepared for the opening by the Keeper, Ralph Cockburn (see Plate 4). Organized by location of picture, it gave only number (matching the numbers attached to each frame in the absence of labels), artist and title, with no analysis or even introduction to the publication. This work was castigated by Gustav Waagen as 'composed, not only with insufficient knowledge, but with great carelessness, since pictures which are inscribed with the name of the real master are quite arbitrarily ascribed to others' (Waagen, 1854: II, 342); his comments reflect the poverty of scholarship in this field in Britain at the time. It was followed by two explanatory catalogues of a type which had hardly existed in Britain in the eighteenth century, reflecting the response of a new public to the new opportunity to view paintings, though the information felt to be suitable derived from a literary rather than artistic tradition. These two catalogues, by William Hazlitt and the plagiarist P.G. Patmore (see Waterfield, 1988: 15ff) offered visitors lyrical accounts of the collection, based on the personal judgement of the writer. They continued to list the paintings according to location, made no attempt to study the historical development of the schools, and gave no information on medium, support, provenance or literature. Dulwich also had its own, somewhat primitive, version of the presentation catalogue, in the form of coloured aquatints after popular pictures, produced by Cockburn from 1816 to 1820.

At the Fitzwilliam Museum, founded in 1816 but not properly organized until the 1840s, visitors were provided in 1841 with a modest octavo catalogue prepared by W. Ridgway, the curator. According to old-fashioned custom, this listed the paintings by number and location (the two being linked), with a few notes on sitters and on any artist responsible for the figures within another artist's landscape composition; while the Mesman collection, also the property of the university, was listed in an even more exiguous

form by its Keeper in 1835. Not until the 1850s did the Fitzwilliam achieve anything approaching a developed catalogue.

CATALOGUES AT THE NATIONAL GALLERY

For the National Gallery, opened in 1824, the provision of catalogues was seen from the earliest days as essential, since the paintings were unlabelled until the 1850s (TMNG, 4 Feb. 1856). The interest shown consistently by trustees, officials and parliamentary select committees in the educational role of the Gallery for artists and the working classes, ensured that such catalogues were produced as economically as possible. A memorandum written just before the opening by a Treasury official to the newly appointed Keeper authorized him to have a catalogue printed: it was to be cheap to produce and purchase, reflecting the parsimonious spirit in which the institution was run. William Seguier was told to 'charge for them a Sum just *barely* to cover the Expence of them: It should not, in any Case, exceed Sixpence.' In the 1824 catalogue, entries were restricted to artist, subject, support and size of painting, with frequent mentions of previous owners if these were, like the Orléans or Colonna collections, regarded as notable. The official commented that this draft went 'far enough for the Public in general' (National Gallery Archive, NG/3/1824, H, W. Vincent to W. Seguier).

The principle enunciated in this memorandum was followed for a further thirty years by the Gallery's official catalogues, with more or less annual reprintings. Clearly the public demanded more, since in the early 1830s alternative versions were produced. As at Dulwich these were not published by the institution but by independent publishers who obtained the right to have the catalogues sold at the museum. The number of independent catalogues or guides produced in the Gallery's early years, and the controversy that sometimes surrounded them, reflected the popularity of the National Gallery from its earliest days. One of the first such publications, following Hazlitt's essay included in the *New Monthly Magazine* of 1823, was *Valpy's National Gallery of Paintings and Sculpture illustrated with forty-six Beautiful Engravings on Steel*: this was an unambitious compilation, including the usual general expository text on the pictures. It was followed in 1832 by W.Y. Ottley's *A Descritive* [sic] *Catalogue of the Pictures in the National Gallery, with*

CATALOGUE
OF THE

COLLECTION OF PICTURES

BEQUEATHED TO

Dulwich College,

BY

SIR FRANCIS BOURGEOIS.

———

*Entrance to the Gallery at the South End of the College,
the right-hand Road.*

———

TICKETS of Admission may be had (*gratis*) of Mr. COCK, 21, Fleet
Street; Messrs. MOON, BOYS, and GRAVES, 6, Pall Mall; Mr. COL-
NAGHI, 23, Cockspur Street; Messrs. COLNAGHI and SON, Pall Mall
East; Mr. MARSH, 137, Oxford Street; Messrs. CARPENTER and
SON, Old Bond Street; Mr. LLOYD, 23, Harley Street; Mr. CLAY, 18,
Ludgate Hill; Mr. MARKBY, Croydon; and Mr. DUNKIN, Bromley.

———

*Without a Ticket no Person can be admitted, and no Tickets
are given in Dulwich.*

It is requested that Money be not given to the *Servants.*

———

CATALOGUE, ONE SHILLING.

4 Title page, first catalogue of Dulwich College Picture Gallery *c*1818.

Critical Remarks on their Merits. This modest octavo volume, sold for a shilling at the Gallery, contained a description of the paintings, an assessment of their merits and an explanation of the action. In terms of classification, the lack of established standards in Britain at the time was reflected in the author's decision in the first edition to group the paintings according to their donors (Angerstein, Beaumont, 'Additional Pictures' and Holwell Carr) with the paintings arranged on vaguely but not consistently chronological principles within each group. The second edition, in 1835, revised the format so that 'the Entire Collection is Arranged Chronologically in one Unbroken Series' (Ottley, 1835: title page).

This publication was supplemented by various more popular works, responding to the large general market for engravings after famous works, to which the Parliamentary Select Committee on the Arts and Principles of Design of 1836 approvingly referred (SC, 1836: vi). In the years up to 1838 a series of inexpensive engravings after paintings in the National Gallery was produced by Messrs. Jones & Co. under the title *The National Gallery of Pictures by the Great Masters*; while in 1834 the artist John Landseer published *A Descriptive, Explanatory, and Critical, Catalogue of Fifty of the Earliest Pictures Contained in the National Gallery of Great Britain.* This private venture aspired to a quasi-official status: the title-page stressed the status of the author as 'Engraver to the King' and so forth, and the work was dedicated to the trustees. In his preface, Landseer explained that he intended his work as a guide to the visitor intending to revisit the Gallery and study the paintings by helping him or her to discriminate between works of good and poor quality, and to distinguish doubtful attributions. His extended critical texts included a discussion of the principal action and of the character of the protagonists as suggested by their physiognomies, reviewed any defects in the painting from an artist's point of view, and used quotations from such authorities as Reynolds and Ottley. He also treated the paintings as the occasion for more generalized commentary, as in an essay on the 'Incipiency of Landscape Painting' included in the volume (Landseer, 1834: 143). Though relatively ambitious, Landseer's text remained traditional, based on a connoisseur's perception.

By the late 1830s the restriction of the material on the National Gallery to official inventory-catalogues and privately produced illustrated souvenirs no longer satisfied the Utilitarian reformers on

the parliamentary select committees investigating the organization of the National Gallery and other public institutions. The 1836 Select Committee chaired by William Ewart, investigating 'the best means of extending a knowledge of the ARTS and of the PRIN-CIPLES OF DESIGN among the people . . . also to inquire into the Constitution, Management and Effects of Institutions connected with the Arts' was heavily influenced by the testimony of Gustav Waagen, Director of the Royal National Gallery in Berlin, and Leo von Klenze, architect of the Alte Pinakothek in Munich, and an authority on museum design and organization. A leading theme of the Committee's Report was the need to emulate the example set by Germany and France in satisfying the desire among 'the enterprizing and laborious classes' for 'information in the Arts' (SC, 1836: iii). As part of a programme that would include the provision of art museums (based on reproduction of famous works) in major provincial cities and the encouragement of accessible publications, the growth of the National Gallery was to be encouraged (SC, 1836: ix–x). Popular instruction was to be stressed: 'The subject of a CATALOGUE or description of the paintings, is an important element in a national collection'. In addition to a *catalogue raisonné*, both Waagen and Klenze were cited as having provided, in Munich and Berlin, detailed labels for each picture.

The recommendations of the Select Committee were followed at the National Gallery, where in 1838 an expanded catalogue was put on sale. This provided brief notices of the paintings, at most of twenty lines each, with historical information on their subject-matter, a short critical commentary and notes on the provenance. Presumably produced by Seguier, this publication, reprinted several times in the 1840s, remained unsophisticated historically, with little more than anecdotal information given on artists or the condition of pictures, and with the paintings listed numerically rather than by school. No attempt was made to suggest any development in the story of art.

During the 1840s the cautious approach of the National Gallery was reversed. The question of catalogues re-emerged in the proceedings of the Select Committee of 1841 on National Monuments and Works of Art, which included the National Gallery in its survey. Regarding the educational role of such monuments as of prime importance, it advocated that 'cheap catalogues, divided into distinct portions for each class or department, should be provided at

our national collections, as a valuable mode of disseminating knowledge, and rendering those collections more generally useful' (SC, 1841: vi). The officials of the National Gallery, still the men appointed in 1824, were submitted to critical questioning on the subject, and their answers are revealing. Seguier declared that the Gallery catalogue could not be arranged by school in view of the impossibility in so small a building of apportioning rooms to individual schools: while not denying the desirability of arranging the paintings by school both physically and in print, he felt that 'the plainest way is, to prepare it (the catalogue) as the pictures are numbered, because in any other way, we could not make so good an arrangement of the pictures' (SC, 1841: 2520 ff). The same catalogue, expanded to cover new acquisitions, was on offer as in the earliest days. It cost a shilling: a cheaper edition was not, he felt, realizable. Seguier's view was supported by the Gallery's Secretary, Colonel Thwaites, who also cited the difficulty, posed by lack of hanging space, of dividing paintings logically, even though they were 'arranged as nearly as possible according to the schools' (SC 1841: 2628).

During the 1840s, when the public organization of the visual arts was the subject of much discussion, the nature and purpose of gallery catalogues came under further review. The desirability of cheap and easily understood publications was clear from *Felix Summerly's Hand Book for the National Gallery*, written by Henry Cole and illustrated with engravings by John, James and William Linnell. Originally published in 1841 in three versions priced respectively at sixpence, threepence, and a penny, this little book was immediately pirated, as Cole recounted angrily in the Advertisement to the 1843 edition, a confirmation of the profitability of these works. Cole continued to publish this booklet during the 1840s, in the 1843 edition supplementing the original basic information with short descriptive texts in spite of the 'extreme difficulty of any verbal description of pictures' (Cole, 1843: v). It was a difficulty that many of his contemporaries had encountered but had not expressed so bluntly. Numerous more scholarly commentaries by this time also supplemented the National Gallery's own publications: not only Hazlitt's but the works of Passavant, Jameson and Waagen. The commentaries of Passavant and Waagen in particular introduced considerations of historical development and accurate attribution which were largely unfamiliar to the British reader, but these com-

mentaries, embodied in longer accounts of British collections, and selective in their listing of paintings, were not full catalogues.

The conservative position taken by Seguier was not to apply for long in a Gallery stimulated by international developments in art historical studies and revitalized by such trustees as Sir Robert Peel and such members of staff as Charles Eastlake. The cost of the catalogue, a recurring subject of consideration, was reduced to fourpence in 1843, the year of Eastlake's appointment as Keeper, with the publication 'By Authority' of a new, brief summary. Eastlake regretted the 'brevity' of this publication (Eastlake, 1845, 18–19), and in 1847 the deficiency was remedied by the publication of a new official catalogue prepared by Ralph Wornum (later appointed Keeper and Secretary), to which Eastlake contributed the Italian entries. This volume represented a notable innovation in British terms, not surpassed for the rest of the century. Wornum's approach was inspired by the work of the German art historian F.T. Kügler (the 1847 revised edition of whose *Handbook of Painting* was translated into English, with Eastlake as editor, in 1855) in stressing the development of schools within a broad political and social framework, rather than discussing particular paintings in literary terms; and by Waagen's *Catalogue of the Picture Collection of the Royal Museum in Berlin*, of 1841, in which the paintings were introduced by an analysis of the principal schools, divided into three principal sections and numerous sub-sections. Wornum listed all the artists in alphabetical order, without distinguishing school, with the British painters consigned to a separate volume. As the prefatory notice explained, the work was 'designed, not merely as a book of reference for visitors in the Gallery, but as a guide to the history of painting, as represented by the examples in the collection' (Wornum and Eastlake, 1847: 4). Categorization by school and period provided the framework for what was seen as 'a Biographical Dictionary of Painters' with the Gallery's pictures acting as illustrations, on the wall rather than within the covers (it was not illustrated). An opening note on the definition of schools of painting was followed by a 'Tabular View of the schools of Painting, as represented in the Pictures in the National Gallery' (Wornum and Eastlake, 1847: 12), in which the Tuscan, Venetian, Roman schools and so forth were listed with the names of major artists given under each century. This was the most fully developed statement to date in catalogue form of the

historical principle of picture collection: ironically, it was one that, faced by the conservatism of his trustees, Eastlake was not yet able to impose on the National Gallery's acquisition policy. It illustrated again the possibility of developing within the format of the catalogue ideas which could not yet be realized elsewhere.

In the 1847 catalogue each artist was given a relatively extended biography; but instead of the anecdotes that had cluttered earlier versions, the text analysed the quality of each artist's production, and outlined the location of their pictures, the work in which they specialized, and their family relationships with other artists. The paintings were described briefly, without the rhapsodic passages of earlier compilers, giving succinct historical information or critical commentary. References to other literature (though not yet full provenances) were given, as was some information on technical matters – reflecting the work on the history of oil technique already carried out by Eastlake. The apparatus of information was efficiently organized, with the National Gallery's purchases and gifts listed by date in a separate section.

Eastlake and Wornum made their catalogue as easily available as possible. Eastlake was not on the staff of the Gallery between 1847 and 1855, but on his return he confounded Seguier's reservations by issuing in 1855 a basic *Catalogue of the Pictures in the National Gallery*, giving only the names and dates of artists and picture titles, and sold for a penny. The same year an *Abridged Catalogue* was published, sold for fourpence: this summarized the 1847 publication, with brief biographies and accounts of the paintings. In 1858, the 1847 catalogue was reissued in a cheap but complete edition, a striking indication of the importance attached by this small but influential group of curators to the dissemination of instruction in the visual arts.

The principles explored by Wornum and Eastlake were more fully developed in Britain during the 1850s and early 1860s. This was a period when a greatly expanded public, both wealthier than before and able to travel by train, was flocking to such major art exhibitions as the Manchester Art Treasures Exhibition of 1857 and the International Exhibition at South Kensington of 1862, and when the influence of the developing study of art history, particularly in Germany, was especially strong in Britain. These exhibitions were the ancestors of the provincial art museums set up from around 1870 onwards. Both Waagen, in two articles published in

1853 (Waagen, 1853), and Prince Albert, in a paper issued as a Supplement to the Select Committee Report on the National Gallery of 1853, developed the view that Waagen had already expressed in organizing the catalogue of the Berlin Royal National Gallery: that a national collection should be organized on historical lines, illustrating not only the progress of art but the rise and decline of individual schools and the mutual influence of schools and artists.

The comprehensive art collection, almost unattainable on a permanent basis, was realized in temporary form at Manchester, and through casts and photographs in the art displays at the reconstructed Crystal Palace, opened at Sydenham Hill in 1854. As far as catalogues went, the influence of this bold historical scheme was more aspirational than actual. The catalogues for the Manchester exhibition contained necessarily brief entries (there were over 2,300 paintings on view) on the works of art, including artist, title, owner, notes on the literature, notes on inscription, iconography and date, and in some cases comparisons with other works, but excluding dimensions, medium and support, or commentary.

That such succinct information was not regarded as sufficient for a permanent collection is apparent from the observations offered by Eastlake in a Treasury Minute of 1855 on the future of the National Gallery (Eastlake, 1855). In this document, Eastlake proposed a style of catalogue comparable in its scope to the most advanced Continental examples, such as Passavant's *catalogue raisonné* of Raphael. Each painting was to be described under twelve headings, in addition to the name of the artist: its place in a larger scheme if appropriate, its subject, dimensions, support, medium and inscription, the location of associated works, versions, copies, engravings, associated drawings, and a 'General History', meaning primarily a detailed provenance. In addition to this published information, the museum should keep 'more circumstantial memoranda' in supporting volumes. These would cover all authoritative references to the work, the condition of the picture, a description of the composition (but only if no engraving existed, avoiding the tedious account of a painting's appearance in which some catalogues even now indulge); the various prices of the painting and records of lost or damaged related works. So comprehensive a style of catalogue entry was not fully realized at the National Gallery or elsewhere in the nineteenth century; Wornum

and Eastlake's 1847 publication remained the Gallery's official catalogue until 1878, when it was superseded by an adapted but not much more comprehensive edition. By the later years of the century the Gallery had slid into a state of inertia in which such scholarly enterprises as Eastlake had hoped to implement were hardly attainable.

The idea of a gallery catalogue as a complete textbook to the history of art was applied beyond the National Gallery in the 1850s – even though Britain still possessed very few public art collections. At Cambridge, the perfunctory inventory of the 1840s was replaced in 1853 by an (anonymous) *Hand-book to the Pictures in the Fitzwilliam Museum*, reflecting the opening of the Museum to the public two days a week. The new volume, which arranged the paintings according to donor, offered considerably more information than its predecessor, including a biography of the artist, a stylistic commentary on the painting, and information on provenance and valuations. Similarly detailed volumes were provided for the Ashmolean Museum and for the new National Galleries of Scotland and Ireland. In Edinburgh, the catalogue prepared by the curator, W.B. Johnstone, acknowledging that the picture labels were not likely to satisfy visitors, was inspired by the catalogue of the National Gallery in London in providing 'a full description of the Pictures, with critical and historical remarks, and short biographical notices of the various Artists' (Edinburgh, 1859: 5). This activity reflects the remarkable liveliness in official encouragement of the visual arts in 1850s Britain. With the death of Prince Albert and of Eastlake in the 1860s the impetus lessened at national level, and official institutions tended to make do, for at least a generation, with the catalogues of the 1840s. Only in the last years of the century did the situation advance with the publication of scholarly compilations, including detailed discussions of attributions and the reproduction of signatures. These were produced at, for example, Dulwich, where the German art historian J.P. Richter published a new catalogue of the non-British paintings in 1880, and at Cambridge, where in 1902 the Assistant Director, F.R. Earp, produced *A Descriptive Catalogue of the Pictures in the Fitzwilliam Museum*, based on the researches of Sidney Colvin. Such erudite volumes were rare: nothing of this sort was found in the provincial museums which sprang up throughout Britain in the last third of the century.

BRITISH ART AND PROVINCIAL MUSEUMS

As we have seen, the tendency of cataloguers around 1800 had been to regard the statement of national individuality as of prime value, a view which reflected and encouraged competitiveness in the definition of a nation's cultural achievements. By and large the catalogues produced in nineteenth century Britain were guided by pragmatic rather than theoretical considerations, so that the division by schools was not stressed to the country's disadvantage; even though the rooms at, say, the National Gallery were increasingly arranged on national lines, with most of the native art being relegated to the basement or to other buildings. In the mid-century a programme for the early development of the British school was worked out, linked to the history of the Royal Academy: the premise was proposed that this school 'began' in the 1760s, the year of the Academy's foundation, foreign artists working in this country at an earlier date not counting as members (see e.g. Dublin, 1867: 18) The collection of British paintings which Robert Vernon left to the nation in 1847 (see Hamlyn, 1993) as a gallery of British art included as an introductory historical section the early masters: Reynolds (represented by a self-portrait) as the founder of British portraiture, Wilson and Gainsborough as the founders of British landscape; with Constable, Turner and Wilkie as the leaders of the next generation. This convention of including examples of eighteenth and early nineteenth century British painters in primarily modern British collections was to become common in the nineteenth century: until very recently a fine intact example of this approach could be seen at Royal Holloway College. Although literature on the British school was slower to emerge, Richard and Samuel Redgrave's *A Century of British Painters*, of 1866, offered for the first time in accessible form a national history; while the British school received prominent attention in the massive art exhibitions of 1857 and 1862. It was a programme that continued throughout the century, culminating in 1897 in the foundation of the National Gallery of British Art on Millbank. The aim of this programme was to propagate the notion that during the late eighteenth and the nineteenth centuries the British school had developed into one of the most important. Certainly the late Victorian insularity, not so much of artists as of collectors, reflected a belief in the superiority of British work. A similar assurance was offered by the Civil Service Estimates published in the Reports of the National

Gallery which annually recorded the fifteen or so most frequently
copied old masters in the collection, and the most popular modern
pictures. Although the National Gallery scarcely contained any
modern pictures other than British works, its unfailing success in
this arena again could be taken to confirm native superiority.

The provincial art museums set up by municipalities in increasing
numbers from around 1870 were ruled by similar considerations.
Their picture collections, given or bequeathed by local dignitaries
or acquired from annual exhibitions, were predominantly British
and modern, with an emphasis on the work of artists associated with
the locality – though French, Dutch and German artists, predomi-
nantly with an academic background, also featured. The prepara-
tion of catalogues by the curators was regarded as a necessary
service in any sizeable institution. These catalogues were prepared
not in the spirit that had led historians to deliberate over the
respective merits of chronologically or geographically based classi-
fication, but with unambitiously pragmatic aims. George Birkett,
for many years Curator of the Leeds City Art Gallery, epitomized
the approach in his preface to the 1898 catalogue sold (for a penny)
to visitors at Leeds:

> Visitors to the Art Gallery and writers in the Press have frequently expressed
> a wish to have placed within their reach, and at a small cost, a Catalogue
> descriptive of the works in the Permanent Collection, together with short
> biographical notices of the Artists.

His catalogue was 'not intended for the learned in matters of the
kind, nor does it lay claim to any literary merit. It is simply a
Handbook, embodying a few leading facts and observations which
may perhaps enable ordinary visitors readily to understand and
appreciate the works placed before them' (Leeds, 1898: 3). Similarly
modest aims were expressed by other curators: their publications
were intended for use in the galleries, rather than for subsequent
study, and the lack of illustrations discouraged later consultation.
In such a context, the theoretical considerations debated by Lanzi
and von Mechel were irrelevant. Birkett stressed the role of his
catalogue when discussing the 'Arrangement of Exhibits'. Although
some galleries arranged their catalogues in alphabetical order of
artists, he found 'no real advantage' in this, preferring 'the simple
consecutive numerical order' (Leeds, 1898: 4) A similar approach
was taken in such large galleries as Birmingham, established in the

late 1860s, with its first list of contents produced in 1870, and more elaborate volumes following; at the Walker Art Gallery in Liverpool, founded in 1873, where a catalogue was issued in 1898 and in a revised version in 1902; and at the Manchester City Art Gallery formed in 1882 and given its first full catalogue in 1894. The Mappin Art Gallery, Sheffield, achieved its first major catalogue in 1914 (see Plate 5).

The information offered in these publications tended to be of a standard type. The artist's name was generally accompanied by a brief biography, and the title of the work by support, dimensions and inscriptions. The source of the object was always listed, since one of the prime functions of such works was to acknowledge the generosity of donors and to solicit more of the same. Aldermen or councillors were given special credit, and portraits of such worthies were accompanied by eulogistic biographies. Many of the entries contained explanatory texts. To the modern reader, these catalogues show a chaotic lack of taxonomical expertise. At Liverpool, for example, oil paintings, watercolours, statues, casts, china vases, drawings and etchings and works on loan from the National Gallery were given in one continuous list with no classification by medium, period or school.

The 1870s was a period of particular vitality in the growth of general education: although the 1871 Education Act did not create a system of universal education it set up the machinery which made universal education possible. The municipal art galleries of late nineteenth-century Britain were established with the aim of contributing to general education and entertainment rather than of appealing to a specialized audience, and they succeeded resoundingly in attracting large popular audiences to view both temporary and permanent displays of modern paintings and sculpture. For such audiences, it was usual to supplement the basic information of the catalogue entry with short descriptive passages of the 'biedermannisch' sort. Such passages repay study, since they represented, at a time when only limited provision was made by art museums for popular education, the most concentrated effort to instruct the general populace in the field of art.

The provincial museums were often founded in association with the educational museum at South Kensington, the forerunner of the Victoria and Albert: thus the Midland Counties Art Museum set up in Nottingham Castle was founded, according to the

'STATEMENT of the objects of this institution', by the Department of Science and Art which ran the South Kensington Museum, 'with a view to the establishment of a permanent Science and Art Museum in Nottingham' (Nottingham, 1878, title page). Such collections were intended to offer instruction in design to workers and manufacturers as well as to teach students of art. The catalogue commentaries accordingly emphasized technical proficiency: at both Manchester and Liverpool the brilliance of the admired teacher Alphonse Legros in producing a drawing in front of a crowd of art students in only an hour and forty minutes was remarked on (Manchester, 1894: nos. 11, 14, 16; Liverpool, 1902: no. 179). In the Walker Art Gallery catalogue the commentary by the Curator, Charles Dyall, on such a picture as J. Fraser's *On the Murray Firth*, suggested that the technical dexterity of the artist could be learnt by others:

> This work is remarkable for the drawing of the waves of the sea, which, with a little stretch of the imagination, appear to be in motion, while the transparency and the foam and spray show how, by very simple means, realistic effects can be produced when the effect is guided by knowledge and facility of manipulation (Liverpool, 1902: no. 282).

Equally, the biographies of artists always gave details not only of awards and exhibitions but of their education. In a number of cases their lack of formal training was stressed, not as a criticism (inclusion of their work in the collection already constituted approval) but as an inspiration to visitors to do likewise. Aspiring artists in Manchester must have been encouraged by the example of William Etty: he suffered frequent disappointment in submitting work to the Royal Academy but 'by discovering his defects, and by great industry in endeavouring to correct them, he had at last conquered his evil fortune' (Manchester, 1894: 20).

As might be expected, the catalogue commentaries contained an element of patriotic and social instruction. At its worst, this was blatant, Dyall in Liverpool being particularly prone to use paintings as the occasion for reflections on the bourgeois virtues to be found among workers. Writing about Stanhope Forbes's *A Street in Brittany* (Liverpool, 1902: no. 281) he commented on 'the contented and happy appearance of the humbler classes' abroad, which showed 'that real happiness is not confined to the powerful and wealthy', while Arthur Stocks' *Motherless* (Liverpool, 1902: no. 322)

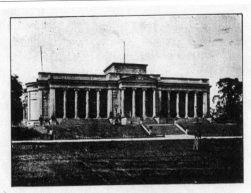

City of Sheffield.

MAPPIN ART GALLERY.

CATALOGUE

OF THE

PERMANENT COLLECTION

OF

Pictures and other Works of Art.

SEVENTH EDITION.

PUBLISHED UNDER THE DIRECTION OF THE
MAPPIN ART GALLERY COMMITTEE.

SHEFFIELD:
WILKINSONS (PRINTERS) LIMITED, FURNIVAL STREET.

1914.

5 Title page, catalogue of Mappin Art Gallery, Sheffield, 1914.

illustrated the comforting truth 'that the finer feelings of human nature are shared by all classes'. Paintings of naval and military engagements provoked predictable homilies. E. Matthew Hale's *The Drums of the Fore and Aft* (Leeds, 1898: no. 14), which depicted the gallant death of two drummer boys in the last Afghan war, was accompanied by a passage from Rudyard Kipling.

Even in the age of Social Realist painting, such commentary was less common than might be expected. The curators often concentrated on explanation of the narrative content of the paintings, though some went further. Dyall at Liverpool and William Stanfield at Manchester favoured the basic exposition. Stanfield offered elucidation, often banal (*The Dead Robin* is glossed as 'Two Children weeping at the Death of their Pet Bird' (Manchester, 1894: no. 1)), a few telling lines of verse, an explanation of the participants, or a topographical analysis of the scene. In some instances the elucidation of subject-matter was thought insufficient, notably in the catalogue prepared at Leeds by Birkett. Though not ambitious in his analysis, Birkett was interested in the visual rather than the narrative elements of paintings, and in suggesting that the viewer need not be content to read a picture like a book. Lady Butler's *Scotland for Ever* (Leeds, 1902: no. 2) was described in excited terms emphasizing not military prowess but 'the foreshortening of the horses, and the wondrous skill with which the idea of the resistless rush is given, the unity of purpose, and the variety of incident, the vigorous individuality of each horse and each trooper . . .'; while Loudon's *Red Sofa* (Leeds, 1902: no. 7) was analysed in formal colouristic terms, with the comment that 'Of real "Motif", there is practically none in the picture'. A. Peppercorn's *The River, Bosham* (Leeds, 1902: no. 32) most clearly illustrated Birkett's approach. He justified the picture's 'great breadth and vigour of handling', remarking that

> Visitors who only care for Pictures in which every detail is worked out for them in a photographic sort of way, will hardly be much impressed with this little work, but to such as prefer the "spirit of the Scene" to more material detail, its great and masterly merits will be readily realized and appreciated.

In spite of Birkett's attempts to broaden the outlook of viewers, most of these municipal catalogues were non-analytical, reflecting the lack of planning in the collections themselves, and used the opportunity of communicating with the masses to introduce an

improving moral discourse. This was a tendency carried further in popular publications produced throughout the century. The discomfort felt in the 1830s over depictions of nudity and erotic feeling was crudely dealt with in such a publication as the Jones and Co. *The National Gallery of Pictures*. Here a moralistic tone was applied to the explanation of the paintings: not only to *Marriage à la Mode*, but to Correggio's *Venus and Mercury instructing Cupid*. Though the writer conceded that a painted Venus can hardly be found

> more entirely naked . . . none else is so modestly contrived . . . calculated to attract us, *chiefly* by the interest which the goddess herself takes in the education of her son . . . Coreggio's [sic] Venus, though eminently graceful, assumes no airs of divinity or of voluptuous blandishment, but presents herself, simply and meekly, in her maternal character, divested of amorous witcheries. (Jones & Co., 1838: no. 110)

A similar sanitized tone was found at the end of the century in the catalogues for the art exhibitions in Whitechapel organized by Canon and Mrs Barnett for their deprived parishioners.

CONCLUSION

Such publications were hardly catalogues; rather, lists with commentaries. It is a depressing reflection on the state of art museums and of art historical knowledge in nineteenth century Britain that a century which for a brief period in the 1850s had witnessed so active an interest in the codification of works of art had by its close produced so few publications of corresponding value. As for the relationship of the British school to the art of other countries, that issue was dealt with only by the tacit avoidance of obvious competition, and by giving the native school a unique standing, dominant in many collections, and finally enshrined in a museum of its own, safe from competition. Such a solution was adopted elsewhere only by such countries as Russia, Poland and Hungary, where a sense of unease about the quality of the native school, and indeed a desire to stress national identity as vigorously as possible, stimulated the creation of a fortress of national art. It is peculiarly ironic that at the time of writing such old-fashioned cultural isolationism should be finding expression once again, in the proposed creation of a National Gallery of Scottish Art.

BIBLIOGRAPHY

Blundell, Henry (H.B.) (1803) *An Account of the Statues, Busts, Bass-Relieves, Cinerary Urns, and other Ancient Marbles, and Paintings. At Ince . . .*, J. McCreery, Liverpool.

Britton, John (1808) *Catalogue Raisonné of the Pictures belonging to the Most Honourable the Marquis of Stafford in Cleveland House*, Longman, Hurst, Rees and Orme, London.

Cole, Henry (1843) *Felix Summerly's Hand Book for the National Gallery*, George Bell, London.

Dublin (1867): G.F. Mulvany, *Catalogue, Descriptive and Historical, of the Works of Art in the National Gallery of Ireland, With Biographical Notices of the Masters* Alex Thom and Co. Ltd., Dublin, for the 1890 copy.

Eastlake, Charles (1845) *The National Gallery*, W. Clowes & Sons, London.

Eastlake, Charles (1855) *Reconstituting the Establishment of the National Gallery*, Treasury Minute, 27 March 1855, National Gallery archives.

Edinburgh (1859): W.B. Johnstone, *Catalogue, Descriptive and Historical, of the National Gallery of Scotland*, National Gallery of Scotland, Edinburgh 1859.

Hamlyn, Robin (1993) *Robert Vernon's Gift: British Art for the Nation 1847*, Tate Gallery, London.

Jones & Co. (1838) *The National Gallery of Pictures by the Great Masters*, Jones & Co., London.

Landseer, John (1834) *A Descriptive, Explanatory, and Critical, Catalogue of Fifty of the Earliest Pictures Contained in the National Gallery of Great Britain*, Richard Glynn, London.

Lanzi, Abate Luigi (1825) [1792] trans. T. Roscoe (English edition) *The History of Painting in Italy*, W. Simpkin & R. Marshall, London.

Lebrun, J.B.P., (1796) *Ideas on the Disposition, the Arrangement and the Decoration of the National Museum*, 1792 edition printed by L'Imprimerie Nationale, Paris.

Leeds (1898): George Birkett, *City Art Gallery, Leeds. Catalogue of the Paintings & Drawings in the Permanent Collection, with Notes, Descriptive and Biographical*, Jowett & Sowry, Leeds.

Liverpool (1902): Charles Dyall, *Walker Art Gallery, Liverpool: Descriptive Catalogue of the Permanent Collection of Pictures*, Walker Art Gallery, Liverpool.

MacGregor, Arthur (1983) *Tradescant's Rarities*, Clarendon Press, Oxford.

Manchester (1894): William Stanfield *Catalogue of the Permanent Collection of Pictures in Oil and Water Colours with Descriptive Notes and Illustrations*, H. Blacklock & Co., Manchester.

Millar, Oliver, (1958–1960) *Walpole Society*, XXXVII, pp. 1–229.

Nottingham (1878): *The Nottingham Castle Art Museum*, Nottingham Castle Archives, published by Nottingham Castle Museum and Art Gallery.

Ottley, William Young (1818) *The Collection of Pictures of The Most Noble The Marquis of Stafford, In London; Arranged According to Schools, and in Chronological Order*, Longman, Hurst, Rees, Orme & Brown.

Ottley, William Young, (1832) (2nd edn 1835) *A Descriptive Catalogue of the Pictures in the National Gallery, with Critical Remarks on their Merits*, 1826 edition John Murray, London.

Plot, Robert (1677) *The Natural History of Oxford-shire*, printed at The Theatre, Oxford.

Sans-Souci (1770): Anon *Description of the Royal Picture Gallery and the Cabinet in Sans-Souci*, Potsdam, p. 4.

SC (1836): *Parliamentary Select Committee on the Arts and Principles of Design* (568) X, 1.

SC (1841): *Parliamentary Select Committee on National Monuments and Works of Art* (416) VI, 437.

TMNG: Trustees' Minutes, National Gallery (National Gallery Archive).

Vienna (1781): Christian von Mechel, *Catalogue of the Paintings in the Imperial and Royal Picture Gallery in Vienna*, Wien.

Vienna (1785): Anon, *Reflections on the Imperial and Royal Picture Gallery in Vienna*, Bregenz.

Waagen, Gustav (1853) *Thoughts on the New Building to be erected for the National Gallery of England, Art Journal*, 1 April, 1 May.

Waagen, Gustav (1854) *Treasures of Art in Great Britain*, John Murray, London.

Waterfield, Giles (1988) *Rich Summer of Art*, Dulwich Picture Gallery.

Wornum, Ralph and Eastlake, Charles (1847) *Descriptive and Historical Catalogue of the Pictures in the National Gallery*, W. Clowes & Sons, London.

3

The Devaluation of 'Cultural Capital': Post-Modern Democracy and the Art Blockbuster

SHEARER WEST[1]

INTRODUCTION

One of the predominant qualities of postmodernism is an elision of mass and high culture which ostensibly democratizes Western experience, particularly leisure life (Jencks, 1992, Foster, 1985). Theorists claim that the division between an élite high art and a popular art of 'the masses', which was consolidated by the development of modernism, has now been obliterated by the encroachment of electronic technology and the plethora of simulacra which is its product (Baudrillard, 1985). Left-wing writers (Habermas, 1985; Jameson, 1985) have attacked the mindless consumerism of postmodern society, but their stance has been maligned for its romantic humanism and its élitist rejection of art forms, such as television and video, which genuinely appeal to a diverse population (Collins, 1992; Hutcheson, 1992; Huyssen, 1992). However, the critics of postmodernism have isolated an important flaw in the argument for mass leisure. In contemporary society, the term 'democracy' is used synonymously with 'capitalism', while the quest for a 'classless society' is actually a denial of the real distinctions that continue to characterize modern Western democracies. Leisure is subsumed within the consumerism of multinational capitalism, although it is presented as a levelling influence in contemporary life.

An investigation of leisure activities reveals the ways in which this paradox functions. Charles Jencks (1992) applies the concept of 'double-coding' to postmodern architecture, indicating that a signifier can function simultaneously on more than one level, and can therefore appeal to the educated and uneducated at once. The art blockbuster exhibition – as a site of both the exclusivity of high

culture and the consumerist populism of heterogeneous culture – is a more invidious example of this 'double-coding'. Belcher's (1991: 37) definition of an exhibition as 'showing for a purpose' astutely isolates the important functional quality of exhibitions, but it is important to ask for *what* purposes exhibitions, especially lavish and expensive blockbusters, are launched. Although a specific definition of the art 'blockbuster' is elusive, it could be defined as an exhibition that aims for maximum coverage and maximum publicity to attract maximum attendance. It is an urban phenomenon and tends to be confined to major metropolitan venues. Its purpose is money, its excuse education and entertainment, and it engenders a vast machinery of public relations, media hype and consumerism.

Although represented as a mass activity, the art blockbuster continues to present works of art as cyphers which can only be interpreted by the initiated. While maintaining the hegemony of 'great art', and thus providing a forum for academic debate, blockbusters are inherently commercialized and their very existence promotes business corporations, the press and publishing companies. Bourdieu's (1979) idea that an upwardly mobile population will invest in various forms of 'cultural capital' to reinforce its economic autonomy is here underlined by a form of cultural capital which pretends to be democratic. The art blockbuster alienates the majority of the population through its academic presentation of works of art, and assimilates its educated constituency by forcing it to collaborate with the commercialization of art. An investigation of the components of art blockbuster exhibitions from their first appearance in the 1970s reveals how this 'double-coding' results in culture which continues to mystify, while it professes to educate and entertain.

BLOCKBUSTERS AND THEIR VISITORS

One of the problems with assessing the appeal of the art blockbuster lies in the fact that there are no published statistics to provide an overview of visitor profile or response. Such surveys have become more common in museums, where the need to satisfy the public is an increasing priority (Hooper-Greenhill, 1988; Merriman, 1989a; Merriman, 1989b). Merriman's studies of museum visitors indicate that regular attenders tend to be educated and financially comfortable (Merriman, 1989b: 156), and that the public image of museums among the less educated is negative. Museums are perceived by the

latter group as similar to libraries or churches, rather than as places for fun and relaxation. However, the blockbuster exhibition inspires a different response, whether or not it is actually set within the museum context. The assessment of Gerard Regnier of the Musée Picasso in Paris is particularly revealing:

> When I first arrived at the Museum of Modern Art in Paris in 1966, the museum was a place for the amateur and the connoisseur; a Max Ernst exhibition, for instance, got no more than 5000 visitors, but now we are coping with hundreds of thousands of visitors for any exhibition, whatever the subject, whatever the works, whatever the seriousness, whatever the quality of the exhibition. So we are dealing with a social phenomenon, no longer with an aesthetic phenomenon. ('New Museology' 1991, 94)

Regnier's statement conveys an image of hordes of people avidly, but thoughtlessly, crowding the doors of the latest exhibition. His summary suggests that there is something in exhibitions which has mass appeal and satisfies a social need, but which is separate from the aesthetic sensibilities of the exhibition audience.

This idea of a diverse and voluminous audience for exhibitions is a misleading one. First of all, the increasing cost of entry to blockbusters, and their inevitable location in a handful of metropolitan centres immediately excludes a large proportion of the population. Secondly, while attendance figures for blockbuster exhibitions in the 1980s and 1990s have fluctuated according to the subject, even the most popular exhibitions in New York and London have attracted no more than 658,000 ('Exhibition Attendances', 1993). In terms of box office numbers, this is a large quantity, but even such high numbers do not prove that the visitors represent a genuine cross-section of the population – particularly if the factors of recurrent visitors and foreign tourists are taken into account. Thirdly, Regnier's perception of an ever-increasing audience for art blockbusters is not borne out by British statistics. The most successful art exhibitions in London during the last 15 years were the Dali exhibition of 1980 and the Constable exhibition of 1976; despite the perception of ever-increasing numbers, average attendance figures have not risen substantially, even during the yuppie 1980s. Finally, the financial and educational status of the exhibition audience is taken for granted in numerous criticisms. A stray comment in William Hood's review of the Sienese Quattrocento Painting exhibition at the Metropolitan Museum in New

York epitomizes this tendency. Hood declared that 'the reunited Passion predella by the Master of the Osservanza alone merits the trip to New York' (1989: 242). Although obviously directed towards a specific readership (see below), this article in the English *Burlington Magazine* assumes an audience well versed in the vagaries of Sienese painting, and able to afford the time and the money for a long weekend in New York.

The reasons people attend art exhibitions have equally aroused little speculation, but Belcher offers the most plausible suggestion. Apart from genuine interest, many people wish to go to exhibitions because 'not to have seen the current blockbuster might mean the same exclusion from dinner-party conversations as not having seen the latest West End play or not having read the Booker prizewinner' (1991: 52). The blockbuster provides 'cultural capital' for a socially aspirant middle class, but it is only one of many forms of easy capital which can be accumulated in the contemporary urban context. The devotion to blockbuster exhibitions is part of what Philip Wright characterizes as ' "harrassed" leisure consumption – of cramming as many, preferably concentrated, non-work experiences as possible into the spare time available' (1989: 216). This is exemplified in Britain by the Heritage Minister, who is responsible for libraries, museums, sports and the national lottery – a typical post-modernist smorgasbord which equalizes leisure activities that are actually distinct in purpose and, in some cases, quality. The blockbuster is part of this cultural overabundance, but it provides no more than a minor component of a diversified leisure experience.

BLOCKBUSTERS AND THEIR SUBJECTS

The 'double coding' of the blockbuster can also be seen in the subject of the exhibitions themselves. Most blockbusters are 'retrospectives' of canonic male artists who were part of modernist mythology. During the last twenty years, all of the major Impressionists, Post-Impressionists, early Modernists and Surrealists have had at least one blockbuster devoted to their work, while some of the old masters such as Rembrandt and Leonardo have also been the subject of high-profile international shows. The venues for such blockbusters have gradually been confined to a selection of major museums or exhibition spaces which specialize in large shows: for example, the Royal Academy in London, the Grand Palais in Paris,

the Museum of Modern Art in New York, the Art Institute of Chicago, and the National Gallery of Art in Washington. Such venues tend to present the work of artists whose production is known not so much through art-historical publications, as through its value in the art market or, more typically, its place on calendars, biscuit tins and other consumer paraphernalia. Ironically, the allure of the original is heightened, rather than diminished, by the repetition of its image (Benjamin, 1992), and the mythical, even mystical, quality of canonic modernist painting is reinforced by its placement in an exhibition devoted to the work of an acknowledged 'great artist'.

An examination of a list of blockbuster exhibitions which have taken place since the 1970s reveals just how limited the subject-matter is. The suspicion that exhibition organizers are running out of ideas is affirmed by the repetition of familiar subjects: the Tate Gallery, for example, launched a Constable exhibition in 1991 – only fifteen years after the last major one, and in 1993 the Museum of Modern Art in New York did the same with Matisse, twenty-three years after another major Matisse retrospective at the Grand Palais. Blockbusters present a very limited view of art history, and the exclusions are as significant as the inclusions. It is telling, for example, that the only female artist to have earned her own blockbuster is Georgia O'Keeffe, whose retrospective was first shown in Washington, Chicago, Dallas and New York in 1987–8. However, O'Keeffe's work offered a contribution to the mythology of the 'Great Plains', which fed into the image of America as an adventurous and pioneering nation (Luke, 1992: 68–78). Other women artists have been given attention only in small, albeit important, shows.[2] In art-historical research, the role of women as artists and subjects has occupied an increasingly important role, but blockbuster exhibitions – which pretend to draw on the latest research – tend to ignore such facts. Instead, they offer a hagiographic homage to the 'great' male artists whose place within the canon is assured. The way in which blockbusters are described (as 'the last/only/best show of its kind in the world'), and the sheer number of works included in many of them (over 400 in some cases) are intended to contribute to the mystique surrounding the subject of the show.

While monographic exhibitions occupy a prominent place in the blockbuster repertoire, in fewer instances, theme exhibitions qualify for the status of blockbusters, but here the organizers enter into

potentially problematic and controversial fields. For example, the Guggenheim Museum in 1993 launched an exhibition of early twentieth-century Russian art – 'The Great Utopia: The Russian and Soviet Avant-Garde 1915–1932'. Following the collapse of state communism in the Soviet Union in 1989, this exhibition sought to establish the existence of a developing left-wing avant-garde in Russia after the Revolution, but one whose ideals were seen to falter with the realities of communist rule. Showing both respect for the contemporary Russian federation and a patronizing disdain for the failures of state communism, this exhibition served to give liberal intellectual Americans a safe perspective on communist culture of the inter-war period. However, as with many other 'theme' exhibitions – such as the British Art exhibition at the Royal Academy in 1987 – the Soviet art exhibition attempted to establish a seamless history of modern art, based on a legacy of influence or rejection. The myth of the avant-garde continues to dominate theme exhibitions of modern art, which usually become thinly disguised excuses to reaffirm the canon. This is the case in the Paris exhibition 'Figures du Moderne: L'Expressionisme en Allemagne 1905–14', shown at the Musée de l'Art Moderne de la Ville de Paris in 1993, which seemed to present a history of German Expressionism but really offered audiences a series of 'mini monographs' of famous German modern artists (Lloyd, 1993: 234).

The quest for the popular subject also can result in a distorted or partial view of an artist. The increasing cost of blockbusters, and the understandable wariness of private collectors and museums about lending delicate and valuable paintings (Rogers, 1993; Airlie, 1993; Kelly, 1993), have led to some 'retrospectives' which are not representative. The most obvious example of this was the Seurat exhibition at the Grand Palais in 1991, which claimed to offer an overview of Seurat's work, but did not include four of his most famous paintings. This is not to say that Seurat cannot be understood or appreciated without considering *La Grande Jatte* and *Une Baignade, Asnières*, but the exhibition itself did not provide the full history of a 'great' Post-Impressionist artist that it pretended, and the visitors were thus robbed of the opportunity to affirm their own familiarity with Seurat by recognizing the artist's most frequently reproduced works.

BLOCKBUSTERS AND THE RHETORIC OF BUSINESS

But because of the expense, the risk factors and the need to attract a large public, blockbusters must 'play safe' and they therefore lack the innovative and concentrated focus of many provincial exhibitions, travelling exhibitions (Kelly, 1992) and exhibitions which focus on aspects of a gallery's permanent collection. However, while in Britain the government funds for alternative types of exhibition are reduced, the blockbuster takes an increasingly prominent place in the public perception of art. And the blockbuster gives a limited, misleading and distorted perspective on the history of art by attempting to satisfy the public's desire for familiarity, while repeating old academic formulas which see art history as an inexorable progress towards greater and greater innovation.

The image of the blockbuster is further complicated by the commercialization which permeates it on every level. Economic motivation always lay behind blockbusters, but in recent years, the commercial concerns have become inextricably bound up with the aesthetics of the exhibition. Business rhetoric has invaded the display of culture on every level: there is now a heritage 'industry', and museums offer 'services' to 'customers' (Hewison, 1987; Selwood, 1993). In some countries, exhibitions are directed by 'cultural marketing' agencies, which act as middlemen between the museum and the potential business sponsors (Zorn and Koidl, 1991). The idea of art as a business is so pervasive that the entrance to the Tokyo Isetan Museum of Art is through the Shinjuku Isetan Department Store; this is the ultimate distancing of art from the exclusivity of the public museum where it has been harboured for so long.

It has become fashionable to accept this reclassifying of art as a more democratic approach to a service which ought to be 'customer-led' rather than imposed from the lofty heights of a curator's or exhibition organizer's office (Belcher, 1991: 175), but these economic obsessions – despite their deceptive familiarity – are in many ways more alienating than the intellectual pretensions which preceded them. The subject of the exhibition is no longer as important as the public relations which promote it. Everything is conceived in terms of hyperbole: exhibitions are classified as the largest or most comprehensive; the catalogue is heavier or has more illustrations than any other; the attendance figures are higher and queues longer; the cost of launching the exhibition is unprecedented, etc. The publicity

surrounding the 'Monet in the '90s' exhibition at the Royal Academy in 1990 was concerned as much with the 16,000 pre-booked tickets and the massive cost of the show as it was with the works displayed (Montefiore, 1990). This interest resulted in a series of excruciating puns, such as 'Monet talks', 'Value for Monet' and 'Monet-spinners' (Watson, 1990; Wightman, 1990). The mythology of money is built into public perception of the blockbuster, and this further adds to the allure of the exhibition, while it erects a new barrier between the exhibition and the teeming throngs who attend it. Aside from being incorporated into the very fabric of the blockbuster itself, the business factor also functions on several practical levels: sponsorship, consumer items and exhibition catalogues. It is worth considering each of these areas in detail to reveal how the economic base of the blockbuster both undermines its art-historical credibility and redefines its purpose in terms of money.

Sponsorship is one of the thorniest areas of contemporary exhibition organization. The necessity for seeking sponsorship is undeniable, but the implications of requiring private funding for the arts are worrying, if not chilling. Museums and exhibition organizers consistently deny that their sponsors have interfered in any way with the choice of objects, their display and the approach of the catalogue. Kirby (1988) has shown that some sponsors of museum displays have intervened directly in the layout and explanation of objects, but this sort of dictatorship is rare. However, the premise that the organizers have freedom in their choice of subject and display can be challenged on several levels. First of all, in order to attract sponsors, exhibition organizers and museums are required to present a subject which is likely to have a high profile and attract a large audience. The criteria for selecting subjects worthy of blockbuster status are, as I have indicated, limited. The sponsor may not require a museum or an exhibition organizer to launch a blockbuster on an Impressionist artist, but the decision to have a retrospective of a major Impressionist will be more likely to attract sponsorship. The problem of self-censorship becomes more acute than the proactive interference of business sponsors, and this is further complicated by the often conflicting demands of the numerous individuals involved in launching a major show (Vergo, 1989: 43–4).

Secondly, as with arguments about the funding of political parties, it is important to determine what the sponsors receive in return

for their 'investment'. Many sponsors expect certain perks for their employees and clients, such as free attendance at the exhibition and special events (Danilov, 1988: 149). More important is the publicity companies receive for their role in exhibitions, and the way in which sponsorship enhances the company's public relations. The Association for Business Sponsorship in the Arts (ABSA) defines sponsorship as 'the payment of money for the provision of goods or services by a business to an arts organisation for the purpose of promoting the business's name, products or service' (quoted in Scaltsa, 1992: 387). Exhibitions serve as a sort of glorified form of advertising to companies, whose patronage is mentioned in newspaper critiques (Thorncroft, 1992), and whose logos appear on the publicity posters and in the exhibition catalogues. This may seem a natural expectation for a company which has devoted a substantial amount of funds to a major exhibition, but the use of the blockbuster for advertising purposes cannot be neutral. The appropriation of art enhances the business, by appearing to give it a wider cultural role. Timothy Luke (1992: 160) has defined this relationship most acutely:

> Corporate patronage institutionalizes the self-interests of corporations as the essence of contemporary culture; thus 'art for art's sake' is always actually art for capital's sake as investment in art enables firms to commodify and accumulate goodwill, public repute, and honored status as integral parts of their business strategies. The power of giving or creating meaning, once ignored by capital, now can be applied as the social grease of good civic standing or productive labour relations within the company. Art buys legitimacy, identity, and acceptance, even when one's corporate product otherwise might be creating corruption, dissatisfaction, and animosity.

However, the relationship between art and business also works in reverse: just as art exhibitions serve to elevate the profile of business, business sponsorship serves to diminish the significance of the art. Company statements about arts sponsorship reduce the entire history of art to a series of gnomic utterances about the significance of art to society and act as thinly disguised puffs for a company's own product. The American Express company's 'mission' is typical:

> Art is a universal language, reaching across borders and bringing people closer together. American Express believes the arts play an integral role in enhancing the quality of life for individuals, communities, and nations. As

an international company, we support quality visual and performing arts programs which cross national boundaries and foster understanding among different people of the world. (quoted in Danilov, 1988: 147)

The stress on universality and the deliberate repetition of the word 'quality' does not so much reflect on the art as on American Express's activities as an international firm which services a predominately middle- and upper-class clientele.

More telling is the statement published by the American telephone company AT&T as the preface to the catalogue of the Museum of Modern Art blockbuster: 'High and Low: Modern Art and Popular Culture' of 1990–1. Not only did AT&T provide a computer network for the exhibition curators, but they were also thanked effusively for this assistance in the early part of the catalogue. AT&T's sponsorship statement – which forms a preface to the catalogue – is couched in language which reinforces the mystique that surrounds works of art, and is worth quoting in full:

With this catalogue and the exhibition it represents, AT&T celebrates 50 years of formal association with the arts.

That association is founded on our belief that communication is the beginning of understanding. That refers, of course, to the technology that lets information loose on the world. But it also refers to the arts, which colour that world from a uniquely human perspective.

It is that gift of expression and its promise of understanding that prods our support. It is the illumination of our own ignorance that fuels the search.

The arts, after all, exist not to explain, but to question. To unearth not the answers, but the possibilities. To remind us not of what we are, but what we can be. (Varnedoe and Gopnik, 1991)

The use of sentence fragments and pseudo-religious language serves to elevate the status of the telephone company, while the stress on communications reminds the reader of the company's own product. The platitudinous statements about art are intended to sound profound, but they are actually meaningless and do little but obscure the significance of art for the public. The exhibition itself was particularly controversial in academic circles: although professing to expose the importance of 'popular art' in the twentieth century (broadly defined as advertising, graffiti and comic strips), it was really an excuse to look again at the modernist canon and to show familiar paintings by Picasso, Magritte and others juxtaposed with the 'popular art' which 'inspired' them. The pretense of popularity

was just that and, ironically, it was the 'great' works themselves – rather than the popular culture – which served as the lure to the crowds who flocked to the exhibition.

If the issue of sponsorship complicates the public profile of exhibitions, the sale of consumer items in exhibition and museum shops commodifies the art works displayed. Most blockbusters, like Stephen Spielberg films, are launched with an array of products designed to attract the 'customer' (Coutts, 1986). Posters, T-shirts, paperweights and pencils are only a few of the products which can carry the stamp of a blockbuster, and these items are purchased as both souvenirs and gifts. Exhibition sponsors often have prize draws which are contingent upon having a ticket to the show, and British national newspapers provide free or reduced price tickets to their readers. These objects and media marketing further consolidate the function of the exhibition as an outpost of commodity capitalism: although it may require a certain amount of knowledge to understand a work of art, it does not require an equivalent depth of understanding to appreciate the same work reproduced on the front of an address book.

But the commodity which represents the most problematic interface between the visitor and the intellectual élite is the exhibition catalogue, which usually attempts to appeal to both audiences and is consequently, and often disturbingly, 'double-coded'.

THE BLOCKBUSTER CATALOGUE, POLITICS AND THE PRESS

It has become essential for a blockbuster exhibition to be accompanied by a large and lavish exhibition catalogue, and it has become commonplace for exhibition organizers to claim that their catalogue represents the most recent and up-to-date research in a given area. On one level, catalogues for blockbusters literally exemplify the 'weight of learning': the catalogue of 'The Great Utopia' exhibition, for example, weighs 3.4 kilograms and has 732 pages, while the catalogue of the 1991 Constable exhibition at the Tate Gallery was three times the thickness of that which accompanied the more comprehensive 1976 exhibition. Certainly, most catalogues contain some new information and are a useful research tool for art historians, but much of their size and weight is determined by an excessive number of full-page reproductions and heavy (and expensive) glossy paper. Also, the number of catalogues sold at exhibitions,

and their relatively low price when compared with other art history books of a similar quality indicate a larger constituency than the limited world of academic art history would suggest. The catalogues of blockbuster exhibitions become coffee-table books which are not read so much as thumbed through for their visual appeal. Although catalogues are getting larger and heavier, their external appearance appears to be changing very little; however, their content is changing in subtle but significant ways. For example, the catalogue of the 'Great Age of British Watercolours' exhibition at the Royal Academy in 1993 does reproduce every work of art, but it does not have proper catalogue entries and relies on a few general essays to convey the scholarship that accompanied the exhibition organization. The physical separation of the essays and the illustrations of the exhibited works made it easier for the publishers Prestel to provide several foreign language versions of the catalogue. Foreign language co-editions are particularly crucial in the financing of travelling blockbusters, and in these cases the catalogue can bear even less relation to the exhibition itself – as all works in the catalogue are not necessarily shown at each venue. The catalogue thus becomes a free-standing commodity, which nevertheless gains its marketability on the basis of its association with the exhibition.

In reality, the scholarship that is presented in exhibition catalogues belies the most recent directions of art history and consolidates an approach to art that academic art historians increasingly perceive to be old-fashioned. In fact, the 'new art history', which examines the history of art from various poststructuralist, marxist and feminist perspectives, has been distinctly absent from the blockbuster publications, with the exception of the Richard Wilson exhibition at the Tate Gallery in 1982–3. This exhibition is worth discussing in some detail, as its attempt to take a new approach to a blockbuster backfired and aroused hostility from both the public and the press. The exhibition was an uneasy compromise between an appeal to a public which aspired to be attuned to the aesthetic value of landscape painting, and a pointed marxist critique of the exhibited works. Several contemporary newspaper and journal reviews accused the author of the catalogue, David Solkin, of 'inflicting' his theories on the public (Spurling, 1982; Sutton, 1983). The timing of the exhibition during the early years of Margaret Thatcher's prime ministership was a significant contribution to the rightest hysteria which greeted such a public declaration of marxist

methodology (McWilliam and Potts, 1986). However, it was not only the right-wing press which condemned Solkin's approach. Even the *Guardian* – traditionally sympathetic to the left – was outraged at Solkin's attempt to de-mythologize an old master (Januszczak, 1982). What enraged all critics, regardless of political orientation, was the challenge to what Habermas has called the 'pure immanence of art' (1985: 14). The paintings are meant to 'speak for themselves' to represent art 'for its own sake', and the content is meant to do no more than inspire an empathetic sigh from the beauty-loving public. A similar, but more temperate, version of this attitude emerged in response to the Monet exhibition of 1990 (see above). The author of the catalogue, Paul Hayes Tucker, had done extensive research into the historical context of the 1890s to uncover nationalist implications in Monet's series paintings. Although press criticism acknowledged his scholarship, it equally insisted that this scholarship was superfluous to the exhibition. The *Daily Telegraph* was typical: 'Stimulating though this [Tucker's] argument is, the exhibition is memorable for its power to make us surrender ourselves to the sheer beauty of the pictures on the walls' (Dorment, 1990; cf. Janis, 1990).

Such reactions eschew or deny political meaning in art and attempt to relegate painting to the realm of pure aesthetics. It is significant that the journal of the British Association of Art Historians – *Art History* – does not include exhibition reviews, while the glossy *Burlington Magazine* devotes a huge monthly section to international shows. Articles and reviews in *Art History* tend to reflect the current debates in the discipline, and blockbusters are mentioned only sporadically and usually in pejorative terms. The most obvious example of this is the Pre-Raphaelite exhibition at the Tate Gallery of 1984, which has become a sort of bogey to feminist art historians, following the swingeing attack on the exhibition's premise by Deborah Cherry and Griselda Pollock in *Art History* (Cherry and Pollock, 1984; cf. Pointon, 1989; Pearce, 1991). These authors claim that the exhibition was a shameless advocate of 'Victorian values' in the age of Thatcher and 'provides an affirmation of bourgeois, sexist and racist ideologies' (482). But the persuasiveness of Cherry and Pollock's argument is undermined by a close examination of contemporary reviews of the exhibition which revealed similarly negative responses to it. In fact, Terence Mullaly of the *Daily Telegraph* (1984) – certainly an advocate of the 'Little

England' values that Cherry and Pollock were maligning – found the Pre-Raphaelite show extremely distasteful and declared 'If I were Minister of Culture in Moscow I would immediately ask to be allowed to put on tour the Pre-Raphaelite exhibition.' Mullaly obviously felt that the depiction of late nineteenth-century decadent aestheticism was somehow closer to the ideals of the communist culture he despised than to the traditional Englishness he espoused. John Russell Taylor in the *Times* (1984) denied outright that the exhibition was 'a nice wallow in sentimental Victorian nostalgia', while the left-wing *New Statesman* titled its review 'Mrs. Thatcher's Neo-Victorian Age' (Spurling, 1984). Similarly, the distaste of feminist Lynn Pearce for the 'never-ending images of heart-sick, sex-starved women' (Pearce, 1991: ix) matched that of the male *Sunday Telegraph* reviewer, who shuddered at the 'druggy' appearance of Rossetti's late paintings of women (Shepherd, 1984). Although these authors were in many cases operating from radically different ideological premises, their conclusions were often the same.

What is apparent here is not that blockbusters are a politically neutral area, but that their political messages are ambiguous and open to interpretation. Edward Said (1985: 136) has expressed eloquently his conviction that

> culture works very effectively to make invisible or even 'impossible' the actual *affiliations* that exist between the world of ideas and scholarship, on the one hand, and the world of brute politics, corporate and state power, and military force, on the other.

The erasure of these affiliations is reinforced by an insistence that art exhibitions are not about politics, even while critics and art historians use the exhibitions to make political points. The stance of political neutrality is assumed rather aggressively by a wide range of exhibition reviewers in the *Burlington Magazine*. Despite massive changes in society, politics and art-historical methodology, the reviews in the *Burlington* have not altered significantly over the last twenty years. Reviewers make a case for the 'greatness' of the artists represented in the exhibition; they pay homage to the scholarship of the catalogue; and they offer a thorough description of the content of the exhibition and the display of the works. The hyperbole which characterizes commercial hype surrounding exhibitions also appears in the *Burlington* reviews, but laundered of its associations with vulgar lucre and given instead an ostensibly academic

context. The 'pure immanence of art' is asserted, and there is a patronizing disdain for anything that smacks of politicizing. Many national newspapers and magazines similarly pretend political neutrality, by using emotive purple prose to describe the works on show. Others concentrate more on the composition and behaviour of the audience at the opening reception than on the works of art themselves.

However, newspaper reviewers implicitly politicize their responses to exhibitions by their direct or indirect attempts to make the subject of blockbusters accessible to their readership. The numerous, generally positive, reviews of the Otto Dix exhibition at the Tate Gallery in 1992 concentrated principally on two aspects of his life: his depictions of war and his association with both the eastern and western parts of Germany. The BBC series *Arena*, for example, spotlighted Dix in a show entitled 'Otto Dix: A Tale of Two Germanies' (13 March 1992), making the artist into a sort of heroic embodiment of unified Germany. In the wake of German reunification and the Gulf War, these themes seemed the most appropriate ones to the media at the time. What many reviewers evaded were the disturbing and distasteful implications of Dix's paintings of women and sex crime which did not fit with the celebration of unified Germany that this retrospective otherwise served to commemorate.

Newspapers with a distinct political orientation often interpret the subject of blockbusters in a way that will potentially appeal to the political convictions of their readership. Thus the *Guardian* attacked the Tate Gallery's Swagger Portrait exhibition (1992), for its display of 'the unbridled conceit of the monarchy, aristocracy and, later, the wealthy bourgeoisie' (Kent, 1992). The liberal left profile of the *Guardian* made acceptance of an exhibition which glorified the conspicuous consumption of the Stuart court and the Georgian landed élite problematic. The right-wing *Daily Telegraph* expresses its political orientation through its *denial* of the political significance of painting. Its review of the 'German Art in the Twentieth Century' exhibition at the Royal Academy in 1985 claimed that the works on display were not really art. There followed a predictable nationalist point:

> The British prefer the dangerous tendency towards prettiness – always just around the corner in Paris – or will opt for the anodyne simpering of their

own painters, in preference to the unmerciful intellectual and emotional confrontation presented by German artists. The trouble is that by the end of the exhibition one cannot blame the British. One wishes a single German artist of any calibre ever expressed a sense of *joie de vivre.* (Mullaly, 1985)

The blockbusters themselves may deny or eschew politics, but this very open-endedness allows them to be subsumed within competing political discourses.

CONCLUSION

The avoidance of politics in the art blockbusters stands in direct contradiction to the unashamed political stance of international exhibitions of the nineteenth and early twentieth centuries (Greenhalgh, 1989). But as Greenhalgh (1988) has pointed out, the international exhibitions served both to educate and entertain a large proportion of the population; indeed, such exhibitions increasingly responded to the perceived desires of working-class audiences. International exhibitions included both art and industry within their programmes, but during their pre-eminence, art and industry were vital components of European culture. In today's society, fine art has been marginalized by the encroachment of film, video and television, while services have replaced industry as the stamp of 'postindustrial society' (Jameson, 1991). The art blockbuster follows the modernist separation of art from society, politics and everyday life; art becomes a sort of icon to be worshipped and admired, but not fully understood. The blockbuster is still perceived to be a populist event, even while such exhibitions really reinforce Bourdieu's idea of the 'way in which a consensual recognition of dominant culture is produced while at the same time most are excluded from participating fully in it' (Merriman, 1989a: 163).

The populist profile of the art blockbuster lies not so much in the display of fine art as in the commercialization of the event itself, which reduces it to yet another form of leisure, equivalent to football matches and pop concerts. Shelton has asserted that 'In no other sphere of society do institutions so vehemently disavow economic interest as among the publishing trade, theatre producers, galleries and museums' (1990: 82), but the art blockbuster positively embraces the rhetoric of consumer culture and draws its mass profile from this factor. This is not genuine mass culture or the

democracy of post-industrial society, but a master narrative of capitalism which is the characteristic of the contemporary western world. The art blockbuster is an imposition of commodity culture onto a gullible population of all classes (Horkheimer and Adorno, 1973), and its presentation as mass entertainment serves to mask but not obliterate its real élitism. The 'cultural capital' which attendance at exhibitions represents is devalued by a false association between high art and the masses.

This form of 'double-coding' makes the art blockbuster a truly post-modern experience: through its academic pretensions, it seems to lure an educated audience, but it is accompanied by commercialization, hyperbole and sensationalism which give it more populist qualities. However, this seeming democratic profile is belied by the fact that the 'great artists' represented and the 'great works' shown are allowed to retain their mystique and allure. Visitors to art blockbusters worship at the shrine of great art, while the overwhelming spectacle of crowds, queues and commodities prevent them from engaging meaningfully with the works on display. The art blockbuster thus stands as an example of both the simulacra extolled or despised by postmodernist writers and the 'cultural capital' desired or ridiculed by critics of post-industrial multinational capitalism. It is an uneasy combination and highlights the paradoxes of the 'democratic' society in which westerners are said to live.

NOTES

1 I would like to thank Oliver Garnett and the staff at the Tate Gallery Archive for assistance with this work. Although they provided valuable information, the ideas presented here are my own.

2 See, for example, the Elizabeth Siddal exhibition at the Ruskin Gallery in Sheffield (1991); the Camille Claudel exhibition at the Musée Rodin in Paris (1991); 'Domesticity and Dissent: Women Artists in Germany 1918–33' at the Leicestershire Museum and Art Gallery (1992); the Angelica Kauffman exhibition at the Royal Pavilion, Brighton, and York City Art Gallery (1992–3); and the Gabriele Münter exhibition at the Lenbachhaus in Munich (1993).

BIBLIOGRAPHY

Airlie, Shiona (1993) 'Borrowing time', *Museums Journal*, 93: 27.

Baudrillard, Jean (1985) 'The ecstasy of communication' in Hal Foster (ed.) *Postmodern Culture* (London and Sydney: Pluto) pp. 126–34.

Belcher, Michael (1991) *Exhibitions in Museums* (Leicester: Leicester University Press).

Benjamin, Walter (1992) 'The work of art in the age of mechanical reproduction' in Hannah Arendt (ed.) *Illuminations. Walter Benjamin* (London: Fontana) pp. 219–53.

Bourdieu, Pierre (1979) *Distinctions: A Social Critique of the Judgement of Taste* (London: Routledge & Kegan Paul).

Cherry, Deborah, and Griselda Pollock (1984) 'Patriarchal power and the Pre-Raphaelites'. *Art History*, 7: 480–94.

Collins, Jim (1992) 'Postmodernism as culmination: the aesthetic politics of decentred cultures' in Charles Jencks (ed.) *The Post-Modern Reader* (London: Academy) pp. 94–118.

Coutts, Herbert (1986) 'Profile of a blockbuster', *Museums Journal*, 86: 23–6.

Danilov, Victor (1988) 'International exhibition sponsorship', *International Journal of Museum Management and Curatorship*, 7: 139–50.

Dorment, Richard (1990) 'Seeing Monet's masterpieces in a different light', *Daily Telegraph*, 7 Sep. 1990, p. 16.

'Exhibition attendances: voting with your feet', (1993) *Apollo*, 136 (December): 368–9.

Foster, Hal (ed.) (1985) *Postmodern Culture* (London and Sydney: Pluto).

Greenhalgh, Paul (1988) *Ephemeral Vistas: The Expositions Universelles, Great Exhibitions and World's Fairs 1851–1939* (Manchester: Manchester University Press).

— (1989) 'Education, entertainment and politics: lessons from the great international exhibitions' in Peter Vergo (ed.) *The New Museology* (London: Reaktion) pp. 74–98.

Habermas, Jürgen (1985) 'Modernity – an incomplete project' in Hal Foster (ed.) *Postmodern Culture* (London and Sydney: Pluto) pp. 3–15.

Hewison, Robert (1987) *The Heritage Industry: Britain in a Climate of Decline* (London: Methuen).

Hood, William (1989) 'Review of Sienese Quattrocento Painting exhibition at the Metropolitan Museum, New York', *Burlington Magazine*, 131: 241–4.

Hooper-Greenhill, Eilean (1988) 'Counting visitors or visitors who count?' in Robert Lumley (ed.) *The Museum Time-Machine* (London and New York: Routledge) pp. 213–32.

Horkheimer, Max, and Theodor Adorno (1973) 'The culture industry: enlightenment as mass deception' in *Dialectic of Enlightenment* (London: Allen Lane) pp. 120–67.

Hutcheson, Linda (1992) 'Theorizing the post-Modern. Towards a poetics' in Charles Jencks (ed.) *The Post-Modern Reader* (London: Academy) pp. 76–93.

Huyssen, Andreas (1992) 'Mapping the postmodern' in Charles Jencks (ed.) *The Post-Modern Reader* (London: Academy) pp. 40–72.

Jameson, Frederic (1985) 'Postmodernism and consumer society' in Hal Foster (ed.) (1991) *Postmodern Culture* (London and Sydney: Pluto) pp. 111–25.

— (1991) *Postmodernism, or, the Cultural Logic of Late Capitalism* (London: Verso).

Janis, Eugenia Parry (1990) 'Review of "Monet in the '90s" exhibition at the Royal Academy', *Burlington Magazine*, 132: 887–9.

Januszczak, Waldemar (1982) 'False vision of a rural setting', *Guardian*, 9 Nov.

Jencks, Charles (ed.) (1992) *The Post-Modern Reader* (London: Academy).

Kelly, Judith (1992) 'Cats, parrots and other temporary beasts', *Museums Journal*, 92: 29–31.

— (1993) 'Neither a Borrower . . . ?', *Museums Journal*, 93: 32–5.

Kent, Sarah (1992) 'Portrait of an ego', *Guardian*, 27 Oct., Arts 7.

Kirby, Sue (1988) 'Policy and politics: charges, sponsorship and bias' in Robert Lumley (ed.) *The Museum Time-Machine* (London and New York: Routledge) pp. 89–101.

Lloyd, Jill (1993) 'Review of "Figures du Moderne. L'Expressionisme en Allemagne 1905–14" exhibition, Paris', *Burlington Magazine*, 135: 234–5.

Luke, Timothy (1992) *Shows of Force: Power, Politics and Ideology in Art Exhibitions* (Durham, NC, and London: Duke University Press).

McWilliam, Neil, and Alex Potts (1986) 'The landscape of reaction: Richard Wilson (1713?–1782) and his critics' in A.L. Rees and F. Borzello (eds) *The New Art History* (London: Camden) pp. 106–19.

Merriman, Nick (1989a) 'Museum visiting as a cultural phenomenon' in Peter Vergo (ed.) *The New Museology* (London: Reaktion) pp. 149–71.

— (1989b) 'The social basis of museum and heritage visiting' in Susan Pearce (ed.) *Museum Studies in Material Culture* (Leicester: Leicester University Press) pp. 153–71.

Montefiore, Hugh Sebag (1990) 'Hang him high – putting Monet in his place', *Sunday Telegraph*, 9 Sep., p. 5.

Mullaly, Terence (1984) 'Every picture tells a story', *Daily Telegraph*, 10 Mar., p. 9.

— (1985) 'A relief to get out of the Academy'. *Daily Telegraph*, 19 Oct., p. 11.

'The new museology' (1991) special issue of *Art and Design*.

Pearce, Lynne (1991) *Woman, Image, Text: Readings in Pre-Raphaelite Art and Literature* (Hemel Hempstead: Harvester Wheatsheaf).

Pointon, Marcia (ed.) (1989) *The Pre-Raphaelites Re-Viewed* (Manchester: Manchester University Press).

Rogers, Malcolm (1993) 'It takes two', *Museums Journal*, April: 28–9.

Said, Edward (1985) 'Opponents, audiences, constituencies and community' in Hal Foster (ed.) *Postmodern Culture* (London and Sydney: Pluto), pp. 135–59.

Scaltsa, Matoula (1992) 'Defending sponsorship and defining the responsibility of governments towards the visual arts', *Museum Management and Curatorship*, 11: 387–92.

Selwood, Sara (1993) 'Museums, heritage and the culture industry', *Art History*, 16: 354–8.

Shelton, Anthony Alan (1990) 'In the lair of the monkey: notes towards a post-modernism museography' in Susan Pearce (ed.) *Objects of Knowledge* (London: Athlone) pp. 78–102.

Shepherd, Michael (1984) 'Getting the PRB together', *Sunday Telegraph*, 11 Mar.

'Exhibition attendances: voting with your feet', *Apollo*, 36: 368–9.

Spurling, John (1982) 'Classic calm', *New Statesman*, 19 Nov.

— (1984) 'Review of the Pre-Raphaelite exhibition at the Tate Gallery, London', *New Statesman*, 10 Mar., p. 27.

Sutton, Denys (1983) ' "A meditative love of nature": the Richard Wilson exhibition', *Apollo*, 117: 39–45.

Taylor, John Russell (1984) 'Artistically alive and well', *Times*, 7 Mar., p. 8.

Thorncroft, Antony (1992) 'Sponsorship: identity crisis', *Financial Times*, 3 Feb., p. 11.

Varnedoe, Kirk, and Adam Gopnik (1991) *High and Low: Modern Art and Popular Culture*, exhibition catalogue (New York: Museum of Modern Art).

Vergo, Peter (1989) 'The reticent object' in Peter Vergo (ed.) *The New Museology* (London: Reaktion) pp. 41–59.

Watson, Peter (1990) 'Value for Monet', *Observer*, 28 Oct., p. 35.

Wightman, Gavin (1990) 'Monet talks', *New Statesman*, 14 Sep.

Wright, Philip (1989) 'The quality of visitors' experiences in art museums' in Peter Vergo (ed.) *The New Museology* (London: Reaktion) pp. 119–48.

Zorn, Elmar, and Roman Koidl (1991) 'Exhibition marketing: the relationship between industry and the museums', *Museum Management and Curatorship*, 10: 153–60.

4

The Collection Despite Barnes: From Private Preserve to Blockbuster

VERA L. ZOLBERG

INTRODUCTION

When Dr. Albert C. Barnes died in 1951, his obituary in the *New York Herald Tribune* attributed to him 'the finest privately owned art collection in America . . . and more ill will than any other single figure in American art'. As late as 1987, his biographer, Howard Greenfield, was still able to assert that the 'incomparable collection' continued to be housed in the mansion built specifically for it, in the midst of a 'splendid twelve-acre park', and classes continued to be taught by the 'loyal graduates' of his school, who deviated not at all from the aesthetic theories that Barnes had invented (Greenfield, 1987: 1). With the entry of at least part of the Barnes collection into the world of travelling blockbuster exhibits, the barriers that their owner had so painstakingly erected against its circulation have now been breached, no doubt for good. On the face of it, we may imagine Barnes turning over in his grave, but, as I will show, the end of privacy for this most private of collections may not be completely out of keeping with his aims. The travelling exhibition confirms, however, that just as an artist loses control over his creations once they have left his hands, the same may be said of their collectors, no matter how canny in drafting their last Wills and testaments. For even gifts given 'in perpetuity' may be disposed of by art museums; and some curators have said that 'perpetuity' means twenty-five years. At the outside, as the Barnes case confirms, it may not last beyond the death of the last heir.

Throughout his years of prosperity Barnes was determined to use his art works to convey his own vision of what he called *The Art in Painting* (Barnes, 1925). It was the principal goal of the school that he established to house his collection. With unsurpassed gusto, he used every legal means available to keep his works together, not to

add or subtract from them, and to control the interpretations of art expressed, whether of his own works or those of public collections. While he lived, he fought off the State of Pennsylvania and its agents who tried to force him to open his doors to a larger public, unselected by himself or his loyal followers. They, in turn, pursued the combat until virtually their own demise. Ironically, the very structures, laws, codes of ethics and institutions that Barnes abhorred may provide the only shelter against the total dispersion of his art works.

I will explore social relations between collectors and their art works, the conflict between the ambitions of the collector expressed through the art museum, and the constraints within which museums operate. Generally, these constraints include economic limitations, governmental requirements, and professional codes of governance. They take on specific connotations in the concrete terms of Albert Barnes and his creation.

BARNES AS A COLLECTOR OF THE AVANT-GARDE

Although Barnes was a unique 'character', he was not alone in collecting modern art. What was unusual about him was his devotion to art that was still a mark of independence (Impressionism) and outright daring (Post-Impressionism and the 'Primitive'), while at the same time seeking out certain older and even ancient works because of the educational theories he was in the process of devising. His aesthetic ideas guided him throughout his life and left their mark on his intellectual heirs.

Collectors and patrons are usually treated by sociologists as 'gatekeepers' – mediators in the process whereby artists and their works gain entry into the pathways leading to professional success. As such, they are manipulators of value in the marketing process. While there is considerable truth in this characterization, it would be overly simple to believe that the impact of collectors and patrons stops there. Equally significant is that, sometimes at some risk to their own reputations, they played an indispensable role in establishing the institutions that have come to lend durability and fame to their works, the art museums. Especially in the United States, almost all art museums have depended upon donations of works to fill their halls. In retrospect, the collectors' risk-taking, when successful, gave the works of formerly derided modern artists the institutional respectability we now take for granted.

Just as most innovative artists were ridiculed at the turn of the century, so were the collectors of their works, who astonished and scandalized the more conservative members of the art world. It is worth asking why these quite wealthy individuals would subject themselves, as many did, to the mockery they incurred. Even more difficult to fathom is why some of them went so far as to become *patrons* of the artists who created these works. And why, eventually, did a few actually devote themselves to founding museums and spreading the news about what seemed like strange, avant-garde art styles composing what came to be known as Post-Impressionism?

The collectors of Post-Impressionism were not the first to support unusual art styles: they followed in the footsteps of 'independent' collectors of Impressionist works, as well as of anti-Academic art styles more generally, throughout the nineteenth century. Despite the declining fortunes of the Academic system, around the end of the century Academic works still fetched far higher prices than any of the works of innovative artists.[1] But by the time of the Post-Impressionist collectors, Impressionist art works were gaining in value. Yet it is not simply that the Post-Impressionist collectors were speculators, though some of them may well have had an eye to the potential return on speculative art buying to the exclusion of other considerations. I believe, however, that there is more to collecting art than can be explained by the language of investment, since, after all, there are other ways to spend money or invest. Unlike most other financial transactions, buying art is imbued with symbolic significance that goes beyond material profit and into the arena of status.

Art works, as Thorstein Veblen observed, have long been used instrumentally in social strategies to create or maintain status. In relatively open societies, collectors who were members of the establishment, however constituted and wherever located, have provided models of taste for emulation by imitators of less prominent standing. In Europe, establishments tended to be from an aristocracy; in the United States, from the world of high finance, as represented by a J.P. Morgan. As a taste community, they represent what I have characterized as 'Conservatives'. They served as models for 'social climbers' or *parvenus*, who tended to adhere to taste derived from their target status group. These mimics, whom I have characterized as 'Epigones', (Zolberg, 1983), have at times predominated among art collectors. Conventional in their collecting styles, they shared in

the late nineteenth and early twentieth centuries a consensus that accepted Academic hierarchies of subject-matter, norms or canons. Typical of them among Barnes's Philadelphia contemporaries was Joseph Widener, a self-made millionaire collector of old master works, whose father had, in earlier times, worked as a butcher side by side with Barnes's own father, but who had made a fortune selling meat to the Union Army during the Civil War.

The collectors of the avant-garde, such as Barnes himself, differed markedly either from established élite Conservatives or their Epigones. Innovative collectors fall into two principal sets, of what I have called 'Marginals'. The first were relatively wealthy individuals of the 'wrong' social attributes: too newly wealthy; wealthy through success in newer industries (such as mining, small retail trade), rather than through what had become by the nineteenth century the 'respectable' avenue of high finance; or too recently arrived in their country, especially the United States. Moreover, they were often of a marginal religion, an attribute of some importance. The established élites were members of, and defined their standing by adherance to the dominant churches in their countries: Catholic in France, Anglican in England, Orthodox in Russia, and Protestant in the United States. For America, the most esteemed included Episcopalian (or Anglican), Presbyterian, Congregational, Unitarian and Quaker. These denominations and churches paralleled the highest economic status groups, but, almost regardless of their economic status, adherants of other religions were treated as marginal. The only Baptist in the highest status groups was John D. Rockefeller, most of whose children adopted Anglicanism. Whereas Catholics were viewed as Marginals in America, this was the case for Protestants in France; in England this was the case for Nonconformists or other non-Anglicans; in Russia, Old Believers; and, virtually everywhere, Jews.

Marginality of one sort was often enhanced when combined with other marginal characteristics. For example, one of the leading American avant-garde collectors and patrons was the Catholic, John Quinn, a self-made lawyer from a small town of the mid-west, who rose through political connections to the status of 'the gentleman from New York'. Having played a major role in eliminating duties on the importation of art works, and organizing the Armory Show of 1913, he provided the structures for founding the Museum of Modern Art. In Britain not only were the avant-garde collectors

likely to be Nonconformists, or of Quaker origin, but from 'the provinces' – Wales or Ireland or Scotland, rather than London. In France, the collectors of the Impressionists and the Post-Impressionists were mostly Protestants, Jews, and largely from outside Paris.

What these social characteristics tell us is that in order to understand the differences in the choices made by collectors, it is necessary to scrutinize not only the personality traits of individuals, but also the overall social openness to particular groups at a particular historical moment. Whereas until the late nineteenth century it seemed possible for high income American individuals, even Jews and Catholics, to aspire to enter existing establishments, these avenues were seriously narrowed, especially from the last two decades until the end of the Second World War, precisely the period during which Post-Impressionism flourished.

The second principal set of avant-garde collectors, and perhaps the more puzzling group from a sociological standpoint, are members of high establishment standing who became collectors and advocates of avant-garde art. I characterize them as 'Eccentrics' in that they diverged from the expectations of their well-established status communities. Although their collecting and, sometimes, other behaviours were considered bizarre, they were tolerated by their peers. European nobility was emulated in America by the quasi-aristocracy that was shaped in the post-Civil War era.[2] It was during this period that New Englanders, some of them descendants of the religious dissidents who had arrived on Plymouth Rock in the seventeenth century, undertook the social construction of their high status, of which an important feature was a distinctive aesthetic culture (Dimaggio, 1982). To some degree they came to include in their status community descendants of the French settlements of the mid-west, and some of the 'first families' of the old south.[3]

Whereas most of that Establishment were aesthetic Conservatives, it also produced a number of important Eccentrics, notably the woman who became a leading artist of the period, Mary Cassatt, heiress to a Pittsburgh fortune in railroads and manufacturing. Not only did she make the unconventional choice to be a professional artist rather than dabble genteelly in art, but she expatriated herself, living far from her family as a member of the French Impressionists and close companion and colleague to Degas. Still, her impact on family and friends can be seen in most American museum collections,

not only through her encouragement of their collecting of Impressionist works, but also in the 'rediscovery' of El Greco, whose paintings were gaining acceptance in American museum collections, but with some reluctance.

More directly related to museum founding was the important establishment artist, the Eccentric collector, Gertrude Vanderbilt Whitney. Patron of a certain American, anti-Academic, figurative modernism that was largely excluded from the more conservative museums and less sought after by the European-oriented collectors of modern art, in the late 1920s Ms Whitney founded the Whitney Museum of American Art. The Eccentric artist associated with the collection on which the Solomon Guggenheim Museum is founded was Countess Hilla Rebay. Under the tutelage of this daughter of a member of the lesser nobility of Bavaria, Guggenheim, previously an Epigone, as was his family, became the collector of the most radical, 'non-objective art' – Kandinsky, among others. Beginning in the 1930s, with her advice, he founded a museum of non-objective art, which later came to be housed in the 1950s edifice designed by Frank Lloyd Wright.

Although a considerable number of Eccentrics were aspiring artists and writers, many were not active creators. Of highly respected New England background were the most devoted patrons of modernism, Miss Lilly (or Lizzie) Bliss and Mrs Abby Aldrich Rockefeller. Abby Aldrich was far more established than her husband, a Rockefeller whose wealth was only a generation old. Having been Conservative in taste, Miss Bliss and Mrs Rockefeller shifted drastically when they became part of the Alfred Stieglitz modernist circle. Despite their important social connections, their peers, the trustees of the Metropolitan Museum of Art, refused to accept their offers of Post-Impressionist works. By the end of the 1920s the two women had founded their own institution, the Museum of Modern Art.

Aside from acting as economic 'men',[4] their mixture of goals became part of a search for personal identity. This was especially true of European aristocrats, such as Count Harry Kessler in Germany, a patron of German art Secession movements, bisexual, and supporter of leftwing causes; the Comtesse de Noailles in France, a poet of foreign aristocratic origin; the half-American Lady Nancy Cunard of England, one of the first English collectors to purchase a work by Gauguin, in 1910. Whether outsider Eccentrics or *par-*

venu Marginals, the avant-garde collectors' strivings for status mingled with a belief that art was a *substitute for a moral ethic, a religion.* In the international arena, which was increasingly becoming the normal state of the art world from at least the last third of the nineteenth century, *many of them were looking for something new* – not only in art, but in more subjective ways. I have characterized their complex behaviour as 'creative marginality'. By this I mean that they collaborated simultaneously in constructing their symbolic value of cultural objects, along with their own new social identity.[5] Materially, the two groups, Marginals and Eccentrics, created structural conditions for entry of works into the USA, organized spectacular exhibits such as the Armory Show of 1913, and established museums for their collections. Whether artists or not, they played an indispensable part as 'fellow travellers' or 'groupies' to art movements. As with scientific innovators, Marginals to Establishment status had nothing to lose and Eccentrics could not really lose. But theirs was not only a rational choice; they went further by acting as apostles of the *modern*: through their museums they carried the word to other places. In the process, they constructed a kind of church of the avant-garde aesthetic while at the same time creating a new identity for themselves. Barnes himself played an important part in this project, but he did it on his own terms, which won him few friends.

Both Marginals and Eccentrics rejected conventional life in favour of a bohemianism that they could engage in either full- or part-time. The most important of their circles centred on Gertrude Stein, who came to Paris with her brothers and sister-in-law on a trip to Europe. Descendants of a German-Jewish peddler, living on their income from a legacy of investments in the San Francisco Cable Cars, the Steins stayed for varying lengths of time, and Gertrude Stein stayed in Paris for good. Having made the already unconventional choice of studying medicine, she pursued an even more unorthodox life on the Rue de Fleurus where, with her life companion, Alice B. Toklas, she established a salon of avant-garde literature, music and art. Virtually every American collector came through it, meeting Matisse, Picasso and numerous others through her.

Among their many visitors, Dr Albert Barnes had a particularly colourful background. Born near Philadelphia, Barnes was the son of an unsuccessful butcher, a Civil War amputee, who had married

somewhat above his station. Despite this extremely modest background, young Barnes achieved secondary school education in a highly regarded public high school. He literally fought – as a boxer – and played baseball to earn a living while obtaining his medical degree at the University of Pennsylvania. After graduating at the age of 20, he worked at a state mental hospital to complete his internship requirement, and studied as a postgraduate at Pennsylvania University. He managed to go to Heidelberg for further study, and became a successful employee in a large pharmaceutical company. In his late 20s he met and married (in an elegant Anglican church) a young woman of Establishment background, whom he could proudly display on his next visit to Germany. There he engaged the services of a chemist for his employer, and eventually went into business with him in a scheme that won them both wealth, and for Barnes, a fortune in sales of the patent medicine, Argyrol.

But despite his new-found wealth and his elegant wife, to his Main Line neighbours he was merely 'a thruster . . . a self-made businessman of no breeding, an outsider . . . with gruff, unpolished manners'. As Greenfield puts it, Barnes returned their rejection in kind, playing 'the role they had assigned to him, and he played it well'. (1987: 111). Rather than tolerate what he regarded as false gentility and snubs, he devoted himself to the philosophy of William James and the collecting of art. After a number of years, he undertook to create an educational institution in which he taught art theories that he developed on the basis of conversations with his high-school friend, the artist, William Glackens, and eventually with the American pragmatist philosopher, John Dewey. His allegiance was to students of his own selection: working people, many of them African Americans of modest background.

His ties to African Americans had two probable sources: the first was his experience of being brought by his mother to a black Methodist revival meeting, whose music and fervour impressed him deeply; the second was that he employed many blacks in his Argyrol factory in his old neighbourhood. Increasingly, Barnes closed the door to his collection on all but his invited guests, or students attending his course, in which were permitted to enrol only those who passed a stringent interview and committed themselves to the three-year programme. By all accounts, he was a man who attempted to control everything and everyone, with an urge to dominate that became increasingly uncompromising. In fact, he refused

to allow his works to travel or even be reproduced in colour. Encompassing some 1,000 works valued off-hand at around $1 billion, the collection contains some 200 Renoirs, 80 Cézannes, well over 60 Matisses, 45 Picassos and an enormous array of major Impressionist and Post-Impressionist works created in Paris at the turn of the century, as well as old masters, American modernists, both African primitive and African American, and American Indian art. Barnes displayed these paintings and sculptures in combination with hand-forged metal and wood objects.[6]

Barnes had no more patience for what he considered the mystification of professional art people than he had with Philadelphia's élites. His many altercations with museum directors, curators and art historians resulted in the virtual exclusion of experts and 'ordinary' wealthy people (trustees or other collectors) from his house. Those with the best chance of being admitted were of modest background, of whom a considerable number were African Americans (Glueck, 1989). Impulsively identifying with the underdog, he championed Bertrand Russell, who had become a pariah as a result of a public campaign against his appointment at the City College of New York in 1941 because of his views on adultery and other issues. Given Barnes's irascibility, it may not be surprising that their relationship endured only two years, and led to a bitter breach-of-contract suit from Russell.

Barnes's attention to the socially marginal lower classes and to 'outsider art' was an aspect both of his own social marginality, and of his famously overbearing personality. His friendships tended to be with people who were willing to treat him as their 'boss' or patron. Nevertheless, despite cultivating a reputation for cantankerousness, he made a few intense and long-lasting friendships with social equals, such as the philosopher, John Dewey, and the American artist who remained his close friend until his death, William Glackens.

PRIVATE MUSEUMS FOR THE PUBLIC

It is usually assumed that one of the prerogatives of private property and wealth is that a person who can afford to buy art works should have the right to display them or not, as he wishes. In the United States, however, privacy is restricted in a number of ways depending upon conditions that are to a great extent of the owner's choosing.

Until recently a collector who kept his works at home and made no claims on the state for special treatment could do what he wanted with them.[7] But once he calls upon state or local government to accord his collection a special status, such as that of a foundation or museum, thereby excusing him from certain taxes, then the governmental body in question has the right to something in return. Routinely, this takes the form of requiring that the public be permitted to see the works displayed. But there is more. In addition, the state gains a degree of supervision concerning the disposition of works, including the museum's right to deaccession them. Ever since Barnes had it chartered in 1922 as a non-profit educational institution, both of these restrictions have figured in the history of his collection.

The fame of 'encyclopedic' art museums in the United States – New York's Metropolitan Museum of Art, Boston's Museum of Fine Arts, the Art Institute of Chicago, the Philadelphia Museum, and many more – should not blind us to the incredible diversity that characterizes these institutions. Many of them are quite small or specialized, but even within this category their range in standards, breadth of the collections and openness to visitors is considerable. Private museums are not as subject to the supervision and kinds of legal restrictions that constrain public museums.[8] Among the more prominent is the Frick Collection in New York, whose superb collection of masterworks is housed in the elegant Fifth Avenue mansion built for it by the steel baron, Henry Clay Frick. The Isabela Stewart Gardner Museum in Boston is noted for its impressive collection of Italian 'Primitives' and Renaissance works, Turners, Barbizon paintings, Impressionist works (though some have been stolen and not yet recovered) and her favourite Boston artists' works, largely domesticated Impressionists. Housed in a Venetian Palazzo, brought stone by stone to Boston and reconstructed under her strict supervision, many of her works were purchased during the decades around the turn of the century with the counsel of her protégé, Bernard Berenson. Before her death, Mrs Gardner resisted attempts to permit longer visiting hours than suited her.

Unlike many other museums, Barnes situated his growing collection on the edge of his native Philadelphia, along the Main Line of the commuter train that serves the fashionable suburbs, rather than in the city itself. In this way he was able to combine his wife's interest in the arboretum surrounding their home with his collection.

Philadelphia itself is not entirely an artistic backwater, having within its precincts some important museums, and as the home of the Carnegie-Mellon University, is an important centre for artistic education. Nevertheless, like most other American cities outside of New York, when Barnes was buying art it had long ceased to be a major creative centre. Yet in the 1920s, when news of the Barnes holdings spread, there was no reason to believe that his limestone mansion on North Latch's Lane in Lower Merion, Pennsylvania, would not become an artistic Mecca.

As long as Barnes lived, he excluded all but a select few from his house. From the time of his violent death in an automobile accident until 1961, his loyal successors, including his widow, fought the efforts by the county and the state to force it to be more accessible. Eventually the Barnes Foundation was forced to open its doors to the general public, thereby honouring its obligations and status as a tax-free institution. It continued for many years to limit admissions to no more than 400 visitors each weekend, and for a considerable time only on the basis of a reservation request, either written or, later, by telephone. Visitors were obliged to place everything they carried, including handbags, in lockers. In addition, the museum monopolized publication of works, such as catalogues and books, and although permission might be granted for some of its images to be published by other presses, these were restricted to black and white. The publications that were made available consisted largely of the theoretical writings of Dr Barnes or his trusted associates.

With the death of Barnes's successors at the Foundation, the collection became the property of a small historically black college in Pennsylvania, Lincoln University, where he had been invited to lecture. For this small coeducational institution of about 1,300 students, despite having been the college of the late Supreme Court Justice, Thurgood Marshall, the poet Langston Hughes, Nnamdi Azikiwe of Nigeria, and Kwame Nkrumah of Ghana, the collection is a white elephant. It requires a degree of care in housing and restoration not accounted for in the funds that Barnes and his successors left it. When the new trustees wanted to sell a few works to raise funds to repair the roof and other necessary renovations, they caused great turmoil. The sources of this reaction were both official and unofficial: the State of Pennsylvania and the county in which the Barnes Foundation is located had forgone considerable

tax income since its creation, and were not eager to have the works leave public viewing in their locality. Less official, but equally important is the code of ethics governing museum deaccessioning to which accredited art museums subscribe. The advisory board of the Barnes Foundation, made up of representatives from art museums, had opposed the sales on the grounds that works should not be sold in order to pay for building maintenance or construction, but only to gain works that would benefit the collection. In any case, a museum should first offer its works to other public collections rather than sell them to private parties.

This code governs the behaviour of public as well as private museums that claim professional standing and subscribe to it. It is more binding on how museums behave than legal rules and governmental oversight, because even though they have the right and obligation to superintend them, government bodies are usually reluctant to interfere with museums except in extreme circumstances. When it comes to a museum's professional standing, even violations of the museum's code of ethics are not likely to reach the point of official action, such as litigation. Rather, and perhaps worse, they might lead to the museum's ostracism, and the end of many arrangements from which museums benefit: loans from other museums for special exhibits; an inability to attract prospective employees to fill high staff positions; and government funding.

Although it has so far been stopped from selling works, the Barnes Foundation has been able to break another restriction that it had struggled against, that of allowing part of the collection to travel. Despite opposition from the Trust created by Barnes's late protégée and companion, Violette De Mazia, a large number of the French paintings were sent for exhibition in Washington's National Gallery, the Musée d'Orsay, Tokyo's Museum of Western Art, and the Philadelphia Museum of Art. The President of the Barnes Foundation expressed the hope that through profits from catalogues and books, the building renovation project would be advanced.

CONCLUSION

Since the death of its founder, the Barnes Foundation has become an even greater bone of contention among his successors. His legacy has produced the contradictory result that has placed the modest

African American institution of higher learning into an authoritative decision-making position, but without the resources to maintain his collection as he might have wished. Torn between their desire to 'modernize' and preserve this inheritance as a museum, its governors are restrained by Barnes's followers (former students, community residents), who wish the Foundation to remain totally intact, as a shrine. These extremes would seem to be irreconcilable: the only change permitted was to discard works that had completely deteriorated; but Lincoln University's trustees wanted a free hand to dispose of the collection to pay for a renovation that their opponents consider would do violence to Barnes's intentions. But which of his intentions are to be given priority? The preservation of his works or the educational purposes of the Foundation?

It is ironic that the collection's preservation depends upon a complex of legal jurisdiction from the state, and professional codes of the Museum Association that Barnes often derided. Yet if more modern educational programmes are put in place, a larger number of students than during Barnes's life may be served. The gain of joining the mainstream orientation to museum education would most likely offend and even outrage the author of *The Art in Painting*, but the benefit or loss now depends upon how the new governors conceive of the educational programme. What is certain is that conflicting goals endemic to these cultural institutions will continue to characterize this museum and others.

NOTES

1 See, for example, John Rewald, *Cézanne and America: Dealers, Collectors, Artists and Critics*, Bollingen Series XXXV: 28 (Princeton: Princeton University Press, 1989). He notes that in the 1880s the American collector, George F. Gould paid $70,000 for a painting by the popular academician, Gérôme (equivalent to $13,500 at the time, and with a current value of $560,000). Gould was in the art business and profited considerably from his exhibition of this work throughout the United States. When he resold it to the French collector and department store owner, Chauchard, he received the equivalent of $1,200,000 from him. By way of comparison, an American collector bought a Monet 'Haystacks in Snow' for 10,350 francs ($2,070) with a current value of $16,560 (Rewald, p. 50).

2 Beside the work of Veblen, the sociologist, C. Wright Mills reanalysed the phenomenon in *The Power Elite* (New York: Oxford University Press, 1956).

3 Bertha Honoré Palmer from Chicago used her partly French origin to
 compensate for not being a Bostonian. She had started as a conventional
 collector of academic salon or Barbizon works, but turned from the late
 nineteenth century on to Impressionism and Post-Impressionism. Bertha
 Palmer was an innovator in other respects as well, supporting the suffrag-
 ette movement and patronizing women who tried to be professional artists
 or architects.

4 As will become clear, a great many of the collectors, patrons, and museum
 founders were women. Veblen's analysis is famously adumbrated in *The
 Theory of the Leisure Class* (New York: Random House, 1934 [1899]).

5 'Une marginalité créatrice: Les collectionneurs de l'art d'avant-garde' in
 L'Art et la Contemporanéité edited by Jean-Olivier Majastre and Alain
 Pessin (Brussels: La Lettre Volée, 1992).

6 The exact number of his works is difficult for an outsider to establish. The
 figures I cite refer chiefly to paintings, and come from Grace Glueck in the
 New York Times, 19 Oct. 1989: p. C18. According to Geneviève Breerette
 in *Le Monde*, Wednesday 8 Sep. 1993: p. 14, there were 2,000 objects,
 including sculpture and furniture, of which 190 were works by Renoir, 69
 by Cézanne, about 60 by Matisse. Greenfield speaks of 200 Renoir paint-
 ings, nearly 100 Cézannes, over 60 Matisses, more than 30 early Picassos,
 etc.

7 Theoretically, this means that he might damage works if that so pleased
 him. In recent years a number of states, including Massachusetts and New
 York, have adopted legislation that prohibits abuse of visual works, some-
 what along the lines of *droit moral* in France and other countries.

8 For example, when Pennsylvania's Reading Public Museum and Art Gal-
 lery, owned by the Reading school district, proposed selling some twenty-
 five works in order to create an endowment essential to its continued
 existence, it sparked a conflagration. Located in a former mill town some
 fifty miles north-west of Philadelphia, the museum had consigned the works
 in question to Sotheby's in order to raise some $7 to $11 million. Because
 of the public outcry, and pressure from cultural institutions, the museum
 was temporarily enjoined from the sale by a county judge on the grounds
 that state law required prior court approval because it was 'public
 property'.

BIBLIOGRAPHY

Barnes, Albert C. (1925) *The Art in Painting*, The Barnes Foundation Press,
 Merion, PA (subsequently revised and reprinted).
Dimaggio, P. (1982) 'Cultural entrepreneur-ship in 19th century Boston',
 Media, Culture and Society, 4: 33–50

Glueck, G. (1989) 'Small university gains control of the Barnes Foundation', *New York Times*, 19 Oct. 1989: 19.

Greenfield, H. (1987) *The Devil and Dr Barnes: Portrait of an American Art Collector*, Penguin Books, London and New York.

Zolberg, Vera L. (1993) 'New art – new patrons: coincidence or casualty in the 20th century avant-garde' in *Contributions to the Sociology of the Arts*, ed. ISA Research Committee on Sociology of Art, Research Institute for Culture, Sofia, Bulgaria.

5

The Public Interest in the Art Museum's Public

J. MARK DAVIDSON SCHUSTER

INTRODUCTION

What is the public interest in art museums? Why are they not simply private affairs created by those who desire to have them, managed by those who want to work for them, supported by those who are willing to pay for them, and attended by those who are interested and not attended by those who are not?

It is not hard to find examples of just such museums, though they have become increasingly uncommon. Indeed, one of the distinguishing features of virtually all American art museums has traditionally been that they are private non-profit institutions, but it would be incorrect to conclude that because they are private institutions they are outside of the purview of the public interest or immune to the effects of public policies. One need go no further than the panoply of special tax incentives that are characteristic of American arts support to be persuaded of this point (Feld *et al.*, 1983). But all countries enjoy a heritage of art museums created by private individuals at one or another moment in history, whether or not these museums have, by now, migrated to the privileged position of government museum. And museums enjoy a wide variety of public support policies and programmes, even if the menu of those policies and programmes differs somewhat from country to country.

But what is the public interest in art museums? In my view, the public interest in art museums is two-fold:[1]

- A society wishes to support and sustain museums so that its artefacts and ideas will be available to future generations, and
- A society wishes to support and sustain museums so that its citizens can and will come into contact with the artefacts and ideas that the museums contain.

My intention here is not to launch a debate on this subject but to reveal my biases so that my comments in this paper can be set in their proper context. I have chosen the word 'contact' with great care. I would argue that the public interest ought to be indifferent to exhibiting art works on a wall, even indifferent, perhaps, with respect to scholarly research concerning those art works, but that it should pay attention to the frequency and quality of the interaction between those art works or that research and its citizens. Neither mere existence nor making more art is sufficient justification for a public interest.[2] Even high quality existence or high quality artistic production is insufficient from the standpoint of the public interest if that quality does not carry over to become characteristic of interaction with the public.

Moreover, if one accepts my second principle, that the public interest must be based on interaction with a public, then it also follows that my first principle is inseparable from my second. The benefit for future generations is contact postponed.

From this point of view, neither a government funding agency, nor an art museum itself, can be indifferent to the composition of its audience. In the last decade, with the rise of both public and private non-profit funding mechanisms that take a large part of their mandate to be increasing the breadth of exposure of citizens to the arts, these questions have become even more important in public discourse concerning museums. Government, for its part, is naturally concerned with the depth of the audience, the breadth of the audience, and the quality of the interactions that the audience has with the arts institution, pushing in all three directions at once. With increasing demand for government support and increasing constraints on the level of that support, these pressures will become even stronger. To stake a claim for public support, art museums will (and should) have to clearly document the nature of their interaction with their public. For their part, museums are beginning to do much of this anyway, adopting some of the vocabulary and mannerisms of the private sector through identifying their 'consumers' and potential consumers and 'marketing' their services: all activities that require a much more fine-grained understanding of the composition of their audiences (*Journal of Arts Management and Law*, 1985; Hood, 1984).

AUDIENCE RESEARCH AND ART MUSEUMS

What do we know about the public for art museums? Who are the people who attend? And who are the people who do not attend? Which groups are over-represented and which ones un-derrepresented in the museum's public? How well can one predict whether or not an individual will attend an art museum by knowing something about his or her demographic characteristics and something about his or her pattern of participation in cultural activities? Might it be possible to expand and shape the current audience for art museums either by attracting people who are not currently attendees or by increasing the frequency of attendees' attendance? These are the questions one would like to be able to answer.

There is, perhaps, a longer tradition of audience studies among art museums than among any other type of arts institution. In part, this is because historically museums have been seen more as educational institutions, with a corresponding concern for reaching all parts of the population, than have performing arts organizations. In the nineteenth century, particularly in the United States, the distinction between private and public museums began to fade, not so much in their institutional status as in the public they were consciously trying to serve. Burt (1977) goes so far as to suggest that the American museum began with a deliberate appeal to the public. The motivation for establishing a museum became not so much the need to house a collection as the desire to provide an opportunity for the general edification of the public. Yet, by the 1940s the Committee on Education of the American Association of Museums still felt that museums had not taken their education potential seriously enough and asked Theodore Low (1942) to write what became a widely distributed essay arguing that museums should see themselves as 'social instruments'. Thus, the seeds of the debate between the education and outreach functions of a museum, on the one hand, and the conservation, preservation, and art scholarship functions, on the other, were planted early, establishing the need for studies of the museum audience. A second factor, the fact that museum exhibits offer wonderfully controlled environments for behavioural studies, has also contributed to the corpus of audience studies.

Studies of the museum's public have taken two primary forms: audience surveys and participation surveys. While the former is the more common, the latter, a more recent approach to studying the public for the arts and culture, is arguably proving to be the more

interesting. I will quickly summarize what is known about the museum's public from the collected results of the corpus of audience surveys, and then I will turn to a more detailed analysis of what we are beginning to learn from the new generation of participation surveys.

AUDIENCE SURVEYS

The audience survey[3] has been a popular device for studying a museum's audience, and many museums have done quick, low-cost, seat-of-the pants surveys of their audiences. Fewer have invested the resources to assure that these studies have been carried out according to the norms of good statistical practice. In the United States, evidence from several hundred museum and performing arts audience surveys was brought together by Dimaggio, Useem and Brown (1977). Carefully aggregating the results of these diverse studies and despite the broad variation in quality, they were able to broadly summarize the demographic composition of the public for the arts in the United States:

- The audience for the arts was more highly educated, was of higher occupational status, and had a higher income than the population as a whole.
- Women were slightly over-represented in the arts audience.
- The median age of the arts audience was close to the median age of the population at large but varied widely from audience to audience and art form to art form.
- Minorities were under-represented in the arts audience in comparison to their share of the relevant metropolitan populations.

With respect to the public for museums:

- Museum audiences were somewhat more representative of the American public than performing arts audiences.
- There were smaller proportions of professionals, of the well-educated, and of those with higher incomes in museum audiences than in performing arts audiences, but
- Art museum visitors were better educated, wealthier, older, and composed of more professionals than visitors to other kinds of museums.

A decade after the publication of this study audience surveys had become so popular in the United States and their quality, from a statistical point of view, had become so mixed that the National Endowment for the Arts felt it had to prepare a guide to good practice in surveying one's audience (Research Division, 1985), but even in this otherwise very helpful manual there is a surprising flaw: it neglects to distinguish between visitors and visits, a conceptual difference that must be carefully handled in any audience survey.

A similar survey of some 150 Canadian arts audience studies, most of them audience surveys, was conducted by McCaughey (1984). Her findings were similar:

- The arts audience as a whole differed significantly from the total population in its composition. Audience composition also differed across art forms.
- Most striking about the arts audience was the degree to which educated individuals participated. In the visual arts well over half of audience members had some kind of post-secondary education.
- The studies showed a relationship between arts participation and income, but income was also related to education level, the more important indicator.
- Women greatly outnumbered men in performing arts audiences and slightly outnumbered them in art gallery audiences, but men outnumbered women in museum audiences.[4]
- Participation was highest among young and middle-age groups.
- Professionals, managers and other white-collar occupations were over-represented in the arts audience. Students and house-wives were also over-represented.
- Frequency of attendance at performing arts events, art galleries and art films all increased with education.

In the Netherlands, Ganzeboom and Haanstra (1989) have compiled 182 studies of museum audiences and re-analysed them. Unlike the studies mentioned above, they added a set of variables describing the institutions and their programmes so that they could begin to study the interactions between the characteristics of these museums and the composition of their publics. As a result, their findings are more subtle:

- Museum visitors were far from homogeneous with regard to social background. The education level of visitor groups varied from moderately above the average for the Dutch population to well above that average.
- Differences in education levels among the audiences of various museums were directly linked to the 'accessibility' of each institution and its collections.
- Surprisingly, museums and exhibitions with an intensive public relations machine attracted a better educated public than might be expected on the basis of the level of information accessibility. Thus, these efforts had actually narrowed the audience rather than broadening it.[5]

This last point foreshadows the results of the new generation of audience studies to which I now turn my attention.

PARTICIPATION STUDIES

Recently, a new set of studies has become available for analysing the publics of art museums. These studies, which might be termed 'participation studies', focus on the participation of the adult population in artistic and related activities by sampling the *population* in a particular place rather than by sampling the *audience* of a particular institution. As a result, one is able to study the characteristics of those who do not participate in artistic activities as well as those who do. Moreover, participation figures make it considerably easier to draw the important analytical distinction between visitors and visits. Participation studies naturally focus on visitors, identifiably different individuals who may or may not participate in a particular artistic activity, whereas audience surveys naturally focus on visits.

Moreover, a set of participation studies is now available that facilitates cross-national comparisons. For this paper, I have been able to assemble relatively extensive results of participation studies in ten North American and Western European countries plus the Canadian province of Québec. In addition, I will present some data from three or four other countries, though not the complete participation study. Because participation studies are more comprehensive, more complex, and, as a result, more expensive than simple audience surveys, they have typically been commissioned

by Ministries of Culture or Arts Councils. A number of countries have made a commitment to conduct participation studies at regular intervals in order to be able to better track changes in participation and audience composition over time. Because of this higher commitment of resources these studies are generally of higher statistical quality than audience surveys.

Participation studies take as their primary indicator the 'participation rate', the percentage of survey respondents who say they have engaged in a particular activity in a specified period of time. Participation rates are often calculated for a number of subgroups of the population, and some of the most interesting results come from dividing the population into a variety of demographic groups. Thus, participation rates tell us what proportion of particular groups in the population are visitors.

Participation rates for art museums – the United States
Americans have the view that attendance at cultural events and cultural institutions is much more ingrained in other countries, particularly in Western Europe, than it is in the United States. This is not simply a matter of the grass being greener; we honestly believe that other countries are more 'cultured' than we are and that that should translate into higher levels of cultural consumption and participation elsewhere.

Let me begin with the United States as my base of comparison. Table 5.1 summarizes American participation rates in art museums and art galleries for selected demographic variables. These data are based on the 1985 Survey of Public Participation in the Arts (SPPA), sponsored by the National Endowment for the Arts and conducted by the United States Bureau of the Census in collaboration with the University of Maryland (Robinson *et al.*, 1987). (The first Survey of Public Participation in the Arts was conducted in 1982, and the third in 1992. As I write this paper, data from the latest study are just becoming available.)

First, let us establish the base participation rate. When asked if they had visited an art museum or art gallery in the preceding twelve months, 22 per cent of the adult American population said that they had. Two out of every nine adults. When this participation rate and the participation rates for other cultural activities were first published in the United States they created quite a stir. Prior to SPPA the only participation studies that were available

Table 5.1 *A Cross-national Comparison Of Art Museum Participation Rates: The United States*

Question: During the last 12 months, did you visit an art gallery or an art museum?

		Art gallery/art museum participation rate (%)
Overall:		22
Income:	<$5,000	16
	$5,000 – $9,999	11
	$10,000 – $14,999	15
	$15,000 – $24,999	19
	$25,000 – $49,999	28
	≥$50,000	45
Education:	Grade school	4
	Some high school	7
	High school graduate	14
	Some college	29
	Four-year college graduate	45
	Graduate school	55
Occupation:	Professional	49
	Middle managerial	37
	Sales/clerical	27
	Craftsman	14
	Operatives	9
	Labourers	10
	Service workers	16
Age:	18–24 years	22
	25–34 years	25
	35–44 years	26
	45–54 years	23
	55–64 years	18
	65–74 years	16
	≥75 years	10
Gender:	Female	23
	Male	21
Race:	Black	11
	White	23
	Other	26
Region:	New England	24
	Mid Atlantic	19
	East Northcentral	20
	West Northcentral	23
	South Atlantic	19
	East Southcentral	11
	West Southcentral	23
	Mountain	28
	Pacific	32

Source: Analysis conducted by the author using data from United States Bureau of the Census and the National Endowment for the Arts, Survey of Public Participation in the Arts, 1985.

were the *Americans and the Arts* studies conducted every two to five years by the Louis Harris polling organization (National Research Center of the Arts, 1984). These studies had consistently reported extremely high participation rates – nearly 60 per cent in the case of art museums, for example. Yet the arts field, even though it knew that these numbers were impossibly high, the result of an overtly advocacy-oriented questionnaire, was nevertheless delighted to use these data when it was politically advantageous. The publication of the SPPA data has rightfully dampened the enthusiasm for the Louis Harris data, though the *Americans and the Arts* surveys seem to be continuing unabated.

If the overall participation rate is two out of nine, which sub-groups in the population are more or less likely to be art museum-goers? The SPPA data allow disaggregation according to a number of demographic variables:[6]

Income: As income rises the participation rate rises, from 11 per cent to 45 per cent. Thus, differences in income levels are particularly helpful in explaining relative likelihood of attendance. There is one exception to the general increase in the probability of attendance over income, though: a decrease from 16 per cent to 11 per cent between the lowest and the next lowest income categories. An important component of this seeming anomaly is the fact that adults who are currently students are disproportionately in the lowest income group. In the United States, at least, students seem to adopt the attendance patterns of the people whom they will be like when they graduate more than they adopt the behaviour patterns of their non-student contemporaries. (As will be seen in the data for other countries, students are often separately identified in participation studies.)

Education: Educational level is also clearly correlated with partici-pation rate. The participation rate rises from 4 per cent of adults with a grade school education to 55 per cent of adults with some graduate school education, a difference of 51 percentage points. Taking this difference between the highest participation rate and the lowest participation rate when measured over the same variable as a rough measure of the ability of a variable to predict differences in attendance levels, education is the most important predictive variable in this list of demographic variables. (This result echoes the

results of the audience surveys summarized above and has been repeated throughout a wide variety of studies of arts audiences.)

Age: With respect to age, participation rates are roughly constant in the low to mid 20 per cent range until age 55 where they begin to tail off. The highest participation rate, 27 per cent, occurs in the 35–44 year bracket, perhaps reflecting increased attendance among families with children.

Gender: Women are slightly more likely to attend than are men.

Race: There is a clear difference in the participation rate between blacks and whites, with whites roughly twice as likely to have visited an art museum in the previous year. But much of this difference may be attributable to differences in education level or income level between whites and blacks rather than to actual racial differences. On average, other racial and ethnic groups have a participation rate that is approximately the same as that of whites.

Region: An analysis of the population by region shows that New England has a participation rate that is somewhat higher than average but that the Mountain states and the Pacific states have considerably higher participation rates. High participation rates in the west are particularly focused in the large metropolitan areas. According to special Census Bureau tabulations for selected metropolitan areas, the highest metropolitan area participation rates are all in the western states: a very high 41 per cent in the San Francisco bay area, 28 per cent in the Los Angeles area, and 38 per cent in other central cities in the west. In addition, Boston has a 26 per cent participation rate, Baltimore/Washington, DC, 26 per cent, Chicago 27 per cent, and cities in Texas 31 per cent. This suggests an important possible explanation for the differences in participation rates for each of the geographic variables: Is the variation in participation better explained by the geographic distribution of museums than by geographic differences in the population? In other words, to what extent is attendance a function of the supply of museums rather than of the demand for museums inherent in the demographics of particular populations?

Occupation: Participation rates by occupational category range

from a low of 9 per cent for operatives (machine operators) to a high of 49 per cent for professionals, a large range of 40 percentage points. Both the managerial and the professional categories show participation rates well above the overall average, but both categories also have higher than average incomes and education levels, so looking at occupation by itself may mask the effect of these other important variables.

Taken together these variables present the most complete overview available of the profile of the audience for art museums in the United States (Schuster, 1991a). When viewed from this perspective, the art museum audience is certainly unrepresentative of the American public, and unrepresentative in ways that should be of concern to public policy, but yet these numbers by themselves are somehow quite dissatisfying. Are they high? or low? Are they unusual? One way to judge them is through a cross-national comparison. How do art museum participation rates among the American public compare to the corresponding rates in other countries? To what extent are participation rates a reflection of the culture of the country in which they are being measured?

Participation rates for art museums – other countries
Cross-national comparisons in arts policy are particularly plagued by the wide variation in policy, approaches and definitions across countries and across cultures (Schuster, 1987), and it is no less complicated here. These studies differ in two ways: in the use of wider or narrower analytic categories and in the use of different time periods over which participation is measured.

The differences begin in the simple use of words that we often take for granted. There are considerable variations in what is considered to be an 'art museum', an 'art gallery', or an 'art exhibition' across these countries. For example, in the Netherlands the word 'gallery' indicates a commercial establishment that displays and sells works of art; this is also true in some regions of the United States, but in other regions 'gallery' is used interchangeably with 'museum', e.g. the Walker Art Gallery or the National Gallery.

But there are also differences in how the boundaries are drawn around the institutional sector of concern. In some cases the artistic medium is specified – painting and sculpture are included in one British category and photography comprises another – in others it

is not. The narrowest analytic category of all is 'exhibitions of painting or sculpture by *living* artists' in the Irish study. The broadest is 'museums and exhibitions' in the Austrian study and in one of the Dutch studies. In comparing the data across countries, these differences are particularly troubling, though often two different categories, one which is narrower than the American 'art museums and art galleries' and one which is broader (often 'all museums'), are available in the data and can be used to bracket the participation rate that would be most comparable to the American participation rate.[7]

With respect to time period there is somewhat less variation. Most of the studies ask the respondent to think back to the previous twelve months. One of the Dutch studies, however, asks how often a person goes (on average) and aggregates any answer of once a year or more. The British studies are not linked to a particular twelve-month period but attempt to ascertain whether or not an individual 'currently attends' or 'attends nowadays'. Studies in Denmark and Germany have estimated participation rates over six months. Unless one is attempting a very precise micro-analysis of individual behaviour by month, it is unlikely that these differences contaminate comparisons too much; it is not inconceivable that people would offer more or less the same answer no matter which of these ways of delimiting the time period is used.

With these caveats in mind, we can now turn to the data. The overall participation rates are summarized in Table 5.2. To this summary table I have added participation rates for countries for which only the participation rate but no other information has been published. (Participation rates for groups of institutions that are clearly broader than the American 'art museums and art galleries' are given in brackets.)

Despite the differences in definitions and categories across these studies, the most striking thing to emerge from these results is that *the overall participation rates are surprisingly similar to one another*. This becomes even clearer in Figure 5.1 which is based on selected participation rates for only those countries whose analytical categories seem to be the most comparable. With few exceptions the participation rate is in the low to middle twenties. And this is true *despite the fact that there are major differences across these countries with respect to government policies vis-à-vis art museums; with respect to the mix of private, quasi-public, and public institutions; with*

Table 5.2 *Participation Rates For Art Museums By Country*

Country	Participation rate %	Category
United States:	22	For 'art museums or art galleries'
Great Britain (a):	21	Currently attend 'art galleries or art exhibitions'
	15	Currently attend if 'less than once a year' is omitted
Great Britain (b):	21	Nowadays attend 'painting or sculpture exhibitions or galleries' or 'photography exhibitions or galleries'
	(32	Nowadays attend 'museums')
Netherlands(a):	21	For 'galleries'
	(41	For 'museums')
Netherlands (b):	(51	For 'museums or exhibitions')
France:	15	For 'art galleries'
	23	For 'temporary exhibitions of art or sculpture'
	(30	for 'museums')
Spain:	21	For 'art exhibitions in a gallery or an exhibition hall'
	(28	For 'museums')
Portugal:	24	For 'exhibitions'
Sweden:	12	For 'art museums'
	25	For 'art or craft exhibitions'
	30	For 'art museums or art or craft exhibitions'
Norway:	27	For 'art exhibitions'
	(26	For 'museums')
Denmark:	25	For 'exhibitions of art'
Finland:	35	For 'art exhibitions'
Québec:	28	For 'art museums'
Germany:	(25	For 'museums and exhibitions')
Austria:	(48	For 'museums and exhibitions')
Poland:	13	For 'contact with fine arts in museums, galleries, or exhibitions'
Ireland:	8	For 'exhibitions of painting or sculpture by living artists'

Sources: Sources for each of these countries are given at the bottom of Tables 5.3–5.12 with the exception of Denmark, Germany, Portugal and Poland. These participation rates are taken from Høst (1991), Wiesand (1991), Conde (1991), and Kostyrko (1991).

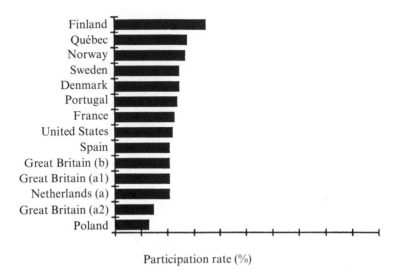

Participation rate (%)

Figure 5.1: A comparison of overall participation rates for art museums

Notes: In compiling Figure 5.1 I have had to make a number of compromises
 and subjective decisions. I have omitted studies for which only an
 overall participation rate for all museums is available (Austria) and for
 which the institutional boundary is much too narrow (Ireland) and
 have chosen the narrower definition when two exist (Spain, Norway).
 Where a middle ground institutional definition exists (France,
 Sweden), I have omitted participation rates for the narrowest and
 broadest specifications. But I have included the participation rate for
 art galleries in the Netherlands, even though the CBS study clearly
 indicates that these are commercial art galleries; the participation rate
 for all museums seems too broad to use as the one summary statistic. I
 have chosen to represent the British Target Group Index data twice,
 once as summarized in the Arts Council of Great Britain's report (a1)
 and once with a reduced participation rate that may be more nearly
 comparable to the other studies summarized here (a2). The difference
 is that in the latter case respondents who indicated that they 'attend
 nowadays' but 'less than once a year' are considered not to have
 attended in the last year, whereas they are included among those who
 'currently attend' in the Art Council's summary (Verwey, 1991).

respect to the level of public subsidy of the museum sector; and with respect to the level of admission charges. Between one-fifth and one-fourth of the adult population participates in cultural activities by attending an art museum, a relatively small range that is quite robust across different societal and policy contexts.

There are, of course, intriguing variations across this set of countries. The Nordic countries seem to have higher participation rates. Is this attributable to higher education levels? To differences in the expenditure of leisure time? To a greater emphasis on continuing adult education? The Québec participation rate is a bit higher than the others, but the 28 per cent figure is for 1989 as compared to a participation rate of 23 per cent in 1983. This size change is virtually unknown in audience statistics and may be attributable to sampling variations or a one-time event that would affect participation more at the provincial level than at a national level. The Polish participation rate of 13 per cent in 1985, on the other hand, is a good bit lower than the norm, having declined from 19.5 per cent in 1972. In this case, participation rates for the traditional cultural sectors seem to be falling – 'all those forms of participation in culture are becoming more and more selective, confined to the elites' – while participation rates in mass culture are only remaining stable (Kostyrko, 1991).

If we were to compare the statistics for all museums, again forcing comparability on the broader categories where they are reported, we would observe much the same result. Participation rates across all museums also do not vary very much.

The similarities across countries are not limited to overall participation rates. These similarities, as well as further variations, can be explored with the more detailed data provided in Tables 5.3–5.12. (Because there are two studies for both Great Britain and the Netherlands, both studies are summarized in the tables.) When disaggregated over various demographic variables, the participation rates remain remarkably similar across these studies, particularly when differences as to which museums or exhibitions are being considered are taken into account:

- Participation rates rise dramatically with both income and educational levels in all countries. Where both variables are available, the difference in participation rates across educational levels is greater than across income levels, indicating that

Table 5.3a *A Cross-national Comparison Of Art Museum Participation Rates: Great Britain*

Question: About how often these days do you go to the following . . .?
(*List included 'art galleries or art exhibitions'. Respondents were asked to choose one of six categories ranging from 'once a month or more often' through 'once a year' to 'never go these days'.*)

		Percentage who currently attend
Overall:		21
(*overall rate net of those who answered 'less often' than once a year.*)		(15)
Annual household income:		
	<£5,000	13
	£5,000 – £7,999	15
	£8,000 – £10,999	20
	£11,000 – £14,999	21
	£15,000 – £19,999	23
	£20,000 – £29,999	30
	≥ £30,000	42
Age when terminated education:		
	14 years or younger	8
	15 years 13	
	16 years 17	
	17 or 18 years	28
	19 years or older	49
	Still student	38
Class:	Upper middle or middle class	41
	Lower middle class	27
	Skilled working class	15
	Working class and lowest subsistence	11
Age:	15–19 years	25
	20–24 years	22
	25–34 years	23
	35–44 years	26
	45–54 years	23
	55–64 years	21
	≥65 years	13
Gender:	Female	22
	Male	21
Region:	Greater London	28
	Scotland	25
	Wales	17

Source: British Market Research Bureau, *Target Group Index 1990/1,* data reported in Verwey (1991).
Notes: Survey conducted in mid-1991. Class is of household head. Selected regions reported here.
'Currently attend' includes all individuals who gave any frequency except 'never', so it includes people who 'attend these days but go less often than once a year'.
Figures in brackets do not include these respondents; data are not available in a form that will allow these people to be subtracted out of all categories above.

Table 5.3b *A Cross-national Comparison Of Art Museum Participation Rates: Great Britain*

Question: Now I would like to talk to you about arts and cultural activities. Which, if any, of these do you ever attend nowadays as a visitor or member of the audience?

(*List included 'museums', 'painting/sculpture exhibitions or galleries', 'photography exhibitions or galleries', and 'craft exhibitions or galleries'.*)

		Percentage who attend 'painting/sculpture exhibitions or galleries' or 'photography exhibitions or galleries' nowadays	Percentage who attend 'Museums' nowadays
Overall:		21	32
Age when terminated education:			
	16 years or younger	14	25
	17 or 18 years	28	40
	19 years or older	48	58
Class:	Upper middle and middle	39	51
	Lower middle class	28	39
	Skilled working class	15	29
	Working class	12	24
	Lowest subsistence	13	17
Working status:	Working	22	37
	Not working (not student)	17	28
Age:	16–19 years	21	31
	20–24 years	21	33
	25–34 years	20	35
	35–44 years	24	40
	45–54 years	24	36
	55–64 years	24	29
	≥65 years	16	22
Gender:	Female	21	30
	Male	21	34
Ethnic Origin:	European	21	32
	African, Caribbean or South Asian	14	29
Region:	Greater London	24	35
	Great Britain (not London)	21	32
	Scotland	25	35
	Wales	14	26
	Urban conurbation	20	31
	Rural	21	32

Source: Research Surveys of Great Britain (1991).
Notes: Survey conducted in June/July 1991. Class is of household head. Selected regions reported here. The variable 'Working Status' is calculated for adults from 16 to 54 years old.

Table 5.4a *A Cross-national Comparison Of Art Museum Participation Rates:*
The Netherlands

Questions: Have you visited a gallery during the past twelve months?
A gallery is a place where you can both view and buy works of art.
Have you visited a museum in the Netherlands during the past twelve months? (We mean both visits to the permanent collection of a museum and visits to special exhibitions.)

		Gallery participation rate (%)	Museum participation rate (%)
Overall:		21	41
Age:	6–14 years	11	54
	15–24 years	16	39
	25–34 years	24	41
	35–44 years	24	43
	45–54 years	29	43
	55–64 years	25	37
	65–74 years	23	34
	≥75 years	13	22
Gender:	Female	23	42
	18–24 years	20	43
	≥25 years	25	40
	Male	20	39
	18–24 years	14	34
	≥25 years	23	38

Source: 1991 data provided by Frans Hoeve, Central Bureau of Statistics, to the Boekmanstichting. [Data from the same survey but for 1987 have been published in Jonkers and van Reijn (1991).]
Note: Data are from the Supplementary Facility Use Survey conducted by the Central Bureau of Statistics in 1991.
Survey is of the resident population 6 years old and older, so the overall participation rates and the aggregate participation rates for women and men include children.

education is the better predictor of an individual's probability of participation. Participation rates near 50 per cent or even higher are common among the most highly educated segments of these populations. In these respects, participation studies reinforce the results of the many audience surveys.

• In line with the results for income and education, participation rates are much higher among higher socio-economic groups and among professionals.

• Participation rates do not vary much by age. They rise slightly through middle age then drop off. Even if overall participation rates are low and do not change in response to public policy initiatives, one might argue that public policy is not evenly

Table 5.4b *A Cross-national Comparison Of Art Museum Participation Rates: The Netherlands*

Question: How often do you visit museums/exhibitions?

		Museum/ exhibition participation rate (%)
Overall:		51
Income:	Lower 2/3	43
	Upper 1/3	62
Education:	Primary	36
	Lower vocational	35
	Lower secondary	50
	Higher secondary/intermediate vocational	56
	Higher vocational	73
	University	88
Occupation:	Professional/managerial	72
	Intermediate level employees	55
	Lower level employees	51
	Self-employed	36
	Labourer	36
	Primary industry	(47)
Age:	21–29 years	44
	30–39 years	48
	40–49 years	54
	50–59 years	54
	≥60 years	54

Source: Ganzeboom and Haanstra (1989).
Notes: Data based on supplementary questions asked in the Tijdsbestedingsonderzoek (TBO) Survey, a time expenditure survey, conducted in 1985.
Participation rates inferred from answers 'once a year' or more frequently.
Percentages in brackets apply to a very small group.
Income categorization is indirect, based on eligibility for the government health insurance fund.

targeted across age groups and that a reasonable policy might aim for increased participation at certain moments in life. Thus, the percentage of people participating in art museums at some point in their life could be considerably higher than the overall statistics for all age groups. But if policy were working in this way, we would observe peaks of participation in certain age groups; we do not.

• With respect to gender, participation rates for women are more often than not slightly higher than those for men. The most extreme example is Finland where the participation rate for

Table 5.5 *A Cross-national Comparison Of Art Museum Participation Rates: France*

Question: From the following list of activities, which have you done in the past 12 months? (*List included 'go to an art gallery', 'view a temporary exhibition of painting or sculpture', or 'visit a museum'.*)

		Art gallery participation rate (%)	Exhibition of art or sculpture participation rate (%)	Museum participation rate (%)
Overall:		15	23	30
Education:	No diploma, CEP	7	13	18
	BEPC	16	25	35
	CAP	11	19	28
	Baccalaureate degree or equivalent	26	40	44
	Graduate studies	41	58	64
Class:	Agriculteurs	5	13	20
	Artisans, commercants, et chefs d'entreprise	12	18	28
	Cadres et professions intellectuelles superieures	43	61	60
	Professions intermédiaires	26	40	48
	Employés	13	23	26
	Ouvriers qualifiés	7	15	23
	Ouvriers non qualifiés, agricoles	7	11	24
	Students	20	29	41
	Housewives	10	19	23
	Retraités	10	16	22
	Autres inactifs	12	15	17
Age:	15–19 years	14	22	38
	20–24 years	19	29	32
	25–34 years	17	27	35
	35–44 years	15	26	32
	45–54 years	16	26	30
	55–64 years	14	21	27
	≥65 years	8	14	19
Gender:	Female	15	24	29
	Male	14	22	31
Region:	Rural communities	7	14	24
	<20,000 residents	10	20	24
	20,000–100,000 residents	13	23	25
	>100,000 residents	18	25	31
	Paris	48	56	59
	Remainder of Paris metropolitan area	20	33	43

Source: Département des études et de la prospective (1990).
Notes: Survey conducted in 1989. Socio-economic class is for the interviewee.

Table 5.6 *A Cross-national Comparison Of Art Museum Participation Rates:*
Spain
Question: I am going to read a list of activities. For each one tell me if you have
done this activity at least once. Have you done it in the last twelve months?
(*List included 'visit an art exhibition in a gallery or an exhibition hall', and 'visit a*
museum'.)

			Art exhibition participation rate (%)	Museum participation rate (%)
Overall:			21	28
Gender:	Female		21	27
	Male		22	28
Age:	Female	18–19 years	38	45
		20–24 years	39	45
		25–44 years	25	34
		45–64 years	16	20
		≥65 years	7	12
	Male	18–19 years	32	42
		20–24 years	27	34
		25–44 years	29	38
		45–64 years	17	21
		≥65 years	11	15

Source: de Zárraga and Bonor (1991) summarized in Ministerio de Cultura (1991).
Note: Survey conducted in late 1990.

women is 50 per cent higher than the rate for men. This has led
one researcher who has worked with these data to conclude that
despite 'the stagnant or waning fortunes of the performing [and
visual] arts, there are mechanisms which will safeguard their
recruitment basis. Women, and especially middle class women,
seem to be the carriers of the torch in these areas of participa-
tion.' (Mitchell, 1991) The data from other countries, however,
do not seem to bear this out.
• Geographical location can make a large difference in participa-
tion, particularly in large metropolitan areas where major cul-
tural institutions tend to be clustered.

Taken together these statistics are remarkably consistent across
countries. They strongly suggest that museums everywhere, despite
their particular circumstances, are serving virtually identical audi-
ences, and they question the ability of public policy or museum's
actions to have much success in changing that audience's profile.
 Of course, participation rates are only one way of looking at

Art in Museums

Table 5.7 *A Cross-national Comparison of Art Museum Participation Rates: Sweden*

Percentage of the population aged 15–79 years that visited an art museum or an art or craft exhibition in the previous 12 months.

		Art museum participation rate (%)	Art or Craft exhibition participation rate (%)	Art museum or art or craft exhibition participation rate (%)
Overall:		12	25	30
Education:	Completion of compulsory school (Grade 9)	6	15	18
	Some high school	12	28	33
	High school diploma or equivalent	28	45	54
Age:	15–24 years	8	20	25
	25–44 years	13	27	32
	45–64 years	16	32	38
	65–79 years	8	16	19
Gender:	Female	14	30	35
	Male	10	20	26
Region:	Stockholm	24	26	37
	Göteborg and Malmö	16	26	33
	Other large cities and densely populated areas of the north	9	26	30
	Countryside including the south, the middle, and sparsely populated areas of the north	7	24	26

Source: Nordberg and Nylöf (1989).
Note: Survey conducted in mid-1988.

museums's publics. Focusing on participation rates does not reveal, for example, relative frequency of attendance. It is certainly possible that while the cross-section of the population being served by art museums is quite similar across countries, the frequency of attendance might be rather different in those places where 'museum going' has become more a part of daily life. And that fact may be of interest for public policy purposes, particularly if one's policy is to increase the depth rather than the breadth of attendance.

The limited data that are beginning to become available on frequency of attendance suggest that it is not the case that frequency

Table 5.8 *A Cross-national Comparison of Art Museum Participation Rates: Norway*

Percentage of the population visiting art exhibitions and visiting museums during the last 12 months.

		Art exhibition participation rate (%)	Museum participation rate (%)
Overall:		27	26
Socio-	Farming, fishing	6	12
Economic	Unskilled worker	9	19
Group:	Skilled worker	13	14
	Office worker	15	28
	Intermediary administration	37	37
	Professionals and administrative leaders	50	44
	Business leaders	46	38
Age:	<30 years	27	28
	30–50 years	33	33
	>50 years	21	21

Source: Rosenlund (1991).
Notes: Survey conducted in 1987.
Participation rates by age are estimated from graphical presentations of the data.

of attendance is systematically higher in other countries than in the United States. In fact, there is the possibility, although it cannot be tested with the data that are available in published form, that frequency of attendance by visitors may actually be higher in France and the United States than for other countries.[8]

The French study reports relatively high means of 4 visits per visitor to museums, 6 visits per visitor to art galleries, and 5 visits per visitor to temporary exhibitions; the American data yield an estimate of 3.4 visits per visitor to art museums and art galleries; but remember that these data are over a combined category – art museums plus galleries. Data from the other participation studies are quite similar to one another, and if it were possible to return to the raw data and create combined categories that more nearly correspond to the American category, it is possible that the average frequency of attendance would be on the order of magnitude of the American figure. The Spanish data yield an estimate of 2.1 visits per visitor to museums and 2.2 visits per visitor to art exhibitions; the RSGB study in Great Britain yields estimates of 1.9 visits per visitor

Table 5.9 *A Cross-national Comparison Of Art Museum Participation Rates:*
Finland

Percentage of the adult population who have visited art exhibitions at least once
during the preceding year.

			Art exhibitions participation rate (%)
Overall:			35
Gender:		Female	44
		Male	29
Class by Gender:	Senior clerical employees	Female	86
		Male	62
	Junior clerical employees	Female	56
		Male	30
	Service sector	Female	23
		Male	24
	Workers	Female	26
		Male	26
	Farmers	Female	17
		Male	14

Source: Mitchell (1991).
Note: Study conducted in 1981.

for museums in general, 2.1 visits per visitor to painting and sculpture exhibitions and galleries, and 2.0 visits per visitor to photography exhibitions and galleries; the Netherlands Central Bureau of Statistics data yield estimates of 2.0 visits per visitor to museums and 2.2 visits per visitor to galleries, while the Netherlands study reported by Ganzeboom and Haanstra yields an estimate of 1.9 visits per visitor to museums; and the Québec study reports a mean of 2.1 visits per visitor to art museums.[9]

Put together with the participation rates reported above, these statistics suggest in a very broad way that while the art museums of all of these countries attract more or less the same proportion of the adult population, only the French (and, possibly, the American) art museums do a somewhat better job of getting those visitors to make repeat visits. But one has to be a bit careful in interpreting this indicator. The narrower and more dedicated an audience, the higher visits per visitor are likely to be. An institutional form with a broad but relatively uncommitted audience would have a lower value for this indicator. So, from this indicator alone, one might just as easily conclude that French and American arts museums do a better job of filtering and narrowing their audiences. Thus, one might

Table 5.10 *A Cross-national Comparison Of Art Museum Participation Rates: Québec*
Question: During the last twelve months have you visited an art museum or an exhibition in an art museum?

		Art museum participation rate (%)
Overall:		28
Family income:	<$20,000 (Canadian $)	15
	$20,000–$29,999	18
	$30,000–$39,999	27
	$40,000–$49,999	26
	≥$50,000	44
Education:	0–7 years	12
	8–11 years	17
	12–15 years	27
	≥16 years	56
Employment:	Active	30
	Inactive (not working)	21
	Students	39
Age:	18–24 years	25
	25–34 years	25
	35–44 years	32
	45–54 years	27
	≥55 years	29
Gender:	Female	26
	Male	30
Region:	Québec metropolitan area	35
	Montréal metropolitan area	37
	Remainder of province of Québec	23

Source: Pronovost (1990). Further detail given in Garon (1992).
Notes: Survey conducted in May and June, 1989. Survey also included young people from ages 15 to 17, but they were deleted from published results so that figures would be comparable to earlier studies, which only included ages 18+.
Participation rate for all museums is 39 per cent.

plausibly look for either a larger value or a smaller value of 'visits per visitor' as an indicator that public policy with respect to the art museum's audience is working. As in many fields, multiple indicators are required to fully understand the impacts of policy.

IN SUMMARY

While far from conclusive, when taken together these studies suggest that across most western countries art museums may well

Table 5.11 *A Cross-national Comparison Of Art Museum Participation Rates:*
Austria
Question: How many times have you visited museums and exhibitions in the last
year?

		Museums and exhibitions participation rate (%)
Overall:		48
Education:	Minimum level of obligatory education	36
	Apprenticeship	42
	Professional training	59
	Baccalauréat	79
	Higher education	81

Source: Institut für empirische Sozialforschung (1991). *Notes:* Survey conducted in
1989. Participation rate is calculated by adding together the percentage of the
population that said it had gone once or twice in the preceding year to the percentage
that said it had gone more than twice.

be serving similar segments of their national populations and that
in large part this receptivity seems to be a function of the same
demographic factors. I suppose that this result – that art galleries,
art exhibitions, and art museums speak more readily to certain types
of individuals than to others – is not a terribly surprising one. They
are, after all, the institutional creation of certain social groups, and
they serve the needs of those groups best. This set of topics has
begun to be addressed by a wide variety of sociological studies of
art museums. Moreover, there are good reasons for art museums to
be of mixed mind about changing their audience. Even though
public policy might want them to enlarge their audiences to include
under-served groups, in a system with an increasing emphasis on
private support it is in the museum's interest to target a narrower
group of well-off audience members rather than to spread its
development efforts too thinly. In other words, the policy impera-
tive and the economic imperative may actually work against one
another.

 In many respects my analysis has been a relatively straightfor-
ward one, based on the demographic variables that are commonly
cited as important in identifying target groups for participation in
the museum public and, therefore, in analyzing audience participa-
tion. But irrespective of this policy intent, they would be of interest

Table 5.12 *A Cross-national Comparison Of Art Museum Participation Rates: Ireland*
Question: Which, if any, of the activities on this list have you attended in the past two years? And which have you attended in the past year?
(*List included 'an exhibition of paintings or sculptures by living artists'.*)

		Participation rate in exhibitions by living artists (%)
Overall:		8
Class:	Middle class	20
	Skilled working class	3
	Semi-skilled/unskilled working class	4
	Farmers	2
Age:	16–24 years	10
	25–34 years	7
	35–49 years	11
	50–64 years	5
	≥65 years	4
Gender:	Female	8
	Male	8
Region:	Dublin	13
	Rest of Leinster	5
	Munster	9
	Connacht/Ulster	3
Area:	Urban	11
	Rural	4

Source: Sinnott and Kavanagh (1983).

because of the significant differences in participation rates that are, in fact, observed across them.

This group of variables has a very interesting common property, however: they are all variables over which neither the individual museum nor any arts funding agency has any influence (except, perhaps, by actually moving the museum!). They are not instrumental variables. It is difficult to imagine, for example, the museum that would be in a position to increase the level of formal education or income of its potential audience in order to increase the local participation rate. One is left with the impression that potential visitors are prisoners of their own demographics and that museums are prisoners of the demographics of their potential local audiences. Seen from this perspective, a museum does not have free choice in determining who its public will be: whatever audience filters are in place work extremely effectively in controlling the profile of the audience. Nevertheless, it may help to unravel the individual decisions taken by potential visitors in choosing whether to attend a

museum; many of the participation studies I have mentioned are now being used by researchers in exactly this way.[10]

To be sure, a demographic analysis can help to document that the audience is much larger than had been hoped for or smaller than had been feared, or that particular segments of the population are not being reached as much as the museum or public policy might like. It can indicate if the overall demographics of the audience have changed over time, but attributing those changes to specific interventions is difficult. Change in audience composition is a slow, resistant process. A demographic analysis of the audience is descriptive rather than prescriptive, and one should resist the temptation to conclude that one knows more than one actually does about audience behaviour and motivations when armed with these demographic results.

So the time has come to return to my opening points about the public interest. My analysis leaves me with an unresolvable dilemma. While it is perfectly reasonable for the public sector to specify, or to be concerned with, specific target audiences, whether or not it is possible to reach them is another matter. If the audience for art museums is resistant to change but the kernel of public policy lies in constant, renewed, and expanding contact with an audience, do public officials have no choice but to reconcile themselves to the fact that art museums will continue to serve the same segment of the adult population? Should they be forced to admit and accept that museum policy is a policy for the benefit of a particular social class? Should art museums take the position that they are simply going to rest on their laurels, taking the position that 'we are what we are'? Perhaps so. Whether or not the museum should be held responsible for an inability to enlarge and change its audience is problematic. But I, for one, hope that the data in this paper will not mean that museums are for evermore exempt from having to worry about their audience profile.

Why not challenge ourselves in a new way? The trick for public policy is how to keep dangling a carrot in front of art museums's (and other cultural institutions's) noses in a way that keeps them trying to expand contact with their publics when the data suggest that it is extremely difficult. The trick for the art museum is to continually challenge itself.

Neither of these will come easily. The forces that lead to a particular audience composition are powerful and robust. Either a

completely new type of institutional form or a completely new type of public policy may be required.

EPILOGUE

Until the mid-nineteenth century most museums were founded around private collections, and access was restricted to an audience selected by the collector, though few went to such great lengths as Sir Ashton Lever in 1773:

> This is to inform the Publick that being tired out with the insolence of the common People, who I have hitherto indulged with a sight of my museum, I am now come to the resolution of refusing admittance to the lower class except they come provided with a ticket from some Gentleman or Lady of my acquaintance. And I hereby authorize every friend of mine to give a ticket to any orderly Man to bring in eleven Persons, besides himself whose behaviour he must be answerable for, according to the directions he will receive before they are admitted. They will not be admitted during the time of Gentlemen and Ladies being in the Museum. If it happens to be inconvenient when they bring their ticket, they must submit to go back and come some other day, admittance in the morning only from eight o'clock till twelve. (Wittlin, 1970)

In the late eighteenth century, individuals who wished to visit the British Museum had to present their credentials at the office and await word, sometimes for months, as to whether they would receive an admission ticket (Wittlin, 1970). When they did receive a ticket they were 'shown around at a rather breathless pace in parties of five or ten by a member of staff' (Wilson, 1989). But it was not until 1960 that the Barnes Foundation in Philadelphia was forced, in exchange for its status as a tax-free institution, to open its doors to the general public, though admissions were still limited to 400 per week (Burt, 1977; Meyer, 1979).

Time, public policy, and institutional choices did break down these barriers, albeit slowly. Whether a further mix of time, public policy and intent on the part of museums will serve to further democratize the audience remains an open question. The imperative of institutional survival in an increasingly privatized sector coupled with these institutions's natural appeal to specific social groups may once again cause the museum audience to become relatively insulated from the broader society of which it is a part. May it not be so.

NOTES

An earlier version of this paper was presented at 'Art Museums and the Price of Success: The United States, the United Kingdom, and the Netherlands', an International Museum Conference sponsored by the Boekmanstichting, Amsterdam, The Netherlands, 10–11 December, 1992. Research for this paper was made possible through a sabbatical support grant from the Dirección General de Investigación Científica y Técnica of the Spanish Ministry of Education and Science and through a Cooperative Agreement with the Research Division of the National Endowment for the Arts. To both agencies I am extremely grateful. Two earlier versions of the comparative analysis have been published in Schuster (1991a and 1991b). Special thanks to Janneke Reijseger and Ineke van Hamersveld of the Boekmanstichting and Andrew Feist of the Arts Council of Great Britain who helped me considerably in my attempts to reconcile the differences among various data sources.

1 The careful reader will notice that my approach here differs from what one more usually finds in the cultural economics literature where there is, appropriately, an emphasis on the economic (or political) justification for public sector involvement. For an excellent summary of these arguments see Duffy (1992). In contrast, in this paper I take the justification for public involvement as given and emphasize, instead, the locus on which that public involvement should focus.

2 I am not concerned here with the buildings that museums inhabit. Many, of course, are of considerable architectural and historical interest to society and are deserving of preservation. Even so, the principle of the public interest would be manifested in much the same way.

3 These surveys are often called 'visitor surveys', but this is a misnomer. They are often actually 'visit surveys', surveys which give an equal probability of selection to each *visit* to the museum rather than surveys which give an equal probability of selection to each *visitor*.

4 There is some possibility that this is due to response bias if, as has been suggested, women are more likely than men to fill out these types of surveys.

5 This finding is similar to the British Museum's conclusion that 'temporary exhibitions apparently attract older visitors but few first-time visitors', a result that one would not necessarily expect given the level of special promotion of such exhibits (Wilson, 1989).

6 In a comparative study, these classifications themselves are reasonable subjects of scrutiny. They reflect something of a society's policy preoccupations: e.g. race and ethnicity feature prominently in the United States and Great Britain studies. Finland is particularly concerned with the interaction between gender and class. The United States, Great Britain and Sweden pay attention to geographic distribution questions. In Eastern

Europe, on the other hand, the trend so far has been to measure volume of attendance rather than participation rates.

7 In some cases, the study offers multiple categories that can be combined to correspond to various boundaries of the art museum sector. For example, the RSGB Omnibus Arts Survey in Great Britain (Research Surveys of Great Britain, 1991) offers the possibility of many different recombinations of smaller categories. I have chosen to leave 'museums' alone, not adding any of the other categories to it. To simulate 'art museums and art galleries', however, I have combined 'painting and sculpture' and 'photography' but have not included crafts. My guess is that Americans if asked about art museums would not normally include crafts/craft galleries.

8 Notice that I have chosen the indicator 'visits per visitor' for this comparison rather than 'visits per person'. The former yields a higher number, of course, but it is arguably a better indicator of the depth of experience that the attending audience is receiving.

9 In the American, Spanish, Dutch and British cases I have had to estimate these means from grouped data, which introduces imprecision into the estimates, but a sensitivity analysis shows that under varying assumptions the relative levels of these statistics vary very little. One of the problems in the comparative analysis of these data sets is that they each use different categorization schemes to collect data on frequency of attendance. For example, one Dutch study used 'zero', 'less than one', 'one', 'two to three', and 'four to eleven' visits per year and 'one or more' visits per month; the other used 'zero', 'one to three', and 'more than three'. The Spanish study, inexplicably, used 'zero', 'one', 'two to three', 'four to six', 'more than seven', and 'on vacation'. Only the Québec study asked respondents to give an actual number of attendances in the previous year. In the 1992 SPPA the National Endowment for the Arts has changed from using categories to asking for a raw number, a change that should facilitate the type of analysis I have attempted here.

10 The Research Division of the National Endowment for the Arts has commissioned a series of research reports based on the 1982, 1985 and 1992 SPPA data, and many of these reports concern or will concern themselves with the micro-level decisions of audience members looking at such factors as socialization into the arts.

BIBLIOGRAPHY

Burt, Nathaniel (1977) *Palaces for the People: A Social History of the American Art Museum*, Little, Brown and Company (Boston).

Conde, Idalina (1991) 'La participation à la vie culturelle: Observations sur le Portugal' in Zentrum für Kulturforschung, *Participation in Cultural Life: papers presented to the European Round Table on Cultural Research*, Archiv für Kulturpolitik (Bonn), pp. 237–46.

Département des études et de la prospective, Ministère de la Culture et de la Communication (1990) *Les Pratiques Culturelles des Français: Nouvelle Enqûete 1988–1989*, La Documentation Française (Paris).

d'Harnoncourt, Anne, Paul DiMaggio, Marilyn Perry and James Wood (1991) 'The museum and the public' in Martin Feldstein (ed.) *The Economics of Arts Museums*, University of Chicago Press (Chicago) pp. 35–60.

de Zárraga, Jose Luis and Marisa Marin Bonor (1991) *Encuesta del equipamiento, prácticas y consumos culturales de los españoles, Volume I, 'Prácticas y consumos culturales de los españoles: Analisis de resultados'*, Gabinete de analisis sociologico, Grupo METIS, for Spanish Ministerio de Cultura (Madrid), January.

DiMaggio, Paul, Michael Useem and Paula Brown (1978) *Audience Studies of the Performing Arts and Museums: A Critical Review*, Research Division Report no. 9, National Endowment for the Arts (Washington, DC.), Nov.

Duffy, Christopher (1992) 'The rationale for public funding of a national museum' in Ruth Towse and Abdul Khakee (eds) *Cultural Economics*, Springer-Verlag (Berlin) pp. 37–48.

Feld, Alan, Michael O'Hare and J. Mark Davidson Schuster (1983) *Patrons Despite Themselves: Taxpayers and Arts Policy*, a Twentieth Century Fund Report, New York University Press (New York).

Ganzeboom, Harry and Folkert Haanstra (1989) *Museum and Public: The Public and the Approach to the Public in Dutch Museums*, Ministry of Welfare, Health and Culture (Rijswijk, The Netherlands), August.

Garon, Rosaire, Direction de la recherche et de la statistique, Ministère des Affaires culturelles du Québec (1992) 'Le progrès d'une décennie en matière de participation culturelle 1979–1989', *Chiffres à l'appui*, 7, 2: 1–9.

Heinich, Nathalie (1988) 'The Pompidou Centre and its public: the limits of a utopian site' in Robert Lumley (ed.) *The Museum Time Machine*, Routledge (London) pp. 199–212.

Hood, Marilyn G. (1984) 'Staying away: why people choose not to visit museums', *Museum News*, 61, 4: 50–7.

Hooper-Greenhill, Eilean (1988) 'Counting visitors or visitors who count?' in Robert Lumley (ed.) *The Museum Time Machine*, Routledge (London): 213–32.

Høst, Helvinn (1991) 'The situation in Denmark' in Zentrum für Kulturforschung, *Participation in Cultural Life: Papers Presented to the European Round Table on Cultural Research*, Archiv für Kulturpolitik (Bonn) pp. 77–83.

Institut für empirische Sozialforschung (1991) 'Kulturelle Aktivitäten der Österreicher 1972–1989' a survey for the Bundesministeriums für Unterricht, Kunst und Sport, in Zentrum für Kulturforschung, *Participation in Cultural Life: Papers Presented to the European Round Table on Cultural Research*, Archiv für Kulturpolitik (Bonn) pp. 21–8.

Jonkers, T. and T. van Reijn (1991) (eds) 'Cultural participation' in Zentrum für Kulturforschung, *Participation in Cultural Life: Papers Presented to the European Round Table on Cultural Research*, Archiv für Kulturpolitik (Bonn), pp. 209–14.

The Journal of Arts Management and Law (1985) 15, 1: special issue, 'Consumer behaviour and the arts'.

Kostyrko, Teresa (1991) 'Participation in cultural life in Poland – past and current trends' in Zentrum für Kulturforschung, *Participation in Cultural Life: Papers Presented to the European Round Table on Cultural Research*, Archiv für Kulturpolitik (Bonn) pp. 233–6.

Low, Theodore L. (1942) *The Museum as a Social Instrument*, The Metropolitan Museum of Art for The American Association of Museums (New York).

McCaughey, Claire (1984) *A Survey of Arts Audience Studies: A Canadian Perspective, 1967–1984*, Research and Evaluation, The Canada Council (Ottawa), September.

Merriman, Nick (1989) 'Museum visiting as a cultural phenomenon' in Peter Vergo (ed.) *The New Museology*, Reaktion (London) pp. 149–71.

Meyer, Karl (1979) *The Art Museum: Power, Money, Ethics*, William Morrow (New York).

Ministerio de Cultura (1991) *Equipamientos, prácticas y consumos culturales de los españoles, Coleccion Datos Culturales, numero 1*, Secretaría General Técnica, Ministerio de Cultura (Madrid).

Mitchell, Ritva (1991) 'The participation of the population in various fields of cultural life: recent quantitative evolution and forecast trends' in Zentrum für Kulturforschung, *Participation in Cultural Life: Papers Presented to the European Round Table on Cultural Research*, Archiv für Kulturpolitik (Bonn) pp. 85–119.

National Research Center of the Arts, Inc. (1984) *Americans and the Arts*, Louis Harris and Associates (New York), October.

Nordberg, Jan and Nylöf, Göran (1989) 'Kulturbarometern i detalj: Tema konst, museer och utställningar' *PUB informerar*, May.

Pronovost, Gilles (1990) *Les comportements des Québécois en matière d'activités culturelles de loisir, 1989*, Publications du Québec (Québec).

Research Division, National Endowment for the Arts (1985) *Surveying Your Arts Audience*, National Endowment for the Arts (Washington, DC).

Research Surveys of Great Britain (1991) *RSGB Omnibus Arts Survey: Report on a Survey on Arts and Cultural Activities in Great Britain*, Arts Council of Great Britain (London).

Robinson, John, Carol Keegan, Marcia Karth and Timothy Triplett (1987) *Public Participation in the Arts: Final Report on the 1985 Survey*, 'Volume I: Overall Project Report', unpublished report, Research Division, National Endowment for the Arts, (Washington, DC).

Rosenlund, Lennart (1991) 'Norway answers to C.I.R.C.L.E. questionnaire' in

Zentrum für Kulturforschung, *Participation in Cultural Life: Papers Presented to the European Round Table on Cultural Research*, Archiv für Kulturpolitik (Bonn) pp. 215–31.

Schuster, J. Mark Davidson (1991a) *The Audience for American Art Museums*, Seven Locks Press (Cabin John, Maryland).

Schuster, J. Mark Davidson (1991b) 'I visitatori dei musei d'arte: più paesi a confronte', *Economic della Cultura*, 2, 1, 2: 30–43.

Schuster, J. Mark Davidson (1987) 'Making compromises to make comparisons in cross-national arts policy research', *Journal of Cultural Economics*, 11, 2: 1–36.

Sinnott, Richard and David Kavanagh (1983) *Audiences, Acquisitions, and Amateurs: Participation in the Arts in Ireland*, Arts Council (Dublin), March.

Verwey, Peter (1991) *Target Group Index 1990/91*, Arts Council of Great Britain (London), September.

Weisand, Andreas (1991) 'Cultural participation in Germany – trends and results of current research' in Zentrum für Kulturforschung, *Participation in Cultural Life: Papers Presented to the European Round Table on Cultural Research*, Archiv für Kulturpolitik (Bonn) pp. 137–51.

Wilson, David (1989) *The British Museum: Purpose and Politics*, British Museum Publications (London).

Wittlin, A. (1970) *Museums: In Search of a Usable Future*, MIT Press (Cambridge, MA).

Wright, Philip (1989) 'The quality of visitors' experiences in art museums' in Peter Vergo (ed.) *The New Museology*, Reaktion (London) pp. 119–48.

6

Audiences – A Curatorial Dilemma

EILEAN HOOPER-GREENHILL[1]

INTRODUCTION

Museums and galleries are at a time of enormous change. In the United Kingdom, both central and local government are demanding greater accountability combined with an emphasis on quality of provision, while at the same time funds and resources for museums are being reduced. During the 1960s and 1970s, museums in Britain were seen as deserving public support because they represented a civilized society, and contributed to a public culture. During the 1980s, these attitudes were overridden by the ideology of the free market. Today, museums and galleries must increasingly earn their own livings and at the same time demonstrate social relevance to justify those public funds that they do still receive. These circumstances are not peculiar to Britain, but are familiar in many parts of the world.

The briefing papers for the conference 'Art Museums and the Price of Success', at which a shorter version of this paper was delivered, suggested that the most frequent response to this situation in art museums was the mounting of blockbuster exhibitions to bring in the crowds. If this is indeed the case, I would suggest that this response brings with it a number of problems. The emphasis on mega-exhibitions leads to a tremendous strain on resources, increases competition between art museums, leads to an emphasis on commercialism and entails planning based on revenue-generation. This emphasis may result in a serious neglect of the permanent collections and displays.

This approach is also likely to lead to a lack of consideration for the needs of audiences. The audience for the museum is seen in terms of *visitors*, those who will actually come, rather than in terms of *audience*, all those who might come, if the experience were judged (by them) to be worthwhile. *Visitors* themselves are conceived in

extremely narrow terms, judged more in terms of what they will spend rather than what they might experience.

The emphasis on mega-exhibitions with their intention to draw in large numbers can also lead to conceptualizing the museum experience in terms of tourists. Tourists tend to visit once only, ticking off the art museum on a long agenda of places that merely need to be seen to be experienced. The demands of tourists are satisfied by just walking through the galleries for an hour or so; a greater engagement with the collections is not often required. Other approaches to audiences are obscured by this assumption of the visitor as tourist. These other approaches might mean developing the museum to appeal to local residents, might concentrate on methods to broaden the audience base, or might concentrate on reviewing and improving the experience that visitors to the art museum might have.

In the past, art museums have been notorious for precisely this lack of attention to the needs of their audiences. Where other types of museums, such as science museums or science centres, history museums and childrens' museums, have researched how they might make relationships with their actual and potential visitors, art museums have tended to remain aloof. Where other types of museum have begun to explore the *quality* of the experience of the visitor, art museums have concentrated on increasing the *quantity* of visitors.

I would like to suggest that it is time for art museums to shift the emphasis from quantity to quality, and that lessons on how to do this can be learnt in part from other types of museums, but also from some new ideas being developed in art galleries themselves. Paradoxically, it is likely that as the quality of the experience is raised, visitor numbers will also increase, whereas if effort is put into merely increasing numbers, the quality of the experience is likely to fall.

How can the attention be shifted from quantity to quality? There are two important areas that need to be addressed.

First, the nature of audiences should be considered very seriously. What type of people go to art museums and why? What are their needs, and how can art museums respond? In Britain, recent attention to the marketing of museums has led to new, more in-depth ways of conceptualizing audiences.

Secondly, policies and practices of exhibitions need to be reviewed to consider how both permanent displays and temporary

exhibitions can be improved to enable a better experience for all visitors. Where displays are easy for people to relate to, local and repeat visitors will increase. Where the experience of the art museum is comfortable, enjoyable and personally extending, people will seek it out.

ART GALLERY AUDIENCES

Who goes to art galleries? Very many studies over the last ten years have shown the gallery audience to be more affluent and better educated than the general population (Hooper-Greenhill, 1985; Hooper-Greenhill, 1994). Eckstein and Feist summarize the British data, and point out that 'recent surveys have repeatedly demonstrated that museum visiting in the UK remains primarily a white upper/middle class pastime' (Eckstein and Feist, 1992: 77).

Schuster (this volume) usefully summarizes the data from several countries, including Britain, North America and Europe, and concludes that despite the fact that there are major differences between countries in the management, administration and funding of art galleries, audiences consist of a small highly educated wealthy upper/middle class élite. This he proposes rather ruefully as an essential aspect of art galleries, concluding that the institutional form itself necessarily entails this type of audience. He suggests that in order to achieve an audience with different characteristics an entirely new type of institutional form or a completely new type of public policy will be necessary.

Curators and directors of art galleries have had access to information about the nature of their public for some time. Some have also become aware that, short of changing the entire institutional form, modifications to the 'product' change the nature of the 'customer'. For example, at Leicester Museum and Art Gallery (the New Walk Museum), a policy to broaden the ethnic mix of local visitors led in the early 1980s to the establishment of a staff position with specific responsibilities to develop relevant collections and exhibitions. Over the years, exhibitions have been held that have targeted various sections of the local community. An art exhibition 'Caribbean Expressions in Britain' was mounted in conjunction with an exhibition about Caribbean history. The local Afro-Caribbean community made up a large part of the audience. An exhibition of Chinese jewellery attracted the Chinese community.

'Traditional Indian Arts of Gujarat' appealed to the Asian community in Leicester, many of whose families had come to Leicester from Gujarat, in north-west India, via Uganda (Smith, 1991). Relating the exhibitions to the interests of different audience segments of the local population in Leicester resulted in new audiences for the museum.

A further example expands this point and shows how this method of broadening audiences has been used strategically by one art museum.

Walsall Museum and Art Gallery held an exhibition exploring Sikh culture, history and religion from February to April 1992. Entitled 'Warm and Rich and Fearless', and originally curated by Bradford Art Galleries and Museums, this exhibition was taken as an opportunity to develop links with a section of the population of Walsall to whom the gallery had previously been irrelevant. It was decided to expand the skills of the gallery curators by appointing a Community Events Co-ordinator whose task was 'to promote the exhibition to local Sikh communities and to consult them regarding appropriate participative links; to translate their needs into creative projects which might include live performance, practical workshops, demonstrations, involvement in displays and interpretation; to be involved in the planning and implementation of these projects, to a given budget' (Walsall Museum and Art Gallery, 1992a).

This was a new way of working for the gallery, and has been described as 'one of the most exciting and rewarding ventures in which the staff have been involved' (Walsall Museum and Art Gallery, 1992b). Strong links were made with the Sikh community through the Events Co-ordinator, who was himself a Sikh able to speak Punjabi. The process was not without its difficulties, and success was largely achieved through the skills and knowledge of this temporary member of the gallery staff.

This project did not mean that the art museum was completely reinvented. The institutional form remained, with the exhibition looking much like any other. The methods for public programming were not in themselves very different from methods that museum educators have developed over the years. What was different was the specific targeting and the employment of an appropriate expert. Again this is not so very unusual – experts are often employed by art galleries to work with exhibitions. Usually these are collection experts. This expert, however, was an expert in the needs of the

target audience. Being able to speak Punjabi was a major advantage in building the links between the artefacts and the culture from which they had come. The exhibition was slightly modified and relevant public programming introduced through working with the agenda of the target group, negotiating their needs in relation to the possibilities and constraints of the museum.

Exhibitions over the last ten years at Leicester, Bradford, Kirklees, Walsall and in other places too, have demonstrated conclusively that people who are not regular visitors will visit art galleries if there is something there that they find of relevance. This is particularly the case if advisory groups drawn from the relevant communities have been established, as has been the case in Bradford and Leicester (Smith, 1991) and Walsall. The process of negotiation of interests and values itself partly creates the new audience.

As these examples demonstrate clearly, opening up the experience of the art gallery to specific cultural groups expands the nature of the audience. This has been achieved through accumulating relevant collections, by borrowing from other museums or members of the community on a temporary basis, and also by active collecting in the local area and in the relevant country of origin. In addition, as exhibitions and collections were developed, advice has been sought from the relevant community experts, short-term project workers have been appointed, and in some instances permanent advisory groups which meet on an annual basis have been established (Smith, 1991).

Targeting specific sections of the gallery audience has successfully enabled some art galleries to develop that section of the audience. That this success is not always noticeable in broad audience statistics is explained by the fact that these targeted exhibitions are generally temporary exhibitions, and if museums target different sections of the community from year to year, overall figures will be low. In addition, most statistics on museum and gallery audiences are necessarily drawn from the published reports of work generally carried out by governmental bodies or market research firms. These on the whole have tended to produce large-scale quantitative accounts that obscure detail at the local level. The paucity of research in the museum and gallery field ensures that there are very few written accounts of how specific exhibitions have been developed and new audiences recruited, and therefore few reports of innovative work that researchers can turn to. As a result, much

good practice is lost, barely recorded in the museum archives, let alone opened to critical interest, and the overall large-scale picture remains undisturbed. This does not serve the art museum world well. Until reports of the work are written and made readily available, museums and galleries will remain open to the charge of doing nothing to change their élitist image, in spite of the fact that some individual institutions have been working very hard to do so, with considerable success.

My examples so far have considered target groups drawn from a range of ethnic communities. Target groups can, however, be defined in a number of ways, and it should be recognized that most individuals will fall into more than one group. Groups can be identified in terms of life-stage, which would include families, school groups, young retired, elderly people; or level of educational achievement – beginning learners, some knowledge of the subject-matter, or scholars. Target groups should include those with special needs, with visual, physical, auditory or learning impairment, or with young children, or with elderly members in their party. Gender, class, race and religion are other dimensions that are useful. Demographics (age, gender, education) and psychographics (lifestyle characteristics) are both regularly used by market researchers outside museums and galleries to identify target groups for niche marketing.

The number of examples of exhibitions with specific target groups is growing very rapidly and, as they develop, good practice can be logged. In January and February 1994 at the Herbert Museum and Art Gallery, Coventry, an exhibition of nineteenth-century prints and drawings was set up in one gallery space with a target audience of Key Stage 2 children. With the English National Curriculum, Programmes of Study and Attainment Targets are structured according to four Key Stages: Key Stage 2 (KS2) consists of children aged 7–11 years. At the research stage of the exhibition, the material to be displayed was reviewed and selected with an eye to the National Curriculum documents, particularly in history and art, and teachers were interviewed as to how they could use the material with this age of student. The exhibition when mounted was divided into five themes – one displayed on each wall and one based on material in a display case in the middle of the room. A teachers' pack was prepared at the same time using the same themes: the division of the space and material meant that teachers could use the

room easily with five groups of children, who were expected to visit in class-groups of about 30. Material on a Coventry school was included to enable the children to think about what their peers would have experienced 100 years before (Adler, 1993).

The exhibition was of course open to other visitors who would have seen an exhibition looking remarkably like most other art gallery exhibitions – smallish prints and drawings on white walls, perhaps hung rather lower than usual. The only overtly unusual feature was a child-sized silhouette based on a photograph of a pupil from the 19th century school, who welcomed visitors to the gallery and whose face was repeated on additional labels. These (rather small) labels, which were placed next to the standard art gallery labels, used a very discreet text bubble to ask one question of each of the items on display.

During the running of the exhibition, a programme of visits to the schools that used the exhibition was carried out as an integral part of the exhibition plan. Teachers and children were interviewed, childrens' drawings and writings were examined, and other results of the visits to the gallery discussed. At the time of writing the results are not yet available, but such an evaluation provides a huge amount of material that demonstrates the way the gallery has been used. For funders and governing bodies, this represents the true value of the gallery.

This form of detailed audience-related planning enables accurate provision for researched needs, provides the information required for focused marketing, and enables the collection of qualitative data that demonstrates the use value of the institution. The development of an exhibition policy that considers which audiences will be targeted, how, when and how often audience research will be carried out, and what evaluation will be done, greatly assists the management of this process.

The concept of targeting has become built into the forward planning of museums and galleries (Ambrose and Runyard, 1991; Ambrose and Paine, 1993: 20–5). In many museums and galleries, the idea of 'the general public', or 'the museum visitor', as a large amorphous mass, has been replaced by the concept of target groups. The concept of target groups facilitates audience research into particular needs and actual interests. In addition it enables each exhibition to be reviewed in relation to the requirements of specific groups. The exhibition programme as a whole can be planned to

provide for the needs of different groups or communities over a period of time.

The introduction of qualitative research, including the notion of target groups, into museums and galleries has partly come about with the development of marketing in museums and galleries. In the past, many museums have carried out visitor surveys looking at how many people visited the museum or gallery, where they have come from, with what level of education, and so on. Government departments and other bodies such as tourist or leisure authorities have conducted participation studies among sample populations, looking at what percentage of a population visits museums how often (Hooper-Greenhill, 1994: ch. 3). Both of these forms of research tend to produce quantitative data in the form of statistics. Once the needs of a range of target groups are considered in relation to museum provision, a different focus for research becomes necessary. It becomes important to know what the experience means to people. How do visitors make sense out of their visit? How do they interpret the visit and what perceptions do they have of museums in general? Qualitative data, which reveals and illuminates attitudes and perceptions becomes necessary.

A museum that genuinely wants to provide a service that is relevant to its audience has to go even further than this, and ask those who do not at present visit museums what their perceptions are, and then has to consider how far either the perceptions, or the museum experience, can and should be changed.

Work in the area of qualitative research has begun in both Britain and the United States. In the United States the work of the Getty Centre for Education in the Arts (1991) has involved using focus group research methods with groups of non-visitors, first-time art gallery visitors and gallery staff. Focus groups are groups of people with similar characteristics who are gathered together with a trained researcher to discuss in an open and free-flowing way what they feel about a particular product, or, in this case, experience. The Getty research was a large-scale project, with profound and important results, involving 11 art museums across America. A market research company familiar with the leisure and heritage industry worked with the art museums to identify staff expectations and

assumptions about the museum visitor's experience. Public expectations and actual experiences were also analysed and compared with the expectation of museum staffs.

The project report contains a great deal of fascinating material which is very difficult to summarize. The museum participants in the project clearly enhanced their professional knowledge of visitors and the joys and problems of museum visiting. Major gaps between staff expectations and visitor experiences were manifested in relation to orientation, information and direction. Both repeat and first-time visitors wanted more support in deciding what to look at and in knowing what was significant about specific objects. More information about the events, activities and services that were available was felt to be needed, and many visitors, especially first-time visitors, found the buildings very confusing and intimidating (Getty Centre for Education in the Arts, 1991: 44–5).

Perhaps even more important than concrete findings such as these was the change of philosophy that the project engendered in the museum participants. Listening (through a two-way mirror) to visitors talking about their experiences in art museums, one director concluded that art museum priorities had shifted; the centrality of the object had been replaced by the centrality of the encounter, and that quality, once defined solely in terms of the object and connoisseurship, has come to refer also to the visitor's experience (Getty Centre for Education in the Arts, 1991: 111). Along with this has come the realization, at least for some participants, that directors of art museums had failed to take account of the visitor's experience, leaving this to the education department, while the main emphasis of the museum was concentrated on acquisition and care of collections. 'Acquisition and presentation [were seen] as the chief priorities of the museum, overshadowing education, appreciation and interpretation'. In a 'post-collecting' age, this had to change, with more of an emphasis on *using* rather than increasing collections (Getty Centre, 1991: 46).

This long-term, large-scale research project, with an excellent project report and accompanying video, demonstrates the commitment in some sections of the American art museum world to broadening audiences and to improving the experiences of visitors. It also demonstrates an availability of research funding which is rare elsewhere in the world.

A project also using qualitative research methods, in Britain,

illustrates a similar desire to expand the relevance of museums and galleries, but has been limited to one museum. The project grew out of individual convictions, and although an excellent report has been produced, it remains an internal management document and is not therefore easily available, except by writing to the museum.

The London Borough of Croydon appointed a curator in 1989 to open a new museum, based on small social history and art collections. The museum was to be part of a larger arts centre based around the library, and would open after five years. This lead-time has been crucial in the planning of the new museum, as it has enabled the curator and (gradually) her staff, to carry out considerable market research before the design of the museum was completed. The market research has in fact influenced the entire concept of the museum (MacDonald, forthcoming).

A market research firm was employed to investigate, by using focus groups, the perceptions held about museums by people who traditionally have rarely visited them (Susie Fisher Group, 1990). These groups were identified through demographic research, which clearly indicates which sections of the population tend not to visit. Researchers talked to Asian and black teenagers, elderly men, mothers with very young children, and other groups who are generally conspicuous by their absence in museums and galleries.

Among the barriers to museum visiting to emerge from the research were feelings that the arts and museums were irrelevant, 'too virtuous', that 'do-gooders' were the sort of people who went to museums, that you had to have specialist knowledge to understand the displays, that it would be a luxury, that other things were more important. The overall atmosphere of museums was felt to be one of 'keep off'. People believed that they would be physically uncomfortable, cold, on their feet all the time, peering to see depressing old relics whose significance could only be understood through a great deal of hard work deciphering complicated wordy explanations (Susie Fisher Group, 1990: 21–2). It was discovered that both museum visitors, and those who did not visit, thought all museums were quite boring, and that visitors went largely from a sense of duty.

From this early research, the plans for the new museum evolved. It has been decided not to use the word museum in order to avoid preconceptions. Displays will include ideas about the present and the future as well as the past. In order to represent sections of the community that are not represented in the existing social history

collections, new collections are being built up. Short-term contracts have employed an Irish and an Asian researcher, two cultural groups that have a strong presence in the local area. Members of the Chinese community have been consulted over the redisplay of the existing Chinese porcelain collection. Trial exhibitions have been held in the local shopping precinct, partly to experiment with modes of display and partly to meet and talk to people. In drawing up the budgets for the new museum, exhibition budgets will include a sum for evaluation. Audience research, including concept testing, will also be allowed for (MacDonald, forthcoming).

The introduction of market research methods into museums and galleries has provided methods that curators and directors can use to begin to get closer to their actual and potential audiences. By exploring attitudes and values and beginning to understand the problems that many people have with art galleries, it is becoming possible to modify the policy and resource priorities to enable a closer fit with the everyday world of both new and repeat visitors. When museums and galleries are seen as a normal part of the lives of ordinary people then the audience will consist of more than the élite.

IMPROVING DISPLAYS FOR VISITORS

The market research studies discussed above indicate that many people find that art (and other) museums have little relationship with their interests and experience. Most people lead fairly parochial lives and their interests centre round their families, their work, their hobbies. Essentially these interests are small-scale, domestic and personal. Museums that represent the world through large-scale universal themes do not speak to those people who do not experience the world in this way. Many non-visitors and rare visitors feel that museums have nothing to do with daily life (Merriman, 1991: 64).

It might be argued that it is a function of museums and galleries to offer the opportunity to transcend the everyday world and to forget the trials of the trivial. This *is* an important aspect of the museum experience, but visitors will find it difficult to achieve if feeling intimidated, not sufficiently knowledgeable and uncertain of how to behave. Educational psychology reminds us that we need to feel welcomed and comfortable before we can allow our mind to escape to higher realms and new learning.

Most art museum staff do not spend much time thinking about how the exhibitions can be made of relevance to people who know nothing of art. On the other hand, many non-art museums are beginning to find ways of linking their collections with everyday life. In Hull, in Yorkshire, for example, the new history gallery presents the history collections in relation to the life-stages of people rather than to a municipal history of Hull. Display themes are 'Childhood', 'Marriage', 'Death', rather than 'Eighteenth Century Hull', or 'The Development of Local Industries in Hull' (Frostick, 1991). A similar approach is taken in Birmingham to the redisplay of the ethnographic collection: themes such as 'Eating and Drinking', 'Making Music', and 'Symbols' are used in a cross-cultural approach (Peirson Jones, 1992). A similar ethnographic theme was used some years ago at the Museum of Popular Arts and Traditions in an exhibition entitled 'La France et La Table'.

Most themes used in art galleries are very predictable – the artist and his (sometimes her) work, an art historical school or period, a style. This type of approach requires the visitor or potential visitor to recognize and value significant artists, styles, art historical periods and schools. Why is it always seventeenth century Holland and nineteenth century France? The geography of art history is bizarre! Without the basic structuring of concepts that is informed by a knowledge of art history, the themes of many exhibitions are remote and incomprehensible. Theming according to everyday categories and classifications has been very successful with other types of collections. Would exhibitions of paintings on the themes of, say, 'Eating and Drinking', 'Making Music', 'Children', broaden the audience?

Exactly this approach has been taken at Walsall Art Gallery in the re-display of the Garman Ryan collection. Paintings and sculptures in this small but outstanding collection of work by artists such as Rembrandt, Picasso, Constable, Modigliani, have been grouped in themes of 'The Family', 'Work', 'Leisure', 'Children', 'Animals', 'Trees' and 'Birds'. Guides to the collection introduce a new set of themes – 'Working Women in the German Ryan Collection', 'A Guide to Clothing in the German Ryan Collection', and others all focus on specific ways of reading the collection that can relate to interests visitors might either already have, or might even develop in the gallery.

Efforts to relate collections to people are often scorned by art

curators, either (overtly stated) because they 'talk down' to people, or (actually meant) because these efforts to appeal to non-specialist visitors do not reveal the extensive expert knowledge of the art curator. These attitudes are no longer appropriate. Leaflets such as those described above open up ideas in relation to the objects, they make interesting connections between them, and they enable links to be discovered between what visitors already know and what they can find out. This is the real stuff of learning and engagement.

It is now generally recognized that people learn in a variety of ways; that there is a range of learning styles. Some people take in information best through reading; some through discussion; some through doing something actively and then thinking about the experience; some learn best through other people (Gardner, 1983; Hooper-Greenhill, 1994, 140–70). Different types of question are asked by different types of learner: these include 'why', 'how', and 'so what' questions. People typically process information best when able to learn in their own way. In many museums, therefore, a mix of types of learning opportunity is offered: looking and thinking; object-handling; interactive exhibits; demonstration; reconstructions; drama; film. Many non-art museums are developing ways to enable people to enter an active process of exploration and discovery that has the potential of becoming personally meaningful to them, recognizing that it is only when experiences are personally meaningful that they are truly valued. Most art museums limit the mode of learning to looking and reading, a physically passive yet intellectually demanding form of learning. People who are more comfortable learning in more active and concrete modes are disadvantaged.

Discovery centres which enable the handling and exploration of collections have become enormously popular, and some museums are integrating the potential for active engagement into their glass-case displays (Frostick, 1991). Some art museums have found ways of enabling handling and interaction with fine and decorative art collections. The Victoria and Albert Museum, for example, has placed two large Chinese jars in its new Tsui Gallery of Chinese Art. At the Museum of Civilisation in Québec an exhibition on the art and culture of Tunisia was supported by a small discovery room where perfume vessels could be handled and the perfume smelt, simple musical instruments could be played, music could be listened to, large leather cushions could be sat upon, a short film about

6 A visitor studies the decisions involved in preparing a Japanese breakfast tray, and makes choices as to which objects to use from the interesting selection provided. National Museums of Scotland travelling Japanese Discovery Room at the Horniman Museum, London. (Photo: Eilean Hooper-Greenhill)

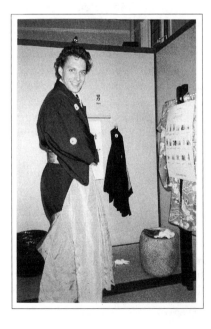

7 Following visual instructions, a young man experiments with getting dressed in traditional-style Japanese clothes. Appropriate clothes are provided for women to try on. National Museums of Scotland travelling Japanese Discovery Room at the Horniman Museum, London. (Photo: Eilean Hooper-Greenhill)

aspects of women's lives could be viewed. The extremely successful Discovery Room at the National Museum of Scotland has led to the development of a travelling Discovery Room with Japanese material, where visitors can set a table for breakfast, wrap presents, try on a kimono and so on (Statham, 1993) (see plates 6 and 7). Exhibitions specifically targeted at people with visual handicaps have been familiar in galleries in Britain for some years. These enable handling of art works, some of which have been specially commissioned (Nottingham, Leicester), and some of which have been chosen from the permanent collections (British Museum).

Exhibitions which enable the use of more than just the visual sense are always enormously popular. One of the great pleasures of working in museums and galleries is the very special opportunity to work very closely with objects of all sorts. Visitors enjoy this just as much as curators! The feeling of privilege in being able to get very close to real, old and rare things is very seductive, although little research has been carried out to explore precisely why. Ongoing evaluation research into learning from objects revealed that quite young children thought that looking at an object 'makes you feel more important than looking at a postcard' (Barnes, 1994).

Exhibitions which allow the play of the imagination and memory through enabling people to make personal links, and which enable the intellect to operate in its preferred way through offering a range of ways of accessing information will broaden the numbers and types of people that can enjoy art museums. This in itself, however, will not entice infrequent visitors to art museums. Effective marketing, interesting press coverage, outreach workshops and other methods must present the museum as a desirable and comfortable place to go.

WHOM ARE ART EXHIBITIONS AND MUSEUMS FOR?

A case-study shows some of the ways in which one art museum has researched the needs of visitor target groups and has created a new permanent gallery which takes account of the findings.

The Laing Art Gallery, Newcastle-upon-Tyne, is a traditionally imposing museum building with a classical façade. The gallery is funded by the local authority, and is a local art gallery in an important and historic regional city (Millard, 1992). The museum director, John Millard, and his staff were aware that the gallery was

seen as irrelevant and intimidating by very many local people. They set out to re-display some of the permanent collections in such as way as to change this perception. The permanent exhibition 'Art on Tyneside' opened in the summer of 1991. It aims to show aspects of the history of the fine and decorative arts on Tyneside since the sixteenth century.

The exhibition team included the education officer and a social historian as well as fine and decorative arts experts. The exhibition had two main target groups; school children aged 9–12, and people with disabilities. Experts such as teachers and disability advisers were consulted throughout the process of the development of the exhibition and specific provision is made for these groups. The exhibition team also wanted to avoid gender stereotypes.

The displays mix fine art objects such as paintings and prints with decorative art objects such as glass, furniture and ceramics. The display approach offers opportunities for a range of learning styles, and the use of many senses. Figures are used in reconstructed contexts like room-settings. There are opportunities for touching, such as scraps of silk and brocade next to a case showing an eighteenth century dress. Interactive devices enable active participation: for example a magnetic board with adhesive shapes based on the stylistic features of classical facades enables visitors to experiment with architectural design. Appeals to senses other than the visual are to be found with smells, such as the smell of coffee, and the sounds of the coffee-drinkers talking, in the coffee-house reconstruction.

Specific provision for people with disabilities is made. For people with visual impairment, provision includes a raised track, clear and raised room numbers, things to touch, non-reflective glass, tape guides and thermoforms (sculpted versions of a painting mounted on a bat). Subtitles on video screens and notes accompanying the displays help those with hearing impairment. The exhibition is accessible throughout for wheelchair users.

The other target group for the exhibition, children of primary school age, are provided for in a number of ways, which include the interactive and tactile devices; information provided especially for them in the form of cartoons, with two cartoon characters to follow through the exhibition; and very clever worksheets that take the user through the exhibition in role as either a craftsperson, an artist or an architect.

This exhibition has revitalized the gallery and given it a new and dynamic local presence. During the first two years after opening, the visitor numbers increased by 60 per cent, from 86,238 to 139,059 in 1992. Most of these visitors are local people. About a year after opening, a regional newspaper printed a guide to museums in the north-east of England with the Laing Art Gallery being the only museum to get a top score for its appeal to both adults and children (Millard, 1994).

'Art on Tyneside' represents one way of presenting art historical themes so that those without specialist knowledge can appreciate them. It is an introductory show, giving glimpses of classicism, eighteenth and nineteenth century silverwork, glass engraving, nineteenth century British painting, and so on. The methods used here include reconstructions, period rooms, and full-size figures. These methods are not appropriate for all types of art work, but can be particularly suitable when fine and decorative arts are combined. Other ways of making exhibitions that make no assumptions about the level of knowledge of the visitor should perhaps be developed for other types of collection. It is also useful to balance introductory shows with shows that demand more from visitors.

Interestingly, one of the very few negative responses to the exhibition has come from an art critic. The *Daily Telegraph* reported that the exhibition was a 'vile accretion';

> poor in design and vaccuous in content 'Art on Tyneside' proved to be the most abysmal museum installation I've ever encountered. But it was clear from the visitors' book that, with some sectors of the public, 'Art on Tyneside' has been popular. I suppose one must accept this. If some visitors are so unimaginative that they need such half-baked gimmicks to make history come alive, then by all means let them have them. But not in a museum. (Dorment, 1993; quoted in Millard, 1994)

The vehemence of the language is surprising, revealing a strong degree of scorn and distaste for the pleasure that the general public have found in paintings. The comments raise interesting and difficult questions for art galleries, the most important of which is whom do we make our exhibitions for? Non-specialist audiences or art critics? In many art museums the answer will most definitely be art critics. Many art exhibitions are mounted with a very sharply focused 'weather eye' on the reputation and career possibilities inherent in the exercise. This raises ethical and moral imperatives which are rarely discussed with the seriousness they demand.

Why are art exhibitions made? The main reason in many cases is a specific passion on the part of the curator. Often this relates to developing knowledge about an artist, an art form, an art movement. Clearly one of the most important roles for art museums is to explore and promote art of the past, the present and the future. Art museums have a responsibility to society to care for art and make it available through exhibitions, writing, and good scholarship. I would argue that they also have the challenge to introduce art to those who do not yet understand why they should be interested. In art museums such as those in Britain which are very largely funded out of the public purse, this becomes a social responsibility. In times of recession, it becomes a matter of survival.

At the present time, art museums serve a small well-informed audience that is relatively satisfied with what is on offer. This audience need not be compromised by making additional provision for new audiences that need more information, more introductory frameworks and more reasons for becoming involved with art.

The extent to which different galleries are willing or able to consider the interests and needs of new visitors will depend on a variety of matters, including the strength and vision of the director, the composition of the governing body, the level of the revenue budget, the philosophies of individual members of staff. Although there are examples of new ways of working in galleries, as we have seen, the older ways, which tend to exclude the vast majority of the population, have the power of inertia behind them. In addition, the lack of written project reports of good practice, and the failure to write up successful approaches to building links between galleries and communities means that much excellent work is completely unknown.

The development of an exhibition policy which is planned to take account of the characteristics of a range of target groups enables galleries to assess and resource their provision according to the needs and interests of their audiences. This has proved easier both to understand and to achieve in Britain in art galleries funded by local authorities, rather than in national art museums. At city or county level, institutions are smaller, and the links between the gallery and its audiences are perhaps easier to define and research than in a national gallery, where arguably the audience is both national and international. Local art galleries are very often part of a museum complex where new ideas can be shared between all

sections. The effectiveness of working with local communities in the social history museum, for example, may lead to the adaption of these techniques in the art gallery. It is also at local authority level that budget reduction has been felt most acutely. At the present time in Britain, while most national museums and galleries are flourishing, local museums and galleries need to demonstrate their relevance to local audiences in competition with other local amenities such as swimming pools, day-care for the elderly and nurseries. The on-going reorganization of the local authority structure across England and Wales poses a further threat for many local art galleries. Local galleries are seeking to strengthen their political positions by broadening the audience base, establishing strong links to named groups and centres, working in partnerships with a network of agencies, and improving professional practice through audience research and evaluation.

Although many things have changed for national museums and galleries in recent years, the size of the institutions, the arms' length management structure of trustees, and the much higher level of resources combined with much larger and more diffuse audiences means that national galleries can survive comfortably while asking fewer questions about the experiences or expectations of their audiences. Where innovation is to be identified in the national galleries, it is frequently in the outstations rather than in the central gallery.

In addition, national art galleries exist within a network of social relations where powerful interest groups are able to use their power, wealth and status to maintain their own class positions. Powerful sponsors, influential friends, critics that command large audiences – these and other factors create strong influences that work towards keeping art museums free and untainted by the 'hoi polloi', those 'unimaginative people' that need 'gimmicks to make history come alive', and which perhaps are needed to take the place of higher education, an elevated social status and specialist knowledge about art. Vision, courage and determination are required by those art museum staff who wish to jolt the forces that maintain this élite position onto a different and more democratic track.

There is in Britain a vast pool of interest in the arts. The Report of the National Inquiry into the Arts and the Community (1992) quoted a survey carried out on behalf of the Arts Council, and pointed out that 79 per cent of the population say that they attend

at least one type of arts or cultural event nowadays. In addition 53 per cent of the population of Great Britain take an active part in at least one arts or craft activity. Although 48 per cent visit all exhibition and museum venues on a regular basis, only 18 per cent visit galleries of painting and sculpture (RSGB, 1991). There is an extraordinarily large drop between participation in the arts in general and the visiting of galleries of fine art. This gap is created and sustained, perhaps unknowingly, by those who work to support the continuation of art exhibitions that ignore the needs of their publics.

Art galleries do not have to become completely new institutions to broaden their visitor profile. They need to develop empathy towards their audiences both actual and potential, increase their knowledge of what is recognized as contemporary good practice in exhibition design and, most important of all, they need to shift their resource and policy priorities from objects to people.

NOTE

1 This paper has been developed from 'Giving people what they want: quality or quantity in art museums?', a paper given at the conference 'Art Museums and the Price of Success', which was organized by Boekman Stichting, Amsterdam, Netherlands, 10–11 December 1992.

BIBLIOGRAPHY

Adler, C.P. (1993) 'Creating effective exhibitions', unpublished Master's thesis, Department of Museum Studies, University of Leicester.

Ambrose, T. and Paine, C. (1993) *Museum Basics*. Routledge, London and New York.

Ambrose, T., and Runyard, S. (eds) (1991) *Forward Planning: A Handbook of Business, Corporate and Development Planning for Museums and Galleries*, Routledge, London and New York.

Barnes, C. (1994) 'Evaluation project. Outline report one', unpublished research report, Museum Education Evaluation Project, Department of Museum Studies, University of Leicester.

Dorment, R. (1993) 'Are galleries losing art?' *Daily Telegraph*, 9 Sept., p. 14.

Eckstein, J. and Feist, A. (1992) 'Attendances at museums and galleries', *Cultural Trends 1991*, Policy Studies Institute, London, pp. 70–9.

Frostick, E. (1991) 'Worth a Hull lot more', *Museums Journal*, 91(2): 33–5.

Gardner, H. (1983) *Frames of Mind*, Paladin Books, London.

Getty Centre for Education in the Arts (1991) *Insights: Museums, Visitors, Attitudes, Expectations*, J. Paul Getty Museum, California, USA.

Hooper-Greenhill, E. (1985) 'Art gallery audiences and class constraints', *Bullet*, 5–8.

Hooper-Greenhill, E. (1994) *Museums and their Visitors*, Routledge, London.

MacDonald, S. (forthcoming) 'Changing our minds – planning a responsive museum service', in E. Hooper-Greenhill (ed.) *Museum: Media: Message*, Routledge, London.

Merriman, N. (1991) *Beyond the Glass Case*, Leicester University Press, Leicester.

Millard, J. (1992) 'Art history for all the family', *Museums Journal*, 92(2): 32–3.

Millard, J. (1994) 'Hands on art', *Museum Visitor*, 10, British Association of Friends of Museums, 49–54.

Peirson, Jones, J. (1992). 'The colonial legacy and the community: the Gallery 33 project', in I. Karp, C.M. Kreamer and S. Lavine (eds) *Museums and Communities: The Politics of Public Culture*. Smithsonian Institution Press, pp. 221–41.

Report of the National Inquiry into Arts and the Community (1992) *Arts and Communities*, Community Development Foundation Publications, London.

RSGB (1991) *Report on a Survey on Arts and Cultural Activities in G.B.: Research Surveys of Great Britain Omnibus Arts Survey*, Arts Council of Great Britain.

Smith, N.P. (1991) 'Exhibitions and audiences: catering for a pluralistic public', in G. Kavanagh (ed.) *Museum Languages: Objects and Texts*, Leicester University Press, Leicester, pp. 119–34.

Statham, R. (1993) 'Getting to grips with Japan', *Journal of Education in Museums*. 14: 8–10.

Susie Fisher Group (1990) *Bringing History and the Arts to a New Audience: Qualitative Research for the London Borough of Croydon*. Susie Fisher Group, London.

Walsall Museum and Art Gallery (1992a) Brief for Community Events Co-ordinator for 'Warm and Rich and Fearless', unpublished document.

Walsall Museum and Art Gallery (1992b) Evaluation report for 'Warm and Rich and Fearless', unpublished document.

7

Extending the Frame: Forging a New Partnership with the Public

DOUGLAS WORTS[1]

INTRODUCTION

It is not news to anyone that museums everywhere are suffering as a result of intense pressures that are changing the ways in which our cultural organizations operate. Serious staff layoffs, deep cuts in programming budgets and heightened expectations for relevant cultural programming are now part of everyday reality for virtually every museum professional. Clearly, some of the pressures we are feeling have their source outside the museum, largely in the form of scarce financial resources. By forging partnerships with corporations, schools, universities and other cultural organizations, museums can help to achieve economies of scale while maximizing their human and financial resources.

But not all of the forces of change within the museum world are based on the scarcity of money. There are also significant pressures being applied from within museums – pressures to bring about serious changes in the way we understand and carry out our institutional missions. Reform-minded museologists around the world are doing what they can to redirect museums towards becoming hubs of cultural activity that play a vital role in the living identity of their community. Many new partnerships are being formed between museums and other cultural groups within society with the goal of making museums more relevant for people. From my perspective, this more philosophical reason to forge new partnerships is at least as important as the economic-efficiency rationale. In this paper, I want to discuss a particular kind of partnership which can help museums to relate better to their communities – specifically, I will address the benefits of an honest and respectful partnership between museums and the public.

I will preface my remarks by saying that this period in the

evolution of museums is both extremely exciting and extremely frustrating. It is a time of great uncertainty, and great insight. This paradoxical aspect of professional museum life is unnerving, yet I believe strangely appropriate for the dramatic changes that we have yet to live through. If all of this is vague and abstract, I apologize – I will become concrete shortly – but I want to make clear that this paper reflects both my great hopes for important advances in the museum world, as well as my enormous frustration at the inertia that I often feel is working against positive change. Please keep in mind that I am optimistic – there are a lot of great advances occurring in our field. *Excellence and Equity: Education and the Public Dimension of Museums* (published by the American Association of Museums (AAM)); the Museum Assessment Program III: Public Dimension (which is a peer review programme sponsored by the AAM to help museums develop their public dimension in a forward-looking way); and the expanding interest in the theories and practice of 'ecomuseology' are three examples of significant forces within North American museums. But as our profession travels further down these various roads, I would not be surprised if museums look increasingly unmuseum-like – and that's OK.

Over the past decade, I have been involved in developing some non-traditional interpretive techniques in our museum. I and a small group of reform-minded individuals at the Art Gallery of Ontario (AGO) began using interactive labels, computers and audio in special 'education' exhibits almost 10 years ago. In concert with these initiatives we also developed a range of audience research techniques to improve our understanding of visitors and their reactions to both the traditional and the newer displays. Today, the whole institution is thinking more seriously about visitors and is attempting to relate to the public in sensitive ways. The AGO seems committed to both an expanded use of interpretive strategies in exhibitions and to an integration of audience research into planning processes. But now, more than ever, I feel the need for the Gallery to shift, in a fundamental way, the kind of relationship it has with the public – to become true partners with our visitors and to share authority over the experiences which happen in the galleries.

Museums have long been considered special places where the authoritative insights of trained experts are shared with members of the public. It is true that we as an institution have something unique to offer the public – the collections we amass and our

intellectual insights into the creativity of artists. However, to para-
phrase Picasso (and many other artists for that matter), in produc-
ing an art work, the artist carries the creative process *half* way – it
is the responsibility of the viewer to complete the process. This
visitor-centred half of the creative process is based on the per-
sonalizing of symbolic objects. This process is not prescriptive, so
institutions cannot control how the personalizing occurs. Museums
can, however, be supportive of visitors as they personalize their
experiences with the art works.

What does the visitor side of creativity look like? This creativity
is idiosyncratic – sometimes tentative, sometimes dogmatic; at times
it is intensely moving, other times shocking, while at other times it
is insightful. To this writer, visitor-based creativity provides a pow-
erful complement to the intellectual insights of the museum experts.
Accordingly, I submit that one of the core partnerships that needs
to be fully developed in museums (and particularly art museums) is
an honest and respectful relationship between the public and the
institutions – a partnership in which the many meanings of art can
be explored and honoured.

ABOUT THE ART GALLERY OF ONTARIO

As a backdrop to the visitor-generated material that will be dis-
cussed later, it is useful to provide an idea of the museum at which
I work. As a result of a recent expansion project completed in
January of 1993, the Art Gallery of Ontario (AGO) in Toronto is
now one of the ten largest art museums in North America. The
capital project occurred at the same time that the museum witnessed
the retirement of its Director of 30 years, the development of a new
strategic plan, massive organizational restructuring and the surfac-
ing of serious financial problems amidst a world-wide recession. In
light of all this, the new AGO has emerged in remarkably good
shape.

In describing its mission, the AGO uses all the right words – we
are educational, we build, conserve and research collections, we
even aim to meet the needs of our extremely multi-cultural popula-
tion. But the more of my life I spend at the Gallery, the more I
wonder what our mission actually means. I ask myself what insights
and knowledge we really have, and how that relates to visitor needs.
And, for that matter, how do we understand the needs of the public?

While we don't have the answers to such questions, I do feel that the Gallery is becoming more sensitive to the needs of visitors.

This most recent phase of the museum was designed, both externally and internally, to feel friendlier and more accessible to visitors. For example, the new building provides at-grade access, rather than the old entrance which required visitors to climb imposing stairs and cross over the moat-like, sunken driveway. The old building had a cold, white stucco facing, which has been replaced by warm, red brick. Passers-by are more effectively invited in, not only to visit the exhibits, but also to shop in one of the large retail spaces which make up most of the building's facade. It is hard to make a city-block-sized building approachable, but efforts are being made to do just that.

Once inside the building, after navigating through the somewhat austere entrance hall, visitors encounter an introductory exhibit that discusses the many meanings of art and which encourages visitors to explore their personal reactions to the works. This installation reflects the new general attitude of the museum regarding the visitor experience – that the personal perspective, whatever that may be, is important. The exhibit itself will benefit considerably from further planned development, but the general direction reflects a positive, new attitude towards visitors at the Art Gallery of Ontario.

All of the new and refurbished galleries were developed by teams of professionals, with curators, educators, designers and conservators making up the core teams. Wide-ranging discussions within these teams led to a new institutional commitment to creating exhibit spaces that are modulated in scale, colour and atmosphere, which is a major departure from the normally white-walled, scarce-seating, everything-looks-more-or-less-the-same kind of art gallery which the Art Gallery of Ontario has been in the past. So, we now have many types of spaces for visitors to explore: some exhibit halls are dramatically lit and intimate; the elegant old master galleries now have vibrantly coloured walls and comfortable seating; the contemporary galleries take a variety of forms, some large, others smaller, but with a traditional austerity to them (some things are hard to change); and many new spaces are intimate, domestically scaled rooms for lingering and exploring.

Seating has never been more abundant – even though we can always use more. And now, every gallery space offers at least some form of interpretive material, with some exhibits containing a wealth of materials for visitors to use. A new print and drawing

centre has opened which provides the public with access to any of the works on paper that are in the collection. Additionally, a new 'hands on' gallery has been built for visitors of all ages to explore many different creative processes, as well as aspects of the collection. All of this has led to high levels of satisfaction amongst our visitors.

ABOUT THE CANADIAN HISTORICAL GALLERIES

Much of the initiative for the progressive approach to the new AGO evolved from work done by the team responsible for the Canadian Historical Galleries. In 1988, this team of educators, curators and designers was the first such group in the Gallery to form a partnership that was dedicated to improving exhibition techniques, based on visitor experiences of the exhibits. As part of this undertaking, the team developed, for the first time, audience research projects dedicated to exploring the complexities and variations of visitor experiences in exhibits. Based on research results, many interpretive strategies, such as the use of computers, audio and interactive labels, were fully integrated into the displays, with the aim of supporting visitors in focusing on, enjoying and making sense of the displays. The results were very positive and have been summarized in several publications (Worts, 1990a; 1990b; 1991a; 1991b; 1991c).

In 1991, the Canadian Historical Collection team understood that most of its efforts at improving the visitor experience up to that point had been geared towards making it easier for people to be more focused with the art works and to help them to explore contextual or analytical issues related to the art. Still, the team wanted to improve the interpretive systems it had developed and extend its understanding of the nature of symbolic experiences with art works. One of the leading areas for the team to explore was how personal meanings related to viewing an art work – ones that do not necessarily fit into the critical framework for understanding objects – functioned in an art gallery setting.

With funds received from the Government of Canada, the Canadian Historical Collection team hired three consultants to assist in exploring three areas of psychology that were felt to be important to understanding how people make meaning with art works in museums. These areas were environmental psychology, cognitive

science and depth psychology. The team met regularly with the consultants for a period of about a year, working through a set of exhibit-related issues and strategies that was to become critical to how the new Canadian Historical Wing would be developed.

As for the Canadian Historical Collection galleries themselves, they developed as fifteen uniquely designed rooms that are varied in scale, colour and lighting. They range from the intimate to the grand, and virtually all spaces have seating. The purpose of this diversion from the art gallery tradition of white-walled spaces with even lighting is to keep the visitors' senses engaged so that museum fatigue does not set in. In addition, this approach offers the chance to use space to create something of an historically appropriate context for the art works.

All of the new galleries in this wing reflect our visitor-oriented philosophy that there are many meanings associated with a work of art. This approach is manifested in several ways. One is the use of binders in which questions are asked concerning, for example, the importance of an artist or his/her art work, and for which responses are provided from many different and often conflicting perspectives. By offering a range of plausible reactions to an issue, it is hoped that visitors will feel more comfortable that there is no 'right' answer. This tactic is supplemented with a request for visitors to reflect on what the art work(s) mean to them. 'Share Your Reaction' cards are dispensed in about two dozen locations throughout the Canadian Historical Wing for written and drawn responses to the exhibits. Additionally, audio programmes, computers, visible storage, wall signs and text panels have been added to the displays to encourage more focused exploration of the art works.

One of the biggest challenges in the reinstallation of the Canadian Historical Collection was deciding how to organize the overall hanging. Eventually the team decided on a chronological organization, but with four considerations:

1 Although the chronology would be evident, it would not dominate the interpretive strategy. Rather, the interpretive emphasis would be placed on local foci in each area (e.g. a specific theme, an artist, etc.), leaving the chronology as a backdrop;

2 No assumptions would be made about visitors having a clear association with any given period of Canada's history;

3 We would provide a visual sense of what life was like in
 Canada during these periods, using images from popular
 culture. These installations would be called 'Signposts';
 and,
4 That we would encourage visitors to relate the personal
 associations they had with the time periods, using 'Share
 Your Reaction' cards.

In this way, visitors would be able to keep track of where they were
in the chronology of the overall display, build/reaffirm/challenge
their sense of Canada's histories, relate the art works to the life of
Canada (or question the lack of any clear relationship), and bring
their own knowledge/associations to bear on the visiting experience.
All of these strategies were new dimensions in the AGO's way of
installing its permanent collections.

'SHARE YOUR REACTION' CARDS

One of the most interesting outcomes of the reinstalled galleries
relates to the use of the 'Share Your Reaction' cards. Over a period
of about nine months, approximately 12,000 cards were used – and
at least 5,000 of these were left in the drop-off bins in the galleries.
The cards have proved to be quite remarkable for their diversity of
form and content. We are finding that comments are not superficial
judgements, such as 'loved it' or 'hated it', which often characterize
comments books. Instead, the bulk of comments are personal and
reflective. Many provide insight into how visitors are interacting
with particular objects or groups of art works. Often there is great
sensitivity and intensity in the responses. A large number of visitors
who use the cards choose to draw imagery of one kind or another.
Some people copy pictures on display. Others adapt images on
display to their own creative ends. Still others will create wholly new
images, presumably inspired by their time in the gallery, or which
reflect what is on their mind at the moment. Often, people seem to
want to see themselves reflected, either literally or symbolically, in
their imagery – and in their writing for that matter. This has been
an important psychological phenomenon for Gallery staff to be-
come aware of – people want to see themselves reflected in their
visits to museums. This has the potential to affect dramatically the
way in which art displays are conceived and installed.

The following visitor responses (1–11) (see Plates 8–15) present some of the public's written and drawn responses to their experiences in the galleries, as reflected in the 'Share Your Reactions' cards. This idiosyncratic material provides a glimpse into a powerful area of creative meaning-making that is part of the potential of every visitor. It is most easily approached through a plate-by-plate description.

Response 1 (Plate 8): A copy of Lawren Harris's *Above Lake Superior* by a 14-year-old girl. The fine detail of this image suggests that the visitor had a deeper than average level of experience with the painting (research has indicated that visitors in the past spent an average of 7 seconds with paintings that they stopped to look at). Also, the detailed description of herself suggests that she felt quite comfortable during this experience.

Response 2 (Plate 9): A child's adaptation of Tom Thomson's painting *The West Wind*, in which she has replaced the central tree in the original painting with an image of herself. She declares that she wants to be an artist when she grows up.

Response 3 (Plate 10): An adaptation of a landscape by Arthur Lismer, *Sand Lake, Algoma*, in which the visitor has turned the original waves into 'sad fish'. This seems to be another clear instance in which the mood and identity of the visitor is projected into their reaction to the art. I feel it is important that the institution understand that this kind of experience exists and that it must be acknowledged and respected. Trying to 'teach' visitors about the historical dimensions of the Group of Seven would be largely pointless for visitors having this type of experience.

Response 4 (Plate 11): An image that bears no resemblance to any painting in the collection. It is a powerfully drawn image that seems to have come from the visitor's imagination. Being in the gallery seems to have inspired not only the image, but also the emotionally charged text which speaks of the Canadian landscape as the basis of the soul of the Canadian spirit.

Response 5 (Plate 12): An adaptation of a Lawren Harris painting in which the exquisitely drawn image has an additional element – a

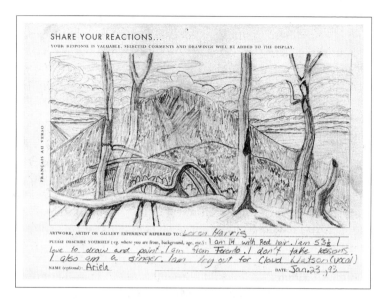

8 Reaction card: Copy of Lawren Harris's *Above Lake Superior* by a 14-year-old girl.

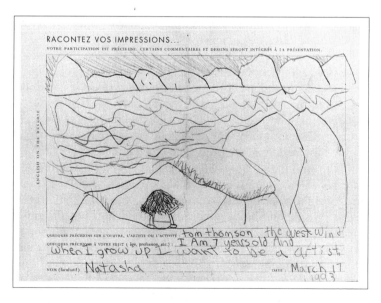

9 Reaction card: Adaptation of Tom Thomson's painting *The West Wind*.

stylized dead figure hung from the tree. It is hard to know what this means, but I feel the institution needs to understand that some visitors make very powerful, idiosyncratic meanings with the collection.

Response 6 (Plate 13): A visitor's reflection on a painting that depicts the town in which her grandmother was born. The experience has filled a gap in an important personal relationship.

Response 7 (Plate 14): A competently drawn image by a visitor during one of the AGO's free-admission evenings. The powerful imagery of the broken dollar sign and the derelict on the sidewalk is supplemented by a strong endorsement of the Gallery's commitment to providing at least limited free access to the collections. This is another strong image in which the visitor's own (symbolic) image is included in their reaction.

Response 8: A visitor wrote:

> I would like to know why in this entire Art Gallery, people of colour are not represented. I would like to see more art about the Indian culture and also art on the Black race. I am really disappointed that in a city where we are so multicultural, only European cultures are seen in the art gallery. I would not bring my child here, because we are not represented. We are not recognized for any of our talents – I am a black woman, who is a Canadian (born).

This critical attack on the institution results from this visitor not seeing herself or her race reflected in the exhibitions. She forcefully raises an issue that the institution needs to address if it really wants to be an art gallery for the people of Ontario. She makes it clear that there is a problem, and that the solution must be negotiated between the public and the institution.

Response 9 (Plate 15): A graphic image of 'shit' on a large dollar sign is one persons's way of questioning the value of contemporary art. The card shows clearly that at least some visitors are mystified about the function of such art, and are angry that museums do so little to rectify the problem. Comments like this, which challenge the museum to bridge the communication gap between contemporary art and the public, are common in art museums. But the visceral

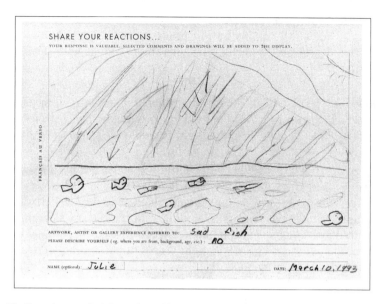

10 Reaction card: Adaptation of landscape by Arthur Lismer.

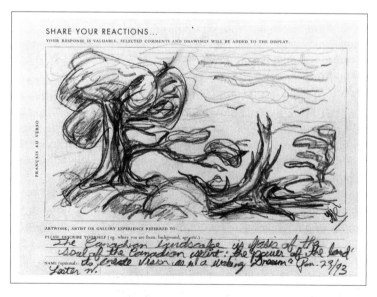

11 Reaction card: Image of Canadian landscape.

and judgmental tone of the card, coupled with its non-specificity, suggests that the problem itself is serious and wide-spread, yet not clearly understood or articulated. Perhaps the dilemma springs from people not being able to see themselves reflected in contemporary art – either through the experience of recognizable collective symbols in the works, or through the evocation of personal meanings. In any case, the museum must take more responsibility for this problem than it has in the past.

Response 10: A visitor wrote:

> For me, the most evocative painting in the AGO is the *West Wind*. I come to see it regularly because I am immediately transported back to my childhood and early teens and the pleasures of childhood summer holidays on the shores of Georgian Bay. All the paintings in the Group of Seven speak to me of my Canadianism, but it is the *West Wind* that speaks to my heart – I am 64 years old and live in London, Ontario.

This reflection on Tom Thomson's painting *The West Wind* shows how one visitor differentiates identity-related meanings associated with Group of Seven paintings. Most of the paintings speak to his/her sense of nationalism, but *The West Wind* evokes special memories from youth and is associated with the personal 'heart'.

Response 11: A visitor wrote:

> The 'new' galleries are a tremendous improvement over the old. Coming here is now an engaging and intimate experience. One feels able to concentrate more clearly on works of art or particular periods without feeling overwhelmed or alienated. Coming here is now a joyous experience, whereas before it felt like a duty! Thank you. – I am an illustrator and painter, living in Toronto.

For those who worked on developing these exhibits, this reaction is very satisfying.

The range of responses is quite remarkable – and they display a kind of personal insight into the art experience that the Gallery itself could not articulate. For me, these images and comments need to be seen by the Gallery, so it can learn more about the felt power of the objects in our collections, but these reactions also deserve to be integrated into the interpretive strategy of the exhibits themselves

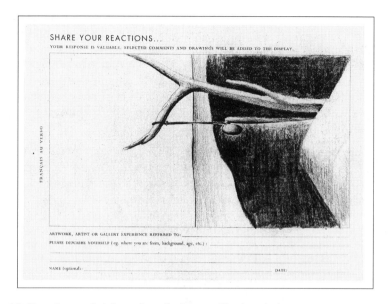

12 Reaction card: Adaptation of a Lawren Harris painting.

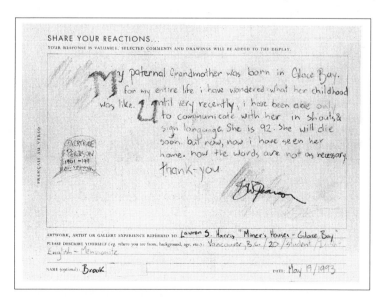

13 Reaction card: Visitor's reflection of a painting depicting her
 grandmother's birthplace.

and experienced empathically by other visitors. One possible out-
come of such an integration is that other visitors may find greater
comfort in entering the realm of personal meaning-making in a
more conscious way.

One particularly exciting installation, called 'Explore a Painting in
Depth', models different ways of engaging with an art work – from
examining relevant contextual information, to consulting an expert,
to eliciting personal and idiosyncratic meanings with the aid of the
imagination. This installation contains a single picture by J.E.H.
MacDonald, entitled *The Beaver Dam* (1919). The painting is of a
wilderness setting with the following components: a still pond to the
left, an arcing beaver dam with an empty canoe pulled up it to the
right of centre, rushing water in the right foreground, a boulder with
latent anthropomorphic characteristics located behind the rushing
water, and a backdrop to the entire scene of a dense forest that
pushes its way up to the edge of the rocky shore. In many ways, this
picture is quite typical of the Canadian landscape paintings that
make up this entire area of the Gallery.

The 'Explore a Painting in Depth' viewing facility consists of a
seating unit, with sound-proofing material on three sides, and the
painting, located directly in front of the seats and surrounded by
three walls. Through this design, visual and auditory distractions
coming from nearby exhibit areas are minimized. By using the
headsets and CD technology provided, visitors can choose to listen
to three audio programmes while they focus their attention on the
painting. One programme carries the curator's engaging insights into
the art work. A second provides several dramatized comments about
the artist, by friends and family of MacDonald. The third, which is
the most innovative technique currently in use at the Gallery, is a
reflective imaging exercise that leads visitors into a reverie with the
painting – encouraging their imaginations to create highly personal
links with the painting. In it, the 12-minute recording encourages the
viewer to relax and enter into a semi-dream-state with the picture.
The first task is to establish a strong mental image of the painting.
Then the viewer is invited to enter imaginatively into the space of the
picture and to experience the sights, sounds, smells and potential of
being in the setting. The wide range of response cards filled out in

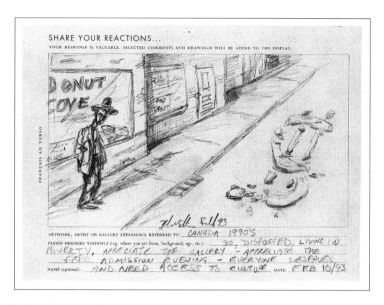

14 Reaction card: Visitor's reflection on poverty and free access to collections.

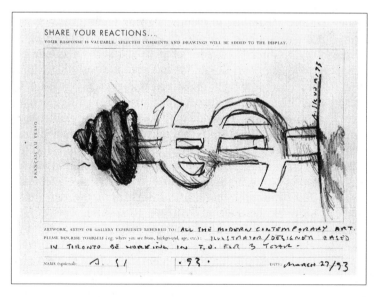

15 Reaction card: Graphic image of 'shit' on a dollar sign.

this facility has proved to be a very rich resource that provides many insights into the viewing process, the painting and the visitors. Responses 12–22 illustrate a range of creative visitor experiences relating to this picture.

Response 12: A visitor wrote:

> I enjoyed the sensual journey into the painting. Sight, smell, cool/cold autumn day was evoked. Clear air and water. Loneliness – the empty canoe vaguely depressing. The suggestion(s) of human form in the rocks and sticks of the dam add another dimension of questioning the artist's interpretation of the scene. Thank you for making me enter the world of the Canadian north! – I am 56 years old, WMF, from USA, some art training.

This response demonstrates how some visitors use their imaginations to enter the world of the painting and create personal meanings for themselves. Many users of this facility experience the smells, sounds and textures of nature, as well as other powerful associations with the image.

Response 13: A visitor wrote:

> I hate to be negative, because on the whole the new gallery is wonderful. But program #1, female voice, The Beaver Dam exploration is very silly. I was hoping to hear about art – and maybe the other selections cover this – but this heely-feely approach to art is just a bit much! Less new age, more content, please.

Not everyone likes the imaginative approach to viewing artworks – or at least not the approach taken here. This visitor is expressing a desire for 'content', as presented by the experts in the institution. By referring to the tape as 'heely-feely' the visitor is clearly dismissive of the subjective approach in this programme. A certain portion of our audience has difficulty with, and perhaps even feels threatened by, a non-analytical approach. However, a significant portion of the audience feels very good about making personal connections with art works.

Response 14 (Plate 16): A common theme in animating the imagination of visitors is the projection of the self into the response. In this case, a child has entered the picture, hopped into the canoe and gone

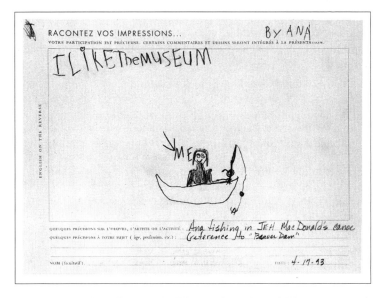

16 Reaction card: Projection of self into a picture by a child.

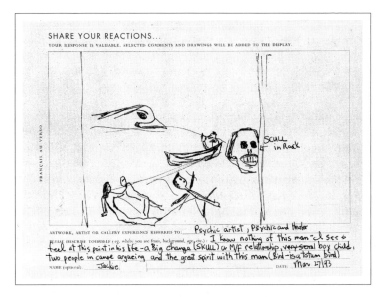

17 Reaction card: Response of a self-proclaimed 'psychic artist'.

fishing. She also declares 'I like the museum'. She has concretized the experience in a way that hopefully will remain memorable.

Response 15: A visitor wrote:

> Vivid colours and bold strokes bring out the relentless cycle of life, emphasizing destruction and at the same time, rebirth. The piece brought back a stream of memories relating back to a near-death experience I had while in Algonquin Park, along with the soothing sounds and smells associated with nature. I am 17 years old and am a student from Unionville High School. I am originally from Pakistan and have lived in Toronto for 7 years to date.

Through the imagination, this visitor has both re-experienced aspects of a 'near-death experience' he had had in a northern Ontario park, while reflecting on the natural cycles of life and death.

Response 16 (Plate 17): A self-proclaimed 'psychic artist' has interpreted the picture in what seems to be a very personal way. Most interesting though, is the fact that all of the themes and images raised by this person recur frequently in the reflections of other visitors (such as the rock on the right which has become a skull image).

Response 17 (Plate 18): A visitor who describes him/herself as 'intellectual-type, creative' experienced a transformation of this painting, from an image that was enjoyable to one that is off-putting. The imagination led him/her to see sinister images of death, which is what the viewer responded negatively to. This strong reaction is intensely personal and testifies to the transformative power of the imagination.

Response 18 (Plate 19): A variation on the death-imagery evoked by the painting (see the two responses above), is reflected in a different interpretation of the rock on the right of the canvas. Here, the rock becomes a forest god, symbolizing nature as a holistic force – yes, it has death and decay as an aspect of life, but with a powerful and counterbalancing will to survive. This interpretation of the painting recurs frequently in many idiosyncratic forms.

Response 19 (Plate 20): This visitor entered into the world of the painting, took up an imagined vantagepoint and drew the scene

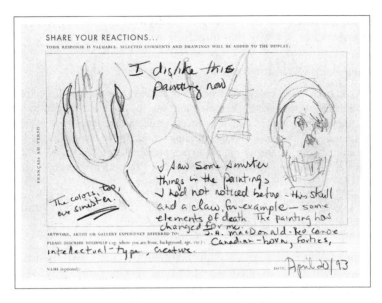

18 Reaction card: Response stressing images of death.

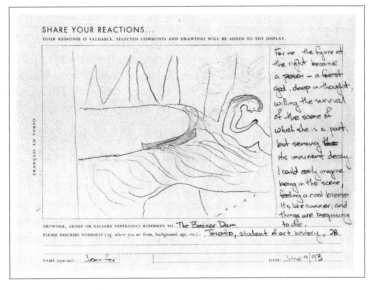

19 Reaction card: Perspective on death imagery.

from the new perspective. She wrote of her experience, 'I'm in the woods behind the rock, (I) climbed up and am looking down. Fresh Wondrous.'

Response 20: A visitor wrote:

> My daughter and I both listened to the 12 minute female commentary about MacDonald's *The Beaver Dam.* By totally focussing on the painting, we were amazed at the mysterious shapes, movements, and colour patterns in the work. It was a thoroughly enjoyable experience, and a unique one for me – a student of Art History (a while ago!). ART = VIOLENCE, RELEASED AND UNDAMAGING. I am a female, 45, originally from Toronto, living in the Ottawa area since 1972. I am with my 14 year old daughter.

A mother and daughter used the facility together. It led to the mother writing about her own sense of intense involvement in the painting, and the enjoyable discussion she had afterwards with her daughter. This woman also felt moved to offer up a reflection on the meaning of art.

Response 21 (Plate 21): Many visitors, like this one, began with the opinion that the painting was boring. Through the intense looking that is encouraged by the programme, this person's judgement was transformed and she ended the experience feeling buoyant and energized.

Response 22: A visitor wrote:

> How do we learn to love our land, our landscape, our country? Not by patriotic harangues by groups and politicians – but by living in it, watching and observing it, and then taking the time to reflect, ponder and integrate. Thank you, AGO for giving me a few minutes of serenity and intense viewing – making me Look and Think! Making me love my land more than I know! I am a bartender in small town Ontario.

One visitor's experience of *The Beaver Dam* led him to reflect about the importance of personal experience (as opposed to 'patriotic harangues by groups and politicians') in developing a sense of identification with a homeland.

All of these cards demonstrate to me how powerful and creative personal meaning-making is in the viewing of art. It is something that we in institutions have not actively encouraged before – in fact, museums have effectively undercut the public in this regard through

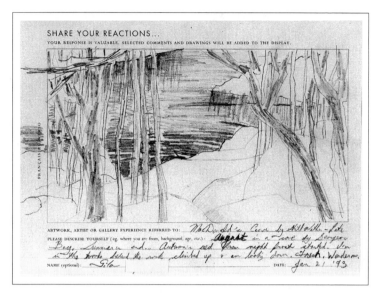

20 Reaction card: Response stressing personal involvement in a painting.

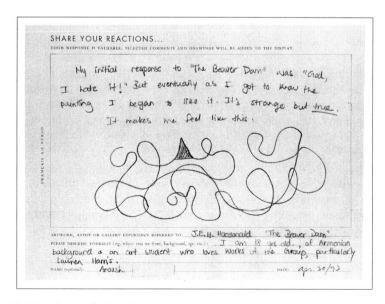

21 Reaction card: Transformation from boredom to interest.

their emphasis on objective judgements by staff 'experts'. Yet clearly the public can provide new insights into the art works.

CONTEMPORARY ART – AN ONGOING PROBLEM

I believe that our institutions can learn a great deal from the so-called 'idiosyncratic' responses of visitors. When people engage their own subconscious, a process of personal creativity begins. Within museums, this process can extend the meanings offered up by the experts in very exciting ways. Perhaps museums need to acknowledge that a major dimension of meaning-making, one that is complementary to the institutional perspective, can be found within the public's own creative responses to the art. And there is a missing complement to our perspective on art – the art of the twentieth century has made that painfully clear. One need only spend some time in the contemporary galleries of any art museum to experience this reality.

I don't think that anybody reading this would argue that the art of the twentieth century frequently leaves visitors feeling hostile and frustrated – and museum visitors are amongst the most educated people in our society. Yet our institutional arguments in defence of particular contemporary art works often feel to the public more like empty rationalizations for what they see as a sham. From my years of teaching in the galleries, I know how hard it is to talk convincingly about certain types of art. Part of the problem with contemporary art, I believe, is the absence of collective meanings associated with many of the images. Much of the art work created in recent decades flies in the face of public expectations for the comprehensibility, beauty and quality traditionally associated with the fine arts – there appears to be no collective symbolic language for people to follow. From the non-insider's viewpoint, if there is a knowable language of art, it seems like a remote phenomenon that must: (i) be acquired through academic degrees in art history, (ii) sound like 'artspeak', and (iii) remain rather unconvincing. Further, most of what experts have to say about contemporary art is extremely intellectual in tone and often does not address the art work itself, but rather its context. Many visitors experience this scenario as an impossible hurdle within the framework of a museum visit. It may be that one solution to this seemingly unbridgeable gap between visitor and museum is respectfully to invite visitors to engage the

works idiosyncratically, to reflect on their personal reactions and to share these reactions with the museum and with other members of the public. Adding the personal dimension of meaning-making to the museum experience, as a complement to the expert vantage-point (hopefully expressed in clear, direct language), may provide another model of how one might relate to an art work at the same time as it may deliver many new insights.

A case in point is one reaction to *Fleeting Breath*, painted by Jock MacDonald in 1959 and now in the AGO collection. Several months ago, I received a 'Share Your Reaction' card from a visitor that has strengthened my resolve to integrate personal meaning-making processes formally into the interpretive strategy of the museum. In this card, a woman wrote about her powerful and personal response to this 1959 Canadian abstract painting. In my many years in this profession, I have never heard any convincing insights into this painting. I have heard and read several art histor-ical tidbits: that it represented part of the Canadian version of the New York School of abstraction; that it was a coming-of-age of Canadian art; that it represented a rejection of naturalistic depic-tions of the world in favour of the embodiment of the inner creativ-ity of the artist, and so on. All of this is fine, and perhaps there is even a fascinating side to the artistic context of the 1950s, but none of it means much if there is no personal connection with the art work. The woman's idiosyncratic associations with the picture provide a vivid example of how the personalizing of an art object can bring it to life in a very powerful way:

Jock MacDonald's 'Fleeting Breath' (which suggests a hand emerging from rubble – or fragmentation as the essential quality of the 20th century) reminds me that my father built a bomb shelter when I was 12 – in 1956 – in our 1920s double-brick home on tree-lined Park Avenue. The street was valued for its streetlights that still looked like gas lights. My father felt a little silly, but wanted more to keep his family of four children safe: he returned from navigating for the RAF in WW2, cramped in metal surround-ings on 16 hour flights, coastal reconnaissance along the Baltic. He returned, but nothing since matches the terror and heightened emotion of WW2. In the 50s, I grew up on war stories, and occasionally went down and stood in the shelter: raw, smooth, concrete, with a maze-like entrance. He never bothered to stock it. There was a wild pink lady's slipper that came up, tiny, every spring in our backyard. I would rather die above, with 'fleeting breath', than go alive below. That's what it was like, and it was never simple.

We, as an institution, cannot fabricate this powerful form of personalized experience. If museums decide that there is merit in integrating the many meanings that individuals experience with art works into the collective wisdom relating to our collections, as I believe we should, then our organizations will have to renegotiate the authority structures relating to the meanings of culturally significant objects. Such a step will demand that effective partnerships be formed with the public.

PROPOSING A NEW FRAMEWORK FOR MUSEUM OPERATIONS

Part of the reform that museums need to undergo is to reassess and re-express their core mission regarding public service. In my view, such a new mission might be:

> to relate to the public, through intellectual and symbolic experiences with art objects, in a way which meaningfully reflects/mirrors the cultural identity of a community and which supports individuals in affirming and evolving their personal identity.

With such a mission, museums could thoroughly re-examine and rebalance the ways in which they currently function in society. They could also begin to explore and articulate the full potential of what public service might imply and possibly achieve. If the emphasis is on relating to the public, rather than informing them, then the operations become more organic and acquire a growth potential.

With such an orientation to the public, museums could expand their functions beyond the current emphasis on exhibitions in the galleries and embrace more fully other modes of communication. Exhibitions of objects and information will continue to be one vehicle within which a productive dialogue with the public could take place. Innovative approaches to publications is another. Television is a third, event programmes is a fourth and computer-based media is a fifth. Whichever vehicles are chosen to realize the mission of the museum, there are three basic components of any communication strategy that need to be taken into consideration (see Fig. 7.1).

Many museums are working hard at addressing two of the components of the communication strategy suggested here – contextual information and institutional valuation. New approaches to writing supporting information with a view to clarity and relevance – and sometimes presenting the information in a number of 'voices' – is exciting. But for me, the most radical and most exciting challenge

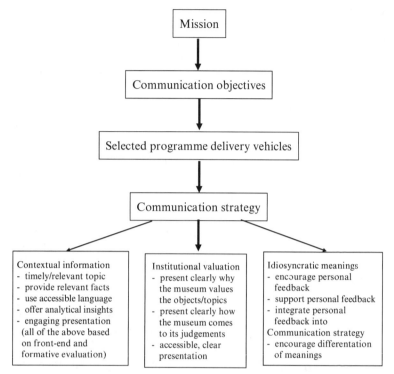

Figure 7.1 A revised museum communication strategy.

lies in the open integration of idiosyncratic meanings into the process of meaning-making.

As part of this proposed framework for museum operations, I would like to offer up a conceptual model of the visitor experience (see Fig. 7.2). The emphasis in this model is on the individual and the many processes and products of experience that happen during interactions with objects, people and places. Here, five processes of interaction mediate between the individual and the world in which that person lives (and all of these processes have both conscious and unconscious aspects). Cognition, emotion, imagination, intuition and physical interactions all contribute to the experience of an individual's sense of identity – either by affirming an existing sense of self, or by providing an impetus for an evolving sense of self. This identity is generally reflected in one's knowledge, beliefs, taste and skills.

Identity is a very complex notion, particularly because it involves

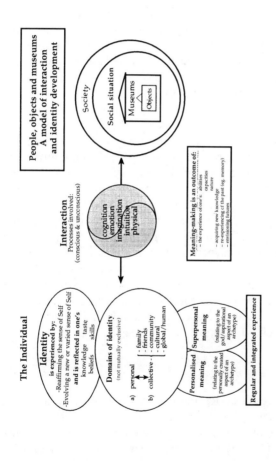

Figure 7.2 Conceptual model of museum experience.

both conscious and unconscious aspects. However, for my purposes here, the concept has been broken down into two general categories, which are not mutually exclusive – that of one's personal identity, or the sense of distinctiveness; and that of one's sense of belonging to a collective identity, such as a family, community or culture. Experiences of cultural objects can set in motion symbolic and literal experiences that can reinforce, undermine or develop one's sense of identity.

This model implies that museums have traditionally honoured certain types of meaning-making processes with museum objects, but have largely ignored others, which are equally important. One hypothesis here is that museums have created an imbalance in how the public experiences symbolic objects and that this imbalance needs to be corrected. Specifically, most museums seem to focus their attention on rare and unusual objects in order to spotlight the extraordinary, superpersonal aspects of human experience. It is assumed that an inspired painting by Van Gogh, for example, is a source of an archetypal experience of nature or humanity. Yet the success of a Van Gogh painting depends on the particular way in which a viewer experiences it – and there is a great range of powerful responses to such art works. The painting must be experienced as something both outside the individual, but also within that person. I have come to think that museums generally encourage visitors to defer any personal, idiosyncratic meaning-making processes to the meanings that conform to the expert consensus (which is itself something of a myth). By encouraging people to experience objects with all of their perceptual capabilities (cognition, emotion, imagination, intuition and physical interaction) the museum can become a much richer forum for the showcasing of living cultures.

CONCLUSION

All of the 'Share Your Reaction' cards demonstrate to me how much creative energy exists within the public – it is a powerful energy that has many faces – unpredictable, moving, insightful. Even when visitor reactions seem elusive and idiosyncratic, it is possible to relate to them empathetically, and I believe it enriches everyone's experiences when we do so. As a cultural institution, museums do have a great deal to offer – insights based on research – and we need to share our insights as effectively as possible. But,

museums have limitations. They cannot experience art works creatively, but rather must rely on the public for this function.

For me, museums in future years will include a new form of partnership with the public – where the many ways of meaning-making are encouraged, supported and respected. I imagine that museums will become places that more effectively present information which interacts with visitor imagination and emotional responses – and which in turn blend with social dynamics. The result will be museums that function more as places of a living culture. If the museum is truly the place of the muses, then museum professionals must realize that the physical and intellectual aspects of our current operations must function more symbolically as triggers that support visitors in activating the muses within all of us. It is this inner space that, in my view, is the real museum.

NOTE

1 This article has evolved from two presentations given in 1993, one at the Museum Education Association of Australia Biennial Conference in Melbourne, the second at the Visitor Studies Association Conference in Albuquerque, New Mexico.

BIBLIOGRAPHY

American Association of Museums (1990) *Excellence and Equity: Education and the Public Dimension of Museums* (Washington, DC: American Association of Museums).

Worts, D. (1990a) 'Computer as catalyst: experiences at the Art Gallery of Ontario', *ILVS Review*, vol. 1, no. 2: 91–108.

Worts, D. (1990b) 'Enhancing exhibitions: experimenting with visitor-centred experiences at the Art Gallery of Ontario', *Visitor Studies: Theory, Research and Practice, Volume 3* (Jacksonville, AL: Centre for Social Design), pp. 203–13.

Worts, D. (1991a) 'Visitor-centred experiences' in A. Benefield, S. Bitgood, and H. Shettel (eds) *Visitor Studies: Theory, Research and Practice, Volume 4* (Jacksonville, AL: Centre for Social Design), pp. 156–61.

Worts, D. (1991b) 'In search of meaning: "Reflective practice" and museums', *Museum Quarterly: Journal of the Ontario Museum Association*, Fall: 9–20.

Worts, D. (1991c) 'The Art Gallery of Ontario's search of the muse', *ILVS Review*, Spring: 109–11.

8

Revolutionary 'Vandalism' and the Birth of the Museum: The Effects of a Representation of Modern Cultural Terror

DOMINIQUE POULOT

INTRODUCTION

The post-Thermidor period and the Directoire were responsible for the development of what Louis Bergeron described as 'a bourgeois version of Plato's Republic'. It began when the wave of vandalism finally subsided and the way was once again clear for talent. In April 1795, Daunou reminded the Convention that

> the Terror had condemned the arts to an extremely rapid [process of] decline. A long tradition of knowledge and learning was being broken, morals were being corrupted and taste was changing with changing standards of behaviour. Talent was either outlawed or regarded with suspicion and paralysed by inaction, poverty or imprisonment, while genius was the greatest of all crimes and its works and any claim to glory were solemn indictments.[1]

Revolutionary 'vandalism' thus appears as a *scandal*, firstly in the sense of the Greek word *skandalon*, a stumbling block which balks attempts at explanation, but also a 'touchstone' for social values (de Dampierre, 1954). Any scandal, in the sociological sense of the term, in fact reveals 'the existence of generally accepted values within a social group, (. . .) moral values in the strict sense of the word, i.e. which relate to a personal code of ethics or, more generally, basic attitudes'. From this point of view, the account of an act of vandalism falls within a logic of denunciation and accompanies a political and cultural programme designed to protect the civilized world against barbarism.

THE INVENTION OF 'VANDALISM'

By demonstrating that 'before the word *vandalism* was invented, the term *Goths and Vandals* was already being used to denounce the destruction of works of art', Gabriele Spigath (1980) to some extent illustrated the aphorism of Karl Kraus: 'the closer one looks at a word, the further back it goes'.[2]

In the eyes of posterity, however, the Abbé Grégoire[3] remains the inventor of the word. His *Rapport sur les inscriptions des monuments publics*, presented to the Convention on 22 Nivôse in the year II (11 January 1794), uses the term to establish the framework and tenor of his argument:

> One cannot inspire in citizens too much revulsion for these acts of *vandalism* bent solely on destruction (. . .) Ancient monuments are another form of commemorative medal, they must be preserved in their entirety; and what sane person would not shudder at the mere thought of taking a hammer to the monuments of Orange and Nîmes?

Mediaeval and modern monuments 'often supplement archives through the events they represent; they determine periods of history: to destroy them would be a great loss'(p. 9).

From the very early stages, the phenomenon was attributed to a counter-Revolutionary plot. On 6 June 1793, Lakanal described it as a series of 'crimes by the aristocracy'. During the session of the Convention held on 26 October 1793, Romme reiterated the view that 'the cowardly oppressors of the English nation want to destroy the monuments that bear witness to the superiority of our arts'. There was a constant suspicion that acts of ignorance were instigated by some hidden agency: 'Near Arles are the remains of a Roman amphitheatre. Certain ignorant people, possibly at the instigation of foreign barbarians, have suggested demolishing them to extract the saltpetre'.[4]

Thus, only ignorance or crime, the one possibly manipulating the other, could explain acts in which the Revolution – the propagator of the Enlightenment – could not possibly have been involved. The adaptability of the reasoning was virtually endless and even the banal greed of those who acquired national treasures could be seen as part of a conspiracy (see Furet, 1978). In reality, since it was inconceivable that 'innocent' obstacles could be placed in the way of the government of the general will, vandalism must necessarily prove to be the result of malicious interventions (Pitt, Catherine . . .).

On 15 July 1794, Grégoire – who had denounced the same acts to the Convention on several occasions – and Fourcroy were given the task of 'collecting facts and preparing a report'.[5] This first *Rapport sur les destructions opérées par le vandalisme, et sur les moyens de le réprimer* (which considered the destruction perpetrated by vandalism and the means of repressing it) concluded, in accordance with the conspiracy theory, that 'the policy of our enemies has always been (. . .) to commit and instigate crimes for the sheer pleasure of imputing them to us, treating us as barbarians who refused sanctuary to the arts.'

Grégoire goes further, however, attacking the anti-intellectualism of a significant proportion of the Revolutionary élite and developing a defence of the arts. He even suggests 'engraving on all monuments and in all hearts: barbarians and slaves hate the sciences and destroy the monuments of the arts; *free men love and preserve them*' (p. 27). Finally his confidence went as far as to envisage teaching the counter-example: 'the conservation of beautifully executed monuments, ordered by the law of 3 Frimaire, can simultaneously inspire genius and strengthen the hatred of tyranny' (p. 11).

The report was gradually distributed, probably due in part to the network of popular societies which relayed information to the French provinces. When the Commission was, in turn, suspected of vandalism (because of its Robespierrist origins), it redoubled its efforts, invoking a veritable inventory of destruction in the provinces. It was against this background that Grégoire wrote the *Second Rapport*, presented on 8 Brumaire in the year III (29 October 1794), in which he promised to present a monthly report to the Convention on the work of the Comité d'Instruction Publique on the conservation of monuments. In particular, he drew up an educational programme:

> In this statue, which is a work of art, the ignorant see only a piece of crafted stone; let us show them that this piece of marble breathes, that this canvas is alive, and that this book is an arsenal with which to defend their rights. The more enlightened and virtuous a nation, the less extensive its code. (p. 10)

The *Troisième Rapport sur le vandalisme*, presented on 24 Frimaire in the year III (14 December 1794), reiterated these convictions which were deeply rooted in 'a sense of what is beautiful

and good' and were naturally linked to 'uprightness and honesty' (p. 21). As the reports were published, there was a corresponding and significant increase in the *corpus* of vandalism. The sudden discovery of acts of destruction, and the associated conformist reprobation, were accompanied by conservative resolutions that Paris intended to enforce in the provinces.

On 25 November 1794, Dufourny advanced the idea of an inspection of the French *départements*: 'to ensure the conservation of the monuments that malice or ignorance might be tempted to destroy' (p. 22).[6] On 5 Ventôse in the year III (23 February 1795), the Commission Temporaire des Arts tried to persuade the Comité d'Instruction Publique to adopt the similar idea of 'travelling representatives whose job it was to keep a watchful eye on all parts of France, to discover what might be plundered and stolen from [the nation], to enlighten the ignorance which does not recognise the treasures entrusted to it, and to put a stop to the destructive violence which is still rife'.[7] The Commission was also concerned with matters of restoration, since in July it ordered that 'no restoration should be allowed which might alter the ancient character' of the monuments of Autun and Orange.[8]

THE EFFICACY OF A DISCOURSE

In his *Mémoires*, Grégoire explained the circumstances surrounding the invention of the word *vandalism*:

> When I first suggested putting a stop to this devastation, I was called a fanatic and accused of wanting to save the *trophies of superstition* on the pretext of a love of the arts. However, the devastation was carried to such lengths that people eventually began to listen and to take notice of what I was saying, and the Comité agreed that I should present a report to the Convention condemning *vandalism*. I invented the word to abolish the act.[9]

As Bernard Plongeron pointed out: 'in the word, which is not chosen at random, there is something of the barbarian, the enemy of Christian civilisation'.[10] The *Rapports* in fact make use of the association of ideas inspired by the term, from the reference to 'barbarians and slaves' in the first *Rapport* to the 'In matters of virtue and enlightenment (. . .) we still have a great deal to learn'[11] of the last. In his final *Rapport*, Grégoire skilfully reverses the accusation originally levelled against him: 'The destruction and

defacement of works of art in which the magnificence of genius is manifest: that is true fanaticism'.

Most of the rhetoric of 9 Thermidor (27 July 1798) refers to this acceptance of the vandal as the foil of civilized society.[12] The word soon became part of common parlance, as can be seen in Madame Vigée-Lebrun's description of the ruined abbey of Marmoutier near Tours: 'all these beautiful things destroyed by an infernal band of boilermakers! Vandals could not have done any worse!'.[13] Moreover, the term 'vandalism' was not only used to refer to the destruction of monuments, but also to attacks against writers, scholars and artists and their scientific and literary works.

The choice of term suggested the use of historical associations to convey the full impact of the iconoclasm being condemned. The commissioners responsible for locating works of scientific and artistic value in the Bayeux district touched on the question in their report to the Comité d'Instruction Publique: the famous tapestry 'has fortunately survived two periods of destruction whose effects were all too similar. We are referring to the sacking of Bayeux by the Calvinists in 1562 and the more recent vandalic irruption'. But it goes on to play down the historical dimension in favour of a conventional description of Barbarians.

The political value of the effects of this discourse was, in any event, and for all those concerned, immediately intelligible. It helped to provide 'an event in search of meaning' (as B. Baczko accurately described the 9 Thermidor) with a suitable focal point and outstanding impact.

Boissy d'Anglas condemned the 5 Messidor in the year III (25 June 1795) as an act of tyranny illuminated 'by the fires of burning libraries'; 'While the scaffolds were awash with the blood of their victims, all monuments to fine art, all repositories of scientific learning, all the sanctuaries of literature fell prey to the fires and destruction of tyranny' (Julia, 1981: 85–86). On 8 August 1795, Girod-Pouzol presented a terrifying report to the Assemblée Nationale: 'France is bathed in blood, both at the hand of the enemy and of its executioners, devastated by anarchy, suffocated by acts of vandalism, prey to the ravages of greed and a victim of the excesses of ignorance and savagery'.[14] The indignation aroused by acts reminiscent of barbarism, and therefore of the past, led to the revilement of the obscurantist fanaticism of the tyrant Robespierre, of the ignorance of central and local government and of individual

acts of treachery. Finally, the French provinces vied with one another to condemn 'the vandalism that the infamous Robespierre had disseminated throughout the Republic', a vandalism that had 'exerted its ravages and violence by destroying many ancient monuments and, through the agency of the Terror, setting fire to or destroying virtually all the paintings of the above-mentioned churches, and even the prints, paintings and engravings of private citizens who feared that ignorance and barbarism would find an excuse to send them to the scaffold'.[15]

One of the testimonies given by the administration of the Musée de Rennes described the threats against the 'repositories of human knowledge' as 'an attack against social order' (Houlbert, 1933: 35–6), while the diatribe of a certain La Harpe,[16] presented at the opening of the *Lycée* on 31 December 1794 under the title *De la guerre déclarée par les tyrans révolutionnaires à la Raison, à la Morale, aux Lettres et aux Arts* (On the war declared on Reason, Morality and the Arts by the tyrants of the Revolution),[17] went even further. It introduced a rhetoric of the future, i.e. of the cultural negation of the dangerous classes. In addition to a vituperative censure of its intellectual nullity, he described the sans-culotte movement as an attempt to usurp culture, as an intrusion of the 'lower' echelons into the exclusive field of 'higher' preoccupations.

By contrast, Gracchus Baboeuf, editor of *Le Tribun du Peuple ou le Défenseur des droits de l'homme*, wrote on 28 Frimaire in the year III that

> the sans-culottes should vilify a certain report written by the Abbé Grégoire in the name of the Comité d'Instruction Publique on what he calls vandalism and in which he laments the destruction of the basilicas of Chartres, Nîmes and Strasbourg, the paintings of *La Résurrection du frère Luc* in Verdun and *La Descente de Croix* in Mayence, the stained glass windows of Gisors, the paintings of the seven sacraments in Grasse, the towers of Bourg, the mausoleum of the Maréchal de Saxe in Strasbourg, the stalactites and stalagmites of Coutances and other base acts of destruction perpetrated by the malevolent puppets of fanaticism. The only monuments he has forgotten to mention are the equestrian statues in the Places Vendôme, des Victoires, de Louis XV and du Pont Neuf, which were destroyed by Parisian vandalism.[18]

In the same vein, *La Tour Babel au Jardin des Plantes ou Lettre de Mathurin Bource sur l'Ecole Normale* mocks the Abbé Grégoire's third *Rapport sur le Vandalism* by pretending to denounce 'those

wretched Jacobins, those wild beasts, those cannibals, those drink-
ers of blood, in short, those ignoramuses who have destroyed the
very *stalactites* and *stalagmites* of Coutances' (Julia, 1981: 165).

It is therefore clear that the directly political import of the
discourse against vandalism is closely linked to the chronology of
the acts of destruction being denounced. The risks involved in
condemning all Revolutionary iconoclasm, including the initial
measures of 1789–90, became increasingly great. It was therefore
essential to define the limits of legitimate acts of destruction, al-
though this was not without its difficulties, given the immediate
circumstances of these events.

DEFINING VANDALISM

It would appear that the inconceivable nature of these contiguous
and yet unsuspected acts gave rise, in the same way as massacres,
to two different types of discourse: the languages of legal and
political assessment. The former is precise and descriptive and
stresses the details of the iconoclastic behaviour. The second, on the
other hand, ignores these details and either justifies the 'vandal' in
a defence of terrorism (which neglects to mention either the monu-
ment or the violence employed) or dismisses this behaviour as
outrageous.

The fact remains that, during the rare trials for vandalism, there
was a possibility that the outraged surprise of the court might be
faced with a reminder of recent destructive unanimity. The prose-
cution not only came up against the moral and aesthetic conscience
of the accused, but also the possibility of his being able to prompt
a recovery of memory on the part of his accusers. Dagorne, a
commissioner in Brest, was accused on 2 January 1794 of 'having
intentionally exaggerated the repressive measures taken against
[members of] the Catholic faith' and, in particular, of having burned
statues of saints from the churches of Quimper on 12 December
1793. As part of his defence, he cited the agreement of the constit-
uent authorities. On 14 June 1794, the president of the Comité
Révolutionnaire of Quimper acknowledged that

> citizen Dagorne asked the Comité to testify to the truth, by stating that all
> the authorities, even the national guard, openly took part in the ceremony
> held on 22 Frimaire during which the statues from the above-mentioned

churches were burned. Having deliberated the matter, the Comité has decided to present this testimony.[19]

But whether they were defined as errors, exaggerations or abuses in the execution of duty – in short, simple deviations from Revolutionary practice – or as the constituent elements of an overall plan by the various factions, or even the disastrous consequence of the involvement of the mob in politics, this destruction had the effect of an unprecedented discovery. This is undoubtedly why the debate on vandalism proved to be mainly a debate on the anteriority of awareness, with everyone wanting to prove their early opposition to the destruction. This was certainly the case for specialists in the fields of politics and administration. The draft report by the Commission Temporaire des Arts on its activities states 'that it had the strength to use the weapons of reason and the love of beauty to oppose not only the fury of the misguided mob, but also the terrible opinions that had deeply tainted some of the members of the Comité itself'.[20] Alexandre Lenoir, an attendant in one of the Commission's Paris repositories, also described himself as 'occupied from the early stages of the Revolution with gathering together monuments to the arts that inept and malicious men wanted to destroy' (*Le Gothique Retrouvée*, 1979). Milony, an architect and commissioner in Troyes, recalled his efforts on 26 September 1794 'to protect the district's objets d'art from the instinctive fury of the misguided mob and the volunteers forming a battalion in Troyes'.

Thus, until the time of the Consulate and the Empire, teachers, writers and journalists claimed to be part of a vanguard of responsible men of letters. In a leaflet included in its issue of 20 Fructidor in the year VIII (1800), *La Decade* claimed that, during the Terror, it had erected 'a dyke to [stem] the [flow of] ignorance that threatened to destroy all the monuments of Genius and the Arts' and in a *Mémoire* of the 10 Messidor in the year X, it recalled its struggle against 'vandalism'.

At worst, it was a matter of admitting irresponsibility. The many reprimands issued by the Bureau de Bibliographie de Paris to its provincial counterparts were answered in much the same vein as the reply from a colleague accused of having cut up 'an old Gothic antiphonary' to compile a bibliographical index: 'I admit that if I have committed an act of vandalism, it was entirely unintentional'.[21]

The commissioners responsible for the inventories of Angély Boutonne even seemed to deplore the absence of any form of vandalism, which they would willingly have opposed: 'there is nothing in the entire district which qualifies as art. Not a single antique monument or edifice of any architectural merit, in fact nothing of any great interest'.[22]

The great wealth of literature devoted to the subject of vandalism is undoubtedly linked to an overvaluation of the event by the intellectual milieu directly affected, either as victims or censors. It is also a natural consequence of the census carried out on the extent of the devastation. The inventories drawn up in the year III, with the more or less explicit aim of defeating the terrorists, were used, during the Consulate and the Empire, to enhance French departmental statistics as well as the general historical perspective.

On 4 Frimaire of the year III, Gault de Saint-Germain was asked by the local administration of the district of Clermont to carry out an enquiry into monuments. He stated that 'forewarned by the rumour of a programme for [their] destruction (!), he took [the necessary] measures well in advance. The commissioners merely made a marginal note of these observations.' The manuscript of the *Notice des tableaux et monuments connus dans la ville de Clermont et aux environs, faite avant les destructions ordonnées par Couthon* (an inventory of paintings and monuments in the town of Clermont and the vicinity, drawn up prior to the destruction ordered by Couthon), initially consigned to the archives of the district of Clermont, was published by Pernier in Paris in the year X (1802) in the *Tableau de la ci-devant province d'Auvergne*.

Cambry[23] justified the hasty publication of his *Catalogue des objets échappés au vandalisme dans le Finistère* (a catalogue of objets d'art which escaped vandalism in Finistère) compiled in the year III: 'since each day brought new offences, as crimes of ignorance and inconceivable thoughtlessness succeeded the crimes of brutality of a few vicious amateurs. I wish,' he continued, 'I could have been everywhere in the Republic at the same time, to save all those monuments which were so precious to history and all right-thinking people . . . They no longer exist!'[24] The message of the *Catalogue* extended beyond Britanny: 'the whole of France is in ruins (. . .) Let us lament the terrible destruction that has been perpetrated in France on these thousands of destroyed monuments'.[25] Later, in his *Description du département de l'Oise*, he again vilified 'the infernal,

systematic destruction of monuments during those disastrous years of 1793 and 1794'.[26]

A NEW CULTURAL APPROACH?

However, the anti-vandalic discourse is remarkable for its continuity of inspiration with the above argument: both are part of the same iconoclastic culture. The *Rapport sur la loi du 7 messidor an II*, containing new legislation with regard to archives, was remarkable in that it presented the fight against vandalism as the legacy of a rationalization of the politics of iconoclasm:

> When the statues of the tyrants were being overturned, and the file and chisel spared none of the symbols of monarchy and feudality, republican indignation was aroused by the evidence of so many outrages against human dignity [recorded] in collected manuscripts. The immediate response was to burn these manuscripts and destroy all trace of these abominated times. Far from thinking of lessening its impact, we instigated severe criticism in order to better condemn what is justly odious to us, and we are only on our guard against ill-considered and excessive haste which could strike a blow against justice and public fortune and expose us to regrets.

Conservation was subsequently often only justified by the need to compensate for exaggerated destruction, with a view to compiling a catalogue of *specimens*. A good example of this is the report on fifteen silver vases from Belgium presented to the Commission Temporaire des Arts on 28 February 1795. The Commission did not consider them 'remarkable, either in terms of craftsmanship, form or their great antiquity. However, as it is essential to preserve monuments from all periods [of history], and since the ravages of vandalism have destroyed nearly all the [monuments] of this type in the Republic of France', it recommended that they be placed in the Cabinet des Médailles rather than sent to the Mint (where 'they would produce one thousand écus at the very most when melted down').[27]

Generally speaking, the condemnations of vandalism confirm the fact that national antiquities accounted for a very small proportion of French patrimony, and therefore the relative insignificance of the loss. In the Abbé Grégoire's three reports of the 14 Fructidor of the year II, 8 Brumaire and 24 Frimaire of the year III (i.e. 1 August, 29 October and 14 December 1794), only Dijon provided

an opportunity to deplore the destruction of pre-Renaissance sculpture (and even then no other details were given). Grégoire specifically regretted the work of Germain Pilon, Jean-Baptiste Poultier and Edme Bouchardon. But although the *Second Rapport* certainly defended three Gothic edifices, it was in the name of their antiquity and by association, to a certain extent, with the pyramids of Egypt.

The defence of natural patrimony, on the other hand, was entirely concerned with anti-vandalic values, as illustrated by the famous reference to stalagmites. In the same vein, during a session of the Commission Temporaire des Arts on 13 October 1794 'a member pointed out that thoughtless citizens, while on guard duty at the Arsenal, actually deface the trees, some of which have been stripped of their bark and hacked with swords'. It was immediately decided that 'military commanders should be requested to post an order in guard-houses to put a stop to this type of defacement'.[28]

Above and beyond the argument developed to fit the circumstances and the convenient justification of the new political order, the anti-vandalic discourse was not therefore at odds with the Revolutionary representation of the past. Consequently, there was nothing surprising in the fact that many Republicans wondered, in the early stages of the campaign, whether putting a stop to the destruction was in fact benefiting the country, and even whether it was not proving dangerous. Some newspapers questioned what they saw as unreasoning conservation. For the anonymous author of the *Journal des bâtiments civils* (journal of civil buildings), published in Prairial of the year IX: 'the modest expenditure of the purifiers of good taste' (in other words, the low cost of iconoclasm) was preferable to, for example, 'the free circulation of funds taken from public moneys' that Alexandre Lenoir invested in a 'barbaric' museum.[29]

In short, for these Republicans, the discriminatory powers of the fight against vandalism (real or imagined) had become distorted to the point of preserving objects of no historical value or interest that a more informed management would have allowed to perish without regret, or even deliberately destroyed. More generally, many people preferred to await the natural consequences of indifference and neglect rather than implement a policy of immediate and reasoned selection. When the *Almanach Parisien* of the year IX (1801) remarked, for example, that 'the above-mentioned Bibliothèque Royale has the most extensive collection of books in the world', it

was not so much a statement of national pride as to provide the opportunity to add immediately that although 'the imagination is overwhelmed by the prospect of so many volumes, it is reassured by a glance at the titles of so many books designed to number and fill shelves (. . .) [where] they will remain until time has destroyed them and returned them to oblivion. If these books were not in the library, it would be incomplete: so let us leave them to rot in peace, since they are part of the luxury of this monument, so precious in so many other respects'.

This is a singular comment, at first glance, only a few years after a condemnation of 'vandalism' couched in extremely violent terms. But, in 1806, Denon used a similar argument (revealing a consensus of élites) to reject a request for the restitution of paintings to the churches: 'It would be ideal if some kind of event caused each century to destroy all the bad paintings that had helped to create good artists' (Boyer, 1969: 70). This is the traditionally accepted argument previously presented in an allegory by L.J.F. Lagrenée: 'Time lends colour to the good paintings and destroys the bad'. The cultural objective is always one of rational purification, but it encounters an optimism which is radically different from the suspicion and mistrust of the year II: from now on it would be the natural course of events that would carry out the selection of works and objets d'art. This confidence is a far cry from the active censorship applied on behalf of the civil society to its own heritage.

Thus, the stimulus for the condemnation of 'vandalism' lies not so much in some form of change of feeling towards the past (which, as we have seen, remains essentially the same) as in the development of a particular political culture. Not only does the denunciation of barbarians confer letters patent of civilization upon whoever utters it 'at a time when (according to Grégoire) the Revolution is acquiring moral standards', but the condemnation expressed by the law also becomes associated with the expression of moral judgement, and thus relegates their actions to the realm of insignificance (*Premier Rapport sur le vandalisme*: see Levy-Leboyer, 1984).

In the same way that Robespierre identified the science of government with the rules of *personal* integrity, Grégoire used personal morality as the basis for a politics of patrimony which, in the absence of any external authority or guarantee, enabled society to establish its own respect for monuments by seeing them as property entrusted to each of its members. Whoever attacks these

monuments is excluded *de facto* from the community of citizens. To destroy monuments, deface commemorative steles and knock statues from their pedestals are acts which are sometimes claimed, even today, as 'political', but which public opinion condemns as illegitimate and, as it were, associated with a negative form of expression and social exclusion (Levy-Leboyer, 1984).

THE PROCESS OF VANDALISM: THE CREATION OF STEREOTYPES

From the *corpus* of condemnations of 'vandals', there initially emerges the image of a scrupulous destroyer who is, however, limited by misplaced zeal and a misapprehension of symbols. In short, an image which coincides perfectly with the interpretation suggested by Vic d'Azyr and Dom Poirier in the *Instruction. . . ,* i.e. that vandalism is misdirected goodwill, lacking in *discrimination*[30] and denounced by the 'specialists' (antiquarians, artists). Reality, in accounts of this type, seems to insist on an overt celebration of the vandal who shrinks from nothing in his attempt to rid the city of anything remotely threatening or suspicious. However uncertain the decipherment, there is an overriding logic which recognizes despised and detested characters everywhere.

The *Mémoires d'un bourgeois d'Evreux* (see Soboul, 1973) provide an example of this enthusiasm which is as misdirected as it is self-confident:

A commissioner (Thibault) from Paris who was in charge of all these works, ordered the stone saints surrounding the cathedral to be cast down (. . .) The statue of Henry I was more robust and resisted all attempts to dislodge it. Thibault himself climbed, with great difficulty, onto a cornice, wrapped the rope around its body, and [began to] shake the statue with all his might at a height of sixty feet or so. They warned him that it would pull him down with it and kill him. He came down and smashed the head [which had been] knocked to the ground. As Thibault destroyed the procession of Charity, he noticed above a gateway opposite the emblem of Les Quatre Fils Aymon, all riding the same horse and all with plumes in their helmets. He was going to destroy this piece of sculpture which can still be seen today, because he thought the plumes were fleurs de lys. Those around him, and especially Monsieur Champagne, one of Evreux' most senior architects, had great difficulty in convincing him that what he thought were fleurs de lys were in fact plumes, and in persuading him to remove the ladder which was already set against the wall.[31]

When his 'knowledge' is purely illusory, and quickly shown to be so, the vandal falls within the common category of 'barbarian'. This does not apply to the professional who has devoted himself to the cause of destruction. Artists and craftsmen – whether initiates or well-versed in iconoclasm – were, more than other 'vandals', convinced of the unworthiness of what they were destroying. Because ignorance is an essential trait of vandalism, intelligence and taste convicted of the same crime appeared as an unjustifiable aberration. The new responsibilities for the purification of public taste, entrusted to artists in addition to their traditional role, sometimes led them to destroy or 'adjust' (and sometimes even repudiate their own) harmful works.

The first victims were obviously the most memorable: those artists who betrayed both art and the Republic and were convicted of professional immorality and political outrage. In his *Rapport à la Convention sur les évènements du 9 thermidor an II*, Courtois accused the painter David of wanting to 'divide up the superb paintings of the Rubens gallery, and give them to art students to *try out their cleaning techniques*' (Beaucamp, 1939: 199–200). On 10 Prairial in the year III (29 May 1795), the Museums department arrested Wicar on the charge of 'having encouraged vandalism by proposing, with Le Sueur, to destroy all artistic masterpieces'.

The less well-known case of Rondot, a goldsmith from Troyes, provides another good example of the very specific nature of the vandalic artist (Babeau, 1874: 239–44). Bô, a government representative in Troyes, had ordered all objects relative to the Catholic faith to be removed from the 'temple of Truth and Reason' and placed in the town hall. Rondot, a national agent, accompanied by local commissioners and members of the Société Populaire, went to Saint-Pierre during the night of 22 January 1794 and melted down the treasure, placing in reserve the enamel work and stones listed in February 1792 and November 1793 as objets d'art. On 7 February, a delegation from the various administrative bodies and the Société Populaire de Troyes sent the metal to the Treasury, together with an address to the Convention, published in the *Moniteur*: 'What need do we have for the gold of Potosi? Let us leave this vile metal to tyrants; iron is the metal of free men'. But in June of that year, when Rondot wanted to entrust the valuable objects to the care of the district so that they could be 'placed in the future museum of the commune of Troyes',[32] officials condemned the

deplorable 'destruction of this treasure, when every possible precaution had been taken to preserve it'.

Rondot was duly arrested and, although he admitted the facts of the incident, denied any 'vandalic' intent.

> You will no doubt be surprised to learn that the so-called monument to art that I am accused of destroying was nothing other than a series of processional crosses, reliquaries and chalices (. . .). This calumny is all the more ill founded (. . .) since I am myself an artist (. . .). And further proof of my attachment to the arts is the fact that, although the enamel "Life of Saint-Loup", comprising sixteen pieces with inscriptions, low reliefs and fragments of the head of Saint-Loup, is of extremely poor quality, it was preserved as an example of the art of that period.[33]

In short, 'the commissioners and myself supervised the entire operation, and nothing that could be considered a loss to fine art was broken up or destroyed. On the contrary, [fine art] *was relieved of some poor quality items of gold and silver.* These items included several Gothic, even barbarian, pieces (. . .); the arts slumbered through those centuries of ignorance, to the point that contemporary artists consider it a lost age and the Gothic genre as a mere corruption of true beauty; I can only believe that (my accuser) is unaware that *Gothic works of art are generally rejected by all museums*'.

However, in the eyes of the denouncers of 'vandalism', the vandal's artistic status merely compounded his responsibility. Milony wrote:

> I agree that you are knowledgeable, and this is what, in my opinion, makes you even more guilty in your destruction of [artistic] treasures. (. . .) You seem to me to be even more ignorant than I am of what constitutes a monument, since by preserving fragments of the whole that was a monument, you claim to have preserved monuments; the same would be true if, having destroyed the Temple of Reason, which is a monument, I attempted to prove that the debris were still monuments.

As well as being a fine illustration of the general fate of pieces of gold and silver, the Troyes affair also enables us to understand the local mechanisms of denunciation, particularly in response to demands from the capital. Accusations were not in fact the result of a simple recording of acts of 'vandalism':[34] they depended on the collective representation of the objects destroyed. In other words, they were directly linked to the value attributed to the object(s)

destroyed or the environment damaged (the cost, the inconvenience suffered, the irreversibility of the damage, the symbolism of the loss . . .).

In short, the emergence of a 'vandalism' deserving of punishment depended on the belief that a legitimate order had been overthrown and a desire to restore the traditional 'complicity' between the works of a particular locality and the community, after the more or less brutal irruption of the iconoclastic crisis. The paradox lay in the fact that such an attitude was to a large extent the result of the iconoclastic episode itself. In fact, the official programme involved ensuring that the urban and, in a wider sense, the cultural landscape was brought into line with the political regime, with the citizens as judges. It was at the origin of an unprecedented and exaggerated attention to a series of images which were suddenly seen as significant. This gave rise to the rhetoric of gazes suddenly 'wounded' and sights 'intolerable' to behold. In this respect, it also fell within the province of the political function of art cultivated by the monarchy of the Ancien Régime, as pointed out by Klaus Herding (Herding, 1988; cited by Gamboni, 1989). The people should assume responsibility and become the censors of the 'restoration' of past works of art, in accordance with the newly defined principles of Reason and Morality. In this way, people were encouraged to recognize a legitimate order which had been destroyed or perverted during the Ancien Régime.

But by continually provoking new disputes over attribution and classification, and asserting an unprecedented civic responsibility towards these objects, this process of Revolutionary appropriation 'revealed' the importance of the relationship between men and objects, making it one of the aspects of the social ideal to be attained. After the event, this enabled its adversaries to denounce the Revolutionary act as an attempt against world order.

VANDALISM: A POLITICAL CULTURE OF EXCLUSION

A traditional interpretation of the phenomena of vandalism postulates, to a greater or lesser degree, that the contradiction between the conservation of works of art and the destruction of the symbols of the outdated regime reflects the state of political relations (and even, ultimately, of the class struggle). A different interpretation of events rejects this interest-orientated definition in favour of a

strictly 'philosophical' construction which identifies the 'paradox' of Revolutionary patrimony with the clash of antagonistic reasoning.

However, if we consider these interpretations more closely, the acts of violence and conservation are not seen as a series of means adapted to rationally calculated or evaluated ends. If we maintain that Revolutionary vandalism was in fact an effect of *discourse*, capable of giving meaning to a political period seeking to define itself, then we must revise the binary interpretation of conservation *versus* destruction, that it created and perpetuated. The iconoclastic crisis revealed the extremely complex *conflict of* antagonistic *classifications*, a phenomenon which determined acts of conservation as well as of destruction, during a 'liminal' period when the traditional significance of things was regarded as 'suspended'. In this respect, the Revolutionary museum provided evidence of contradictory *expositional policies*, which were at one and the same time the effect and the possible solution to the crisis of artistic and cultural referents: the different exhibition areas and the strategies for the presentation of objects within them corresponded to a specific logic and an unprecedented institutional coherence. Patrimony appears as the representation of a relationship with the past, in the form of a *recognition of the past* in the name of the general will, in accordance with criteria developed as a result of the 'reign of criticism' and according to different types of organization. Michelet's intuition when he described a 'Revolutionary tribunal' of archives should be understood in this sense.

The obvious representation of this heritage was – in the most radical episode of the decade – that of a *counter-monument*, whose pattern had been created by such projects as the one proposed by David. But above all, the attitude to be adopted towards the heritage of the past, that chaos of artefacts haphazardly bequeathed by the centuries, fell from then on within the province of the law. And it was in this respect that the destruction or redefinition of the decade differed radically from previous episodes in history: the melting down of silver furnishings and royal gold and silver ware to fill the coffers of the Treasury, religious iconoclasm, the replacement of an outdated decor by another. The sole aim of the flood of decrees, laws and deliberations – naively presented, even today, as 'terrifying' by a certain school of historiography – was to determine the future conditions and forms of a regulated and symbolic form

of violence. In short, the enlightened and democratic concept of a collective patrimony, naturally embodied in an *ad hoc* legislation, defined an area of intervention unprecedented in the modern state, in which 'cultural' and 'national' were closely linked.

In this respect, the accuracy of the apparently polemical remark made by the nineteenth-century scholar, Hennin, is particularly striking in that it pointed out that destruction under the Ancien Régime was carried out on the initiative of the populace, while after 1789 it was carried out on a regular basis at the instigation of authoritarian regimes, in other words 'from the top'. Indeed, in addition to being an affirmation of principles and a form of cultured condemnation, iconoclasm remains, throughout the nineteenth and twentieth centuries, the image of Revolutionary anthropology. To take nineteenth-century France, for example, key dates in the Revolutionary calendar are always marked by symbolic acts of destruction which fulfil various functions, i.e. destroying images of the defeated power, invoking the return of a condemned past. However, an unplanned, iconoclastic insurrection is unanimously condemned and classified as barbarism. Finally, purging a monument of its shameful symbolism is always the prerogative of specialists. These operations must be carried out with care, so that they are never visibly apparent, and as such they are the opposite of all forms of ostentatious violence.

In this way, the invention of the concept of 'vandalism' destroyed the iconoclastic behaviour of the traditional mob, and the legitimacy implicitly attributed to it, by denying it any form of meaning. It sanctioned the impossibility, from then on, of any form of distorted carnivalesque behaviour, for example, or any other forms of traditional violence, being interpreted as legitimate and natural to the life of a society. From then on, citizens, in so far as they were part of the general will, could only act in accordance with the law which expressed the will of public opinion. Their behaviour *vis-à-vis* symbols of the past, like their other social actions, could only be republican and in accordance with the law, or strictly barbaric, i.e. either meaningless or criminal.

Vandalism has therefore helped to establish a series of attitudes towards the past and evidence of this past firmly within our minds. The entire post-Thermidor cultural discourse (inherited by the nineteenth century) is based on this foundation of emotions, this initial upheaval which determined the exclusion of certain types of behavi-

our. At the same time, the conservation of the evidence of the past has become an administrative necessity and attests to the strengthening of the 'cultural' power of the centralized state, freed – by the confiscation and opening of specific places of conservation – from many of the obstacles opposed by the social fabric of the Ancien Régime (Geertz, 1973: 193–233). It is with the new state monopoly as regards the respect due to culture that a sense of patrimony has become an integral part of the civic conscience.

NOTES

1 W. Olander (1983: 101–16) provides a concise summary of this chorus of lamentations for which Daunou and Thibaudeau, in particular, were renowned (*Pour transmettre à la postérité: French Painting and Revolution, 1774–1795*, New York University, 1983, pp. 331–5). See also L. Guerci, 'Gli Ideologues tra filosofia e politica', *Rivista Storica Italiana*, 86 (1974): pp. 101–16 in particular.

2 D. Julia (1981) cites Jeanbon Saint André in 1792, declaring: 'It may seem surprising to men of calmer disposition that one should be accused of being a Goth or a Vandal for trying to prevent a nation having to pay for a scientific investigation that it has no interest in financing'.

3 H. Grégoire (1750–1831) was elected in 1789 by the clergy of the bailiwick of Nancy. Having published a work on the legitimacy of the civic oath demanded of ecclesiastical government officials, he was the first to swear allegiance to the 'Constitution Civile du Clergé' established on 12 July 1790. On the general activities of Grégoire, see A. Gazier, *Etudes sur l'histoire religieuse de la Révolution française*, Paris, 1887. See also Soubol (1973).

4 *Procès-Verbal (PV) (i.e. report) de la Commission Temporaire des Arts* (henceforth *PV de la CTA*), ed. A. Tuetey, Paris, 1912, vol. 1, p. 115.

5 *P.V. du Comité d'Instruction Publique de la Convention*, vol. 4, p. 55.

6 *P.V. du Comité d'Instruction Publique de la Convention*, vol. 1. 4, p. 582.

7 *P.V. de la CTA*, 23 February 1795, vol. 2, p. 136. 'The role of travelling representatives should mainly involve: (1) establishing the existence of artistic and scientific monuments, particularly those of which district administrations are not fully cognisant; (2) taking the necessary steps to ensure the conservation of artistic and scientific objects, prevent deterioration and recover all objects which may have been wrongfully sold; (3) reserving for museums and other repositories, the paintings, statues, engravings, books, manuscripts, items of natural history, furniture and instruments which, because of their rarity, their valuable finish or their importance, should be placed in museums and major libraries'.

8 *P.V. de la CTA*, vol. 2, p. 291.

9 Grégoire, *Mémoires*, vol. 1, Paris, 1837, p. 345. Grégoire used the term for the first time in his *Rapport sur les inscriptions des monuments publics*, presented to the Convention on 22 Nivôse in the year II (11 January 1794): 'One cannot inspire in citizens too much revulsion for these acts of vandalism bent solely on destruction' (p. 9).

10 J. Ehrard and P. Viallaneix (eds) *Actes du colloque de Clermont; Les fêtes de la Révolution*, Clermont, 1977, p. 299. Amusingly qualified by L. de Laborde in *Emaux* (2 vols, Paris, 1835): 'Since each period of history has acts of vandalism with which to reproach its predecessor, and not having an entirely clear conscience itself, it was agreed that the blame should be laid fairly and squarely with the Vandals who would not object' (p. 533).

11 Grégoire, *Rapport*, pp. 16 and 21.

12 The *Journal des Bâtiments* records, for example, on 16 Nivôse in the year X, under the heading 'Vandalisme': 'Acts of barbarism or ignorance have deprived the arts of one of the most beautiful architectural monuments bequeathed to the Gauls by the Romans (. . .) the superb edifice of the Tutèles in Bordeaux' (no. 140, p. 75).

13 M. Vigée-Lebrun, *Souvenirs*, Paris, 1800, p. 337.

14 *Moniteur*, 21 Thermidor in the year III, 25, p. 438.

15 *P.V. de la CTA*, p. 640, 15 December 1794: letter from the administration of the district of Nîmes.

16 Address given at the opening of the Republican Lycée on 31 December 1794. S. Moravia gave a commentary on the text in 'La Battaglia di La Harpe', *Il tramonto dell'Illuminismo*, Bari, 1968, pp. 431–7. See also the article by Fourcroy, *Moniteur*, 16 Fructidor in the year II, pp. 142–8.

17 The condemnation of vandalism by La Harpe falls within the province of a wider interpretation of the Revolution as the destroyer of language, literature, the arts and morality as well as of society, this chaos being itself attributed to the eighteenth-century corruption of the arts. 'A philosophy of envy and usurpation which, from then on, under the pen of writers who were, moreover, extremely circumspect and over-scrupulous, was the forerunner of this destructive instinct which is apparently inseparable from it, since it began by causing confusion within the province of the arts and ended by overturning the entire social order', vol. 13, p. 3.

18 No. 28, p. 856.

19 Cited in: J. Cambry, *Catalogue des objets échappés au vandalisme dans le Finistère dressé en l'an II par Cambry, Président du district de Quimperlé, publié par ordre de l'administration du département*, ed. J. Trévédy, Rennes, 1889, publisher's appendix, pp. 271–2.

20 In: Reports published by A. Tuetey, pp. IX and XXI (see Note 4). In the *Projet du rapport sur la commission temporaire des arts, demandé par l'arrêté du Comité d'instruction publique*, in 1795, the Commission denounced the

supervision of the Comité de la Convention as 'the Jacobinism of Romme and the mistaken ideas of Mathieu' (two of its former presidents).

21 The Librarian of Gaillac to the Comité d'Instruction Publique, on 21 Messidor in the year III, cited in P. Riberette, *Les bibliothèques françaises pendant la Révolution, 1789–1795*, Paris, 1970, p. 84. See also *idem*, the letters from the librarians of Sélestat: 'it was with much greater surprise and pain than yours, that I read your last letter' (p. 82) and Pontoise: 'To declare one's own foolishness is a great sacrifice' (p. 83).

22 *PV de la CTA*, note 1, p. 423.

23 Cambry, the commissioner who in the year III was given the task of compiling a district-by-district inventory of the monuments and objects to be protected in the *département* of Finistère, deplored the 'plundering of libraries belonging to monasteries and émigrés, the dispersal of their books, engravings and manuscripts'.

24 *Catalogue des objets échappés au vandalisme dans la Finistère*, ed. of 1889.

25 The *Catalogue* is in two parts: the reports addressed by Cambry to each of the 9 districts, and the deliberations of the 9 districts in reply. See, in particular, pp. 42, 54, 105, 137, 173 and 239.

26 Published in Paris, in the year XI (1803), republished 1982 as *Trésor de la cathédrale*.

27 *PV de la CTA*, vol. II, p. 148.

28 *PV de la CTA*, p. 469. On 1 October 1794, Leblanc 'denounced (. . .) the destruction of hives in order to harvest their contents. The Commission has decided that this denunciation will be communicated to the Comité d'Agriculture et des Arts, which will be requested to [introduce] a law to strictly prohibit this disastrous practice' (p. 437).

29 *Journal des bâtiments civils*, no. 78, 23 Prairial in the year IX.

30 Cf. According to the traveller Bygge: 'Those vandals destroyed every memorial and monument, without any discrimination whatever. They even demolished the tombs, and dug up the bodies of the most meritorious of their countrymen' (*Travels in the French Republic*, 1798, p. 354, trans. Dominique Poulot, 1981).

31 Pp. 68–9 (Saturday 19 and Sunday 20 October). A. Soboul's conclusion on the de-christianization of Paris is clear: 'The de-christianisation would not have assumed its characteristic proportions, had it not been systematically organised by a certain number of men who did not belong to the sans-culotte movement, but who exploited the anti-religious feelings of certain popular militants' (*Mouvement populaire et gouvernement révolutionnaire en l'an II, 1793–1794*, Paris, ed. 1973, p. 207).

32 *Histoire du terrorisme exercé à Troyes par Alexandre Rousselin et son Comité révolutionnaire, pendant la tyrannie de l'ancien Comité de Salut Public, suivie de la réfutation du rapport de la mission dudit Rousselin, avec les pièces justificatives*, Troyes, in the year III AD, Troyes, Br 711,

pp. 38–9 (Rousselin was the protégé of Barrère; his letters inspired Barrère's report).

33 *Rondot. . . . aux citoyens représentants composants le comité de salut public et de sûreté générale de la Convention nationale*, 4 vols, Paris. The indictment is reproduced on p. 4 (24 Prairial in the year III). It should be generally remembered that the 9 Thermidor was followed – at national and local level – by proceedings against, and even the extermination of, the political and militant figures of the year II, described by R. Cobb in *Police and the People* (translated into French as *La protestation populaire en France 1789–1820*, Paris, 1975, part II, ch. 2.

34 C. Lucas summarizes the confrontation of Jacobinism and its popular adversaries in a series of oppositions: on the one hand 'the primacy of external, de-localised obligations, the primacy of certain general values and a (. . .) broad, collective identity'; and on the other 'a traditionalist and localised response, (. . .) the solidarity of the community and (the) rules of honesty and decency' ('Résistances populaires à la Révolution dans le sud-est', in J. Nicolas (ed.) *Mouvements populaires et conscience sociale*, Paris, 1984, p. 483).

BIBLIOGRAPHY

Babeau, A. (1874) *Histoire de Troyes pendant la Revolution, vol. 2: 1792–1800.*

Beaucamp, F. (1939) *Le peintre lillois Jean-Baptiste Wicar (1726–1834), son oeuvre et son temps*, Lille.

Boyer, F. (1969) 'Napoleon et la restitution par les musées du Louvre et de Versailles des oeuvres d'art confisquées sons la Revolution', *Archives de l'art français*, n.s. 24: 60–80

De Dampierre, E. (1954) 'Themes pour l'étude du scandale', *Annales ESC*, July–Sept. 3: 328–36

Furet, F. (1978) *Penser la Revolution Française*, Paris.

Gamboni, D. (1989) 'La fin de l'Ancien Regime en Suisse et la conservation des emblèmes politiques', *XXIIe Congrès International de Histoire de l'Art*, Strasbourg.

Geertz, C. (1973) *The Interpretation of Cultures*, New York.

Herding, K. (1988) 'Kunst und Revolution', in R. Reichardt (ed.) *Die Französische Revolution*, Würzburg: 200–40

Houlbert, C. (1933) *Le Musée d'histoire naturelle de la ville de Rennes*, Rennes.

Julia, D. (1981) *Les Trois Couleurs du tableau noir: Le Revolution*, Paris.

Le Gothique Retrouvée (1979) *Catalogue of exhibition at Hôtel de Sully*, Paris, Caisse National des Monuments Historiques.

Lévy-Leboyer, C. (ed.) (1984) *Vandalism and the Social Sciences: colloque de l'université René Descartes, Paris, October 1982*, Amsterdam.

Olander, W. (1983) *Pour transmettre à la postérité: French painting and Revolution 1774–1795*, New York.

Soboul, A. (1973) *Mouvement Populaire et Gouvernement Revolutionnaire en l'an 11, 1793–1794*, Paris.

Spigath, G. (1980) 'Sur le vandalism revolutionnaire', *Annales de l'Histoire de la Révolution Française*: 511.

9

Rome, the Archetypal Museum, and the Louvre, the Negation of Division

JEAN-LOUIS DÉOTTE

INTRODUCTION

Some of the texts written by the architectural historian Antoine Quatremère de Quincy prior to his 'Dissertation' of 1806 (published in 1815 under the title *Les Considérations morales sur la destination des ouvrages de l'art*), contain a critique of museums which, in many respects, invalidates the whole of the traditionally accepted argument of the *Considérations*. In 1787, Quatremère expressed his views on patrimony in the 42nd issue of the *Journal de Paris* with particular reference to the restoration of the Fontaine des Innocents. The argument of the *Considérations* outlined in reports made to the Conseil Général de la Seine on 15 Thermidor in the year VIII (3 August 1800), and to the same Conseil Général on 29 Germinal in the year IX (19 April 1801), forms the basis of a critique of museums as responsible for the death of 'living' art.

The *Lettres à Miranda sur les déplacements des Monuments de l'art de l'Italie* of 1796 (letters discussing the damage that would be done to the arts and sciences by the displacement of artistic monuments from Italy, the dismemberment of its art schools and the spoliation of its art collections, galleries and museums) are particularly worthy of analysis (Pommier, 1989).

QUATREMÈRE'S IDEA OF ROME AS ARTISTIC REPOSITORY

As Napoleon I was carrying out his project for the repatriation of works of art (a project comprehensively defended in an essay by François de Neufchâteau), Quatremère, heir in this respect to the pre-Revolutionary European Republic of arts and sciences, revived the memory of a Europe which would disappear with the age of the nation state. The Europe he described was a community of direct

215

cultural exchanges, an 'electric' Europe: in short, a patrimonial Europe whose capital was Rome.

Against this background of cosmopolitanism, the politics of the French Revolution appeared little more than barbaric, worthy of so many Caesars and Alexanders who, while destroying the nations they conquered, also abolished political freedom. Miranda and Quatremère, both men of the Enlightenment, made early predictions that Bonaparte's 'liberation' enterprise would tend towards imperialism. It is Enlightenment that suffers when national treasures are expropriated. Indeed, is there not a real, if somewhat ambiguous, alliance between works of art and liberty?

As Quatremère's first letter puts it:

> The spread of the Enlightenment did Europe the great service of ensuring that no nation would ever be subjected to the humiliation of being described as 'barbaric' by one of its neighbours. There is a noticeable community of learning and knowledge, a concordance of taste, scholarship and industry, among the countries of Europe. In fact, it is true to say that the differences between these countries are often less pronounced than between the provinces of a single empire. And this is because, as a result of a propitious and timely revolution, the arts and sciences belong to the whole of Europe and are not the exclusive property of a single nation. All the thoughts and efforts of right-thinking politics and philosophy should be directed towards maintaining, promoting and developing this community [. . .] Those who attempt to appropriate a sort of exclusive right and privilege to education and the means to education will soon be punished for this violation of common property by barbarity and ignorance. And there is something actively contagious about ignorance. The nations of Europe are in such close contact with each other that anything that affects one of them cannot but have immediate repercussions for the others.

The seventh letter gives a clearer idea of this reciprocal effect:

> Here there is a reciprocal effect. The 'electric' chain which today unites the world of scholarship can only receive and transmit simultaneous impressions. Today, Europe is being carried towards a culture of the arts by a single movement, an impetus which is a direct result of the central power emanating from Italy and Rome. If this power is reduced, then its effect will be diminished.

The European 'republic of letters', which was nothing more than a particular system of communication, presupposed a medium, an 'electric' medium which would be endangered by various

national revolutions. Rome, whose works of art the French Revolution intended to liberate, was already an actual historical continuation, i.e. of the Papal cultural policy which consisted of the continuous *reproduction* of Antiquity, Pope Nicholas V having had the idea of 're-establishing the architecture of ancient Rome'. The task, whose vast scope was truly remarkable, still continues today: 'It is as if an ancient world were being discovered and conquered each day'.

But, revolutionary actions could only discourage such an undertaking. It would take the whole of Europe to realize the wild dream of Nicholas V. As the second letter puts it:

> What will the people of Rome do if these works of art are plundered? Will they continue this task of reproduction? The shamefully venal profit that the city that appropriated them would hope to gain would be profit lost to the arts since, far from benefiting them, it would in fact become the destroyer of this wonderful work of reproduction.

For Quatremère, this implies the promise of a new form of art, a new method which consists of imitating nature, an art born of the spectacle of the reproduction of an entire nation of statues:

> Of all the causes that can revolutionise or revitalise the arts, the most powerful and the most capable of producing an entirely new order of impressions is this general resurrection of a nation of statues, of this antique world whose population increases daily. This world, which Leonardo da Vinci, Michelangelo and Raphaël did not live to see, or of which they saw only the very beginnings, should exert great influence on the study of art and the artistic spirit of Europe. (Letter II)

A revolution in the arts caused by the *archaeological* – and therefore the patrimonial – *reproduction* of Antiquity . . . One cannot help thinking of the young Brunelleschi, travelling from Florence to Rome, excavating, restoring ruins, measuring, drawing, describing, learning the art of ancient materials, and probably considering the possibility of covering a vast building with a cupola.

But it is not merely art – a new form of art – that is at stake. It is also the human intellect, the history of the human intellect, a history that could not be written without opening the pages of this vast book that is Rome

> whose pages have been destroyed or dispersed by time, and in which the spaces and gaps are filled daily by modern research. The power that selected

a few of the most interesting monuments with a view to exporting and
appropriating them, would be like the illiterate who tears the illustrated
pages from a book. (Letter III)

The city of Rome is like a vast, buried library whose 'texts', once
excavated and pieced together, will disclose the wealth contained in
all these 'repositories of knowledge and instruments of learning, just
as it is contained in the repositories' of books, works of art, ma-
chines and natural history. Only such centralized 'collections' make
it possible to write the complete

history of the human intellect and its discoveries, its errors and its prejudices,
the sources of all human knowledge; the discovery of ancient customs,
religious beliefs, laws and social institutions; the artistic monuments of
Antiquity are an even greater source of inspiration as to the methods of
recording history, verifying and interpreting it, resolving its inconsistencies,
completing its omissions and throwing light on its obscurities, than they are
to the imitative arts. (Letter III)

The history of the human intellect cannot but be monumental,
in every sense of the word. And here we see a Quatremère who is
not in the least hostile towards museums, to these repositories of
information, provided that the collection is as vast as possible. A
single museum, a single library – Alexandria for example – would
suffice to contain the entire range of knowledge apprehended by the
human intellect.

The effects of dispersing the ancient monuments of Rome would
therefore be the same as for any source of knowledge whose ele-
ments and materials were dispersed and which would be destroyed
as a result. So, if we consider the problem from the point of view of
the educational value and not the destination of these works of art,
then the works as repositories of knowledge are better kept to-
gether, like the books in a vast library. The location of the reposi-
tory itself is of little importance. What is important is that
information can be diffused via this repository, information that
has been gathered by specialist, 'secondary' agencies.

The development of a synthesis of knowledge, i.e. of the entire
history of the human intellect (and here the model of excellence is
Winckelmann), does not presuppose any degree of proximity be-
tween the scholar and the knowledge. In fact, a certain distance is
essential:

The man of genius, wherever and at whatever distance he may be from both the observers and the objects observed, is the point at which they coincide [. . .]

In this way, Pliny and Buffon – without leaving Rome or Paris – were able to embrace the world and see it through the eyes of all travellers when they themselves had only seen a very small part of it. Thus the true synthesis of the knowledge of Antiquity may be achieved by nations who have never possessed, and individuals who have never seen, ancient works of art (Letter III).

In this respect, there is little need to point out that, a century later, ethnology in France (in the works of Mauss in particular) had virtually ceased to be a 'field' science.

The advantage of bringing art treasures together in one reposi- tory is that it makes it easier to compare objects and develop parallels: in other words, to develop a chronology. For Quatremère, the judgement of artistic taste was, necessarily, a sequential and informed judgement which presupposed the continuity of the works of a particular artist or school. Aesthetic judgement was not made on an individual work, an isolated example, a solitary masterpiece, but on a complete series. It was based on a comparison of works of varying degrees of quality and, therefore, on the principle of conti- nuity:

The recognition of beauty, so vital to artists, is the result of a sort of sliding scale of comparison which classifies works of art, establishes a system of ranking and a sort of order of merit. These rankings are as numerous as the subtleties and distinctions of the human intellect.

The number of works ascribed to each 'rank' is inversely propor- tional to its degree of merit. But the more numerous the subsidiary points of comparison, the more apparent and irrefutable the pre- eminence of the minority, and the more striking and instructive their beauty (Letter IV).

We must turn to the Leibnitzian theories of rudimentary percep- tions and continuity to legitimize the pyramidal hierarchy of works of art as represented by Rome, the great testing ground of continu- ity: *Rome the ultimate series of all series.*

Modern – Kantian – aesthetic judgement, as a judgement of an individual work of art and therefore a sequel to the discourse on the presence and consequently the 'aura' of a work of art, is merely the result of a process of dissociation, destructive discontinuity and isolation. Such a result is brought about by the institution of

museums which, built on the ruins of the great universal Museum of Rome, can only hope to house fragments of this Museum. Aesthetic judgement and art criticism can therefore only be applied to fragments, and the art invented by museums will be a – modern – art of fragments, as shown by the German Romantics at the same time as Quatremère.

Quatremère, because he fostered the myth of the Museum, still numbers among those who realized that aesthetic judgement in the pre-museum age – because it was concerned with the pyramidal hierarchy of works of art – involved making an infinite number of comparisons: 'Thus the small number of truly beautiful antique statues owes its claim to the beauty we find so striking to the infinite number of statues of a similar style, but not of similar merit, amongst which they stand out.' (Letter IV). This being the case, the admiration of beautiful works of art will – because they are admired in isolation – inevitably be accompanied by a sense of weakening, subsidence and collapse due to the absence of context.

> I can confirm that I personally experience this sensation every time I have the opportunity of seeing one of these beautiful antique figures, detached and separated from its family. And yet I am able to say that I have, impressed upon my mind's eye, virtually all the antique figures in Europe, and so carry my points of comparison with me, an advantage which is not shared by the majority of the ordinary viewing public. (Letter IV)

This is an important extract if we take into account that all the European works of art impressed upon his mind's eye must necessarily be *engraved* since, at the time, engravings were the only way of reuniting these fragments and creating a series of images, of which we must assume he was *technically informed.*

And if imagery – like memory and, indeed, knowledge – is always technically informed, then other eras with other reproductive techniques will give rise to other forms of imagery. The difference between the art historian and the ordinary viewing public depends on their ability – or inability – to inform their imagination, avoid the aesthetic contemplation of a work of art in isolation and develop – and (or not) refer to – a background context of *points of comparison.* Judgement for the art historian is therefore a strictly informed judgement, based on the establishment of series.

Quatremère gives some indication of what these points of comparison and series can be. An artist's school or the totality of an

artist's work can create a series. This is why it is crucial that the whole of an artist's work is gathered in one place where it can be studied in its entirety. The need is even more pressing for an artist such as Raphaël whose works are widely dispersed and often not on display. Here again, the pyramidal hierarchy must be re-created. This pyramid is a mirror, a prism, a natural system in which nature is automatically analysed. Here we encounter Leibnitz again. Nature (i.e. natural variety) is, as it were, reflected in the many different schools, each school representing a *characteristic*, a reflective system:

> Each Italian school [has] its own characteristics. In fact, they can be compared to so many different mirrors, in which nature is reflected in all its various aspects and becomes fixed, as it were, by the imitative and artistic processes. Nature is as varied as the ways of perceiving it are numerous. However, these infinitely varied shades of perception can be reduced to a few main differences or characteristics. And thus the most basic forms of imitation have been, as it were, analysed by the various Italian schools, which have become a sort of pictorial prism, in which students see nature broken down and reduced to a system. (Letter VI)

It is this group of characteristics that forms the substance of museum collections and it is therefore, in the final analysis, natural variety that is impoverished.

The theme of variety in art is, as we all know, a commonplace which was revived, in particular, by Alberti's treatise *Della Pittura,* as a result of which it became an aesthetic standard. But then surely Leibnitz' *Monadologia* could be considered, among other things, as a treatise on art. The treatise of an age – in the strongest sense – of perspective. A school of art could be seen as an extremely complex monad. The true basis of art lies in a certain number of characteristics. And what would Rome have been as a monad: the Museum?

THE 'MUSEUM' OF ROME IN RELATION TO THE 'AGE OF MUSEUMS'

If we remain within the sphere of knowledge and therefore, to some extent, of the judgement of beauty and of creation, Quatremère is not radically opposed to museums in so far as they are centralized diffusers of knowledge. This is obviously because the question of the moral (social, but basically *ontological*) destination of the works of art is not raised. The works that he describes no longer have a

destination. While being the worst of institutions in that it suspends the destination of works of art, the Museum is at the same time indispensable because it provides the aesthetic – critical in the sense of the Romantics – discourse with a location. And this location is the Museum.

Although Quatremère was a relentless critic of the museums established by the French Revolution, as well as of older collections, when he writes as an art historian and connoisseur he cannot ignore the fact that there has always been a Museum, and that without it there would be no works of art. In his writings on aesthetics, even and especially in his condemnation of the Museum, he always reverts, in spite of himself, to its state of 'potentiality'.

For Quatremère (and herein lies the potential of art and criticism), the age of the Museum was preceded by the universal Museum of Rome. Rome was in fact the archetypal Museum. For Rome, the ultimate series of all series of works of art, was in fact constituted from the spoliation of Greece and Egypt. The works of art that formed the papal collections were as likely to have been confiscated – particularly from ancient royal Italian courts such as Ferrara – as commissioned. In this way, Rome represented a complete voyage which replaced all other voyages:

> For a truly enquiring mind, the city of Rome is an entire world to be explored, a sort of three-dimensional mapamundi, which offers a condensed view of Egypt, Asia, Greece and the Roman Empire, the ancient and modern world. To have visited Rome is to have made many voyages in one. Consequently, to disperse the works of art collected together in Rome would be to deprive scholars of both their instruments of learning and the object of their research. (Letter VI)

Factually speaking, just as Rome was the prototype, so the pagan religion provided the aesthetic principle of the Museum. This being so, we consider it important to reinstate a 'white' image – in the sense that Maurice Blanchot uses *la parole blanche* in his *Entretien infini* – of the universal Museum of Rome, an image which already has all the characteristics of the 'black' image of the Revolutionary museum as represented by the Louvre. Quatremère could not avoid discovering this 'original' image of what he was denouncing because this image was, and still is, the precondition of his aesthetic writings.

We are therefore saying that the Museum of Rome already had all the characteristics of the centralized repository of all works of

art, of the Louvre for example. With the exception that Rome was also – indivisibly – an historical site, with a particular quality of light, a particular type of sky, and a particular atmosphere. It was a combination of natural and historical elements which, by their very nature, could not be displaced.

But surely the same could be said of any great museum which has become, as it were, the natural site for the works of art it contains, because it has become their setting, their light, in short their permanent resting place. One has only to think of Michelet's despair in the Louvre when the Allies of 1815 repatriated the plundered works of art. Could the *Victory of Samothrace* be moved from the Louvre today? On the contrary, should we not consider that its very landscape, its light, geography and history have become an intrinsic part of the Museum?

By inverting the following text by Quatremère, it becomes clear that everything, from this point on, should be evaluated in relation to the Museum:

> The true Museum of Rome, the museum of which I am speaking, consists, it is true, of statues, colossi, temples, obelisks, triumphal columns, baths, arenas, amphitheatres, triumphal arches, tombs, stucco, frescoes, low reliefs, inscriptions, fragments of decorations, building materials, furniture and utensils. But it also consists of places, historical sites, mountains, quarries, ancient roads, the respective sites of ruined cities, relative geographical features, inter-relationships between objects, memories of past local traditions, existing customs, parallels and comparisons that can only be drawn and made in the country itself. (Letter III)

This makes it clear that, from the point at which he introduced the concept of patrimony, everything that Quatremère considered indissociable, indivisible, untransportable – i.e. which constituted the 'natural' site of the vast numbers of antique works of art – either suffered or would suffer the fate of everything for which he fought during his lifetime. His description of the site could have been even more subtle, stressing the importance of a country's language, symbolic systems of proper nouns, and so on.

It was like a collection of items destined to be recorded and preserved for us to enjoy today. Thus it was the Museum which invented the concept of natural patrimony, the need to preserve nature in so far as it was linked to an historic site. All those elements which, according to classical aesthetics, were classified as the

conditions under which the works of art were created, today suffer the same fate as those same works of art. Artists, like all those involved in art, and even philosophers, must be preserved in the name of an irreplaceable patrimony. But wasn't this, according to Strabo, the function of the first museum, the Museum of Alexandria, i.e. to enable philosophers to meet and discuss their ideas in a pleasant setting, surrounded by statues?

Quatremère even goes as far as to justify a policy of international patrimonial interventionism, the right to intervene to prevent works or art being neglected:

> The great wealth of the arts and sciences is protected by the fact that it belongs to the entire world. As long as it remains public property and is well maintained, it is of little importance which country acts as its custodian. [The country] is merely the curator of my Museum. But it would certainly deserve to be deprived of [its function] if it concealed or abused [this wealth] or allowed it to fall into disrepair. Otherwise, it would have to be paid to take care of it. (Letter V)

The Museum cannot therefore be dissociated from the test of division in the sense that it is used by Machiavelli, whether it is internal – i.e. social and political – division or the division – or rather the difference – of historical time. Both the detractors (Quatremère) and defenders (François de Neufchâteau) of the Museum compare the Louvre with Rome. Quatremère saw the Louvre as contributing to the destruction of an enlightened Europe centred around Rome: a Rome which was at once the great monad, the ultimate collection, the hotbed of (aesthetic) knowledge and the heart of an international society whose links were forged by cultural exchanges. He considered Rome to be a good and sound society because it was the centre of a sound European cultural policy. The Louvre, on the other hand, contributed to the destruction of the concept of 'otherness' and the difference of historical time, without which modernity would cease to exist since the vital point of reference – i.e. Antiquity – had disappeared because it had been plundered. The Louvre therefore introduced a barbaric temporality, which marked the end of imitative art.

But, according to Quatremère's argument, Rome could not be this treasure house and this centre because this was already the age of the Museum. Rome was merely a copy of the Louvre, projected into the past. Rome was the after-event of the establishment of the

Louvre. The temporality of the Museum is essentially retroactive; it is a temporality that moves backwards from the point of its establishment. Thus the continual unearthing of statues during excavations is an act of destruction which is an exact parallel of the destruction of European cultures carried out by the Louvre.

The opposite is true for the Directeur, François de Neufchâteau, who saw Rome – i.e. the papal collections – as the paradigm of alienated art. For him, the Louvre stands in direct contrast to Rome as the liberator of universal art, a place where one can comprehend that each ancient work of art is a concealed allegory of liberty. For every work of art, from the very beginning of artistic creation, has been essentially divided.

But this division, and therefore the very essence of art, could only be seen in Paris by the nation which had the privilege of signing the Declaration of Human Rights. The Museum was therefore the precondition of a good and sound society. By inventing art and writing its history, the Museum negated the difference in historical time, since artists have always worked in the same present, and by reconciling beauty and virtue, it necessarily became a veritable temple of negation, the negation of present, internal division.

THE LOUVRE: THE NEGATION OF DIVISION

The leading museums of Great Britain, the British Museum for example, amassed private collections – at least in the early stages of their history – with scant regard for coherence of presentation or critical discourse. Their French counterparts, on the other hand, were inspired by a political or, more precisely, a politico-metaphysical discourse. They were organized in much the same way as the festivals used by the French Revolution to perpetuate its own image (Ozouf, 1976). This was the politics of aesthetics and not, as in Germany, an 'aestheticisation' of politics.

This political programme was clearly explained in a speech given by François de Neufchâteau, the then Minister for the Interior, during the Festival of Thermidor, held in the year VI to celebrate the return of works of art seized from churches, palaces, Italian collections and, in particular, from the papal collections in Rome. The term *return* is used advisedly, as will become clear.

In his speech, François de Neufchâteau addressed those 'generous and sensitive men, from every clime, [who were] blessed by

heaven and tormented by the love of beauty'. These artists and art lovers from other countries and the French provinces were shown around the museums:

> Today, these masterpieces are here for you to admire, steeped in the morality of a free nation. Amidst this cornucopia of good taste which you see before you, and surrounded by these unique treasures, the French nation – which upholds the law of nature and the sacred right of equality – will necessarily be the guardian of your virtues. While its museums enrich your mind, its laws and examples will enrich your soul. It will make you more worthy to practise the arts, because it will have shown you the greatest art of all, the art of betterment. Fine art, in the hands of a free nation, is the main instrument of social happiness and a useful subsidiary of the philosophy which ensures the well-being of the human race. (Pommier, 1989: 61–4)

Fine art and therefore the museums which housed it had a very precise destination, an ethical and political – i.e. a civic – destination. The actual discourse, by combining various types of discourse and their different types of statement (aesthetic, political, ethical and philosophical) and bringing them together under the primacy of the politico-ethical statement, gave this destination a new form, known as modern politics, as defined by the French Revolution. The present article is not so much concerned with analysing this destination as with understanding the implications for art of this politics of the Museum. For museums were indeed the subject of a political theory, of which there does not necessarily appear to be any evidence outside France. This raises the issue of the 're-destination' of the Museum, an institution which, according to Quatremère, in fact suspended destination.

The Museum of the French Revolution *liberated* art. From the time of the Belgian campaign, the Revolutionary armies did not limit themselves to bringing back occasional works of art plundered here and there. On the contrary, there was a positive policy of *liberation* and *annexation* of works of art. Although the two terms are undoubtedly contradictory, they exactly characterize the ambiguity of the Revolution's foreign policy, an ambiguity which lies at the very heart of the Declaration of Human Rights. It is a well-known fact that the Declaration was intended to be universally applied, and yet it was legitimized by a sovereign nation, the French nation. It was an *individual* – nominally identified – political community which answered for the *universal*. From that point on, the

Revolutionary wars could only be wars of liberation *and* annexation. Works of art would be liberated but could only be placed on public display in Paris.

The 'liberation' of works of art was not (simply) a matter of their spoliation, as was the opinion of Miranda, Quatremère, Burke, the authors of the *Athenaeum* and the artists who objected to their displacement. Prior to the French Revolution, works of art in royal collections and monasteries were not (or rarely) seen by members of the public. The Revolution made it possible for them to be seen without the personal beliefs and values of art lovers being adversely affected:

> Royal arrogance can no longer keep you from the object of your studies. You will no longer have to seek the ostentation of royal courts, or endure the aspect of superstition and cloistered ignorance to enjoy the all-too-brief contemplation of the works of art you have travelled so far to see, returning to your countries, possibly a little better informed but certainly more corrupt. (de Neufchateau, quoted in Pommier, 1989:61–4)

As a product of liberty and equality, French museums were necessarily virtuous and edifying. They were the first institutions to place art on public display. But they primarily housed an art which had developed in the shadow of despotism and superstition. This would appear to be self-evident, but did such an art actually exist? Was there in fact something which resembled authentic art in these places which, as yet, still had a destination?

TOWARDS AN AESTHETIC OF ART

Was it possible for an authentic art form to develop when commissions were either royal or religious (as were the subjects and the places and people for whom they were destined)? Surely these works of art were *adapted to* and therefore inherently marked by their destination. What was there in these works that was something more than a symbol of religion or despotism? What was there in a religious subject – the painting of an altar for example – that could escape the religious destination and, as it were, demand or express the desire or the vocation to be something more, thereby surviving the collapse of the Ancient World or the world of Christian destination.

The answer is probably *art*. But as yet this is only a name, the

name of what remains when the strictly defined element of the work
– i.e. the destination – has collapsed and become hated and de-
spised. There is something that survives and calls out, even though
the destination of the work either no longer exists or, if it does, has
become unacceptable. There is a demand which comes from a long
way off, from unknown ages and other lands. And this demand is
inextricably bound up with the determination to survive. But is it
merely a question of preserving the surviving traces of lost cultures,
evidence of past civilizations, historical sites, the deeds of great
warriors or politicians, of reinstating or emphasizing a particular
meaning? These are the words used to conceal the strangeness of
this recurring element, which is transmitted from one collection to
another, from one museum to another, from one owner to another.
These men and these institutions are merely agents of transmission
and the true mystery lies in the need for objects to transmit (the
minimal destination) and to serve as obscure staging posts.

Here we encounter a temporality – the temporality of collected
objects, works of art – which is not the temporality of religious
works which, although the same, are caught up in the stranglehold
of a particular age and which, because of this, have to make their
mark, to make a statement and have a specific destination. This is
the temporality of suspense, of incompletion, of return, the tempo-
rality of a continuity which extends across the ages, a cyclic tempo-
rality which was excellently described by W. Benjamin and which is
analysed in *Le Musée, l'origine de l'esthétique* (1993).

Today, we subscribe to the idea of preserving the patrimony and
historical sites which for the Revolutionaries constituted the source
of a repressed liberty which had to be allowed to emerge. But the
objects themselves had nothing to do with it: they were incidental.

It was therefore necessary to assume that these objects were
merely caught up in a system for making historical statements.
François de Neufchâteau refers to this distance from the
commission's intended destination as an 'awareness of the future'
on the part of the creators of the past. This means understanding
that there can exist, in the most modest of religious objects, in the
created work, something that is absent and yet somehow deeply
engrained:

> Let it not be thought that the arts wanted to make tyranny agreeable or to
> embellish the dreams of human credulity. These great men were not labour-

ing for kings and pontiffs, for mistaken beliefs and false doctrines. It could be said that genius is the gold of divinity because it is unsullied by impurity. These great men, thrown into centuries of servitude, gave in to the need to create. They created not so much for their age as in response to an instinct for glory and, if one can so describe it, an awareness of the future.

But this division within the work itself, this *something* in the work that escapes destination as it does utility and function, is nothing other, according to the ultimately reductive interpretation of our ideological Directeur, than a *meaning* seeking – i.e. *waiting* – to be expressed. In this spiritualization of the *quod*, anything that relieves this state of waiting is welcome. The spirit or deeper meaning can always take over from (i.e. relieve) the letter or more literal interpretation, as the Old Testament prepares for and heralds the New. A new form of destination – in this case Revolutionary destination – can always invest this *something*, abandoned by an earlier destination, with new meaning. Thus we can see that it is possible to redefine everything that is in a state of suspense, that the neutrality of the Museum cannot escape the return of metaphysics, that aesthetic judgement in the Kantian sense always risks being subjected to rational Thought as though it were demonstrable, that a subject which emerges as part of a statement of fact can always be reassessed from an empirical and historical point of view.

Theories can always be revised and redefined. But a new destination can only be introduced if we remember that it was to some extent already present throughout the world and has contributed to its sense of direction and meaning. A destination is always introduced after the event: and it is because it already existed that its return can be justified. For example, the works of art of Greece and the Renaissance were already free.

When it does return, it is therefore perfectly legitimate for it to lay claim – if necessary by (Revolutionary) force – to what has (always) introduced it, and – from beyond the time during which it was (temporarily) lost – to re-establish links with itself in the present. And it is in this sense that the liberation of the past, as carried out by the French Revolution, and indeed by every revolution, is also a process of annexation.

In this way, it was possible to interpret historical works both as works of art and as this *something* which could only be truly

expressed in a free country – that of the Great Nation – because its very essence was freedom.

This structure of temporality, which is the temporality of the Museum as well as of the history of art and aesthetic criticism, is the temporality of constantly repeated – and extended – creation. In other words, it is the temporality of art. But it is a temporality which necessarily fails in what it creates, since it continually rediscovers what it has contributed. Today, the task of aesthetic criticism consists of identifying the ways in which destination envelops this *something*, which always remains in suspense.

The museums of the French Revolution saw nothing in historical works of art other than images of an alienated liberty crying out to be reinstated. From there, it follows that the seizure of works of art in Italy, Belgium, Holland and subsequently in Spain were not acts of plunder but the fulfilment of a desire expressed by the works themselves. Such a programme could be classified as ideological, but this would be to disregard the temporal structure of all forms of destination, against the ambiguous and paradoxical nature – that intrinsic division – of the work itself, and against the continued belief that art has not been erroneously interpreted as an image of liberty.

To quote François de Neufchâteau:

> They [great men, great artists] undoubtedly foresaw the destinies of nations and, through this legacy of sublime paintings, bequeathed to the spirit of liberty the task of granting them their rightful share of glory and the honour of awarding them the acclaim they felt they deserved. Thus, the French nation was not content with enlightening its contemporaries with the flame of reason. It became the avenger of the arts, freeing them from the humiliation they had endured for so long by releasing so many dead artists from the obscurity in which they languished and simultaneously crowning artists from thirty centuries. It is because of the French nation that they have today taken their rightful place in the temple of memory. If it is indeed true that certain perceptions survive beyond the grave, it is reassuring to think that this solemn circumstance has an audience of invisible onlookers, all those grand masters of fine art born of Greece, Egypt and the two Romes. It would seem that past centuries have gathered down the ages to celebrate this wonderful event and to give thanks to this Great Nation for having snatched the superb images honoured by these great artists from the decay in which religious prejudice and monastic ignorance has kept them buried for so long. Famous spirits whose divine genius and admirable works are brought together within these confines! If you are listening, as I believe you are,

answer this feeble voice and tell me: as you experienced the torment of glory, did you foresee the century of liberty? Yes, it was for France that you produced these works of art. At last, they have fulfilled their destination. So rejoice, illustrious spirits! You are now enjoying the glory that is rightfully yours. You can see the competition inspired by your works of art, to offer a place of refuge to your spirits and give sanctuary to your works, and to ensure, for the first time, the true immortality of fine art. (Pommier, 1989:61–4)

CONCLUSION

The occasion of the Festival of the Return, after the 9 Thermidor (27 July 1798), was obviously seen as marking the end of Jacobin tyranny and the reconciliation of the French nation *vis-à-vis* itself and the power of the Directoire. The suspension of the difference in historical time, embodied by the presentation of works of widely diverse origins, reinforced the suspension of internal political divisions. The destination was still one of a totality which it saw as its ultimate aim and in relation to which it saw itself as *devoir-être*, i.e. as having an obligation to exist. The Museum was therefore a vital instrument in achieving this reconciliatory totality which transcends division. It was a question of constructing a political community using materials which consisted of repatriated works of art and the works which would certainly arise from their unification.

From this point, obscurantism, the despotism of the Ancien Régime and vandalism were driven back upon themselves, like the protagonists in a conflict which formed the very basis of their complicity. It is obvious that the Festival, and therefore the Museum that it commemorated within the same time scale, cannot be regarded as historic landmarks to the memory of a liberated past. This memory, which is created from the suspension of historical time and therefore from the suspension of ages, of the intrinsic destinations of the works of art, and from the suspension of internal conflict within the nation, is in fact based on an act of negation. For it is vital to negate what has caused division within humanity and divided the nation, in spite of the fact that, because of its *raison d'être*, the Museum can only suspend – i.e. not take account of – different destinations, otherwise it would not invent art. That is its system: the need to negate! It must negate the various forms of division and difference!

It will be said that all revolutions make a clean sweep. This may be true, but it is all the more true when a revolution has as its cornerstone an institution which, by definition, denies the difference in historical time. The basis of a political community founded in this way is curious indeed, since art and freedom are generated by an *act of negation.*

Because the Museum constituted a vital part of the new destination, there was an underlying opportunity for that *something* in suspense to emerge. Art would soon triumphantly liberate itself from the Republic. As de Neufchateau put it:

> And when, citizens, will nature and the arts be eager to lavish their favours upon you? In these fortunate times, on the very day that I am addressing you, that transient vandalism has disappeared forever from a land indignant at having borne it! Here is the triumphal procession, the ceremony that will expiate the crimes of the tyranny overthrown on the 9 Thermidor.
>
> Here is a festival, unique among nations, *the festival which undertakes to eradicate all memories,* the triumph of nature, the triumph of the arts, the triumph of liberty [. . .] Citizens of France! Bestow all your respect on this august tomb of all division . . .

The Louvre: the tomb of all division.

BIBLIOGRAPHY

Benjamin, W. (1993) *Le musée, l'origine de l'esthétique,* Editions de l'Harmattan, Paris.

Ozouf Mona (1976) *La fête revolutionnaire, 1789–1799,* Gallimard, Paris.

Pommier, E. (ed.) (1989) *Lettres à Miranda sur les déplacements des monuments de l'art de l'Italie par Quatremère de Quincy,* Editions Macula, Paris.

10

The Historicality of Art: Royal Academy (1780–1836) and Courtauld Institute Galleries (1990–) at Somerset House

MARY BEARD and JOHN HENDERSON

He who enters, not knowing what to expect, gazes a while about him, a stranger among strangers, and goes out, not knowing what he has seen.

J. Baretti (RA Secretary for Foreign Correspondence 1769–89),
Guide Through the Royal Academy (1781: 1)

INTRODUCTION

This paper arises from a lecture delivered in the Kenneth Clark Lecture Theatre in Somerset House for the Courtauld Institute *Public Lectures, Spring 1994*. The lecture was a reading, a re-view of the museum-display in the Courtauld Institute Galleries at Somerset House. We visited the Galleries' display of (to quote from gallery leaflets) 'world-famous paintings . . . in the very centre of the capital' four years after their first installation in Somerset House, just as a major rehang began: our aim was to examine the 'marriage of the collection and the setting', the relationship between the paintings on display and the building which now houses them. The Chairman of the Courtauld Institute of Art had declared:

> The establishment of the Courtauld Institute of Art[']s remarkable collections in Somerset House is a triumph. . . . The exceptional series of Fine Rooms designed for the Royal Academy and other learned societies, needed an equally exceptional occupant. The Courtauld collections could not be more appropriate. . . . I believe . . . discerning visitors . . . will all enjoy and marvel at the renaissance of this great building. (Goodison, 1990)

The match sounded perfect: a premier art collection attached to a

233

prestigious art history institute of education in search of a gallery; an edifice purpose-built for the training of artists, the promotion and governance of the arts, and the exhibition of the cream of the nation's production of paintings. Here is a signal instance of Art in the Museum, with a vengeance.

We put to the installation the question of history. The collection brings with it its own histories, the stories of its art works and their collectors, of the world art market and its constructions of precious charisma – as well as the onus of affirming all this in the terms of its display. But Somerset House promises always to reassert *itself* as its own prize exhibit, and to construe its contents according to its own history, particularly its history as the home of the Royal Academy (RA). This Academy, Joshua Reynolds' brainchild and stamping-ground, remains Britain's primal scene of discourse on art, *the* theatre for viewing, and lecturing on viewing. The building always threatens to regress to the condition of a Soane Museum (RA Professor of Architecture, 1806–37), as if its first tenancy by the Academy (1780–1836) determined its museology outside temporal change, dominating the objects and fixing for ever its own rules of viewing: the Act of Parliament establishing Sir John Soane's Museum in 1833 made it the duty of the curator to keep the assemblage 'as nearly as possible in the state in which Sir John Soane shall leave it' (see Elsner, 1994).

The history of this museum/gallery brings with it more than the prompts of preserved or restored hues on wall and ceiling, the authentic feel of carpeting and upholstery, the style of picture-hang; it parades a social-cultural history which prescribes and authorizes a systematic programme of induction and enculturation, production and presentation, viewing and valuing, marketing and preferment; in sum, a calendar and career for Art in Britain. While some hints of nostalgic reversion to an early nineteenth-century 'period' setting are indeed in evidence today (black/white photographs on the ceiling, no less – recapturing the lost decoration; 'pink, lavender, and pale green' plasterwork, 'some idea of the heady colour-schemes which Chambers intended throughout'; 'other [ceilings] will be decorated in their original colours as and when funds allow', Farr and Newman, 1990: 32, 29), it was the synthetic *historicality* of the site/sight which monopolized our attention in the visit we made.

We went armed principally with the following textual aids:

(i–ii) Baretti's original guide to the RA in Somerset House (1781); P.A. Martini's engraving from J.H. Ramberg's drawing *The Exhibition of the Royal Academy, 1787*, the earliest representation of a RA Summer Exhibition in Somerset House (see Hutchison, 1986: 49 and plate 18; Newman, 1990: 35; Waterfield, 1991a: 123f, 'D4').

(iii–iv) The twin modern guide books that inaugurate the Courtauld Galleries' installation within Somerset House: Farr and Newman, *Guide to the Courtauld Institute Galleries at Somerset House,* 1990, and Newman, *Somerset House: Splendour and Order,* 1990.

BACKGROUND

Sir William Chambers' Somerset House found Georgian funding for the establishment of administrative nerve-centres and governmental offices under the wing of the Royal Navy (the Navy Office). The defiantly imperious frontage, terrace and sea-gate onto the Thames repaid the investment in full, along with the magniloquent sweep of its supporting courtyard. While access from the Strand for callers and their coaches lay through a high-security gatehouse beneath a facade relatively modest in extent, its every surface was coated in symbolic capital – tricked out in relief columns and such, festooned with allegorical sculptures and studded/studied with figural details. Clearly *something* sublime, palatial and unrelievingly Palladian, lay behind.

The grand design of the whole complex was its founding and enabling principle; but the intelligentsia – *glitterati* such as Burke, Johnson (RA Professor of Ancient Literature 1770–84) and Boswell (RA Secretary for Foreign Correspondence 1791–5) together with Reynolds (President 1768–92), Benjamin West (Foundation Member and always already designated heir as President 1792–1805, 1806–20), and Chambers himself (Treasurer 1768–96, by royal appointment) – seized the opportunity to instal in the Strand block, as gatekeepers, their fledgling quango, the Royal Academy (estd. 1768. Forty 'Painters, Sculptors, or Architects': the original professorial posts named 'Painting', 'Architecture','Perspective' and 'Anatomy', see Hutchison (RA Secretary 1968–82) 1986: 25,

269f.). With superb timing (1771), the Academy's offices had spilled
from Pall Mall into Old Somerset House just in time to stake their
claim to stay after the building was condemned (1774) and (after the
suspiciously fortunate sudden death of Chambers' scorned rival for
the commission) replaced (1775–1801). Though shared later on with
the Royal Society and Society of Antiquaries (henceforth RS and
SA), their Strand block was built first (1775–9) and the décor and
furnishings ready more or less straight away (1780). For instance,
Angelica Kauffman (Foundation RA) instantly produced her now
much-admired allegorical ceiling ovals before leaving in 1781 to live
thenceforth in Rome, as the second Mrs Antonio Zucchi (Harris
and Nochlin, 1978: 174–8.). As for the Treasurer, he took his own
hint and awarded himself *chambers* in New Somerset House.

Since the Academy left in 1836/7 (first for uneasy symbiosis with
the National Gallery in Trafalgar Square, later to find their present
home in Burlington House), their gatehouse has 'remain[ed] in use
for its original purpose, as government offices', and so 'has on the
whole survived with gratifyingly little alteration.' (Newman, 1990:
39). The Registrar-General's spell of residence, all those lives cycled
from birth to death through marriage, left no visible traces beyond
hiatus and vacuum – and minor redecorative obliteration (1870s–*c.*
1970).

'The Courtauld Institute Galleries are an integral part of the
Courtauld Institute of Art, University of London' (*estd.* 1931: Farr,
in Farr and Newman, 1990: 19). The Institute brought the teaching
of the history of art to Britain. It moved with its libraries from
Portman Square into the vacant gatehouse wings of the Strand
block in 1989, when it was joined (in another 'marriage': Goodison,
1990) by its art collection, which moved into the RA, RS and SA
rooms in Somerset House from its previous gallery in Woburn
Square (1958–89). The collection centres on Manet's final master-
piece, *A Bar at the Folies-Bergère,* together with a wealth of Im-
pressionist and Post-Impressionist paintings (Le Déjeuner sur
l'Herbe (artist's copy), a Van Gogh *Self-Portrait with Bandaged
Ear*, Cézanne, Degas, Monet, Renoir, Seurat, Toulouse-Lautrec).
But it also includes Renaissance paintings and panels (Botticelli,
Cranach, Tintoretto; Pieter Breugel), Rubens and Van Dyck,
Tiepolo, Gainsborough, Modigliani, Sickert, Ben Nicholson, Gra-
ham Sutherland; Kokoschka; and various furnishings (fifteenth-
century *cassoni*, a Chambers *Medal Cabinet*, Huguenot silver, *objets*

from Omega Workshops, twentieth-century sculpture). Successive benefactions represent the tastes, quirks and wallets of Courtauld, Seilern, Lord and Lady Lee, Fry, Blunt . . .

Woburn Square housed the collection in a state-of-the-art gallery (Plate 22) where contemporary art-lovers could follow at leisure the suavely textured walls' eye-level hang in a well-spaced single row, arranged in harmonized patterns of symmetrical sequence that extended through a connected series of rooms successively glimpsed ahead. Beneath softly shielded daylight and subtle low-ceiling electric lighting, cultivated visitors could sink into a central sofa, breathe the latest safely conditioned air, and watch the flow of fellow admirers across the parquet flooring and past the chairs, *cassoni*, and even the odd harpsichord that lined the walls to keep back the *profanum vulgus*. History here took a back seat, and pleasurable viewing of the Story of Art, in and as the here-and-now, proclaimed connoisseurship and visual wonder. A visitor to these galleries knew just what game they were playing, fully in possession of their thoroughly modern discourse of art.

JUST VISITING

Every museum is as implicated in its past as the Courtauld Galleries – but not to the extent of having separate guide books for its artefacts and for its building. Somerset House offers visitors a lesson or two in the history of its space. Yet the lesson is masked by a reticence about the significance of that history for framing the viewer's experience, as well as by an etiolation of the complexity of that history. In short, study the art *of* historicality: is it possible to incorporate the history of the Royal societies into the viewing and display of the Courtauld collection of the 1990s? Or must we come to the display in competition with history, against the grain of the Fine Rooms' layout and design? Are the Royal Academy and the Courtauld Galleries a happy couple – or terrible twins?

It is instantly clear to any visitor to the Galleries that the buildings in which the collection is housed, the history of these buildings and the historical function of those buildings, are deemed and to be deemed important in their visit. The rooms on the first floor form in their original design and function the offices and work-spaces of the RA, RS and SA; the second floor boasts the Great Room, designed as the RA Exhibition Room, the oldest and

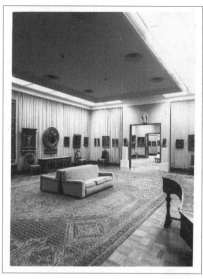

22 The Courtauld Institute Galleries, 1958: Woburn Square (source: Waterfield, 1991: 172, H2; reproduced by permission of the Courtauld Institute of Art).

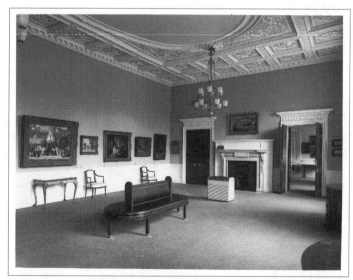

23 The Courtauld Institute Galleries, 1990: Gallery 5, the Royal Society Meeting Room (source: Farr and Newman, 1990: 12–13; reproduced by permission of the Courtauld Institute of Art).

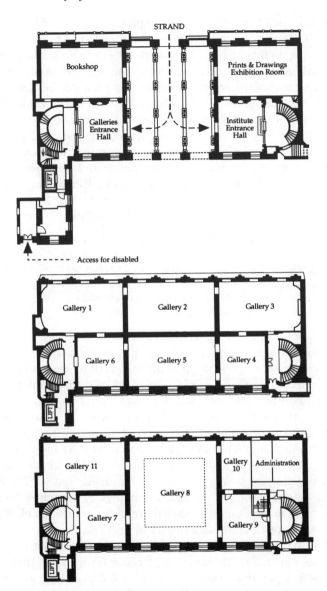

Figure 10.1 Plans of Courtauld Institute Galleries at Somerset House. Above: Ground floor, Centre: First floor, Below: Second floor. (after Farr and Newman, 1990: 31–7).

most historically charged public display area in London (see Fig
10.1). Throughout the Gallery we are directed to see, and relate
our seeing, to that history. The rooms are labelled to indicate their
original function in the organization of the Societies. And Farr and
Newman constantly refer backwards and forwards between pres-
ent display and previous use. The first essay in their guide (1990:
5–17) is on 'The architecture of Somerset House'; and as you follow
their 'Room by room guide' (29–37), the entry for each gallery is
prefaced *in italics* by an architectural description, an account of its
original appearance, and the fate of that decorative scheme: thus,
for example, the entry for 'Gallery 1' (the first Renaissance Gallery
and originally the 'Antique Academy', i.e. former home of the
RA's main plaster-cast collection) reads as follows:

> In the niche at the west end originally stood a large cast-iron stove in the
> form of an obelisk. The plasterwork of the ceiling forms an oval within a
> rectangle, with the initials of the Royal Academy flanked by pairs of brushes
> at the four corners. In the friezes over the doors the squat sprigs of foliage
> put Baretti in mind of 'Gradasso the dwarf' introduced by Raphael in one
> of his most serious paintings. (30)

This is indeed to be a *Guide to the Courtauld Institute Galleries at
Somerset House,* to work in tandem and *overlap* with the *Somerset
House* brochure by Newman. You will have to be a determined
iconophile to read your way into the modern display – of 'Rubens
and 17th century art' – in 'Gallery 3 *(Society of Antiquaries Meeting
Room)*', past notice of Reynolds' former ownership and praises of
a Rubens sketch quoted from his *Eighth Discourse*, with superadded
admiration from Gainsborough (Foundation RA) and Constable
(RA, 1829–37). And in 'Gallery 8 *(Royal Academy Great Room)*',
even skipping the *italics* won't work, for an account of 'The R.A.
"Line" ' (the linear rail on which paintings of particular honour
were hung in the Summer Exhibition) is woven into the plain text
supposedly reserved for description of the collection.

Tensions between pictures and building surface and multiply at
once as you follow the designated route through the first floor
rooms. The paintings have a strong logic and trajectory, an evident
narrative that leads from Gallery 1 to Gallery 6. Start in 1 with the
Renaissance: Botticelli, fifteenth century marriage chests with
'classical' scenes from Livy, supplemented by a Roman funerary
altar [*sic*] to remind us, the Guide says, of 'the rebirth of interest' in

the classical past that informs the renaissance (30). Move on through the sixteenth and seventeenth centuries and Rubens in 2 and 3 and, via Tiepolo and the eighteenth century in 4, to 5's Manets and finally Post-Impressionism in 6. A historical tour through the history of (high Western European) painting, selectively represented by the holdings of the Institute, itself the unselected aggregate of multiple selectively collected and bestowed collections and as such more or less representative, and/or unrepresentative, of the history of art.

But simultaneously visitors follow the other narrative, *italicised* in the Guide and emphasized by the *Somerset House* booklet, the narrative of the building and its history. A more difficult itinerary, this. Three distinct Societies once claimed their share of this space. The RA occupied Galleries 6, 1 and 2. Room 6 was their Ante-Room and Library, 'difficult' as it is 'to envisage where the bookcases could have stood' (Newman, 1990: 33 – where the Modigliani is perched, would be an accurate but scarcely helpful answer). In 1, students at the Academy school were trained, by Academicians serving by rotation as 'Visitors', in drawing casts of ancient sculpture; 2 was their Council and Assembly Room. Served by the staircase on the other side of the gatehouse and entered from the other end of the same floor are the quarters of the SA and RS, which were obliged to share a joint Ante-Room (4) that gave separate access to the SA Meeting Room (3) and the RS Meeting Room (5). Thus the visitor's route transgresses wildly against the logic of the building's history. To travel from Galleries 1 through 6 we must violate the separation of space between the three august Societies; and take a path open only to architects, planners and – the cleaning staff, after all the meetings and classes of the day or month were over and the building left to itself. In stepping from Room 2 into 3, you cross the divide between RA and SA territory; to move on to 4 is to 'reverse' out of the SA territory into its Ante-Room; entry from there to 5 is 'legitimate', but the door from the RS Meeting Room into 6, the RA Ante-Room-*cum*-Library, would never have been opened *in illo tempore*. Even within the RA's own suite of three rooms, the modern visitor is obliged to break up the logic of their interconnection. We entered, not through the formal progression from Ante-Room, Antique Academy to Council Room (6, 1, 2), but – like some drawing tiro of old – straight into 1, the Antique Academy, and after 2 we only rejoined the RA again as we left via its Ante-Room (6).

This *brisure* between the narrative of art and the history of the building leaps to the visitor's mind at various other points in the first floor circuit. One example is the series of chairs that line the walls, just as they did when the Courtauld collection was back in Woburn Square. Under the eye to history, these chairs now stand proxy for the huge change of function that lies masked by the apparent continuity of interest and attachment – in the name of art, culture, the past – that can seem to run unbroken from the three Societies to the Courtauld Galleries. Take Gallery 5, for instance. Here once sat the Fellows of the Royal Society, as in the mid-nineteenth century aquatint that shows one of their meetings (reproduced in Newman, 1990: 38; RS still in residence until the 1870s). A lively and interactive scene of throne, chairs, desk and rows of pews; a sociality that weaves between on the one hand the figures sitting, leaning, engaging and chatting, changing places and huddling in higgledy-piggledy contrast with their stiff-backed trio of presiding officers looking down at once on the body politic and on the viewer of the depiction, and on the other hand the portraits of these same men and their avatars in neat rows of idealized order above their heads. Now compare the chairs that today hug those same walls (Plate 23). Chairs that are no chairs, but quotidian fences guarding the pictures from their visitors; chair custodians that are roped off and labelled as untouchable, prohibiting all semblance of a social relationship with the paintings – which of course are no longer portraits of the denizens, but French masterpieces distanced from the viewer by their enormous market tags and the otherwheres idiom of their Impressionism. For all their apparent appropriateness, these stylish chairs serve not to offer a visual reassurance of continuity between then and now but to emphasize the gap, the disjunction in function, between the meeting room of an élite club and a public art gallery. These chairs which are not for sitting can stand for all the Gallery hints that the visitor may ease imaginatively back into the Fine Room's original appearance, one eye shut while the other evokes through the 'period' style carpet and upholstery, through painstakingly restored colour-schemes, variously archaizing picture-hangs, and every other suggestion that our visit is, impossibly/marvellously, on a continuum with the gentlemanly activities of those presumptively art-loving luminaries who once dwelled here of right. But *which* 'period' – Regency or Impressionism? And *whose* nineteenth century – George IV, or Manet? What

music shall we imagine the Courtauld harpsichord is playing, still, for the members of the SA in Room 3 – and what welcome do we suppose *they* would give the Rubens set in their portraits' place?

GETTING THERE

The way up to the Great Room (Gallery 8) is the famous Exhibition 'Stare Case' (satirized by Rowlandson in a cartoon of the (self-) admiring throng climbing up and tumbling down from the Exhibition: Farr and Newman, 1990: 14). Up or between these breathlessly winding steps were lugged or hoist first all the thousands of fresh-daub offerings, then the myriad invitees and ticket-holding culture-vultures, to the second floor and the Royal Exhibition of their year. First they (and we) passed through Room 7, the Ante-Room to the Great Room, now filled by the Chambers Medal Cabinet and the Courtauld family's Huguenot silverware.

This is the high-point, if not *quite* the last word, in the Courtauld Galleries' exposition of a further history of its own, the history of its own cumulation through benefaction (Farr and Newman, 1990: 21–7). It culminates in the donations which made it possible for the very installation of the Institute and its collections in a renovated Somerset House in 1990. 'Courtauld' in this context, in this room, becomes emphatically not the name of an Institute or Gallery but the name of a family of benefactors/donors, and in fact a firm of 1980s sponsors and lenders of riches: 'Courtaulds plc' (with its own separate guidebook on the silver available beside the silver). The Ante-Room's strange modern glass doors open onto this display with a shock for the visitor, whose tour of the first floor has accustomed them to a steady series of canvasses. The great glass-case of silver with its sensitive security camera makes a post-imperial museological companion for the mammoth mahogany medal cabinet opposite that refers us back to that other history – as if Somerset House was, after all, to be the mausoleum-museum of its architect and designer, Chambers, and all his works (the 'Soane' syndrome). The Cabinet bespeaks the latest pattern in the history of British collecting culture: 'acquired in 1986 with the assistance of the National Heritage Memorial Fund, National Art-Collections Fund, Museums and Galleries Commission, and the Home House Society' (Farr and Newman, 1990: 34). To mark the narrative of nineteenth-century Somerset House there remains in Gallery 7 only

the (bad) Ancient Greek inscription over the doorway into 8, 'NO ENTRY FOR THE UNMUSED' which signalled that 7 was originarily the Ante-Room threshold to the wonders of the mystic Great Room beyond.

Unlike the first floor Fine Rooms, which were more or less uniform in design and susceptible of adaptation to as many functions as could be reconciled with their interconnection, the Great Room was a purpose-built display space designed specifically for the Summer Exhibition (see Fig. 10.1). Accordingly, the historical narrative of the Academy makes this the patent climax to anyone's visit. In one sense, Room 8 belongs with the Academy Rooms 1, 2, 6, but those rooms were always but a marginal digression within the Academy story of viewing/visiting which is defined and realized by the insistence of the Exhibition scenario within the spatiality of the Great Room. True, some of the other Academy Rooms *were* open during the Summer Exhibition, to display in particular the Academy's own permanently installed collection of paintings, the portraits of the members and other masterpieces, as well as the Exhibition overspill; but though it crept into the Exhibition Catalogue, none of this signified within the eventfulness and hype of Exhibition fever. The one place to climb to, and descend from, was this, very special, room.

Here the Guide to the Courtauld Galleries tries to tone down the Academy as but one past tenant precursor to the art collection: 'This vast room, used from 1780 to 1836 by the Royal Academy for its Summer Exhibitions' (Farr and Newman, 1990: 34). But this only betrays and points up the strain of fitting art into this museum: it is simply impossible for the visitor to miss the point that the moulded 'vastness' of the room itself establishes the room's *raison d'être* as the optimum and maximum theatre for a visual potlatch of palette production. Once you enter (however muselessly) you know that Chambers' entire design for the Strand block balanced its winged gatehouse structure over the porticoed archway void precisely so that the soaring ensemble above would perch this centrepiece 'Architecture of Daylight' on high, its monitor-lit sublimity accentuated by the clouded sky on its oval ceiling (now over-painted pale blue) and by the precisely calculated slope of its cove up to 'Diocletian windows to enhance the dignity of the effect' (and square off for the viewer the room's actually oblong dimensions; Compton, 1991: 40; Waterfield, 1991a: 124). This is

where Painting, Architecture and Perspective join forces, the apogee of Somerset House. The best Hanoverian technology shaped the best experience of viewing here that theory could serve up, fit for a king. Recognition of this basic truth is embodied in Baretti's inaugural guide, which both reflects and establishes the official, normative visit to the Royal Academy, from the vestibule on the ground floor, up through the RA's private rooms on the first floor, and ultimately to the climax, on his very last page, of 'The Great Exhibition Room'.

ADJUSTING THE VISIT

The designated path of the visitor to the Courtauld Galleries undoes the rapturous effect. For the collection, the Great Room (Plate 24) must no longer be the be all and end all. The former Exhibition room is now a through-route, part of a loop around the relatively low-key and unsung domestic modern collections of twentieth-century work in Galleries 9 and 10, then back through the other, Strand, side of the Great Room, into Room 11 to inspect the gilt pieties of the fourteenth to sixteenth-century Italian and Dutch collection. The effect of this is again to breach the historical logic of the space, the separate articulation of the Societies that occupied this building. We must butt into what were the private offices of the RA and RS (9 and 10), originally served by their own staircase and situated above their Ante-Room and the SA Meeting Room. In the case of Gallery 11, the Painting School of the Academy, the current visitor's path turns what was designed as an independent space accessed directly from the staircase, so that the students could connect their Antique Academy and painting school operations without intrusion on the Great Room, into a dead-end annexe off the Exhibition Room.

Here, too, the historical narrative of the Courtauld's benefactions loses its trajectory. The Kokoschka *Triptych* 'skying' in the Great Room shows us a 1970s bequest (by Count Antoine Seilern) in the mainstream tradition of donation, 'Courtauld' not 'Courtauld plc'. This is grandee benefaction not fund-raising, industrial sponsorship and heritage! The further collections in Rooms 9, 10 and 11 repeat the first floor mix, for the story of the Institute Galleries' acquisitions has been climaxed and concluded already in the Ante-Room (7).

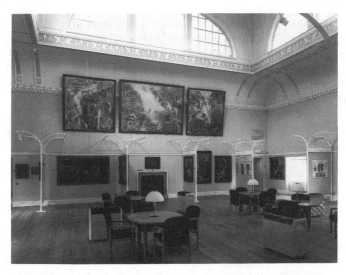

24 The Courtauld Institute Galleries, 1990: Gallery 8, the Royal Academy's
 Great Exhibition Room (reproduced by permission of the Courtauld
 Institute of Art).

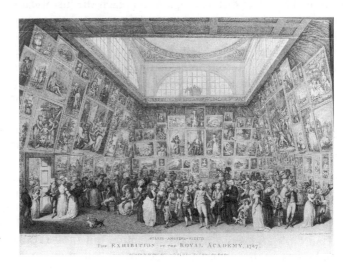

25 *The Royal Academy's Great Exhibition Room* (1787), P. Martini after J.H.
 Ramberg (source: Newman, 1990: 35; reproduced by permission of the
 Courtauld Institute of Art).

Moreover, there is no strong chronological continuation of the first floor story of the history of Western painting to carry us through the sequence of galleries. The 'Thematic Exhibitions' that have been shown in the Great Room have been indifferent to century, the twentieth-century collections in 9 and 10 fizzle out as, at best, a coda to a narrative, set in the low-ceiling and only recently partitioned-off outer reaches of the itinerary, and defused by the tour's continuation back through the Great Room and finally into the 'afterthought' irrelevancy of the back-track into Gothic angularity in 11. On this floor in general, historical consequentiality effectively peters out. Can it really have been the Omega Workshop ambience (in 9) that the visitor was heading for all along? Have we got *anywhere* since we took our bearings from that Roman altar and the Botticelli in 1 – when we arrive before Bernardo Daddi's *Crucifixion and Saints* (1348) in 11?

The historical programme touted for the disposition of the paintings now looks much more like a convenient way to fit the nineteenth-century Impressionist jewels of the collection into one of the two central Fine Rooms which have magnitude but moderation and are dignified by the recessive effect of their double access from either end (5). This congenially elegant display scenario is set to play the masking role of common denominator, bridging two centuries of discerning cultivation of artistic sensibility with effortless ease. It simulates seamless continuity between the Academy and the Institute. According to this mythology, unamused Reynolds, West and Chambers would recognize the colour schemes, relate to the furnishings, and catch up with the modern, but not *aggressively* modern, hang – spacious, eye-level, and size-, colour-, artist- and idiom-co-ordinated. But would they really? History would tell us they must be turning in their graves at us Great Unwashed traipsing through their Council and Meeting Rooms. But how could we art-lovers imagine them refusing Manet? Surely, had they been around, had they seen what we see, *they* would have snapped up Van Gogh and Cézanne when they were alive and around, just as we, *mutatis mutandis*, like to be sure we would have leaped at just the opportunities which the Courtauld benefactors actually took, well before modern discernment hallowed the Parisian splodges and splashes, and beatified the pictures with seven-figure tags and consensus between the art market index and educational discourse on Art . . . ? (see Watson, 1992).

EXHIBITIONISM

The Courtauld Galleries' first attempt to marry their collections to the Great Room took the form, as we have seen, of circulatory linkage with the rest of its floor, straight through the Thamesward side, back along the Strand side, into and out of the Painting School (11), back across to the entrance, for exit through the Ante-/Post-Room (7). The central floor-area was left to a bench or two, plus those ubiquitously companionable pairs of heaters and dehumidifers that have channelled the visitor flow already throughout the first floor. Round the four walls, a series of (rather nasty, steel-pipe heavy, floorboard-scarring) 'screens' were initially installed to achieve a partial disaggregation of the immense space. Eye-level 'thematic displays' devised by the curators and by the teaching staff of the Institute 'invite[d] viewers to look at pictures in different ways' (Farr and Newman, 1990: 34). Visitors could tuck up close into intimate corners and nooks, surprised to round a screen and bump into Van Gogh or a Tahitian Gauguin. No milling crowds, no communal swirl – show-offs keep out!

To judge from the reviews of the opening of the Galleries at Somerset House, no one ever much liked the booths.

> For later generations, the imposing but unyielding character of the Great Room has posed considerable problems. The present (1991) use of the room does not perhaps fully address the difficulties or realise the possibilities of this space. (Waterfield, 1991b: 125)

On the very day of our lecture at the Institute (in spring 1994), we were allowed to witness the Great Room's exhibitions being dismantled, as the first-floor eighteenth-century hang was being rejigged to create a more cluttered 'period'-style concentration of paintings. 'Cézannes all over the floor', we were told outside Gallery 5, closed for the duration. The first phase of Gallery use was itself passing into the history of the Exhibition Room – and taking its matching guidebook along with it (Farr and Newman, 1990: back cover, '*Information correct at time of publication. June 1990*'. Information *in*correct as of February 1994). We wait to see how the 'vast' expanse of the Great Room's hanging space will be used in the second Courtauld installation.

So far, the dramatic coloramas of Kokoschka, 'designed to be seen at a height, . . . commissioned for the ante room of [Seilern's] house [in] South Kensington' (Farr and Newman, 1990: 34), have

made just a token bow to the historical tradition of high-level display in the days of the Academy. The Triptych has played the role of an exemplar, to give the visitor some inkling of the overwhelming spectacularity of a Royal Exhibition. It has been no service to the paintings themselves that they have borne the hybristic weight of such over-exposure: can they *really* carry off a claim to such pride of place, resplendent above the grand fireplace?

The dilemma for the Galleries in the Great Room is not just a practical question of choosing a mode of display that will come off, a pragmatic matter of problem-solving within the imaginary and technical resourcefulness of museum décor or furbishing. As the Galleries' information panel at once declares to the visitor, by its reproduction in the entrance to the Great Room of the Martini/Ramberg representation of the 1787 Summer Exhibition (plate 25), the historical questions and tensions inscribed within this room are not such as will ever be dis-solved or satisfactorily masked. Rather, this is a classic instance of the complexities that constitute the history of viewing, a diagnostic case within museology.

The Great Room is not just an operator of climatic *jouissance* for art-lovers, a machine for conditioning art display as a hypertrophic glut of ocular overload. Rather, '*exhibition*ism' is here intrinsically and ineluctably a matter of *temporality*. For the kind of display for which this space was designed to be the ultimate paradigm was (no) more than a Hanoverian *lusus*. A show here was definitively momentaneous, an occasional, improvisatory temporariness, the temporality of a Summer Exhibition, to last from May until August. Outside the terms of this seasonal recurrence (preparations from selection to mounting; invitations plus policing; dismantling to reclamation of the Gallery for private use by the Academy) the Great Room simply does not exist, never did or could exist. Not in the literal sense, since we know that Academy lectures – such as Reynolds' 'Discourses' and Westmacott's 'Lecture on Sculpture at the Royal Academy, Somerset House, 1830' (engraving by George Scharf, Waterfield, 1991b: 126, 'D8'. Westmacott RA 1811–56, Professor of Sculpture, 1827–56) – were regularly given in the Great Room during the winter. We can also suppose that the girls and boys from the Painting School next door may have spilled out into the Exhibition Room out of season. But symbolically, whatever uses ingenious *ad-hoc*cery could devise for the space, the room does

not exist outside the compass of the temporary exhibition. It is only as the site of the royal show that the space can be imaged.

This has always posed problems for the guide. Baretti, as we said, leads his account of the Academy up to the climax of the Great Room. But it turns out to be the strange climax of a very short paragraph or two. There is, he found, almost nothing to describe about the Great Room, if and when it is not the site of the Exhibition. Emptied of its exhibits and salon throng, the room is visible only as its architect's design: bare dimensions, materials, and a note or two on Mr. Catton's '*Groups of Boys* . . . that fill the Spandrels of a large oval foliage-frame, surrounding a space supposed to be open in the center, through which is seen a very well-executed sky, much more properly introduced there, than the finest picture would have been, for the alledged reason'. As Baretti just 'alledged':

> As the Pictures of the Exhibition were to be the great ornament of the place, very few decorations are introduced on any part of the Room, that the attention of the Beholders might not be called off from the main object. (1781: 31)

PICTURES AT AN EXHIBITION

The Great Room is *meant* to borrow its plumes, masses of them. Hence the notion (and, we are given to understand, the negotiation) already taking shape at the time of the Courtauld's first installation: 'It is hoped to reconstruct a typical Royal Academy hang of the 1780s in the near future' (Farr and Newman, 1990: 35). This suggestion, which involves the admission that the Galleries need more, just plain *more*, than their collections can supply, would aim to come to terms with the design built into the Line, to show off the factory of the sublime once geared to the famous lore of the RA '*Line*' – with its famous *credo* of the structuring of proximity for detail, eye-level for prestige, on or above the 'line' for grandeur and power, distant flying for the marginalization of the second best. And it would address the vital issue of the Great Room's temporality, in its seasonal aspect.

But would such an exhibition resuscitate the *history* of that temporality, the historicality of the Royal Academicians' show? For in many respects the history of the Great Room cuts clean across the celebratory ideology associated with our contemporary idea of

a temporary exhibition or display. This is not celebratory space in any ordinary sense. This was never the spot for retrospective reflection and congratulation, a review of an artist's career, a style or period ('Late Picasso'; 'Post-Impressionism'; 'The Age of Chivalry'). Nor was it an opportunity for fraternal co-operation between fellow organs of the gallery world. The Great Room was meant for a keenly competitive modality of activity; here was a market place for political, social and artistic values, disputing against other venues far beyond as well as within the boundaries of visual and plastic production. The Academy stated its claim to serve the nation as its capital's showpiece of the political cosmos – the universe of Power in its realization through painterly representation, the power of Art. And so the Great Room framed painting's claims to be the prime scene for cultural capital in the stakes of social dominance.

The élite competitors that promenaded each summer around the Great Room were in their own minds orbiting, as they did so, around the Georgian and Regency court. They brought to the culture of painting more than their money, their purchasing power and their gullibility. They brought with them their trading habits and bidding instincts, and their own mystificatory labyrinths of fine-tuning in the calibration of prestige. The very paintings on the wall, winners in the competition for display space, were themselves distributed after the same fashion as courtiers and courtesans, ministers and mistresses, officers and flunkies, princelings and servants. It does not matter that the precise significance of paintings in their relation to the line, to each other, to exhibitions past and to come, to the selecting committee's investments and whims, are shifting and elusive, or that (then as now) experts professed command of the highly differentiated language of art history spoken in this institutional circus (see de Bolla, 1989). The point is that the Great Room was where a discourse on cultural poetics was articulated with an intensity that bespoke the involvement of artistic patronage measured in more than mega-bucks, an art business stamped as the currency of royal preferment.

Artistic production in the Great Room was, then, the analogue of the *social* production among the assembled viewers. This is emphasized in the 1787 engraving through the double role of the Prince of Wales: centre-stage in his company of human players, shown full-length to the viewer as he is shown round his (His)

Exhibition by the Academy incarnate in the person of deafening President Reynolds, and duly surrounded by an admiring catwalk of ladies of fashion and distinction, easy at least on the royal eye. And centre-stage among the painted figures, too, on the full Strand wall that faces the viewer, struts a second, similarly adulatory, *H.R.H. Prince of Wales* (with his black servant: no. 90 in the Exhibition Catalogue); there, in the paintings that flank him, parades another admiring throng, of more painted ladies. To the Regent's right, Maria Cosway's *Enchantress, Portrait of a Lady with her Two Children* (Cat. no. 80: actually a witch whose flourish with the wand echoes Reynolds' waving gesticulation to the Prince in the foreground); to his left, by husband Richard Cosway (Foundation student, then RA 1771–1821), *Portrait of a Lady and her Child, Full-Length* (Cat. no. 93). The hanging of a wall around a centrepiece flanked by symmetrical pictures by size and character/content was standard eighteenth-century form (Waterfield 1991a: 50): as Catalogues show, this became a regular *topos* of Exhibitions at Somerset House, where well-hung Princes of Wales standardly occupied the centre of this same wall of the Great Room, usually, as in 1787, personally painted for the very purpose by Sir Joshua Reynolds himself, the mainstay of painting's ascendancy with royalty. (For another 'regal' centrepiece, though without a live Prince in sight, cf. Scharf's *Royal Academy Exhibition 1828* in Waterfield, 1991a: 125f, 'D7' = front plate 6, in colour. For other representations in the public domain, see Waterfield, 1991a: 55, *Royal Academy, Private View, 1828* (oneiric); and Hutchinson, 1986: plate 19 and endpapers, Rowlandson and Pugin (1808), *The Exhibition Room, Somerset House*: facing the Thamesward wall.)

If these populous visitors drawn to and in the Great Room, in all their exhibitionist sociality, in some ways match the disposition of the art works behind them, if their contested hierarchy feeds off the régime of the line, if they see in the paintings on the walls their ideals for themselves, then also they spoil the clarity that the Academicians' ordering tries so elaborately to establish. The crowd of very different viewing subjects brings their own agendas to their visit, a very wide divergence of diversions, preoccupations and evaluations. (The painted Exhibitions we can inspect foreground the *erotics* both of art-loving specularity and of the interpersonal gaze, the plenty of lascivious ogling, through eye-glasses and spectacles, of live and representational bodies, from the Pall Mall cradle

of Richard Earlom's *The Exhibition of the Royal Academy, 1771*, Hutchison, 1986: plate 7; Waterfield, 1991b: 123, 'D2', with its Adam and Eve centrepiece presiding over princely coquetry, to the Ovidian aspects of Rowlandson and Pugin's 1808 heyday scene.) These visitors come here to make the history of their culture quite as much as the institutional processing on the walls made it. If anything held their divagant trajectories from free-wheeling fragmentation, it could only have been the very royalty that energized them all. The Summer Exhibition at the Royal Academy is made visible exactly as a *royal* occasion. Royal visitation made it what it is: just as the Summer Exhibition defined the space of the Great Room, so royalty defined the Exhibition, often literally, but always and constitutively in symbolic representation. Exhibition visuality brought into perceptibility a secular adventism, the epiphanic radiation of the Prince/Regent, coming lord of all he surveys. The historicality of the Great Room is utterly bound up in the standing rule that it figured the realm of representation by functioning as the image-repertoire to serve (up) and deserve royalty.

What kind of rapprochement could be found between this history of viewing, the history that has defined this space and with it the entire fabric of the Strand site, and the curators' duty to array and promote the Courtauld collections within it? Would the Institute be wise to concentrate on bringing out – exposing, even celebrating – the chasm that must here gape between historicality and contemporary display? It is certainly not practicable to efface it. Does that mean that Institute might best look into Academy to find a common discourse on art through emphasis on their *very different* historical roles as *educational* centres?

CONCLUSION

As museological event, the experience of the Courtauld Galleries in Somerset House underlines how characteristically selective and compromised are the historical stories that museums have chosen to tell about themselves. Art in the Museum here displays the historicality of the museum only by policing that history strictly and determinedly. The art of display masks especially those parts of history which threaten the operation's simplicity, and promotes the primacy of the narratives that form the objects for viewers' attention, prodded before their setting. The Great Room, however, is a

great (British) touchstone: it is one thing to engage with different styles of hang that once, long ago, were current as norms, to explore the history of exhibiting art whether as part of a contemporary curatorial fashion or because the particular circumstances make special demands on the Gallery; it is quite another to explore the entirely different historical régime of viewing embedded in everything that makes this the embodiment of the Academy's founding theoretic for British art. There is no hiding this distinction in the Great Room.

Returning to the first floor of Somerset House, we can identify similar constrictions on the kinds of history which have been allowed to show through the display, by further investigating both the historical information offered to visitors in the guides and the scholarship you can find in libraries. Thus, as we saw, the guide to the Galleries tells us, of the RA Antique Academy/Room 1: 'In the niche at the west end originally stood a large cast-iron stove in the form of an obelisk' (Farr and Newman, 1990: 30), designed by Chambers for the location. But if we now consult Baretti's 1781 guide to the Academy, we will find that the institution being described is stunningly foreign to the idea we have been given, and the effect is matched by the strangeness of the discursive practices of the guide itself. Here is an example taken from Baretti's account of this same Antique Academy. His priority here is the plaster casts: he is precisely not showing us around a practising art institute or a Summer Exhibition centre, but rather he catalogues a working collection of casts, the single group of notable objects permanently displayed in the Academy's rooms. Apart from a pair of Furietti (plaster-)centaurs in the vestibule on the ground floor (Newman, 1990: 30), casts are nowadays strikingly absent from the Galleries. (Scharf's *Entrance Hall of the Royal Academy, Somerset House, 1836* shows, just as the Academy was to *exit* from the premises, a line-up of far more imposing casts welcoming visitors toward a mighty Hercules Farnese framed by the columns and entirely blocking the stairwell vista to centre, Hutchison, 1986: plate 17.) But it turns out that even their recollection in this space would be a far harder feat of the imagination than we may suppose. This was not just the standard collection of Graeco-Roman masterpieces and fragments we anticipate, the '*Apollo* Belvedere, Belvedere *Antinous* and the *Mercury*' of the representations shown us in our Guides (Newman, 1990: 34f., on E.F. Burney's watercolour, c.1785, *The*

Antique Academy at Somerset House; cf. Burney's *The Antique School at Somerset House, 1779*, in Hutchison, 1986: plate 27). The entry in Baretti is entitled 'Smugglerius':

> a jocular name given to this cast, which was moulded on the body of a smuggler for the use of the Academy. As Dr. Hunter, Professor of Anatomy to the Academy, was going to dissect that body in one of his lectures to the young students, it was observed that many parts of its were very fine and worth preserving. Signor Carlini was therefore directed to mould it, and he chose to give it the posture of the Dying Gladiator. (24. That is, the 'Capitoline Gladiator', our 'Dying Gaul', a copy in the Antique Academy visible in both the Burney images *supra*.)

The historicality of this Gallery opens up for us a much more disturbing past than we can have bargained for. In this case, the story not of a cast from ancient sculpture, but a corpse moulded into the pose of ancient sculpture. In the tale inheres a theory of artistic *invention*.

Undeniably, the Academy has been thoroughly sanitized for our visit – consider the following anecdote in the same vein (from Hutchison, 1986: 58):

> In 1801 a cast of the anatomized body of a murderer (James Legge), fastened to a wooden cross, was obtained for the school. It had been skilfully made by Thomas Banks, under the direction of the surgeon-anatomist Joseph Constantine Carpue, to simulate as nearly as possible a crucified figure.

But we re-cite these bizarre details not to be playfully ghoulish, rather to underline how differently constituted, practised and thought was the art enshrined but shrouded from us in its latterday museum, once the *laboratory* of what we must misrecognize as a boldly 'interdisciplinary' project stretching across *our* Fine Arts into *our* Science.

Although it comes from the embryonic pre-Somerset House Academy, Zoffany's cynosure of the Summer Exhibition 1772 (Plate 26:cf. Lloyd and Evans, 1990: 132, no. 59) constructs for us, before us, a paradigmatic early Discourse on Art, probing as well as attesting the quality and lineaments of the society's sociality; yet still more significantly, this picture emblazons a new national manifesto for modern British painting under the inspiration of Reynolds & co. It deserves to be entertained as itself a significant museological intervention on art as/against the history of art, of art as social apparatus, of art as theory. To foreground, the means and

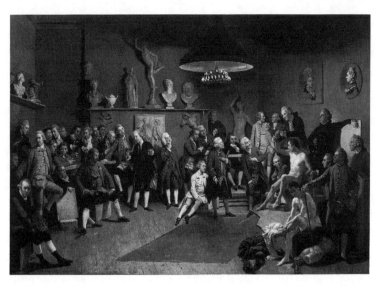

26 *The Academicians of the Royal Academy* (*c*1772), J.Zoffany (source:
Hutchison, 1986: plate 4; reproduced by permission of the Royal Collection
1994, copyright Her Majesty The Queen).

material of production foregather, bracketing the life class scene
within the picture: Zoffany with his palette looks out from bottom
left; a young male model looks out from bottom right, questioning
the viewer's gaze as he strips down for work in the buff and, by
instantaneous chance, falls – your trained connoisseurship tells you
as it told your painter – into the pose of the classical sculpture, the
Spinario. Meantime the Academicians gather round Reynolds: to
his left, Chambers; to his right, William Hunter, obstetrician to
Queen Charlotte and RA Professor of Anatomy (1768–83)
thoughtfully scratches his chin. They concentrate their
conversation and their thoughts, eyes and specs, on the Keeper,
fastidiously adjusting the second model who is already settling into
his nude sculptural pose, an intended pose this time, and one
destined to be held for the two-hour stretch measured by the
hour-glass perched on the threshold of the picture, his hand held
high to grip a cord loop suspended from the ceiling. Against the far

wall stand the materials which the human 'cast' brings into fresh life and the means to interrogate the business of modelling in the life class mode. Above the President, a 'Piccadilly Eros' cast of Mercury alights with arm raised, to pun with the model's pose; in the corner, next to the leaning Librarian (1776–82), there stands the full-length sculpture of an adult male, flayed to reveal the logic of the underlying musculature, and waving aloft *his* right arm to double-pun between *Mercury* and the model. In counterpoint with these ratios between traditional classicism, scientific modernism and the creative inspiration of the play of light and shade over the breathing gleam of objectified humanity, there lurks in the shadow beneath the other stripling model a supine Venus torso, cruelly spiked in the *mons Veneris*, it could seem, by the sharp end of a haughtily sublime Academician's cane: does Zoffany, do others, see the plaster-cast, however beautiful, perfect and conductive to representation, as strictly inert, inanimate and overshadowed by the living, moving, *looking* presence above? (dialectically composed against the medallion portraits of the two female RAs behind, excluded from the male cockpit of the life class. The 'Living Academy' at Somerset House is now the Galleries shop.) However this may be, such a presentation of the RA at work, by the RA at work, shows the RA at work and puts them, still, to work – teaching each other and us the history of art, art set dialectically against its historicality.

When Reynolds is pictured lecturing in the Great Room on the subject of his pictures and their like, when Reynolds lectured in the Great Room about art, when he painted pictures of the basic concepts of (his) art on the ceilings of his Academy's rooms, when he and his Founder Members decided to instal those empty frames on their Meeting Room walls ready for their own paintings and their successors', they were displaying their confidence in the continuation of the system of artistic production which they were putting in place *and teaching*. The investment in all this lay in designing a *future* history for the Academy. What kind of régime of display was that? In what way could we ever incorporate that kind of pre-Gallery, or anti-Gallery, into any display of ours? How could the modern discursivity of the art collection fit into this history?

Any museum, but this museum at Somerset House in particular, is constantly challenged by its own history. Art is precisely put *on the line* by the Great Room, by the insistence of the question of

history in the Gallery; which is to say: by the histor*icality* of art, art *as history* in the museum.

BIBLIOGRAPHY

Baretti, J. (1781) *A Guide through the Royal Academy* (T. Cadell, London).

De Bolla, P. (1989) *The Discourse of the Sublime* (Blackwell, Oxford 1989)

Compton, M. (1991) 'The architecture of daylight' in G.A. Waterfield (ed.) *Palaces of Art: Art Galleries in Britain 1790–1990* (Lavenham, Sudbury)

Elsner, J. (1994) 'A collector's model of desire: the house and museum of Sir John Soane' in J. Elsner and R. Cardinal (eds) *The Cultures of Collecting*, pp. 155–76, 285–9.

Elsner, J., and Cardinal, R. (1994) (eds) *The Cultures of Collecting* (Reaktion, Cambridge).

Farr, D., and Newman, J. (1990) *Guide to the Courtauld Institute Galleries at Somerset House* (Courtauld Institute Galleries, University of London).

N. Goodison (1990) 'Preface', in D. Farr and J. Newman, Guide to the Courtauld Institute Galleries (see above), p.3.

Harris, A.S., and Nochlin, L. (1978) *Women Artists: 1550–1950*, Los Angeles County Museum of Art (Alfred. A. Knopf, New York).

Hutchison, S.C. (1986) *The History of the Royal Academy 1768–1986* (Robert Royce, London).

Lloyd, C., and Evans, M. (1990) *The Royal Collection: Paintings from Windsor Castle* (National Museum of Wales, Cardiff).

Newman, J. (1990) *Somerset House: Splendour and Order* (Scala: London).

Waterfield, G.A. (1991a) 'Picture hanging and gallery decoration' in Waterfield 1991b *Palaces of Art* pp. 49–65.

Waterfield, G.A. (ed.)(1991b) *Palaces of Art: Art Galleries in Britain 1790–1990* (Lavenham, Sudbury).

Watson, P. (1992) *From Manet to Manhattan: The Rise of the Modern Art Market* (Vintage, London).

PART TWO
Reviews edited by
Eilean Hooper-Greenhill

'He Shoots! . . . He Scores!!!': Toronto's New Hockey Hall of Fame is a Winner

DOUGLAS WORTS

Art Gallery of Ontario, Toronto, Canada

'He shoots! . . . He scores!!!'. Virtually all people in Canada, as well as those in many other parts of the world, recognize these words as the climactic shout of a radio or television announcer when a goal is scored during a hockey game. For many decades, radio and television broadcasts have carried these words to millions of people who somehow share with professional hockey players the challenge of competition, the thrill of winning or the agony of defeat. Hockey, in its many professional, amateur and backyard variations, has become an integrated and vital part of the identity of a large number of North Americans. The newly opened Hockey Hall of Fame, located in Toronto, Canada, is a museum which effectively honours the gods of sport in a way that is both personal and transpersonal, and has done so with a flair from which many museums can learn a great deal.

For more than 30 years in Toronto, the Hockey Hall of Fame has been a shrine which housed objects celebrating the human achievements of a very popular sport. It functioned as a museum with an extensive collection of artifacts, including pucks, trophies, sweaters, sticks and the like. However, the function of this shrine changed dramatically in June 1993. At that point, the Hockey Hall of Fame moved to a new home in an historic bank building, located in the centre of the city. The shrine function, which encouraged visitors to experience archetypal aspects of sport – challenge, hero quest, realizing one's potential, etc. – evolved from a largely static facility full of objects to a centre dedicated to all of the living aspects of hockey. As such, this museum has become an even more powerful place where individuals can come and pay homage to the giants of hockey – the men whose skills have inspired youth to strive to develop their own potentials. It continues to be a place where memories of personal challenges, wins and defeats are conjured up

and often shared with others. But now, more than ever before, the Hockey Hall of Fame pays respect to the myriad ways that individuals integrate hockey into their personal lives.

As one enters the museum, which has been heavily financed by major corporations, visitors are made aware that this high-tech facility is organized into a series of 'zones'. First is the 'Great Moments Zone', which presents a video-projected, wall-sized selection of exciting hockey moments from television archives. In some of the video clips, one is captivated by the excitement and intensity of the sport when it is played with great skill. Other footage, however, features humorous 'bloopers' in which great professional focus fails to hit its mark. A 'History Zone' presents artifacts and information on the origins and development of hockey.

One particularly popular area is the 'Dressing Room Zone'. Here, visitors are invited into a full-scale reproduction of the Montreal Canadians dressing room. Visitors can touch authentic clothing and equipment while they watch a 12-minute video (filmed in the actual dressing room) of the Montreal players preparing to go onto the ice for a National Hockey League game. As the video ends with a call for the players to enter the arena, a set of double doors spring open and visitors exit towards what would be the ice rink. The feeling of 'being there' is further conjured up with a blast of cold air, rubberized flooring underfoot and a recording of an enthusiastic crowd. A sophisticated sports medicine display, complete with multi-media exhibit technology, extends the experience of the Dressing Room Zone. It is truly a multi-sensory, imaginative experience.

In the 'International Zone' a complex, interactive videodisc/audio presentation offers insights into the look of hockey in Austria, Japan, the United States and Canada. The nine-monitor television installation is supported with a large satellite map of the world that is animated with a laser beam, synchronized to the interactive display. Another part of this zone is dedicated to exploring women in hockey – specifically examining the development of the Women's World Hockey Championships.

The 'North American Zone' offers an in-depth look at the many amateur and professional hockey leagues that operate on this continent. Using interactive, multi-media technology, along with a large map of Canada and the USA, visitors can access information about the many variations of hockey found in this part of the world.

A special feature of this zone is that people from all over the continent are invited to submit their team photographs and logos for inclusion in an ever-growing visual database, which showcases some of the intensely personal ways in which individuals make the sport of hockey part of their own lives.

A 'Household Hockey Zone' pays tribute to the grassroots of hockey – the Saturday mornings in which whole neighbourhoods of parents and children wake up in the dark and trudge over to a local rink for the kids to play minor hockey. For many visitors, the installations trigger memories of childhood experiences in which friendships, sportsmanship, dreams and disappointments abound.

In the new Hockey Hall of Fame the many realities of hockey are not simply experienced through significant historical objects, touchscreen information kiosks and engaging environments, but also through active participation in the fundamentals of hockey itself. Two extraordinary exhibits exemplify this aspect. The first is an exhibit in which the visitor stands in front of a goalie net, with pads and hockey stick in hand, as professional hockey players shoot pucks at him or her. But the pucks that fly do not endanger the would-be goalie because this exhibit is an experience of 'virtual' reality. Despite the absence of a physical puck, visitors do engage in a whole body response to being a goalie. In the second exhibit, visitors can test their skill by stepping onto a simulated 'ice' surface and shooting pucks at targets. The pucks and sticks in this exhibit are the real thing, and the body experience engendered here is a great complement to the more cerebral nature of other installations.

A highlight of any visit is a stop at the television network exhibit. Here, banks of monitors, miles of cable and an animate (robotic) producer introduce visitors to the behind-the-scenes of a televised hockey broadcast. Visitors who are brave enough can test their skill as a television announcer. A high-tech broadcast booth offers people a chance to watch one of several great moments of professional hockey, complete with the professional commentary carried at the time. Once they have seen the play and heard the commentary, the action is replayed, but this time with printed prompts as to which player has the puck at any given second and *without* the commentary. Thus, the visitor is left to speak, scream or mutter the action and excitement of the play into a microphone, which is played back for the user to hear. It is great fun and yet another example of a non-traditional interpretive strategy in an exhibition.

After having been involved with the many and varied exhibits described above, visitors often find their way to the Bell Great Hall, which is where one finds the coveted awards, trophies and tributes to those 'greats' of hockey who have been inducted into the Hockey Hall of Fame. It is also the sanctuary where one can see, and even touch, the Stanley Cup – hockey's most famous trophy. A palpable feeling of respect and awe is generated both by the presence of the icons of hockey and by the stunning 1880s rococo architecture of the Bank of Montreal building. It seems mysterious that such a place could evoke such powerful feelings – but it does.

Having referred to many qualities of this new facility, it must be said that nothing is ever perfect. From this writer's perspective, the most glaring shortcoming of the new Hockey Hall of Fame, other than the largely unreadable texts that are printed on the glass of many display cases, is the absence of a focus on the shadowy side of hockey. Specifically, very little mention is made of the fine line that separates the conscious striving for excellence and the breakdown into uncontrolled violence – those aspects of the game which demonstrate that the flip side of noble endeavour is destructiveness. This is a serious omission, but one which hopefully will be rectified in the future.

The cultural life of Toronto has been enhanced by the new Hockey Hall of Fame. It is a place that celebrates people and how they live – it pays tribute to a very real part of our culture. Some may suggest that this is a lower form of culture than the arts; however, I would disagree. The Hockey Hall of Fame honours human experience – and that experience includes both archetypal, transpersonal aspects, as well as personal, grounded aspects. In this facility, there is a profound respect for all the individuals who have created the contemporary phenomenon of professional hockey – the stars, the organizers and everyone else who has ever experienced any aspect of the sport. At no point is there any suggestion that hockey relies on the Hall of Fame for its existence. Rather, hockey is simply celebrated here. I believe that museums everywhere need to learn this lesson – that cultural identity exists in people and how they live, not in treasured objects that are kept removed from everyday life. At their best, museums are places where there is a deep honouring of who people are – past, present and future. The Hockey Hall of Fame is one of these places.

St Mungo's Museum of Religious Art and Life, Glasgow

TIMOTHY AMBROSE

Scottish Museums Council

There have been few museums opened in Britain in recent years which have aroused such controversy as St Mungo's Museum of Religious Art and Life in Glasgow. It was never going to be easy to plan and produce a museum of world religions using Glasgow Museums' extensive range of ethnographic collections and new material collected for the purpose. However, it has been achieved with some style and to judge from the extensive press coverage and 'feedback' boards in the museum, not a little curatorial angst. Its very presence and the approach chosen to its subject-matter have forced people to reflect hard on the role and responsibilities of museums in presenting and interpreting the material culture of religion and religious beliefs to their audiences. Glasgow District Council and Glasgow Museums must be congratulated not only for conceiving such a museum in the first instance, but also for producing a museum which actively seeks to increase mutual respect for others' beliefs in the context of today's multi-cultural society.

St Mungo's is housed in a new building in traditional style at the west end of the precinct of Glasgow Cathedral. Originally destined to become a visitors' centre for the Cathedral, lack of money led to the change of function to museum, and the museum's display galleries and facilities have been introduced into spaces not originally designed for these purposes. The domestic nature of the building and the nature and configuration of the public spaces within nonetheless provide a welcoming and relaxing atmosphere.

One of the underlying principles throughout the museum's development, which was characterized by concern for the interests of the public rather than those of curatorial staff, was that all religions displayed in the museum would be treated with equal respect. While the balance of material on display inevitably varies from one area

to another, depending on its availability or suitability for display, this principle shines through the end result. The vast majority of visitors questioned through survey feel that their religion is represented on a fair basis.

The museum can be divided into two distinct but related parts. First, the public service areas at ground floor and basement level consist of a café, meetings room, shop and toilets, and at third floor level an education area. In the right-angle formed outside by the café and meetings room is a Zen Buddhist garden, an inspired part of the development. The whole museum is accessible to people with physical disabilities.

Secondly, there are five main presentational and interpretive areas at first, second and third floor level. At first floor level, an introductory video presentation explores the importance of religion in people's daily lives. Through its choice of ordinary people discussing the relevance of religion to their lives, it helps to set a tone for the museum which encourages people to engage as closely as possible with the later displays.

Visitors then move into an art gallery which shows some 30 major items of representational art drawn from different religions through time and space. This is a contemplative although somewhat sterile space, with high ceilings and daylight flooding into the gallery from tall windows on either side. The balance of exhibits is weighted slightly towards Christianity. Dali's painting of Christ with Saint John on the Cross has a tendency to dominate the other objects on display, although a number are very striking, in particular the bronze Shiva as Nataraja 'Lord of the Dance' displayed in a side gallery. Labels are provided in five languages. Whether items will be changed within this area on a regular or periodic basis is not stated, but the gallery could become rather static if no regime of change is practised.

The third and perhaps most challenging area is a gallery of religious life which explores through a wide range of comparative material the role of religion at different stages of the life cycle as well as the social and political impact of religion. It also presents the six main religions – Buddhism, Christianity, Hinduism, Islam, Judaism and Sikhism – through material specific to each. Care has been taken to provide equal treatment to each religion through the provision of equal space. The thematic displays on birth, childhood, the coming of age, sex and marriage, health, hope and happiness,

and death, with their supporting audio-recordings, investigate the ways in which ritual and religious practice is woven into people's daily lives. The selection and juxtaposition of objects provide some fascinating insights into the ways in which societies throughout the world and through time have been dependent on religious beliefs and practices of all types to help cope with the human predicament. The museum demonstrates how effectively historical ethnographic collections can be mixed with contemporary material to demonstrate how people have responded to common needs. This gallery also serves to remind us that for many people religion is in itself a way of life and not something to be engaged in simply for social or political purposes.

The style of presentation in the gallery is in sharp contrast to the art gallery. The gallery itself is a narrow rectangle, has a low ceiling and is painted predominantly black, which creates rather a claustrophobic feeling. The displays are set either in continuous, internally lit wallcases around the gallery or in a central spine, and the graphic style is brash with graffiti-like titling in a variety of colours. While this approach works well with mixed comparative collections, it is less successful with the presentations on the six main religions. Texts are in colour or white on black; labels provide an object descriptor, a short general or contextual statement and an object description. The focus of the displays is very much on the objects themselves with contextual information limited to sayings or quotes, or audio-presentations on hand-held sets. The gallery suffers from limitations of space which does not allow for more contextualization for the subject-matter. The overall impact of the gallery is reflected in the large number of comments from the public pinned up on 'feedback' boards.

Within the art gallery, at mezzanine level, a small temporary exhibition gallery provides for changing exhibitions. At the time of writing, a touring exhibition on the Australian Aboriginal Dreamtime was in progress.

The final area at third floor level is a gallery devoted to a chronological and thematic presentation of religion in Scotland. Subjects covered include religion in the past, a historical perspective on religions in Scotland, places of worship, Catholics and Protestants, charity, education and missions and missionaries. This gallery provides a more restrained exploration of religion in Scotland, although again the juxtaposition of objects raises many interesting

questions and the public's response can be measured by the 'feedback' boards here. The principle of equal respect for all religions is also applied here to Scotland's prehistory where only archaeology can provide some enlightenment.

The opportunity to interpret Glasgow Cathedral and the adjacent Necropolis which can be viewed from a large picture window at the entrance to this gallery has not yet been taken up. It is a salutary reminder that religions throughout time and space have constructed many large and elaborate monuments as part of their ritual expression. The decision taken here to focus predominantly on relatively small-scale objects and limit discussion and presentation of their wider context can be understood in terms of the restricted space available to the museum. However, more consideration needs to be given in the future to how, for example, the development of an open study centre, the application of information technology in its various forms, or the development of the museum shop, at present extremely restricted in its range of appropriate stock, might help visitors of all types to view the museum's collections in a broader context.

From Petrarch to Huizinga: The Visual Arts as an Historical Source

J. PEDRO LORENTE

Department of Urban History, University of Leicester.

Francis Haskell, *History and Its Images: Art and the Interpretation of the Past* (New Haven and London: Yale University Press, 1993) 558 pp, ill. (£29.95).

The title of the latest and hitherto the most monumental book published by Professor Haskell might be misleading for those of us who care about the representation of history in art or about the interpretation of the past in museums. This book often touches such topics, but it covers much more extensive ground. It is a chronological survey of antiquarians and historians, from Petrarch to Huizinga, who were seduced by the lure of images.

To the many Haskell enthusiasts (and I count myself one of them) the selection appears abundant in familiar characters. We had met in his previous books many of the people, works of arts and monuments which are illustrated here in a new light. Thus, not only is there a unity of argument interweaving those names and images highlighted in this scholarly narrative, there is also a broader point of reference: Haskell's numerous other publications on artists, art patrons, art amateurs, art historians and taste-makers in general. To a certain extent therefore this massive volume, whose initial stage was a lecture given by the author in Paris a few years ago, derives from previous works – significantly, it is dedicated to Nicholas Penny, co-author of one of Haskell's most popular books, *Taste and the Antique*.

Whilst apparently nobody has criticized the starting point chosen for the study, his decision to finish the chronological survey with Johan Huizinga (1872–1945) has been contested in some quarters. Yet it is quite obvious that such an ambitious project could never be concluded but only brought to an end. Besides, Francis Haskell justifies well enough in the introduction his selection of some scholars instead of others as well as his focusing his essay on some of their achievements, bypassing others. Perhaps the problem is rather the fact that the book finishes abruptly, right after the chapter devoted to Huizinga: there is no final recapitulation. The addition of a final chapter, be it called 'conclusion', 'epilogue' or whatever, might have helped the reader better to grasp the main ideas of the author.

That said, we must admit nevertheless that the central story-line is, on the whole, very clearly developed. The main message conveyed in this book could perhaps be summarized as follows: monuments, artifacts and visual arts constitute one of the most fascinating sources of information ever used to search about the human past, . . . but they can also be the most ambiguous of all. Thus, even though cultural historians tended to use them more and more, especially from Voltaire onwards, written sources still retained their primacy. Visual evidence would frequently work as personal stimuli which captured the imagination of scholars, but usually written chronicles continued to be the real basis of their treatises. Moreover, when historical information was inferred merely from visual sources, in the absence – sometimes in contradiction to – written testimonies, the results often turned out to be not real history but fantasy.

The interest of this topic for museum professionals and researchers in museum studies could never be stressed too much. After all, is not the past represented in museums by means of mainly non-written messages, as opposed to what happens in history books?

Not surprisingly, one of the main issues in Haskell's impressing scholarly chronicle is the creation during the nineteenth century of some famous and influential museums of history. Chapter 9, for example, debates the aims and accomplishments of Alexandre Lenoir as mentor of that museum of history created in Paris after the Revolution: the Musée des Monuments Français. The account gives the views of both its partisans and foes, balancing Lenoir's actual achievements in preserving some of the royal and religious monuments from the Ancien Régime, with his anti-historical falsifications of many of the exhibits.

This case is complemented with further examples, from other countries or periods, in chapter 11, entitled 'Museums, illustrations and the search for authenticity'. Firstly, he discusses the Temple of Sibyl which was opened in 1801 by Princess Czartoryski in Pulawy Park, one of her estates near Warsaw. That was a display containing relics, art works and material culture, mainly Polish, dating from different epochs in the past: its aim was to keep alive the memory of a nation that had been dismembered – Poland was then occupied by Austria, Prussia and Russia. Another instance is the Musée Historique opened by King Louis-Philippe at Versailles. That too was a case of political propaganda. It was created in 1833 to transform a palace which was a symbol of royal absolutism into a monument to the past and present exploits of the nation and its monarchs when united together in common causes, in defeating enemies and spreading civilization. But even more politically motivated was the next museum he discusses, the Germanische Nationalmuseum opened in Nuremberg, on 15 June 1853, in a deconsecrated Carthusian monastery. This institution created by the initiative of Hans von und zu Aufsess, was intended to construct a history for a nation that did not yet exist!

The legacy of these institutions was vast and long-lasting. Haskell hints, amongst others, of the Italian network of Musei del Risorgimento, founded in the 1870s to the greater glory of Italian reunification. Other institutions followed suit. Our own century also abounds in halls of fame, war museums, museums of history, theme-parks and other shows featuring historical visions – more or

less politically biased. But let us come back to the nineteenth century and to the real subject of Haskell's book. Because, although the history of museums is an important part of it, *History and Its Images* is actually a study about the evolution of mentalities, not about the history of institutions or, for that matter, not even about the history of art. In fact, this is what makes this research different from most others, and what makes it particularly interesting.

As is well known, the main concern of Professor Haskell is not merely the analysis of the arts, but the disclosure of their inner links with a period's culture, society and taste. In this respect, from a museological point of view, perhaps one of his most personal lessons to us in this book is a key statement he makes on page 222. Discussing Winckelmann's vision of history, for whom any advance in the arts had necessarily emanated from political freedom, Haskell refers to the 1790s, pointing to a later recycling of this philosophy in Denon's arguments to justify 'the removal to a "free" (and, hence, creative) Paris of works of art that had been appropriated from many parts of "despotic" (and hence sterile) Europe'. Thus people's views of history are extremely influential in the further course of history. This seems a suggestive point for those of us who believe that, beyond politics, wars, economy and the other immediate determinants of any historic event, the threats of history are ultimately woven by human beliefs and culture.

Report on the Conference 'Towards the Genealogy of the Museum', Nationalmuseet, Copenhagen, 23–25 September 1993

GAYNOR KAVANAGH

Department of Museum Studies, University of Leicester

The history of museums is a problematic area of study, and many of the problems are specific to the field. As with all such work, the survival of primary sources has been a fairly arbitrary affair – museum curators have not always been the best archivists of their

own business. Moreover, the absence of contemporary documents is often matched by a dearth of visual evidence such as line drawings, plans and, in more recent years, photographs. This causes many difficulties, as museums are a medium of communication and one needs to be able to *see*, and not just read about, museum developments. In fairness, many museums, in particular national museums, have well-ordered archives. As a result, they are in the front ranks when it comes to the historian's attention; even so, there are significant gaps. The views and experiences of visitors are rarely to be found in the records, nor is there likely to be much evidence of opinions other than those of the director or the museum's board.

Historians are well versed in dealing with incomplete records and in using the 'silences' or 'absences' as specific forms of evidence. Their craft necessitates that events and episodes are explored not only in their political settings, but also their social contexts. Further, it is well recognized that both the diachronic and synchronic should receive adequate consideration. This should also be true in the study of museums, but is not always so. With their historiography, a very specific factor comes into play. The histories available to us have been written by museum curators, museum enthusiasts, and academics working within the museum studies field. The stance is therefore usually positive and rarely detached.

Museum histories come down as advocacy for their continued survival, rather than realistic accounts of their development. This is so because often the methodology employed in the work has lacked a critical edge. Received opinion circulates, seemingly without check. As a result, many museum histories provide little more than a continuous, uninterrupted success story, told from 'within' the museum by those who have control. In essence, it is a tired field of study which needs rejuvenation, through the challenge of received opinion and the presentation of fresh perspectives.

Such an opportunity presented itself in the autumn of 1992 when the Nationalmuseet in Copenhagen with the Museology Department of the University of Umeå in Sweden organized a three-day conference with the title 'Towards the Genealogy of the Museum'. The conference was timed to coincide with the exhibition 'Museum Europa' (which explored the development of museums and collections in the seventeenth and eighteenth centuries) and was attended by 100 delegates from the Scandinavian countries.

The title of the conference was purposefully chosen to emphasize the study of *pedigree*, and the co-organizer of the conference, Annesofie Becker, expressed the hope that the study of museum genealogy would assist in 'finding future directions for museums by studying patterns from the past'. The agenda appeared therefore to be set: by stressing the *continuity* of museums, the muffling of museum history was again at risk. Fortunately, a number of the papers broke through the old barriers, and sought both insight and new questions.

Björnar Olsen from Tromso Museum questioned the extent to which the concept of 'prehistory' was and is a 'reality' which preceded archaeological discourse. He argued that archaeological discourse was instead creating prehistory in a mould which was handed to it by the modern episteme. In this, museums of archaeology have had far more than a passive effect on this creation. Archaeology exhibitions, collections and museum buildings 'functioned to make the past visible and concrete'.

Professor Bo Lönnqvist, Helsingfors, also dealt with the creation of categories, arguing that museums promote images of stable human communities. With their suggestion of continuity and authenticity, they stand as a symbol of cultural symmetry. Yet what about the indefinite aspects of culture and the borderlines within and around cultures? Lönnqvist argued that the borderlines in museological structures reveal the hegemonic function of museums and also their relativity.

The theme of archaeology, meaning and museums was also picked up by Arthur MacGregor, Ashmolean Museum, Oxford, who considered the extent to which antiquities were part of the common currency of the early collections. However, with time, perceptions of antiquities changed significantly, both for the collectors and museum visitors. He considered how collections of antiquities contributed to diverse functions including 'dynastic validation, the physical characterization of rediscovered classical (and later indigenous) civilizations, the furtherance of nationalist ideals and the expression of imperialist dominion, in addition to the establishment of the modern discipline of archaeology'. His review considered the role of the museum in the formulation of these successive concepts.

Other papers given by scholars from France, Britain, Germany and the Scandinavian countries, dealt with a wide range of issues

including: the psychology of the collector, the logic of collections, the concept of nationalism in nineteenth-century museum development, and the notion of encyclopaedic knowledge and collections. Papers were also given on the early Kunstkammers in Europe, museums and war during the twentieth century, and the relationship between museums and private collections.

The papers from the conference, published in 1994, provide a useful insight into current scholarship within this field. Hopefully, they will encourage further research and, without a doubt, much work needs to be done. It is to be hoped that in future research some thought might be given to how history has been appropriated in museums. The question 'whose history' needs to be asked every time some unqualified claim is made to 'history' being displayed or embodied in a museum.

Future work should also attempt to uncover the hidden histories of museums, ones that concern power, money and gender. The 'man' so frequently mentioned at this conference betrayed a male way of constructing the world in which museums are a part and the wider story needs to be uncovered. Moreover, someone needs to look at museum failures, inconsistencies and neglect. The gap between the rhetoric and reality in museum development has frequently been a wide one, and we do museums a disservice if we refuse to recognize it. There are amazing, even deafening silences in many of the histories we have to date. The future of museums can only be aided by a more honest questioning of museum history.

The conference succeeded in drawing a broad picture of contemporary understanding of the histories of museums, and confirmed that a great deal of important work is being done. A measurement of its long-term impact will be whether it can promote further understanding or close the door on it.

CALL FOR PAPERS FOR FORTHCOMING VOLUMES

The topic chosen for *New Research in Museum Studies* volume 6 is *Exploring Science in Museums*. The volume will concentrate upon the chosen topic, but may also include papers which deal with other aspects of museum studies. The editor would be pleased to hear from any worker in the field who may have a contribution. Any ideas for papers, or completed papers for consideration, should be

sent to Professor Susan Pearce, Department of Museum Studies, 105 Princess Road East, Leicester LE1 7LG.

Contributions to the reviews section, including reviews of conferences and seminars, videos, exhibitions and books, or any other museum event, are similarly welcomed, and should be sent to Dr Eilean Hooper-Greenhill at the above address.

EDITORIAL POLICY

New Research in Museum Studies is a refereed publication and all papers offered to it for inclusion are submitted to members of the editorial committee and/or to other people for comment. Papers sent for consideration should be between 3,000 and 10,000 words in length, and may be illustrated by half-tones or line drawings, or both. Prospective contributors are advised to acquire a copy of the *Notes for Contributors*, available from the editor, at an early stage.

New Research in Museum Studies has a policy of encouraging the use of non-sexist language, but the final decisions about the use of pronouns and so on will be left to individual authors. However, the abbreviation 's/he' is not to be used.

The editor wishes it to be understood that she is not responsible for any statements or opinions expressed in this volume.

Notes on Contributors

Gordon Fyfe graduated at the University of Leicester in Social Sciences in 1967 and also obtained an M.Phil in Sociology at Leicester. He has been a Lecturer in Sociology at Keele University since 1971 where he teaches courses on the sociology of art and art institutions. He has undertaken research on nineteenth- and early twentieth-century art institutions with particular reference to exhibitions, art reproduction and museums. This work has been published in a range of papers. He is editor (jointly with John Law) of *Picturing Power: Visual Depiction and Social Relations*, Routledge: London (1988). Until recently he was reviews editor of *The Sociological Review*. His current interests include the social context of museum visiting.

Giles Waterfield trained at the Courtauld Institute of Art and worked at the Royal Pavilion, Art Gallery and Museums, Brighton, before joining Dulwich Picture Gallery as Director in 1979. When he went to Dulwich the Gallery had no funds and no professional staff, and he has worked to create an appropriate structure, setting up an education department and introducing an exhibition programme. Since 1994 the Gallery has been set up as an independent trust and it is hoped that this position will lead to substantial new funding. His own academic interests lie in the field of the history of taste, and especially museum history, and British eighteenth and nineteenth century architecture. Exhibitions and catalogues he has organized include 'Soane and After' and 'Collection for a King' (for a travelling exhibition to the United States); while 'Palaces of Art' studied the architecture and development of art museums in Britain. On a related theme, the exhibition 'Art for the People' studied the history of 'philanthropic' galleries set up in late nineteenth-century Britain. He is currently writing a history of British art museums. He is also a member of the Executive Committee of the Georgian Group, and Joint Director of the Attingham Summer School.

Shearer West is a Lecturer in the History of Art Department at the University of Leicester. She has published a book on Chagall

(1990), as well as *The Image of the Actor: Verbal and Visual Representation in the Age of Garrick and Kemble* (1991), *Fin de Siècle: Art and Society in an Age of Uncertainty* (1993), and is co-editor (with Marsha Meskimmon) of the forthcoming *Visions of the 'Neue Frau': Women and the Visual Arts in Weimar Germany*, as well as the author of a number of articles and essays. She is currently editing *The Bloomsbury Guide to Art History*, writing a book, *Utopia and Despair: German Art and Society from Bismarck to Hitler* and preparing a study of the early Venice Biennale.

Vera L. Zolberg is Senior Lecturer in the Department of Sociology of the Graduate Faculty, New School for Social Research, New York City. From 1992 to 1994 she has also held the Chair of Sociology of the Arts of the Boekman Foundation of Amsterdam, under whose aegis she has been lecturing at the Universities of Amsterdam, Leiden, Groningen, and Erasmus University in Rotterdam, as well as the Postgraduate Institute for Social Sciences. Having served as Chair of the Culture Section of the American Sociological Association, she is currently President of the Research Committee on the Sociology of the Arts of the International Sociological Association. The author of *Constructing a Sociology of the Arts*, Cambridge University Press (1990), she has published numerous articles on the museum and on cultural policy, with special attention to the role of museums in broadening the publics for the fine arts. She is completing a book on the Art Institute of Chicago in the context of changing conditions for American art museums for Westview Press. In addition to her museum studies, she is doing research on the sociology of avant-garde art movements, the arts of non-western societies, and the social construction of the 'primitive'.

J. Mark Davidson Schuster is Associate Professor of Urban Studies and Planning at the Massachusetts Institute of Technology, Cambridge, Massachusetts, USA. He spent the 1992–3 academic year as a Visiting Professor in the Division of Legal, Economic, and Social Sciences at the University of Barcelona where he was affiliated with the Centre d'estudis de Planificació and the Centre d'Estudis i Recursos Culturals and continued his research on comparative cultural policy. He is the former Director of the Northeast Mayors' Institute on City Design. Professor Schuster is

a public policy analyst who specializes in the analysis of government policies and programs with respect to the arts, culture and environmental design. He is the author of numerous books, articles and reports including: *Patrons Despite Themselves: Taxpayers and Arts Policy*, New York University Press (with Michael O'Hare and Alan Feld), *Supporting the Arts: An International Comparative Study*, US Government Superintendent of Documents, *Who's to Pay for the Arts? The International Search for Models of Arts Support*, American Council for the Arts (with Milton Cummings), and *The Audience for American Art Museums*, Seven Locks Press. Professor Schuster has served as a consultant to the Arts Council of Great Britain, the National Endowment for the Arts, the Canada Council, Communications Canada, the British American Arts Association, the London Arts Board, the British Museum, the Council of Europe, National Public Radio, American Council for the Arts, Arts International, and the Massachusetts Council on the Arts and Humanities, among others. Professor Schuster has been a Postdoctoral Fellow in the Research Division of the French Ministry of Culture and a Fulbright Fellow and Distinguished Visitor under the auspices of the Queen Elizabeth II Arts Council of New Zealand. He has spoken at numerous international conferences on subjects ranging from the use of matching grants, tax incentives, and dedicated state lotteries to fund the arts to the economic and political justifications for government support for the arts and the role of the arts in urban development. He is a founding member of the Association for Cultural Economics and a member of the editorial boards of the *The Journal of Planning Education and Research, The European Journal of Cultural Policy*, and *Poetics*.

Eilean Hooper-Greenhill trained as a sculptor at Reading University and later as an art teacher. A period of secondary teaching preceded several years of freelance education work in art galleries, museums, art centres, schools and colleges. From 1977 to 1980 she worked as Education Officer in the National Portrait Gallery and since 1980 has been Lecturer in Museum Studies at the University of Leicester. She is the author of *Museum and Gallery Education* (1991), *Museums and the Shaping of Knowledge* (1991) and *Museums and their Visitors* (1994).

Douglas Worts holds a specialist degree in Art History (University of Toronto, 1980) and a Masters of Museum Studies degree (U of T, 1982). Since autumn 1982, he has been employed as an educator at the Art Gallery of Ontario. His work at the AGO has been focused in four primary areas: the development of experimental interactive exhibits; audience research; educational theory in museums; and in-gallery teaching. Beyond his ongoing responsibilities at the Gallery, he has published many articles in both Canadian and international museum journals, and has spoken extensively at conferences and workshops in Canada, the USA and recently in Australia. He has also taught the museum education course in the University of Toronto Museum Studies Program. Additionally, Wort's professional activities have led to him becoming: a contributing editor to the *ILVS Review* (the journal of the International Laboratory for Visitor Studies in Milwaukee); an editorial advisor to the *Journal of Museum Education*; a resource consultant for the Museum Assessment Program (MAP III – Public Dimension), which is a division of the American Association of Museums; as well as a member of the incorporating Board of the Visitor Studies Association.

Dominique Poulot was born in 1956. He is married and has three daughters. Educated at the Ecole Normale Supérieure (Paris), he was *agrégé d'histoire* in 1978 and took a degree from the Ecole des Hautes Etudes en Sciences Sociales. He has completed a thesis at University of Paris-I (Sorbonne) on the political and intellectual attitudes of the French Revolution regarding past times (1989) and a *habilitation* work about the history of French heritage (1993). He was Jean Monnet Fellow at the European Institute University of Florence during the year 1990–1 before becoming Professor of Modern History at the University of Grenoble II. He is presently a member of the Institut Universitaire de France for four years. He has published nearly 30 articles about museums and heritage history at the end of the eighteenth century and beginning of the nineteenth (*Revue d'Histoire Moderne et Contemporaine, Annales ESC, Historical Reflections/Réflexions Historiques, Oxford Art Journal, Ricerche Storiche, L'Année sociologique, Revue suisse de sociologie,* etc.). He is the author of a *Bibliographie critique de l'histoire des musées de France*, Paris (1994), and is currently working on a book about *La construction de la postérité, France, 1780–1830*. He is

member of the editorial board of the journal *Publics et Musées*, of the Comité d'Histoire du Ministère de la Culture, and of the Comité d'Histoire des Musées de France.

Jean-Louis Déotte – born in Paris in 1946 – is married with two sons. For twenty years he has been involved in teacher training as a Lecturer in Philosophy at the Ecole Normale in Caen, Normandy. He studied for his doctorate at the University of Paris VIII where he became a Docteur ès Lettres (Philosophy) in 1990. His thesis was supervised by J.F. Lyotard, Professor Emeritus, currently lecturing at Irvine, USA. His 600-page thesis was entitled: *Le passage du musée*. His work was approved by the Commission Nationale Universitaire d'Esthétique (national university aesthetics committee) in 1993 and he was appointed Senior Lecturer in Aesthetics (MST: Cultural Mediation) at Paris VIII. He was also offered a post as Lecturer in Aesthetics on the doctoral programme in Strasbourg. To date, he has published at least 40 articles on memory and the immemorial, inscribed surfaces, self-portraits, museums, and the relationship between aesthetics and politics. He is also the author of two books: *Portrait, autoportrait*, Paris: Editions Osiris, written in association with Michel Servière and E. van de Casteel, and *Le Musée: l'origine de l'esthétique*, Paris: Edition de l'Harmattan. He is currently writing a second volume in the same series on the subject of the relationship between museums and modern and post-modern Europe: *Oubliez! Politiques de la Cendre*. For seven years, he was Director of Studies at the Collège International de Philosophie where he ran an annual seminar as well as organizing several international conferences in association with the city of Caen, the Directorates of French Museums and Patrimony, the French Ministry of Culture, the Franco-German Office for Youth, the French Ministry for the Environment, the Louvre Museum, the Public Information Library of the Centre Georges Pompidou and the National Defence Institute.

Mary Beard and *John Henderson* teach Classics at the University of Cambridge. They have written (individually) on Roman history, literature, art and culture, and (together) on museums. They were responsible for the controversial exhibition, variously known as '?The Exhibition?' or 'The Curator's Egg', on show in the Ashmolean Museum, Oxford, between December 1991 and May 1992.

Since then they have produced a further exhibition in the Museum of Classical Archaeology, University of Cambridge (1992) based on Euripides' play *Hippolytus*.

Index

A Century of British Painters, 65
A Description of the Earl of Pembroke's Pictures, 51
A Descriptive Catalogue of the Pictures in the Fitzwilliam Museum, 64
A Descriptive Explanatory and Critical Catalogue of Fifty of the Earliest Pictures contained in the National Gallery, 58
A Descritive [sic] Catalogue of the Pictures in the National Gallery etc, 56–8
Abridged Catalogue (National Gallery), 62
Adler, C.P., 149, 162
admission charges, 120–3
Aedes Walpolianae, 51
age, museum participation rates
 Great Britain, 125, 126
 Ireland, 135
 Netherlands, 127, 128
 Quebec, 133
 Scandinavia, 130, 131
 Spain, 129
 USA, 112, 116, 118
Airlie, Shiona, 79, 91
Aitken, Charles, 17, 24, 29, 36
Albert, Prince, 20, 62–4
Alberti, Leon Battista, 221
Allied Artists, 18
Almanach Parisien (1801), 202
alphabetical arrangements, 47–9
Alte Pinakothek, Munich, 48, 59
Ambrose, T., 265–8
 and Paine, C., 149, 162
 and Runyard, S., 149, 162
American Association of Museums (AAM), 19, 111, 165
American Express company, 82–3
Americans and the Arts studies, 115–17
archaeology, 273
Arena (BBC series), 88

aristocracy, 13, 19, 25–8, 34, 95
 French Revolution, 193
Armstrong, William, 31
Art Gallery of Ontario (AGO), 165–8, 170, 186
Art History, 86
art history, 85–9
Art Institute of Chicago, 77–8
Art Journal (1899), 22
"Art Museums and the Price of Success" conference, 143
"Art on Tyneside" exhibition, 157–9
Arts Council (GB), 122, 161
Ashmolean Museum, 64
Association for Business Sponsorship in the Arts (ABSA), 82
AT&T (American telephone company), 83
Athenaeum, 227
audiences, 143–62
 research, 111–33, 150–3, 165
 targeting, 134, 146–50, 157–62
 see also visitors
Austria, 120, 121–2, 134
avant-garde collections, 95–102
Azikwe, Namdi, 104

Babeau, A., 205, 213
Baboeuf, Gracchus, 197
Banks, J.A., 27, 36
Baretti, J., 235, 250, 254, 255, 258
Barnes, Albert C., 94–107
Barnes Foundation, 105–7, 137
Barnett, Canon and Mrs., 71
Barstow, George Lewis, 30
Baudrillard, Jean, 74, 91
Bauman, Z., 13, 36
Bazin, G., 36
Beard, Mary, 280–1
Beaucamp, F., 205, 213
Belcher, Michael, 75, 77, 80, 91
Belgium, 230

Bell, Q., 36
Benjamin, W., 78, 91, 228, 232
Bennet, T., 36
Berenson, Bernard, 103
Bergeron, Louis, 192
Berlin Royal National Gallery, 63
Bernstein, Basil, 10
biographies, artists', 61–2, 64
Birkett, George, 66, 70
Birmingham art gallery, 66–7, 154
Birmingham Post, 18
Blanchot, Maurice, 222
Bliss, Miss Lilly, 99
blockbuster exhibitions, 74–90,
 94–106
Blomfield, Reginald, 36
Bloomsbury group, 29
Blundell, Henry, 48
Bodkin, T., 36
Boime, A., 36
Boswell, James, 235
Bourdieu, P., 6–9, 32, 36–7, 75, 91
 and Wacquant, Loic J.D., 9, 36
bourgeoisie, 12–15, 19
Bourne, J.M., 30, 37
Boyer, F., 203, 213
Bradford Art Galleries and Museums,
 146, 147
Britain, 5–35, 42–71, 122–6, 143–62
 definition of British art, 31, 50–1
 market research, 151–2
 museum participation rates, 120–5,
 131–2
 provincial collections, 51–4
British Association of Art Historians, 86
British Market Research Bureau, 124
British Museum, 14, 137, 157
British Target Group Index, 122
Britton, John, 52–3, 72
Buckman, D., 18, 37
Buffon, Georges, 219
Bullenc, J.B., 37
Bureau de Bibliographie de Paris, 199
Burke, Edmund, 227, 235
Burlington Magazine, 77, 86–8
Burney, E.F., 254–5
Burt, Nathaniel, 111, 137, 139
business class, 11, 32, 96

Cambry (commissioner), 200, 211, 212
Camden Town Group, 17, 18
Canada, 165, 186–7, 261–4
 see also Quebec
Canadian Historical Galleries, 168–70
Cannadine, D., 26, 30, 37
capitalism, the term, 74
Cardew, Major, 24
Carey, William, 54
Carey, J., 27, 37
"Caribbean Expressions in Britain",
 145
Caribbean history exhibition, 145
Carr, J.C., 28, 37
Cassatt, Mary, 98–9
*Catalogue of the Collections of Pictures
 of the Duke of Devonshire,
 General Guise, and the late Sir
 Paul Methuen*, 51
*Catalogue des objets échappes au
 vandalisme dans le Finistere*, 200
*Catalogue of the Paintings in the
 Imperial and Royal Picture
 Gallery in Vienna*, 45
*Catalogue of the Picture Collection of
 the Royal Museum in Berlin
 (1841)*, 61
*Catalogue of the Pictures &c in the
 Shakespeare Gallery, Pall-Mall
 (1785)*, 46
*Catalogue of the Pictures in the
 National Gallery*, 62
catalogue raisonné, 52, 59, 63
catalogues, 42–71, 84–8
categories, creation of, 273
Central Bureau of Statistics,
 Netherlands, 126
Chambers, Sir William, 235–6, 243,
 244, 247, 254
Chantrey Bequest, 5–35
 Chantrey files (CF), 24–5, 37
Chantrey, Sir Francis, 18–19, 31
Cherry, Deborah and Pollard,
 Grizelda, 86–7, 91
Chinese jewellery exhibition, 145
chronological organisation, 48–9, 52,
 58, 169–70
Civil Service, 13–14, 27–8, 65–6

class, 9, 11–16, 19–30, 33–4
 classless society, 14, 74
 museum participation rates, 124–5,
 128, 131–2, 135
 seventeenth century France, 12
 vandalism, 207
classification, 5–35, 42–71
Clegg, Stewart R., 15, 37
Cleveland House, 52
Cockburn, Ralph, 55
Cole, Henry, 60, 72
Collins, Jim, 74, 91
Colvin, Sidney, 64
Comite d'Instruction Publique, 194,
 195
Comite Revolutionnaire, Quimper,
 198–9
Commission Temporaire des Arts,
 195, 202
communication strategies, 187–8
Compton, M., 244, 258
Conde, Idalina, 121, 139
Conseil General de la Seine, 215
conservation, 201
Constable exhibitions, 76, 78, 84
contemporary art, 185–7
Coombes, A.E., 17, 37
Cooper, Douglas, 37
Corrigan, P. and Sayer, D., 9, 10, 37
Cosway, Maria, 252
Cosway, Richard, 252
Courtauld Institute Galleries, 172,
 176, 233–58
Courtauld, Samuel, 17
Coutts, Herbert, 84, 91
Cowdell, T.P., 37
Crawford, Lord, 26
Crewe Inquiry, 9, 22–3, 26, 31, 35, 37
critic–dealer system, 5, 35
Croydon, London Borough of, 152
Crystal Palace, 63
cultural field, 7–9, 30–4
Cunard, Lady Nancy, 99
Curzon Inquiry, 9, 14, 17, 22–4, 26,
 31, 34, 35
Curzon, Lord, 23–4, 34

D'Abernon (RA Council), 24, 26

Dagorne (commissioner in Brest), 198
Daily Telegraph, 23, 87, 88, 159
Dali exhibition (1980), 76
d'Anglas, Boissy, 196
Danilov, Victor, 82–3, 91
Daunou, 192, 210
Davidoff, L., 37
Davis, F., 37
d'Azyr, Vic, 204
De Bolla, P., 251, 258
De Dampierre, E., 192, 213
*De la guerre déclarée par les tyrans
 révolutionnaires à la Raison*, 197
De Mazia, Violette, 105
de Zarraga, J.L. and Bonor, M.M.,
 129, 140
Declaration of Human Rights, 225, 226
Della Piuttura, 221
democracy, the term, 74
Denmark, 271–4
Deotte, Jean-Louis, 280
Département des études et de la
 prospective (1990), 128, 140
Description du département de l'Oise,
 200–1
*Description of the Royal Picture
 Gallery and the Cabinet in
 Sans-Souci* (1770), 45
Devonshire House, 51
Dewey, John, 101, 102
d'Harnoncourt, Anne *et al*, 140
Dicksee, President (RA), 24
Dimaggio, P., 9, 10, 37, 98, 107
 and Useem, P.J. and Brown, P., 112,
 140
displays, improving, 153–7
Dix, Otto (Tate Gallery exhibition
 1991), 88
Dodsley, Robert, 51
Dorment, Richard, 86, 91, 162
double-coding, 74–5, 77, 84–9, 90
Dresden gallery, 46
Du Maurier, G., 27–8, 32, 37
Dublin (1867): G.F. Mulvany, 65, 72
Duffy, Christopher, 140
Dufourny, 195
Dulwich College Picture Gallery,
 55–7, 64

Duncan, C., 37–8
Duncan, C. and Wallach, A. (1980),
 14, 38
Duveen, Lord, 17
Dyall, Charles, 68, 70

Earp, F.R., 64
Eastlake, Charles, 19, 61–4, 72
eccentric collectors, 98–100
Eckstein, J. and Feist, A., 145, 162
economic factors, 80–4
Edinburgh (1859): W.B. Johnstone, 72
education
 Education Act (1871), 67
 educational psychology, 153
 museum participation rates, 112–14,
 117–18, 127, 128, 130, 134
Edwards, E., 38
Electoral Gallery, Dusseldorf, 46, 48
Elias, N., 11, 38
Elsner, J., 234, 258
 and Cardinal, R., 258
employment, 127, 128, 131, 132, 133
"encyclopedic" art museums, 103
English National Curriculum, 148
engravings, 58
Entrance Hall of the Royal Academy,
 Somerset House, 254
Entretien infini, 222
ethnic minorities, 101, 125, 145–6, 152
Etty, William, 68
Europe, *see under country eg Britain;*
 France etc
Ewart, William, 59
Excellence and Equity etc, 165
"Exhibition Attendances" (1993), 76, 91
exhibitions
 art blockbuster, 74–90
 display improvements, 144–5, 154–9
 early picture gallery catalogues, 43,
 62, 71
 employing experts, 146–7
 living artists, 119–20
 targeting audiences, 145–9
 trial, 153
 see also Royal Academy, exhibitions
experience, conceptual model of
 museum, 189

"Explore a Painting in Depth",
 177–85
expository guides, 45–6

Farr, D. and Newman, J., 234–5,
 238–9, 243, 248–50, 254, 258
Feld, Alan *et al,* 109, 140
*Felix Summerly's Hand Book for the
 National Gallery,* 60
feminism, 85–7
fields, definition and purchase of, 9
"Figures du Moderne: Expressionisme
 en Allemagne 1904–14"
 exhibition, 79
Finland, 121–2, 127–9, 132
Fitzwilliam Museum, 55–6, 64
Flint, K., 17, 38
Fontaine des Innocents, 215
Foster, Hal, 74, 91
Fox, C., 15, 38
France, 5, 12, 59, 154, 215–32
 French Revolution, 193, 216–17,
 222, 226–7
 French School, 21–2, 50–1, 54, 66
 museum participation rates, 121–2,
 128, 131–2
 The Louvre, 225–7
 vandalism, 192–210
Fraser, J., 68
Frick, Henry Clay, 103
Frostick, E., 154, 155, 162
Fry, Roger, 7–8
Fuller, Peter, 38
Furet, F., 193, 213
Fyfe, Gordon, 5–41, 276

Galerien, T., 18, 38
gallery, definition of, 119
Gamboni, D., 207, 213
Ganzeboom, Harry and Haanstra,
 Folkert, 113, 127, 132
Gardner, H., 155, 162
Gardner, Isabela Stewart, 103
Garon, Rosaire, 133, 140
Gault de Saint Germain, 200
Geertz, C., 213
gender, 124–36, 235, 250
Georgia O'Keefe exhibition, 78

"German Art in the Twentieth Century" exhibition, 88
German Ryan collection, 154
Germany, 50, 59, 66, 88, 121
Getty Centre for Education in the Arts, 150–1, 163
Girod-Pouzol, 196
Giroud, Mark, 38
Glackens, William, 101, 102
Glasgow museums, 265
Glueck, G., 102, 108
Goblot, Edmond, 9, 38
Goodison, N., 233, 236, 258
Graham, William, 33
Grana, C., 38
Grand Palais, Paris, 77–9
"Great Age of British Watercolours" exhibition, 85
Great Exhibition Room, Royal Academy, 244–54, 257–8
Greenfield, Howard, 94, 101, 108
Greenhalgh, Paul, 89, 91
Gregoire, Abbe, 193–8, 201–3, 210, 211
Greutzner, A., 38
Grew, Nehemiah, 43
Grosvenor House, London, 54
Gucht, Vander D., 38
Guggenheim Museum, 79
Guide to the Courtauld Institute Galleries at Somerset House, 240
Gulf War, 88

Habermas, J., 74, 86, 91
Hale, E. Matthew, 70
Hall, S., 26, 38
Hamlyn, Robin, 17, 38, 65, 72
Hammerton, P.G., 34, 38
Handbook of Painting, 61
Handbook to the Pictures in the Fitzwilliam Museum, 64
"hands-on" galleries, 168
Harris, A.S. and Nochlin, L., 236, 258
Harris, Louis, 115–17
Haskell, Francis, 7, 268–71
Hayes Tucker, Paul, 86
Hazlitt, William, 55–6, 60
Heath, Thomas Little, 30

Heinich, Nathalie, 140
Henderson, John, 280–1
Hennin (19th Century scholar), 209
Herbert Museum and Art Gallery, Coventry, 148–9
Herding, Klaus, 207, 213
"High and Low: Modern Art and Popular Culture of 1990–1", 83
history, 10, 64, 234
 inspiration for collections, 48–9, 61–2
 of museums, 271–4
 visual arts as sources, 268–71
Hobsbawm, E., 39
Hockey Hall of Fame, 261–4
Hoeve, Franz, 126
Holland *see* Netherlands
Holmes, C.J., 28, 39
Holroyd, Charles, 17, 36
Home House Society, 243
Hood, Marilyn G., 110, 140
Hood, William, 76–7, 91
Hooper-Greenhill, Eilean, 75, 91, 140, 145, 150, 155, 156, 163, 278
Horkheimer, Max and Adorno, Theodor, 90, 91
Horniman Museum, London, 156
Host, Helvinn, 121, 140
Houghton collection, 50–1
Houlbert, G., 197, 213
Hughes, Langston, 104
Hull history gallery, 154
Hungary, 71
Hutcheson, Linda, 74, 92
Hutchison, S.C., 35, 39, 235, 252–3, 254, 255, 256, 258
Huyssen, Andreas, 74, 92

Impressionists, 77, 95, 103
"Incipiency of Landscape" essay, 58
income, 117, 124, 127, 133
Ingham, Geoffrey, 13, 28, 39
Institut fur empirische Sozialforschung (1991), 134, 140
International Exhibition, South Kensington (1862), 62
inventory-catalogues, 44–5, 55, 58–9
Ireland, 119–20, 121–2, 135

Isabella Stewart Gardner Museum, 103
Italy, 50, 54, 215–25, 230

Jameson, Frederic, 60, 74, 89, 92
Janis, Eugenia Parry, 86, 92
Japanese Discovery Room, travelling, 156–7
Jencks, Charles, 74, 92
Johnson, Samuel, 235
Johnson, T., 20, 39
Johnstone, W.B., 64
Jones & Co, 58, 70, 71, 72
Jones, T., 39
Jonkers, T. and van Reijn, T., 141
Journal of Arts Management and Law, 110
Journal des batiments civils, 202
Julia, D., 196, 198, 210, 213

Kauffman, Angelica, 236
Kavanagh, Gaynor, 271–4
Kelly, Judith, 79, 80, 92
Kent, Sarah, 88, 92
Kessler, Count Harry, 99
Kirby, Sue, 81, 92
Kirklees exhibition, 147
Klenze, Leo von, 59
Kostyrko, Teresa, 121, 123, 141
Kraus, Karl, 193
Kugler, F.T., 61

La Decade, 199
"La France et La Table" exhibition, 154
La Galerie Electorale de Dusseldorf, 46, 48
La Tour Babel au Jarden des Plantes etc, 197
Laing Art Gallery, 157–8
 Newcastle-upon-Tyne, 157–9
Lakanal, 193
Lamb, W.R.M., 25
Lambert, R.S., 39
Landseer, John, 58
Lane, Hugh, 17
Lang, G.E. and Lang, K., 9, 39
Lanzi, Abate Luigi, 46–7, 49, 72
Le Gothique Retrouvée, 199
Le Musée, l'origine de l'esthetique, 228

Le Tribun du Peuple ou le Défenseur des droits de l'homme, 197
Lebrun, J.B.P., 50, 72
Leeds (1898, 1902), 70, 72
Leeds City Art Gallery, 66
Legros, Alphonse, 68
Leibnitz, G.W., 219, 221
Leicester, Sir John, 54
Leicester Museum and Art Gallery, 145, 147, 157
Lenoir, Alexandre, 199
Les Considerations morales sur la destination etc, 215
Lever, Sir Ashton, 137
Levy-Leboyer, C., 203, 204, 213
Leyland, Frederick, 33
Linell, John, James and William, 60
Liverpool, 68, 70, 72
 (1902): Charles Dyall, 68, 72
Llewellyn, William, 24
Lloyd, C. and Evans, M., 255, 258
Lloyd, Jill, 79, 92
London Borough of Croydon, 152
London and its Environs (1761), 51
London Royal Society, 43
Lonnqvist, Bo, 273
Louvre, 50, 222–7, 232
Low, Theodore, 111, 141
Lucas, E.V., 18, 39
Luke, Timothy, 78, 82, 92
Luxembourg museum, Paris, 5, 14–16
Lycee, 197

McCaughey, Claire, 113, 141
MacColl, D.S., 17, 21, 22, 35, 39
MacConkey, K., 39
MacDonald, Jock, 186
Macdonald, S., 152, 153, 163
Macgregor, Arthur, 44, 72, 273
Machiavelli, Niccolo, 224
Macleod, D.S., 33, 39
McWilliam, Neil and Potts, Alex (1896), 86, 92
Mallock, W.H., 28, 39
Manchester (1894), 68, 70, 72
Manchester Art Treasures Exhibition (1857), 43, 62

Manchester City Art Gallery, 63, 67, 68, 70
Manson, J.B., 17
Mappin Art Gallery, Sheffield, 67, 69
Mappin, Thomas, 32–3
marginality, 97–100
market research, 150–3
Marshall, Thurgood, 104
Martini, P., 235, 246
Marxism, 85–6
Massey, D. and Catalano, A., 25–6, 39
Massey Inquiry, 9, 25, 35, 39
Matisse exhibition, 78
Meiklejohn, R.S., 30
Memoires d'un bourgeois d'Evreux, 204
Merriman, Nick, 75, 89, 92, 141, 153, 163
Mesman collection, 55–6
Metropolitan Museum, New York, 76, 99
Meyer, Karl, 137
mezzotints, 51
Michelet, Jules, 208, 223
middle classes, 11, 16, 19–20, 25–7, 77, 276–7
Midland Counties Art Museum, 67–8
Millar, Oliver, 72
Millard, John, 157–8, 163
Milony (architect and commissioner in Troyes), 199
Minihan, J., 14, 20, 29–30, 39
Ministerio de Cultura (1991), 129, 141
Miranda, J. Sa de, 227
mission, 82–3, 187–90
Mitchell, Ritva, 129, 132, 141
Modernists, early, 77
Monadologia, 221
Monet exhibition, 80–1
Moniteur, 205
Montefiore, Hugh Sebag, 81, 92
Moore, George, 17
Morgan, J.P., 96
Mowatt, Francis, 30
Mullaly, Terence, 87, 89, 92
municipal art galleries, 67
Musée de l'Art Moderne de la Ville de Paris, 79
Musée de Rennes, 197

Musée des Monuments Français, 50
Musée d'Orsay, 105
Musée Napoleon, 50
Musée Picasso, Paris, 76
Museo Pio-Clementino, 47
Museum Assessment Program III: Public Dimension, 165
Museum of Civilisation, Québec, 155
Museum of Modern Art, New York, 77–8, 83, 99
Museum of Modern Art, Paris, 76
Museum of Popular Arts and Traditions, 154
Museums and Galleries Commission, 243

Napoleon I, 215
National Art Collections, 26, 243
national considerations, 48–51
National Curriculum, English, 148
National Endowment for the Arts, 113, 115–16, 139, 141
National Gallery, Ireland, 31, 64
National Gallery, London, 43, 119, 236
catalogues, 43, 56–64
Chantrey Bequest, 13–14, 16–17, 19, 23
National Gallery of Art, USA, 77–8, 105, 119
National Gallery, Scotland, 64, 71
National Heritage Memorial Fund, 243
National Museum of Scotland, 156, 157
National Research Center of the Arts, 117, 141
national schools, 50–1
Nationalmuseet, Copenhagen, 271–4
natural history collections, 46
Negrin, L., 5, 40
Netherlands, 50, 113, 120–3, 126–7, 230
Neufchateau, François de, 215, 224, 225–6, 230–1
New Critics, 17
New English Art Club (NEAC), 8, 17, 18
New Monthly Magazine (1823), 56
New Statesman, 87

New Walk Museum, 145
New York Herald Tribune, 94
Newman, J., 235, 240, 246, 254, 258
News Chronicle, 23
Nicholas V, Pope, 217
Nkrumah, Kwame, 104
Noaillesc, Comtesse de, 99
Nordberg, Jan and Nylof, Goran, 141
North America, 9, 114, 165
 see also Canada; Québec; USA
Norway, 121–3, 131
*Notice des tableaux et monuments
 connus dans la ville de Clermont
 etc*, 200
Nottingham (1878), 68, 72
Nottingham museum, 157

occupation, 118–19, 127
O'Keefe, Georgia, exhibition, 78
Olander, W., 210, 214
Olsen, Bjornar, 273
Ottley, William Young, 52–4, 56–8, 73
Otto Dix exhibition, "A Tale of Two
 Germanies", 88
Ozouf, Mona, 225, 232

Palais Royale, Paris, 46, 50
Parliamentary Select Committee on
 Art and Principles of Design
 (1836), 58
Parliamentary Select Committees *see*
 Select Committees
participation studies, 114–33
Passavant, 60, 63
Patmore, P.G., 55
Pearce, Lynne, 86, 87, 92
Pearson, N., 20, 40
Pedro Lorente, J., 268–71
Peel, Sir Robert, 61
Peirson Jones, J., 154, 163
PEP (1946) *The Visual Arts*, 40
PEP Arts Enquiry (1946), 14
Perkin, H., 27, 40
Pevsner, N., 20, 40
Philadelphia Museum of Art, 105
*Pictorial History of Lower Italy, or the
 Florentine, Sienese etc*, 46–7
Pliny, Gaius, 219

Plongeron, Bernard, 195
Plot, Robert, 73
Plymouth, Lord, 26
Pointon, Marcia, 86, 92
Poirier, Dom, 204
Poland, 71, 121–2
political factors, 27, 34, 85–90
Pommier, E., 226, 232
Portugal, 121–2
Post-Impressionism, 7, 77, 79, 95–8
 shows (1910, 1920), 7
Post-Modernism, 74, 90
Poulot, Dominique, 279
Poultier, Jean-Baptiste, 202
Poussin, Niccolo, 54
power, 8, 11, 25, 27
Poynter, E.J., 17, 19
Pre-Raphaelite exhibition (Tate 1984),
 86
prehistory, 273
Premier Rapport sur le vandalisme, 203
presentation volumes, 46–7
Primitives, 95
Prince Regent, 13–14, 253
private collections, 51–6
private museums, 102–5
provincial museums, British, 65–71
professional classes, 9, 11, 27, 28, 32,
 34
Pronovost, Gilles, 133, 141
provincial art museums, 66
publicity, 80–1
Pye, J., 40

quality, 144
quantity, 144
Quatremère de Quincy, Antoine,
 215–24, 227
Québec, 121–3, 132, 133, 155
*Quelques Idées sur la Disposition,
 l'Arrangement et la Décoration
 du Museum National* (1796), 50
Quilter, Harry, 40

race, 118
 see also ethnic minorities
Rae, George, 33
Ramberg, J.H., 235, 246

Rapports sur le Vandalism, 194–8, 201, 203, 205
Redgrave, Richard and Samuel, 65
Reflections on the Imperial and Royal Picture Gallery in Vienna, 45
regional variations, 130, 133
Regnier, Gerard, 76
Reitlinger, Gerald, 40
Report of the National Inquiry into the Arts and the Community, 161, 163
Research Division, National Endowment for the Arts (1985), 141
Research Surveys of Great Britain (RSGB), 125, 131–2, 139, 141, 163
Reynolds, Joshua, 65, 234, 235, 252, 257
Richard Wilson exhibition, 85
Richter, J.P., 64
Ridgway, W., 55
Robertson, David, 40
Robespierre, Maximillian, 196–7, 203
Robinson, J. *et al*, 115, 141
Rockefeller, John D., 97
Rockefeller, Mrs Abby Aldrich, 99
Rogers, Malcolm, 79, 92
Rolfe, F., 28, 40
Rome, 50, 215–25
Romme, 193
Rondot (goldsmith from Troyes), 205–6, 213
Rosenlund, Lennart, 131, 141–2
Rothenstein, John, 17, 18, 23, 24–6, 40
Rothenstein, William, 40
Rousseau, Jean Jacques, 18
Rowlandson and Pugin, 252–3
Royal Academy (RA), 65, 77–8, 233–58
 catalogues, 51–2
 Chantrey Bequest, 6–8, 12–13, 17–19, 23–24, 28, 31–4
 Exhibitions, 12–13, 19–21, 29, 32, 51–2, 79, 81, 85, 88
 the Great Room, 244–54
Royal Commission (1863), 20, 35
Royal Holloway College, 65

Royal National Gallery, Berlin, 59
Royal Navy, 235
Royal Society of Painter–Etchers, 17
Rubinstein, W.D., 40
Russell, Bertrand, 102
Russia, 71, 79

Said, Edward, 87, 93
St Mungo's Museum of Religious Art and Life, Glasgow, 265–8
St Petersburg, 50–1
Sans-Souci, 45, 73
Savage, M. *et al*, 20, 27, 40
Scaltsa, Matoula, 82
school, classification of paintings by, 43
Schuster, J. Mark Davidson, 119, 142, 145, 277–8
Science and Art Museum, Nottingham, 68
scientific collections, 43
scientific taxonomy, 46–7
Scott, John, 19, 25–6, 40
sculptures, classical, 47–8
seating, 167–8
Seed, J. and Wolff, J., 40
Seguier, William, 56, 59–60, 61
Select Committees, 19, 23, 58–60, 63, 73
Selwood, Sara, 93
Seurat exhibition, 79
"Share Your Reaction" cards, 169, 170–7, 190
Shee, M.A., 40
Sheepshanks, John, 19–20
Shelton, Anthony Alan, 89, 93
Shepherd, Michael, 87, 93
Shinjuku Isetan Department Store, 80
Sienese Quattrocento painting exhibition, New York, 76–7
Sikj culture exhibition, 146
Sinott, Richard and Kavanagh, David, 135, 142
Smith, C.E., 20, 40
Smith, D., 40
Smith, N.P., 146, 147, 163
Soboul, A., 204, 214
Social Realist painting, 70

socio-economic groups, 131
 see also class; income
Solkin, David, 85–6
Somerset House, 233–58
Somerset House brochure, 240, 241
South Kensington, 19–20, 62, 67–8
South London gallery, 16
souvenirs, privately produced, 58–9
Soviet Union, 79
Spain, 50, 121–2, 129, 230
Spielmann, M.H., 41
Spigath, Gabriele, 193, 214
sponsorship, 9, 20, 27, 81–2, 83, 84, 161
Spurling, John, 85
Stafford, Marquess of, 52
Stanfield, William, 70
state formation, 9–15
Statham, R., 163
Stein, Gertrude, 100
Stevens, A., 34, 41
Stevenson, R.A., 17
Stieglitz, Alfred, 99
Stone, Lawrence and Stone, J.C.
 Fawtier, 41
Strong, R., 19, 41
subsidy, public, 120–3
Sunday Telegraph, 87
Supplementary Facility Use Survey,
 126
Surrealists, 77
Survey of London, 20, 41
Survey of Public Participation in the
 Arts (SPPA), 115–17
surveys, 111–33
Susie Fisher Group, 152, 163
Sutton, Denys, 85, 93
Swagger Portrait Exhibition, 88
Sweden, 121–3, 130

*Tableau de la ci-devant province
 d'Auvergne*, 200
Tadema, Alma, 8, 27
Tate Gallery, 5–7, 14–18, 21–6, 29–35
 Constable exhibitions, 78, 84
 Richard Wilson exhibition, 85
 Swagger Portrait exhibition, 88
Tate, Henry, 19, 32–3
tax incentives, 109

Taylor, John Russel, 87, 93
technology, electronic, 74
Thatcher, Margaret, 86
The Art in Painting, 94
*The Collection of Pictures of The Most
 Noble The Marquis of Stafford
 etc*, 52–3
"The Great Utopia: the Russian and
 Soviet Avant-Garde 1915–32",
 79
The Guardian, 23, 88
*The Journal of Arts Management and
 Law (1985)*, 141
The National Gallery of Pictures, 71
*The National Gallery of Pictures by the
 Great Masters*, 58
The Times, 23, 87
themes, 21, 49, 79, 154
Thorncroft, Anthony, 82, 93
Thornton, A., 31–2, 41
Thorwaldsen Museum, Copenhagen,
 47–8
Thwaites, Colonel, 60
Tijdbestedingsonderzoek (TBO)
 Survey, 127
Tillyard, S.K., 27, 33, 41
Toklas, Alice B., 100
Tokyo Isetan Museum of Art, 80
Tokyo's Museum of Western Art, 105
Torstendahl, R., 20, 41
Traditional Indian Arts of Gujarat
 exhibition, 146
Troisième Rapport sur le vandalisme,
 194–5
travelling exhibitions, 94, 156–7
Treasury, 17, 24, 26, 28, 29, 56, 63
Troyes, 205, 206
Trustees' Minutes National Gallery
 (TMNG), 56, 73
Tsui Gallery of Chinese Art, 155
Tucker, Paul Hayes, 86
Tunisia art and culture exhibition, 155
Turner collection, 18

United Kingdom *see* Britain
United States Bureau of the Census,
 115–16
University of Maryland, 115

USA, 109, 115–19, 121–2, 130–2, 150

Valpy's National Gallery of Paintings and Sculpture etc, 56
van der Doort, Abraham, 44
vandalism, 192–5, 196, 198–210
Varnedoe, Kirk and Gopnik, Adam, 83, 93
Vatican, Rome, 47–8
Veblen, Thorstein, 96
Vergo, Peter, 81, 93
Vernon, Robert, 19
Verwey, Peter, 122, 142
Victoria and Albert Museum, 14, 67, 155
Vienna, 45, 48–50, 73
Vincent, H.W., 56
visitors, 76, 143–4, 169–85
 children, 158
 disabled/handicapped, 8, 157
 improving displays for, 153–7
 profiles, 75
 reasons for attending art exhibitions, 77
 see also audiences
von Mechel, Christian, 45, 48, 49

Waagen, Gustav, 15, 41, 55, 59–63, 73
Walker Art Gallery, 67, 68, 119
Walpole, Horace, 51
Walsall Museum and Art Gallery, 146, 147, 154, 163
Waterfield, Giles, 55, 73, 125, 235, 244, 249, 252–3, 258, 276

Watney, S., 41
Watson, Peter, 81, 93, 258
Watts Collection, 16
Weiner, Martin J., 41
West, Benjamin, 235
West, Shearer, 276–7
White, H.C. and White, C.A., 5, 32, 35, 41
Whitechapel Gallery, 16, 17, 71
Widener, Joseph, 97
Wiesand, Andrew, 121, 142
Wightman, Gavin, 81, 93
Williams, R., 41
Wilson, David, 137, 142
Wilson, Richard (exhibition Tate 1982–3), 85
Wilton House, 51
Winckelmann, J.J., 49, 51
Wittlin, A., 137, 142
Woburn Square, 237, 238
working classes, 11, 15, 16, 27
Wornum, R., 61
 and Eastlake, C., 61. 62, 63–4, 73
Worts, Douglas, 168, 191, 261–4, 278–9
Wright, Philip, 77, 93, 142

Young, J., 54

Zoffany, John, 255, 257
Zolberg, Vera L., 96, 108, 277
Zorn, Elmar and Koidl, Roman, 80, 93